Richly contextualized via a masterful introduction, this book's story of the Eurovision Song Contest sings with the verve of topicality. The 'new' Europe is revealed in fascinating guises through clear-eyed accounts of what has been invested in its performance in particular places and among specific audiences. In the macronarratives shaping this global contest as much as the micromoments of its annual unfolding, national and supranational politics, we learn, are no less intriguing than that chameleon-like entity we still call Europe. A provocative and timely collection.

–Helen Gilbert, Professor of Theatre, Royal Holloway, University of London.

A book full of insight, facts, opinions and great stories about the world's most successful TV format ever.

–Svante Stockselius, Executive Supervisor of the Eurovision Song Contest (2003–2010).

This impressive collection takes Eurovision studies to the next level, and it is especially timely now that the new post-Wall unified Europe faces some of its greatest economic and political challenges. The newly expanded Song Contest is far more than just an entertaining or embarrassing TV show – it's actually still 'a battlefield', in the memorable words of one of the book's contributors; a way of channeling the tensions and rivalries that still lurk beneath and now often break through the surface of this ideal imagined Europe.

How do Britain and Russia see and sing themselves from their post-superpower positions, how do Israel and Serbia and Azerbaijan perform their inclusion in the European project, how do ethnic minorities like Roma play a role within national and cultural identities, and how do feminists and queers find themselves represented in a show that attracts many women and gays? The eleven contributors shine a light on all these questions and more in their incisive and often provocative analyses, while the lively panel discussion brings in broadcasters'

voices. All this makes for exciting new views on the 'new' Europe and its changing 'Euro-visions' that bridge music, culture, politics, and economics every spring.

–Ivan Raykoff, Associate Professor,
The New School; Co-editor of *A Song
For Europe: Popular Music and Politics in the
Eurovision Song Contest* (2007).

Studies in International Performance

Published in association with the International Federation of Theatre Research
General Editors: **Janelle Reinelt** and **Brian Singleton**

Culture and performance cross borders constantly, and not just the borders that define nations. In this new series, scholars of performance produce interactions between and among nations and cultures as well as genres, identities and imaginations.

International in the largest sense, the books collected in the *Studies in International Performance* series display a range of historical, theoretical, and critical approaches to the panoply of performances that make up the global surround. The series embraces 'Culture' which is institutional as well as improvised, underground or alternate, and treats 'Performance' as either intercultural or transnational as well as intracultural within nations.

Titles include:

Ketu Katrak
CONTEMPORARY INDIAN DANCE
New Creative Choreography in India and the Diaspora

Sonja Arsham Kuftinec
THEATRE, FACILITATION, AND NATION FORMATION IN THE BALKANS AND MIDDLE EAST

Daphne P. Lei
ALTERNATIVE CHINESE OPERA IN THE AGE OF GLOBALIZATION
Performing Zero

Peter Lichtenfels and John Rouse (*editors*)
PERFORMANCE, POLITICS AND ACTIVISM

Carol Martin (*editor*)
THE DRAMATURGY OF THE REAL ON THE WORLD STAGE

Carol Martin
THEATRE OF THE REAL

Yana Meerzon
PERFORMING EXILE, PERFORMING SELF
Drama, Theatre, Film

Lara D. Nielson and Patricia Ybarra (*editors*)
NEOLIBERALISM AND GLOBAL THEATRES
Performance Permutations

Alan Read
THEATRE, INTIMACY & ENGAGEMENT
The Last Human Venue

Shannon Steen
RACIAL GEOMETRIES OF THE BLACK ATLANTIC, ASIAN PACIFIC AND AMERICAN THEATRE

Marcus Tan
ACOUSTIC INTERCULTURALISM
Listening to Performance

Maurya Wickstrom
PERFORMANCE IN THE BLOCKADES OF NEOLIBERALISM
Thinking the Political Anew

S. E. Wilmer
NATIONAL THEATRES IN A CHANGING EUROPE

Evan Darwin Winet
INDONESIAN POSTCOLONIAL THEATRE
Spectral Genealogies and Absent Faces

Forthcoming titles:

Adrian Kear
THEATRE AND EVENT

Studies in International Performance
Series Standing Order ISBN 978–1–4039–4456–6 (hardback)
978–1–4039–4457–3 (paperback)
(*outside North America only*)

You can receive future titles in this series as they are published by placing a standing order. Please contact your bookseller or, in case of difficulty, write to us at the address below with your name and address, the title of the series and the ISBN quoted above.

Customer Services Department, Macmillan Distribution Ltd, Houndmills, Basingstoke, Hampshire RG21 6XS, England

Performing the 'New' Europe

Identities, Feelings, and Politics in the Eurovision Song Contest

Edited by

Karen Fricker and Milija Gluhovic

First published 2013 by
PALGRAVE MACMILLAN

Palgrave Macmillan in the UK is an imprint of Macmillan Publishers Limited, registered in England, company number 785998, of Houndmills, Basingstoke, Hampshire RG21 6XS.

Palgrave Macmillan in the US is a division of St Martin's Press LLC, 175 Fifth Avenue, New York, NY 10010.

Palgrave Macmillan is the global academic imprint of the above companies and has companies and representatives throughout the world.

Palgrave® and Macmillan® are registered trademarks in the United States, the United Kingdom, Europe and other countries.

ISBN 978–0–230–29992–4

This book is printed on paper suitable for recycling and made from fully managed and sustained forest sources. Logging, pulping and manufacturing processes are expected to conform to the environmental regulations of the country of origin.

A catalogue record for this book is available from the British Library.

A catalog record for this book is available from the Library of Congress.

Contents

Figures

Series Editors' Preface

The *Studies in International Performance* series was initiated in 2004 on behalf of the International Federation for Theatre Research, by Janelle Reinelt and Brian Singleton, successive presidents of the federation. Their aim was, and still is, to call on performance scholars to expand their disciplinary horizons to include the comparative study of performances across national, cultural, social, and political borders. This is necessary not only to avoid the homogenizing tendency of national paradigms in performance scholarship, but also to engage in creating new performance scholarship that takes account of and embraces the complexities of transnational cultural production, the new media, and the economic and social consequences of increasingly international forms of artistic expression. Comparative studies (especially when conceived across more than two terms) can value both the specifically local and the broadly conceived global forms of performance practices, histories, and social formations. Comparative aesthetics can challenge the limitations of national orthodoxies of art criticism and current artistic knowledges. In formalizing the work of the federation's members through rigorous and innovative scholarship, this series aims to make a significant contribution to an ever-changing project of knowledge creation.

<div style="text-align: right">

Janelle Reinelt and Brian Singleton
International Federation for Theatre Research
Fédération Internationale pour la Recherche Théâtrale

</div>

Acknowledgements

The editors would like to thank, first and foremost, the authors in this book for their superb contributions, along with the further membership of the Eurovision and the 'New' Europe Research Network, who participated in network workshops: Phil Jackson, Paul Jordan, Robert Kulpa, Apostolos Lampropoulos, Katarzyna Marciniak, Vesna Mikić, Katalin Miklóssy, Toni Sant, Justyna Sempruch, and Meyda Yeğenoğlu. A special thanks to the Eurovision stakeholders who participated in the panel discussion included here; and thanks to Meelis Kompus, Igor Kovalev, Paddy O'Connell, and Barry Viniker, who participated in a panel discussion at the 2010 Eurovision Song Contest (ESC) co-sponsored by this project and the Eurovision Research Network.

We gratefully acknowledge the support of the UK Arts and Humanities Research Council for the Research Networking grant which enabled this project. Initial and ongoing funding support was provided by the University of Warwick and Royal Holloway, University of London, and further support in the production process by McGill University and Brock University. Thanks to Katie Normington, Urvi Makwana, and Hitesh Patel at Royal Holloway; and Nadine Lewycky, Katie Klaassen, and Liese Perrin from Research Support Services at the University of Warwick – especially to Liese, for her expert stewardship of our grant application process.

We thank Janelle Reinelt and Brian Singleton for their support of this project throughout its life, and Paula Kennedy at Palgrave for her enthusiastic and patient participation as editor. Thanks to Paula's assistants Ben Doyle, Tom Earl, and Sacha Lake for their help in the production process.

Thanks to our research assistants, María Estrada Fuentes and Sarah Butcher, and to Agnieska Polakowska for editorial assistance. Thanks to Phil Jackson and Toni Sant in their Eurovision Research Network guises for collaboration on several projects along the way.

At the European Broadcasting Union (EBU), thanks to ESC event supervisor Sietse Bakker for his ongoing support of Eurovision research and of this project specifically, and to ESC communications coordinator

Jarmo Siim for answering questions along the way, and for help in accessing images of the contest.

Thanks to Gilli Bush-Bailey, Matthew Cohen, Helen Gilbert, Angela Krzeminski, and Dan Rebellato from the Department of Drama and Theatre, Royal Holloway, for their support, and a particular thanks to Jonathan Powell, head of Media Arts at Royal Holloway, for his Eurovision expertise. At the University of Warwick, thanks to Jim Davies, Nadine Holdsworth, Chris Bilton, Eleonora Belfiore, Ruth Leary, Claire Nicholls, Catherine Brennan, and Lindzey Mullard for their support and advice over the years.

Many colleagues, friends, and family have offered us helping hands and support, in ways both direct and lateral, as this project developed. Karen would like to thank Vicky Angelaki, John Hadoulis, Marina Markovic, Isis Menteth Wheelwright, Thames Menteth Wheelwright, Elena Moreo, Dejan Radojevic, and Julie Wheelwright for Eurovision-related favours and expertise. Thanks to Mel Mercier for the opportunity to present research in progress at University College Cork. And thanks to Michael Bacon, David Binder, Sean Brennan, Emma Brodzinski, Susan Conley, Maria Delgado, Kiara Downey, David Fancy, Brent Fowler, Céline Gagnon, Sean Heslop, Erin Hurley, Chris Megson, Sophie Nield, and Maura O'Keeffe for supporting me and my work beyond the call of friendly duty. To my family, Elizabeth, John, and Pat Fricker, thank you for your steadfast and loving support. A particular shout-out to my Eurovision family for great times from Athens, Helsinki, and Volos on forward: Apostolos, Brian, Milija, Paul, Peter, and especially Phil. *Era Stupendo.* Finally, and most of all, I would like to thank Loughlin Deegan and Denis Looby for inviting me to a Eurovision party ten years ago, little knowing what madness would ensue; and for their engagement with my Euro-projects, and loving hospitality, ever since.

Milija offers many thanks to Sandra Šuša, executive producer of the 2008 ESC in Belgrade; Sietse Bakker; Aleksej Zoric, head of the Serbian service at the BBC World Service; and Aleksandar Kostadinov, head of the Croatian delegation at the 2012 ESC, for their assistance in obtaining press accreditation at the ESC in 2008, 2010, 2011, and 2012. Many thanks to the University of Warwick for study leave in the autumn of 2012, which helped greatly the final stages of my work on this manuscript. Thanks also to Leila Alieva, Elhan Bagirov, Khayal Guliyev, Emin Huseynov, Rasul Jafarov, Kamran Rzayev, Jahangir Selimkhanov, and Sabina Shikhlinskaya for their various acts of assistance and generosity during the 2012 ESC in Baku. Thanks to Milena Dragićević Šešić for providing initial contacts for some of them. Thanks also to my

students at the University of Warwick, the University of Helsinki, and the University of Arts in Belgrade for their enlightening discussions about the ESC over the years.

With devotion I thank my families on both sides of the Atlantic, especially my parents Miladin and Borika Gluhović. Most of all, for his love and support and for seeing me though yet another marathon, my heartfelt thanks to Brent Fowler.

Contributors

Elaine Aston is Professor of Contemporary Performance at Lancaster University, UK. Her monographs include *Theatre as Sign-System* (1991, with George Savona), *Caryl Churchill* (1997/2001/2010), *Feminism and Theatre* (1995), *Feminist Theatre Practice* (1999), *Feminist Views on the English Stage* (2003), and *Performance Practice and Process: Contemporary [Women] Practitioners* (2008, with Geraldine Harris). She is co-editor of *The Cambridge Companion to Modern British Women Playwrights* (2000, with Janelle Reinelt), *Feminist Futures: Theatre, Performance, Theory* (2006, with Geraldine Harris), *Staging International Feminisms* (2007, with Sue-Ellen Case), and *The Cambridge Companion to Caryl Churchill* (2009, with Elin Diamond). She has served as Senior Editor of *Theatre Research International* (2010–2012).

Karen Fricker is Assistant Professor of Dramatic Arts at Brock University, Ontario, Canada, and has taught at Royal Holloway, University of London. She previously researched Eurovision fandom with Elena Moreo and Brian Singleton as part of a postdoctoral research fellowship at Trinity College Dublin. Her research on the Québec theatre artist Robert Lepage has appeared in, among others, *Contemporary Theatre Review*, *The Routledge Companion to Directors' Shakespeare*, *Globe: Revue internationale d'études québécoise*s, and *L'Annuaire théâtral*. Her volume for Manchester University Press on Lepage's original stage productions is forthcoming. She is the founding Editor-in-Chief of *Irish Theatre Magazine* and has written about theatre for the *Guardian*, *The Irish Times*, *The New York Times*, and *Variety*, among other publications.

Milija Gluhovic is Associate Professor of Theatre and Performance Studies at the University of Warwick, UK. His research interests include contemporary European theatre and performance, memory studies, and discourses of European identity, migrations, and human rights. His monograph *Performing European Memories: Trauma, Ethics, Politics* is forthcoming with Palgrave in 2013. He is also the director of an Erasmus Mundus MA in international performance research, an EU-sponsored programme taught collaboratively at the University of Warwick, the

University of Amsterdam, the University of Helsinki, and the University of Arts in Belgrade.

Yana Meerzon is Associate Professor in the Department of Theatre, University of Ottawa, Canada. Her research interests are in theatre and drama theory, theatre of exile, and Russian theatre and drama. Her articles have appeared in *New England Theatre Journal, Slavic and East European Journal, Semiotica, Modern Drama, Theatre Research in Canada, Journal of Dramatic Theory and Criticism, Canadian Theatre Review,* and *L'Annuaire théâtral.* She published *The Path of a Character: Michael Chekhov's Inspired Acting and Theatre Semiotic*s in 2005. *Performing Exile – Performing Self: Drama, Theatre, Film* was published by Palgrave, in the series Studies in International Performance, in 2012. She has co-edited two volumes on a similar subject: *Performance, Exile and 'America'* (2009, with Silvija Jestrovic) and *Adapting Chekhov: The Text and Its Mutations* (2012, with J. Douglas Clayton).

Mari Pajala is University Lecturer in Media Studies at the University of Turku, Finland. Her research interests are in the fields of TV history and culture, cultural memory studies, and feminist media studies. Her research on the ESC has been published in book form in Finnish: *Erot järjestykseen! Eurovision laulukilpailu, kansallisuus ja televisiohistoria (Ranking Differences: The Eurovision Song Contest, Nationality and Television History)* (2006); in a shorter monograph in German: *Finlande: zero points? Der Eurovision Song Contest in den finnischen Medien* (2007); and in articles in journals, such as *Media History* and *VIEW: Journal of European Television History and Culture.*

Dmitri Priven teaches in and coordinates the Teachers of English as a Second/Foreign Language programme at Algonquin College in Ottawa, Canada. His articles on first-language attrition and minority language education have appeared in the *Canadian Journal of Applied Linguistics, International Journal of Bilingual Education and Bilingualism,* and *Journal for the Education of the Gifted.* He has also published as literary translator from Russian. His last major project was a new translation of Chekhov's *Three Sisters* for the Shaw Festival in Niagara-on-the-Lake, Canada (with Yana Meerzon). His translation of Dmitri Lipskerov's *The Last Sleep of Reason* appeared in *Toronto Slavic Quarterly.*

Peter Rehberg is DAAD Associate Professor in the Department of Germanic Studies at the University of Texas at Austin, US. He has

published in the fields of queer studies, popular culture (including several articles on the ESC), and German studies. He has also worked as a journalist and has published one collection of short stories and two novels (*Fag Love*, 2005; *Boymen*, 2011). Recent academic publications include 'Hipstersex: postpornografische Erzählungen im schwulen Fanzine *Butt*' in *Pornografisierung von Gesellschaft*, eds. Martina Schuegraf and Angela Tillmann (2012); and ' *"still wonder where his male identity is"*. Bjarne Melgaard's Ruin of Masculinity' in *Goddesses. A Reader*, Ed. Andrea Kroksnes (2011). He is currently working on a book on post-pornography.

Katrin Sieg is Professor of German jointly affiliated with the BMW Center for German and European Studies and the German Department at Georgetown University, US. She is the author of three books on German and European theatre, including *Ethnic Drag: Performing Race, Nation, Sexuality in West Germany* (2002) and *Choreographing the Global in European Cinema and Theater* (2008), and she has published a range of articles in feminist studies and critical race studies as they intersect with performance. Her research on the ESC is published in the *European Journal of Cultural Studies* and *Theatre Research International*.

Brian Singleton holds the Samuel Beckett Chair of Drama and Theatre and is Academic Director of The Lir – National Academy of Dramatic Art at Trinity College Dublin. He is a former president of the International Federation for Theatre Research and former editor of *Theatre Research International*. He is Series Editor (with Janelle Reinelt) of the Studies in International Performance series (Palgrave). He has published on orientalism/interculturalism, gender, and performance in many books and journals. His most recent monograph is entitled *Masculinities and the Contemporary Irish Theatre* (Palgrave, 2011). He has also published several articles on Eurovision fandom and queerness with Karen Fricker and Elena Moreo.

Ioana Szeman is Senior Lecturer in Drama, Theatre and Performance Studies at the University of Roehampton, London. Her first book project, *Stages of Erasure: Roma and the Politics of Performative Citizenship in Postsocialist Multiculturalism*, is based on ten years of ethnographic research with Romani communities, artists, and activists in Romania. Her current research focusses on gender and labour in state theatres and directorial practices, and the success of Romanian directors abroad during and after socialism. Her articles have appeared in *Theatre Research*

International, New Theatre Quarterly, TDR, and *Performance Research*, and she is a member of the *Feminist Review* editorial collective.

Marilena Zaroulia is Lecturer in Drama and the programme leader of the MA in popular performances at the University of Winchester. Her research focuses on contemporary performance and cultural politics, and post-1989 British and European theatre. She has published on Thomas Ostermeier's *Hamlet*, David Greig's dramaturgy, Greek national identity, and the Olympic Games. She is currently working on a monograph studying the relation between British theatre and Europe since 1989 and co-convening 'Inside/Outside Europe: Performances of Capitalism, Crises and Resistance', a research project studying performances of crises and crisis as performance in contemporary Europe.

Introduction: Eurovision and the 'New' Europe

Karen Fricker and Milija Gluhovic

The year 2012 was a tumultuous one for Europe. The sovereign debt crisis, considered by many to be the biggest challenge 'to hit Europe since World War II' (Smith, 2012a), deepened, with protests against austerity measures spreading from Greece to Portugal to Spain, as the latter vacillated about whether or not to request a bailout from the International Monetary Fund (IMF) in the face of crippling national debt. Eurozone countries, led by Germany, approached a showdown with the IMF about the increasingly apparent failure of austerity measures to save the Greek economy. The arrest and detention of members of the feminist punk rock collective Pussy Riot in Moscow, after having staged a performance critiquing the Orthodox Church's support of the Russian president, Vladimir Putin, in a recent election, drew global attention to the oppressiveness of Russian society under Putin's leadership. Russia and Turkey became variously implicated in the bloody conflict in Syria even as the United Nations and European Union (EU) prevaricated about taking action in the region (see *The Economist*, 2012c; Tisdall, 2012). The resource-rich republic of Georgia saw its first power shift via election (as opposed to revolution) since its independence in 1991, though experts predicted that billionaire Bidzina Ivanishvili and his Georgian Dream coalition would be challenged to see through a peaceful transition from the authoritarian government of Mikael Saakashvili (see *The Economist*, 2012b; Harding, 2012).

That the EU was awarded the Nobel Peace Prize in December 2012 in recognition of its contribution 'to the advancement of peace and reconciliation, democracy and human rights in Europe' for six decades (www.nobelprize.org) was greeted with elation in Brussels but surprise and protest elsewhere. Several former winners of the prize, including the South African archbishop, Desmond Tutu, contested the award, writing

1

in an open letter to the Nobel committee that the EU 'clearly is not one of "the champions of peace" Alfred Nobel had in mind' when founding the prize in 1895, because it relies on 'security based on military force and waging wars rather than insisting on the need for an alternative approach' (ctd. in Nordstrom, 2012). The governments of many EU member nations supported the US-led invasion of Iraq and formed part of the coalition leading military operations in that country during the 2003–2011 war (Lévy et al., 2005: xiii–xiv); while, two decades earlier, the EU along with many of its members drew criticism for 'failing to intervene rapidly in a series of wars on its doorstep as Yugoslavia collapsed' (Baker and Korayni, 2012). This troubled record on military, political, and humanitarian concerns in Europe, along with the extent of economic, social, and political strife across the expanded Europe at the time of the award, contributed to the sense among some observers and commentators that giving the prize to the EU was highly problematic.

Clearly, the questions of what constitutes Europe, the extent of its powers and responsibilities, and what holds it together despite the many local, regional, and international forces pulling it apart remain as urgent as they were in 1949, when ten Western European nations came together 'to develop throughout Europe common and democratic principles' by forming the Council of Europe (CoE) (Council of Europe, 2012); in 1950 and 1958 when the European Coal and Steel Community and the European Economic Community (EEC) – the forerunners of the EU – were created to promote economic cooperation and greater European interdependence (EU, 2012); in 1989, when the Iron Curtain fell; and again in 2004 and 2007 with subsequent EU expansions.[1] Throughout these tumultuous 60-some years, as political and economic harmony proved ever-elusive, popular culture, the arts, and broadcasting were touted as possible means for fostering and disseminating a shared sense of European unity and values, however perhaps fleeting and difficult to quantify. The European Broadcasting Union (EBU), founded in 1950, is widely understood as a conduit for pan-European communication and understanding via the sharing and exchange of programming, though these idealistic principles are in fact more perceived than intended. As Patrick Merziger and Klaus Nathaus point out, the EBU was founded 'not so much as a tool to foster European integration, but as a joint venture to produce content for television, the new medium, at lower costs' (2009: 204). As a 2009 conference on Western European popular culture suggested, the initiatives that have proved longest-lasting and most effective in promoting – at least at the level of production – an image of shared European culture are structured

as national competitions, including 'world fairs and television formats such as the Eurovision Song Contest [ESC]' (ibid.: 208).

The project that produced the present volume – the Eurovision and the 'New' Europe Research Network – is driven by an understanding of the ESC as a stage on which these changing realities of Europe are being played out, particularly in the wake of perestroika and the Iron Curtain's collapse. Following Janelle Reinelt, with the phrase ' "new" Europe' we gesture not only to post-Soviet countries eager to participate in the grand narrative of Europe but also to an entity 'in the process of emerging... that might become, replace, or perhaps parasitically inhabit the older Europe' (2001: 265). The project proposes the contemporary ESC as not just a mirror but perhaps a driver of changing conceptions and realities of Europe and Europeanness since the fall of the Berlin Wall. The ESC, with its unique, imaginative, and aesthetic modality, has always been a symbolic contact zone between European cultures – an arena for European identification in which both national solidarity and participation in a European identity are confirmed. It is also a site where cultural struggles over the meanings, frontiers, and limits of Europe, as well as similarities and differences existing within Europe, are enacted (see Reinelt, 2001).

As Merziger and Nathaus indicate above, the ESC was founded in 1956 to create shared content for the fledgling EBU. The brainchild of EBU employee Marcel Bezençon, it was modelled on Italy's Festival della canzone italiana di Sanremo, a competition of original popular songs founded in 1951 that is still thriving in the 21st century (Sanremo Festival, 2012). The basic concept of the ESC, which has remained consistent throughout its enlargement and evolution, is that European countries compete against each other to write and perform the best original pop song that year. While the ESC is framed as a contest of nations – it is not artists' names, for example, but names of countries that appear on the scoreboard[2] – it is run by broadcasting organizations, which select and present the competing songs and, in the event that they win, are given the opportunity to host the competition the following year.[3] The contest is run by an executive supervisor, who is a full-time EBU staff member. Its governing body, the reference group, is made up of a small group of executives from participating broadcasters. The reference group is responsible for maintaining, enforcing, and sometimes changing the contest's rules; a strongly held value among contest decision-makers is that the ESC format remains successful because it is constantly being innovated, as European and global cultures themselves evolve (see Chapter 4). Language rules, for example, have changed

throughout the contest's history. Initially, entrants could sing in any language; from the mid-1960s through to the end of the 1990s (with several hiatuses), songs had to be sung in an official language of the competing nation; and since 1999, entrants have once again been allowed to choose their language. Seven countries – Belgium, France, Germany, Italy, Luxembourg, the Netherlands, and Switzerland – competed in the first ESC in Lugano in 1956. The winner was the Swiss entry, 'Refrain', sung by Lys Assia. In its first 30 years the contest steadily grew in size, as countries from the Nordic and Mediterranean regions joined. The entry of EBU members Israel in 1973 and Turkey in 1975 was early evidence of the contest's challenges to traditional, continental, Western-centric understandings of Europe.[4]

Particularly since the 1990s, the ESC has been changing rapidly in response to the continent's shifting political, social, and economic realities. The number of competing countries has nearly doubled (from 22 participants in 1990 to 43 in 2011), and new entrant countries and first-time winners have come to dominate the contest: from 2000 to 2008, every winner was an Eastern or Southern European nation. This prompted concern among some Western European media and contest insiders, who portrayed this as invasion or wrongful domination. Their anxiety echoed, and was fuelled by, larger tensions within Europe about westward migration, and perceived differing levels of economic and cultural development between Western and non-Western European nations. Voting practices became a focus of negative Western commentary on the changing ESC. The press and social media depicted the tendency of neighbouring countries to exchange votes, and of countries with significant immigrant populations to vote for the countries of these immigrants' origin (such as high votes for Turkey from Germany), as suspect and unfair. Actually, research has shown that such voting exchanges based on physical proximity, cultural similarity, and/or diasporic links have existed since the contest's early days (see Yair, 1995; Yair and Maiman, 1996; Fenn et al., 2005; Gatherer, 2006).

A rules change following the 2008 contest, which reinstated expert juries to provide 50 per cent of the votes, alongside a 50 per cent public vote (following a decade of contests decided entirely by televoting), was an attempt by the EBU to placate Western broadcasters unhappy with the new-entrant winning streak, and the realignment of European power relations that it might mirror (see Chapter 4). This change also underlined the financial domination of the contest by Western broadcasters: in 2009 it was confirmed that the 'Big Four' countries (the UK, Germany, Spain, and France) contribute 40 per cent of the overall EBU budget because of their large population numbers (see Roberts, 2009:

151–152).[5] Such affirmation of the power that affluent Western nations hold over the running of the contest parallels the emerging reality that Central and Eastern European states have not come to enjoy the same level of economic prosperity as their Western neighbours. One of the central foci of this research project is an at attempt at a clear, even-handed look at the lived political, economic, and social realities of the 'new' Europe in the 2000s, as it has become increasingly evident that the utopic hopes of European unity following on from 1989 have not materialized.

With subsequent wins in 2009 and 2010 by longtime participant nations Norway and Germany, the voting rules change appeared to have had its desired effect of reshifting the ESC balance of power westward. However, the win in 2011 of the resource-rich Caucasus nation of Azerbaijan, which had joined the competition only four years before, provided the EBU with arguably its most politically contentious Eurovision contest to date (Figure I.1). As Milija Gluhovic recounts (Chapter 10), the 2012 Eurovision hosts grabbed headlines worldwide, initially for the unprecedented amount of resource poured into the contest in the Azeri capital, Baku, but then faced a less welcome spotlight as human rights abuses, including forced evictions and containment of

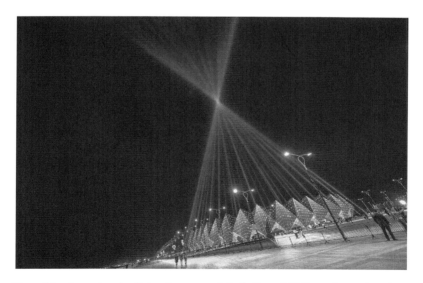

Figure I.1 A spectacular light show over Baku's Crystal Hall on the night of the 2012 ESC final. The Azeri organizers custom-built the venue to host the contest
Source: Andres Putting.

public assembly in the run-up to the contest, came to light. In this volatile environment, much Western coverage of the Azerbaijan contest proved hyperbolic and imprecise, and had the result of 'confirming European perceptions of Muslims' intolerance and authoritarianism, rather than broadening their perception of Europeanness', as Katrin Sieg argues (219). In this we see the latest iteration of a long-held historical tendency towards bipolar representations of Europe as civilized West vs. barbarian East. A further goal of this project has been the disruption of such binaries in favour of more nuanced readings of the interdependencies and flows between former West and former East, and of the historic power relations that constructed and perpetuate visions of the two-sided Europe.

It was with this background and goals in mind that, in 2009, we launched a research network which came to include nearly two dozen scholars from varying disciplinary backgrounds, including Central and Eastern European studies, cultural studies, gender and queer studies, French studies, German studies, media and television studies, musicology, political history, sociology, and theatre and performance studies. Network members represent a range of cultural and national backgrounds, hailing from Bosnia and Herzegovina, Canada, Finland, Germany, Greece, Hungary, Ireland, Malta, Poland, Russia, Serbia, Turkey, the UK, and the US; and they are based in higher education institutions throughout Europe and North America. An initial workshop held at Warwick University, UK, in June 2009 advanced thinking on the key themes of the project. A grant from the UK's Arts and Humanities Research Council enabled three workshops in the first half of 2011, organized around three themes which also provide the tripartite structure of this volume. The first workshop, held at Royal Holloway, University of London, UK, in February 2011, featured presentations on the theme of 'European Margins and Multiple Modernities', which explored the ESC as a site of articulation of a new European identity in a way that moves beyond simplistic notions of West and East, querying the idea of Europe as an ideological, cultural, and geopolitical construct. A second workshop at the Palazzo Pesaro Papafava, the University of Warwick's teaching facility in Venice, Italy, in April 2011, was called 'Queering Europe', bringing scholars together to explore the ways in which gender and sexuality are performed and problematized on the Eurovision stage, and the ways in which the contest and its stakeholders are engaged in the politics of gender and sexuality. A final workshop gathered at the Fachhochschule Düsseldorf, Germany, in May, during the week of the 2011 Eurovision contest, to address the theme 'Feeling European:

The Eurovision Song Contest and the European Public Sphere', looking at the relationships between European publics and the contest, with a particular focus on the strong feelings that it engenders.

We intend for this research to participate in and contribute to the ways in which key stakeholders understand the ESC and its meanings, and thus we invited the participation of broadcasters, participants, journalists, and fans to several of our network activities. Paul Marks-Jones, president of the UK chapter of the *Organization Générale des amateurs de l'Eurovision*, the official ESC fan club, attended the Royal Holloway workshop, as did Peter Devine, a journalist for Manchester Evening News Media (UK) with a particular interest in the ESC. Included in that workshop was a panel discussion featuring broadcasters involved in the production and management of the ESC, from Denmark, Finland, Romania, and the UK. An edited transcript of that discussion is included here (Chapter 4).

Before we move on to these thematic areas, it is important to introduce and explore the central term in this research. Assumptions and beliefs about what we understand by 'Europe' – geographically, historically, institutionally – have always been a matter of contention. Addressing the question of geography, for example, Catherine Lee and Robert Bideleux have suggested that ' "Europe" has never been a fixed geographical area with permanent and generally accepted boundaries' (2009: 164). They quote with approval Count Richard Coudenhove-Kalergi, founder in the 1920s of the Pan-Europa movement, who argued that 'Geographically, there is no European continent; there is only a European peninsula of the Eurasian continent' (qtd. in Lee and Bideleux, 2009: 164). Following in this intellectual tradition, Jacques Derrida presents Europe as a 'small sticking-out peninsula which wants to represent at all costs "men's progress" with respect to Asia' as part of a critique of a Eurocentric imagination built upon the superiority of European values (1992: 20). On the other hand, scholars such as William Outhwaite assert that 'the conventionally defined borders of Europe are . . . as "natural" as they come' (2006: 109). However, these 'natural boundaries' (the Ural Mountains to the east, the Mediterranean Sea to the south, and so forth) become compromised when we take into account that as a result of its colonial past, jurisdictionally, Europe includes countries and territories located across the world. As Peo Hansen remarks, the current EU stretches into Africa, the Caribbean, South America, the Pacific, and the Indian Ocean, belying typical representations of the EU as being congruent with the commonly recognizable geographical boundaries of Europe. (For Hansen, the EU's disinclination to acknowledge this

fact also reflects its reluctance 'to deal with the history and legacy of colonialism', which continues to have implications for the inclusion and exclusion of minorities and migrants in relation to the EU today [2004: 57; see also Gluhovic, 2013].) Beyond Europe's borders belonging to its nation states or the EU there are also those belonging to the various 'Europes' formed by the CoE, which includes countries such as the Russian Federation and Azerbaijan; by the 49 countries of the European Higher Education Area (Bologna Process), which includes the South Caucasus countries, the Russian Federation, Turkey, and Ukraine; and by many other networks and associations that call themselves 'European'.

Étienne Balibar, one of the leading contemporary theorists of European borders, asserts that 'from the cultural, economic and political point of view Europe has never been a *closed space* since it emerged as a historical reality', and that 'the "borders of Europe" do not exist, except as "arbitrary" delimitations whose justifications lie in strategic and technical reasons' (2009a: 6–7). Indeed, the fall of the Berlin Wall, which symbolically marked the end of an internal East–West divide within Europe, has led to the misapprehension that borders within Europe are less relevant. However, the tiered approach to enlargement to include Central and Eastern European states and the Schengen arrangements are examples of the ways in which the EU has secured new borders by creating differing 'others' within Europe (Zielonka, 2002; Engel-Di Mauro, 2006). Furthermore, violent security policies are being waged in the name of Europe by countries that serve as the main entry points to Fortress Europe – now exacerbated by the conjecture of the 'global war on terror'. This has led to a sustained increase in the death toll among migrants and refugees from poor countries (particularly in Africa and Asia), pointing to what Balibar terms the 'material constitution of Europe' and exclusions that it engenders (Balibar, 2009b: 202). Other scholars assert that Europe should be understood neither as a geographical nor as a political entity, but rather as 'a succession of contending ideas and competing values, norms and practices', including those associated with the development of the EU, which in the contemporary world has become almost synonymous with Europe (Lee and Bideleux, 2009: 166). But, as Catherine Lee and Robert Bideleux observe, 'The mental map of "Europe" is constantly altered and redrawn and thus it is only possible to try to capture a "snapshot" of "Europe" at a given moment and not to find an enduring "Europe"', which therefore 'makes the striving to establish a shared European identity all the more problematic' (2009: 168).

In her study entitled *Becoming Europeans: Cultural Identity and Cultural Policies*, Monica Sassatelli notes that in the wake of the first attempts at European integration, pro-European political and intellectual elites started to realize that legal and economic integration alone would not create a united Europe. Hence, since the 1980s, identity-formation and 'culture-building' have become explicit political objectives in the campaign to promote what EU officials and politicians call the 'European idea'. Substantial cultural funding programmes run by the EU (but also the CoE and so-called grass-roots agencies, such as the European Cultural Foundation) are attempts to create a European cultural space which might then foster the emergence of solidarity among Europeans. For instance, the EU's Culture 2000 and its predecessor and successor programmes have sought to create new linkages among Europeans formerly divided by the iron curtain as well as the economic North–South axis. In addition, EU funds have been used to foster collaboration and exchange between EU and non-EU countries in Eastern Europe, and with Middle Eastern and North African cultural partners in the Mediterranean region. While lack of space here prevents us from addressing at length the academic and institutional debates on European cultural identity, EU cultural policy, and the relationship of culture, identity, and governance in the European context, we would like to point, along with Luisa Passerini, to the dangers which are implicit in 'flattening the European identity on the idea (and the reality) of a united Europe' (2012: 122). According to this cultural historian, the different ideas and ideologies regarding a united Europe, and the questions of what the constituent parts of Europe share in common and what it means to be European, are better kept distinct:

> The theme of a united Europe is in force in the political, social, economic and cultural fields, while identity refers to a field which is at the same time wider and narrower, which moves from everyday life in both its material and emotional aspects to 'high' and 'low' cultural forms, of the elites and the masses.

> (ibid.)

Part I. Feeling European: The Eurovision Song Contest and the European Public Sphere

If, then, as Passerini has argued in reference to Europeanness, new types of European identification do not conflict with self-recognitions based on gender, age, and cultural belonging (ibid.: 126; see also Passserini,

2007), or, as Derrida puts it, one can feel European 'among other things' (1992), how does the Eurovision Song Contest (ESC) (in its new configuration) reflect and shape the sense of belonging to Europe that has emerged in the last 20 years? In their introduction to the edited collection *Festivals and the Cultural Public Sphere*, Liana Giorgi and Sassatelli address the significance of contemporary arts festivals, examining the ways in which they negotiate and communicate collective identities. Noting an explosion of festivals throughout the world and especially in Europe over the past decade, they remark that 'some festivals are explicitly defined as sites for contestation and democratic debate', while 'almost all carry political messages one way or another' (2011: 2). In a similar vein, we argue that multilateral, complex projects and events, such as the ESC, may be a way of creating a new European awareness, offering insights into the diverse simultaneous realities that are lived in Europe, increasing the intercultural competence and sensitivity of both artists and audiences, and becoming a force shaping a notion of European citizenship.

As such, our work participates in a broader move in theatre and performance studies to 'revise, extend, challenge and enliven existing notions of publics and publicness' with the goal of uncovering 'new strategies for thinking about and engaging with global transformations' (Levin and Schweitzer, 2011: 1). As Laura Levin and Marlies Schweitzer, co-editors of an issue of *Performance Research* on 'Performing Publics', argue, a performance studies approach is useful in gaining purchase on 'the idea of a public' which has become so intrinsic to contemporary life as to be 'taken for granted', as was the influential assertion of Michael Warner in *Publics and Counterpublics* (2002: 8). Such an approach considers the ways in which a group of spectators constitutes a temporary public; explores the changing definitions of shared and private experience, and the changing relationship between them; and 'describe(s) a performative relationship between individuals – the ways that identities, identifications, and ideologies serve to relate and differentiate people within the public sphere' (Levin and Schweitzer, 2011: 2). As we have been exploring, contentions around and shifts in understandings of 'Europe' render it a difficult concept to grasp, visualize, and experience; part of the enduring appeal of the ESC to spectators and producers, we contend, is its capacity annually to engage a vast pan-European public, temporarily produced via the contest's liveness and symbolic power. As Reinelt argues, it is essential to take 'major media entertainment performances' seriously as sites for the articulation of publics (2011: 27): the ESC's status as a popular, mass-media event (reaching, in official

EBU accounts, some 100 million telespectators annually, doubtless more when live internet viewing is considered) is central to its ability to produce a sense of Europeanness.

As Reinelt further argues, following Warner, we also cannot under-estimate the capacity of publics to interact with mass performances in resistant ways, thus producing themselves as counterpublics 'that come into being creating an alternative or rival public culture ... resistance can sometimes be found in unlikely places' (2011: 19, 27). Such a concep-tion of counterpublics resonates with readings of the ESC such as offered by Peter Rehberg elsewhere (2007), and in Chapter 9, which understand the contest, because of its 'camp qualities, queer fan base, and European audience', as offering to queer spectators 'an opportunity to experience a feeling of belonging both on the national and transnational level, which is rendered more complicated or foreclosed in other cultural mainstream contexts and the public sphere in general' (2013: 178). The contest also provides a forum where the weaknesses and failures of Europe as an inclusive and functional public sphere are materialized and rendered available for critique, as Marilena Zaroulia and Sieg argue in chapters 1 and 11, respectively.

We observe similar serious consideration of the capacity of global TV spectacles to produce publics and counterpublics in the work of Helen Gilbert and Jacqueline Lo, who launch their book-length study of cross-cultural performance in Australasia with a consideration of the opening ceremony of the Sydney 2000 Olympic Games, describ-ing it as an 'emphatically global *and* local performance, designed not only to capture the imagination of a vast media audience but also to present the nation to itself through popular and allusive iconogra-phies' (2007: 1). The foregrounded inclusion of Aboriginal peoples in the ceremony, they argue, allowed Australian organizers to offer an 'allegory of postcolonial reconciliation' within the expected celebration of Olympic Games values, such as democracy and 'community among nations' (ibid.). In a similar spirit, an upcoming (Autumn 2013) spe-cial issue of *Contemporary Theatre Review* edited by Jen Harvie and Keren Zaiontz will consider 'the role of cultural performance in hosting and staging the 2012 London Olympic Games', understanding not just the Cultural Olympiad but the games as a whole as offering 'opportunities to interrogate and challenge official narratives, modes of address and assumptions, and to propose alternative priorities' (Harvie and Zaiontz, 2013). Nadine Holdsworth, for her part, reads the hit TV series *Britain's Got Talent* (a concept now franchised globally) somewhat against the grain, not as yet another money-making opportunity for producer

Simon Cowell via, in some cases, the subjecting of credulous competi-
tors to the 'sneering cruelty' of the show's judges (Salmon, 2013), but
rather as a highly public site wherein the UK 'exhibits and celebrates
many of the values [it] likes to project about itself as a nation: patrio-
tism, democracy, and eccentricity, to name a few' (2010: 2; see Karen
Fricker's discussion in Chapter 2).

Throughout our research we have become particularly interested in
the roles that affect plays in viewers' various affiliations to the ESC, lead-
ing us to inquire into the ways in which individual contest acts, and the
spectacle and gesture of the contest as a whole, stimulate feelings and
different levels of identification (with the nation, with the region, with
Europe itself, and with subaltern groupings, such as gay/queer or immi-
grant).[6] Erin Hurley's book *National Performance: Representing Québec from
Expo 67 to Céline Dion*, showing how 'affect may provide another way
into reading performances as national or as nationalising *alongside* the
referential reading', offers one possible point of departure for theorizing
performance–nation relations (2011: 168). According to her, 'thinking
affect opens the door to seeing how people may produce themselves
as national, even in conditions that militate against it' (ibid.: 169). For
instance, she shows how pop diva Céline Dion's 'emotional labours both
lay the affective groundwork of the nation and re-key common under-
standings of arts-nation links by shifting the frame of reference from
signification to "affection" with its unpredictable and non-utilitarian
effects' (ibid.: 169). While Hurley focusses on theorizing performance's
emotional labours vis-à-vis nation by examining cultural production in
modern Québec,[7] the emotional labour that European artists perform
and the affective alliances they enable for their audiences in the ESC
furnish their own set of challenges for theorizing performance–nation
relations. If, as Balibar argues, the idea of the 'European people' remains
'aporetic' – given, for instance, the ongoing Eurozone crisis, and vari-
ous modes of inclusion and exclusion in the European sphere – then
what kind of shared emotional repertoires emerge in the ESC arena
(Balibar, 2009a: 13)? What kinds of 'politics of emotion' (Ahmed: 2004),
we wonder, are enacted on the Eurovision stages?

The affective components of European citizenship and the European
public sphere are at the core of the chapters in Part I. Other key ques-
tions that these address are: What are the synergies and contradictions
between the idea of Europe as constructed by official EU discourses and
programmes (i.e. by Euro-elites in Brussels), and the idea of Europe
as enacted by the ESC, historically and in the present day? To what
extent could the ESC be seen as actively fostering a European public

sphere – understood here as a 'composite public sphere consisting of interconnected national public spheres'? (Kaelble, 2010: 12)?[8] Does the ESC with its embodied practices through gestural, sound, and image vocabularies enhance possibilities for effective public engagement and the formation of new publics and counterpublics; and if so, how does the ESC enhance the communicative circuits of public engagement needed to sustain democratic praxis (Reinelt, 2011)? How can current theorizations of affect help us to understand ESC voting practices, including what is controversially referred to as 'bloc' and diasporic voting, and grass-roots campaigns among minority, in particular gay, communities, to support particular acts?

We open Part 1 with Zaroulia's contribution, ' "Sharing the Moment": Europe, Affect and Utopian Performatives in the Eurovision Song Contest' (Chapter 1), which through its combination of scholarly analysis and personal memoir explores the way in which feelings associated with the ESC are negotiated in the private and public sphere and experienced through the body. In close dialogue with Sara Ahmed's theorization of affect in relation to social meaning, and Passerini's reflections on Europe and emotions, Zaroulia offers an introspective account of distinct moments of her emotional engagement with the ESC and the kinds of tension and reflection these have provoked. While a decade ago Balibar could write that European unification 'has reached a point of irreversibility' (2004: viii–ix), the present financial crisis in Europe allows Zaroulia to look at the whole European (EU) project with a sceptical eye, while also trying to understand the contemporary dialectic between the EU and her native Greece in this critical conjecture, and the way this is reflected by the ESC.

Fricker joins this conversation about affect and the cultural public sphere with her contribution ' "It's Just Not Funny Any More": Terry Wogan, Melancholy Britain and the Eurovision Song Contest' (Chapter 2). Focusing in particular on Sir Terry Wogan's ESC commentary for the BBC over several decades, Fricker probes UK narratives about the ESC to show how they mediate and construct a particular vision of Europe and the UK's place in relation to it. Wogan's increasingly conservative rhetoric, argues Fricker, reflects some deep-seated British anxieties about the place of the UK in the context of the evolving Europe, but is also symptomatic of a particular strand of postcolonial melancholia (after Paul Gilroy, 2005) and a nostalgic mode of engagement with the British colonial past and imperial supremacy. What the current bout of postimperial nostalgia in the UK also masks (a critique which can easily be applied to other former European colonial powers) is a lack of a

critical engagement with the past and Europe's negative inheritance (see e.g. Spencer, 2009; De Medeiros, 2011). But if we shift our perspective from the UK's nostalgia and look at its participation in the ESC in its own right, we can see that its recent 'Eurovision entries offer a portrait of a lively and diverse society attempting to adapt to a cultural showcase whose codes and conventions are rapidly changing' (74).

In her treatment of disappointment and conspiracy theories, Mari Pajala's contribution, 'Europe, with Feeling: The Eurovision Song Contest as Entertainment' (Chapter 3) is in direct dialogue with Fricker's piece. Pajala reminds us that ESC performances and results often evoke strong emotions, focussing 'on three kinds of situations where feelings engendered by the ESC result in action: voting, complaining, and singing along' (79). Calling on Richard Dyer's theorization of entertainment and utopia (1992), Pajala identifies specific qualities of the ESC that engender feeling-responses, and she explores the different ways in which fans and media figures cope with the many disappointments that the contest can present – by the fostering of conspiracy theories, but also by reparative means, such as fan polls. Her view of the regional and local nature of fan affiliations to certain songs leads her to conclude that 'the contemporary ESC both reproduces historical divisions and tensions in Europe and provides opportunities for new connections and affinities'.

The final chapter in this part (Chapter 4) is a transcript of the panel discussion held in February 2011 at Royal Holloway, University of London, featuring high-level contest stakeholders including Kjell Ekholm, former ESC head of delegation for YLE (Finland); Jørgen Franck, then director interim of TV at the EBU; Steve Hocking, a BBC executive producer who is also vice-chair of the EBU's TV committee; and Mariana Rusen, who heads up press and publicity for TVR (Romania)'s ESC participation. The discussion provides insight into the material, logistical, and affective considerations that underlie the organization and delivery of this complex transnational event. As participants underline, the ESC has since its inception been at the forefront of technological innovation in live television broadcasting, making it an event in which TV executives and technicians across Europe are very keen to participate. Significant concerns are voiced about how the consistent enlargement and spectacularization of the contest renders hosting it financially and logistically challenging for smaller countries, a problem that underlines and is exacerbated by the uneven economic development of the 'new' Europe. Throughout the discussion, the importance of the contest as a point of national identification and pride is underlined; Ekholm

describes Finland's 2006 win and subsequent hosting, after 40 years of participation including frequent poor results, as the end of a national 'trauma' (96). For Franck, the contest is a significant point of trans-European identification, which he describes as the ESC's 'mission': 'The music is a tool that we use to bring the broadcasters and the populations of Europe together' (99).

Taken together, the chapters in Part I explore different modalities of our engagement and identification with Europe, Europeanness, and being European, bringing into being new understandings relevant to the worlds we, in different parts of Europe, inhabit together.

Part II: European Margins and Multiple Modernities

Among many 20th-century attempts to locate a central point of European identity that might distinguish it from the identities of other peoples and continents, the equation of Europe with modernity, progress, and 'the particular site of the invention of the universal and its revelation to the world' – an identification as old as the Enlightenment – holds a prominent place (Balibar, 2009a: 3). However, the experience of the two world wars; the bloody post-war decolonization drama; the decline of Europe's political, economic, and military supremacy; and contemporary processes of economic globalization resulted in a new expression of European self-understanding centred on the concept of multiple modernities. Originally developed by the sociologist Shmuel Eisenstadt (2000, 2001, 2003, 2006), the term offered a corrective to earlier conceptions that understood modernization as a process of Westernization, a unilateral process that emerged in the West and, 'in its diffusion globally, brought other societies and cultures into line with its own presuppositions' (Bhambra, 2011: 316). Emphasizing the existence of multiple modernities, Eisenstadt brought an appreciation of the differences manifest in the world and different ways in which societies developed and transformed as a result of the process of modernization, which resulted in various distinct modernities.

However, as Gurminder Bhambra notes, while trying to moderate previous Eurocentric perspectives in sociological debates on modernization, the multiple modernities paradigm still presents modernity as a phenomenon that originated in Europe. In her view, this approach differs from previous theories of modernization only in its insistence that 'in its diffusion outwards [modernity] interacted with the different traditions of different cultures and societies and brought into being a multiplicity of modernities' (ibid.: 316). While Eisenstadt's theory focusses on many

world cultures and on the different ways in which they adapted to pro-
cesses of modernization, 'these modernities are defined in terms of a
central institutional core that was taken from the European experience
and the particular cultural inflections of that core as it was interpreted
through the cultures in other places' (ibid.). Furthermore, as Bhambra
argues, even though this theory acknowledges different ways of being
modern, it still does not contest *'what it is to be modern'*, sidelining
concerns about *'the social interconnections in which modernity has been
constituted and developed'* (2010: 38). For instance, this theory circum-
vents the colonial-imperial processes by which the dissemination of
European developments occurred. Challenging this dominant under-
standing of modernity from a postcolonial studies perspective, Bhambra
insists on 'global histories and interconnected experiences' that require
'both critique and the production of a different archive of knowledge'
(2011: 325).

Scholarly positions such as Eisenstadt's, which still privilege a
Western-centric narrative of modernity and Europe, also disavow the
problematic place of Eastern Europe and the Balkans within such a
narrative. As Larry Wolff argues in *Inventing Eastern Europe* (1994), dur-
ing the Enlightenment, Western Europeans invented 'Eastern Europe'
as a construct of an expanding geographical and cultural imagination,
replacing the older division between South and North associated with
the Renaissance (see also Bjelić and Savić, 2002; Todorova, 2009). A cru-
cial binary opposition between civilization and barbarism permitted
Eastern Europe to be seen as a frontier area on the fringes of 'civi-
lized' Europe, as well as the antechamber to an Asia still 'barbarian'
but available to the civilizing impact of Enlightenment philosophy.
Despite attempts to reassert the epistemological value and agency of
the European economic and political peripheries that 'have consistently
faced the charge of either a lack of modernity or a "lag" in achieving
it' (Boatcă, 2007: 368), the division between West and East has per-
sisted with remarkable tenacity in the European cultural imaginary and
may explain recurring prejudices and preconceptions that perpetuate
fractures and oppositions, both real and imaginary, in the European
world.

As the West expands to the East, the relation between hegemonic
Western identity and 'substandard' Eastern European identity with its
multiplicity of identifications calls for knowledge transfer and knowl-
edge exchange, especially on the subject of identity. Chapters in this
second section explore how these tensions and perceptions are played
out and reflected in the ESC. Some of the key questions that the chapters

ask are: Are there still factors in the contest and its reception that reproduce traditional East/West binaries? Does the contemporary ESC reflect a resituated concept of Europe which transcends essentialisms, incorporating an awareness of both the historical development of Europe and the dynamics of its current transcultural makeup? In what ways do colonialism, postcolonial migrations to Europe, and the formation of new diasporas relate to one another and constitute Europe, and how do they circumvent common conceptualizations of Europe (as white, Christian and nationally constituted) as well as common dichotomies, such as the internal East/West divide within Europe? How are these phenomena reflected in the ESC? What are the factors involved in the two dominant attitudes towards the event that evolved in the last decade: 'the Western, more ironic stance towards the competition, with its camp ideology, its connections to gay culture, etc' and 'the more sincere and strategic attitude of the participating nations from Eastern Europe' (Bolin, 2006: 195)?[9]

Chapter 5, 'Back to the Future: Imagining a New Russia at the Eurovision Song Contest' by Yana Meerzon and Dmitri Priven, focuses on the dialectics between the European Union (EU) and Russia in the context of the ESC, reminding us that Russia's identity as a European nation remains contested both inside and outside Russia. 'In Soviet guise Russia became the kernel of an alternative modernity', which sought to compete with the modernity characteristic of the West (Sakwa, 2012: 215).[10] The collapse of the Soviet Union in 1991 marked the end of state socialism in the East and the fully communist society it promised, and triggered the country's quest for a new, post-communist identity, prompting Russian ideologues to actively construct new historical narratives that could be used in the present. As Meerzon and Priven argue, Russia's involvement in the ESC is ideologically co-opted by Russian political elites engaged in mobilizing the new Russia's pop and subcultures for their nation-building purposes. Discussing recent Russian acts at the ESC as well as the Russian hosting of the ESC in 2009 as an instrument of current ideology, the authors show how Channel 1 Russia, the official TV conduit of the Dmitry Medvedev–Vladimir Putin ruling party and the producer of ESC 2009, exploits Russians' collective nostalgia for Soviet and international popular music in order to present the Soviet past in an attractive, retouched manner and to promote the ruling elite's ideological narratives. In the process they also investigate discourses on the EU in the so-called eastern neighbourhood and Russia, showing how Russia's participation at the ESC reflects evolving regional relations and the geopolitical narrative in this part of Europe.

In 'From Dana to Dustin: The Reputation of Old/New Ireland and the Eurovision Song Contest' (Chapter 7), Brian Singleton explores the relationship between Ireland's volatile economic fortunes in the late 20th and early 21st centuries, and its unrivalled ESC record (it has won the contest more times – seven – than any other nation). Ireland's geographical placement as an island nation at the westernmost point of Europe, and its history of colonization by the UK, contributed to Ireland suffering a 'lag' in terms of economic and industrial development, and a similar self-perception as part of the European periphery, more usually associated, as Wolff and Manuela Boatcă argue above, with Eastern Europe. In the estimation of leading Irish cultural commentator Fintan O'Toole, pre-1990s Ireland saw itself as 'a romantic but backward periphery' to the rest of the EU (1997: 15). As Singleton argues, culture was the sturdiest platform on which pre-contemporary Ireland built its international reputation – and not just literature, theatre, and music, but also Eurovision success with a number of winning songs in the 1970s and 1980s that followed a recognizable formula: a young, attractive artist singing a heartfelt ballad. ESC wins at pivotal points in the nation's history, he argues (starting with Derry native Dana's victory in 1970 at the height of the Northern Irish Troubles), provided Ireland with a popular pan-European stage on which to project images of a peaceful and increasingly confident nation. From the late 1990s, however, as Ireland's economy burgeoned to extraordinary (and, as it turned out, unsustainable) levels in the period now known as the Celtic Tiger, Ireland's Eurovision fortunes waned, with a series of low-scoring entries; 'new economic narratives of reputation', argues Singleton, supplanted 'the much-vaunted notion of Eurovision being synonymous with Ireland's international reputation'. In the final part of his chapter Singleton focusses on the popular duo, Jedward (John and Edward Grimes), who represented a partial return to Eurovision form for Ireland when they sang for the country at the 2011 and 2012 contests, projecting a 'universal cultural image of youth and youthfulness' (159).

The unmaking of Europe as a space of exemplarity, exception and privilege, as well as the recognition that the history of European modernity could not be distinguished from the imperial and colonial violence that has accompanied it, have been followed by a search for new identifications. As Passerini notes, 'the insistence on European values has largely substituted the effort to indicate contents of [European] identity' (2012: 124; see also Delanty and Rumford, 2005; Hamersveld and Sonnen, 2009; Sassatelli, 2009). Today the EU celebrates itself as a paragon of diversity, a convivial space for realization of multicultural

values such as tolerance, mutual recognition, and common happiness of its peoples. Yet there is a wide discrepancy between a European citizenship proclaimed in official EU discourses and the actual lack of rights experienced by many ethnodiasporas, migrants, and refugees from non-European and Eastern European countries, which raises many questions about the politics of belonging and non-belonging and the cultural identity of the 'new' Europe – questions that are vital for the future of the European continent (see e.g. Leveau et al. 2002). In her contribution ' "Playing with Fire" and Playing it Safe: With(out) Roma at the Eurovision Song Contest' (Chapter 6), Ioana Szeman focusses on the European Roma 'problem' as one of the oldest and most violent modalities of exclusion in the European sphere, showing how the idea of a cosmopolitan Europe 'united in diversity' (the EU motto) takes little account of diversity within Europe as constituted by minorities within states. She discusses the discrimination and marginalization of Roma in particular in relation to the contemporary 'ethnicization' of the ESC and discourses of Europeanization. Drawing on Balibar's distinction between 'ethnos', a historical community of membership and filiation, and 'demos', which he defines as 'the collective subject of representation, decision making, and rights' (2004: 8), Szeman shows how 'Roma find themselves in the gap between "ethnos" and "demos" not only in Romania, but across Europe.'

In an excellent collection of essays entitled *Romani Politics in Contemporary Europe: Poverty, Ethnic Mobilization, and the Neoliberal Order*, Nando Sigona, Nidhi Trehan and their collaborators demonstrate that the recent reunification of the continent, an affirmation and consolidation of neoliberal and social policies, and a growing economic crisis have contributed to the increasing marginalization of 'millions of Romani citizens, for whom chronic unemployment and social exclusion have become the norm' (Sigona and Trehan, 2009: 2). Suffering from chronic poverty and malnutrition, and often deprived of basic human rights, such as cross-border movement, access to education, health, housing, and cultural rights, in recent years, Roma have also experienced racism, mass persecution, and violence perpetrated across Europe by both institutional and non-institutional agents (see Fassin, 2010).[11] And while Roma once used to play, along with Jews, 'a central role in establishing connections between the different cultures of Europe (especially in the artistic realm, in the case of "Gypsies")' (Balibar, 2009c: x), Szeman offers a less celebratory account of the filtering of Roma representations and identities through global entertainment media, including the ESC. Rather, seeing ethnic elements (in terms of

both music and performers) in the ESC as 'free-floating signifiers representing an unspecified cultural anchorage' (Björnberg, 2007: 23), she argues that these performances, most often coming from countries in the former East, are open to multiple readings, but are also heavily grounded in their local contexts. While fostering counterpublics and transnational affiliations, the inclusion of ethnic (and/or sexual) minorities in the ESC entries reflects not (necessarily) progressive social realities but rather their function as exotic tropes. While agreeing with Szeman's critique of the current circulation of traditionally ludic, entertaining Roma images, we also contend that the Roma presence in the ESC arena serves as a potent reminder that their current plight is a European problem. Along with Balibar, we suggest that by addressing it as such, 'Europeans will not only eliminate a source of internal conflicts and violence that could become unbearable but also construct their common citizenship' (2009c: ix–x). On the other hand, as both Szeman and Balibar argue, in addition to the recognition of the Romani people's human rights by European polities, their emancipation in Europe also requires a greater sense of solidarity of Romani people from all over the Continent.

Part III: Gender Identities and Sexualities in the Eurovision Song Contest

Our project follows on from a first wave of contemporary ESC scholarship, including a collection edited by Ivan Raykoff and Robert Deam Tobin (2007) and two special editions of journals (Tuhkanen and Vänskä, 2007; Georgiou and Sandvoss, 2008). A theme running through that research is the particular affiliation that some gay men feel to the ESC, which scholars – including contributors to this volume Fricker, Rehberg, and Singleton – have examined through the lenses of queer, camp, kitsch, and LGBT politics. While Marija Šerifović's victory for Serbia in 2007 prompted some assessment of the ESC from feminist and lesbian perspectives (see Fricker, 2008; Vänskä, 2007), the scholarship had so far remained dominated by readings of the significance of the contest to Western gay male spectators. A goal of the present project is to extend this research on the queer and camp appeal of Eurovision towards wider readings of the ways in which gender and sexuality are performed and problematized on the Eurovision stage. It also aims to explore claims of gay male ownership of the ESC from the perspectives of feminism and emerging scholarship broadening discussions of sexuality and gender beyond Western paradigms. Some of the questions

informing Part III include: To what extent can Rehberg's assertion that Eurovision has been 'a rare occasion where queer people have access to a sense of nationality' (2007: 61) be extended to the contest's new-entrant countries? Are some new-entrant countries' performances legible as conscious queerings of the idea of Europe itself? And what are the ways in which (Eastern) European artists perform, disavow, and/or contest their racial, national, and sexual identities in the ESC? As the organizers of the II European Geographies of Sexualities conference (Lisbon, 2–7 September 2013) express in their call for papers, many contemporary modes of knowledge production reflect inequalities and hegemonies that need to be challenged. Seeking to investigate the topic of sexualities 'across diverse areas ranging from cultural, social and feminist geographies, to political and economic domains', they point out the hegemony of 'Western' perspectives on gender and sexuality and 'the relative invisibility, and lesser significance of research on sexualities in other social and cultural context', a phenomenon that hampers a transformative transnational dialogue on these topics.[12] One of the goals of this volume is precisely to take part in redressing these imbalances by offering critical perspectives on a multiplicity of gender experiences in different parts of Europe. The four chapters in this last part emphasize research which places attitudes to and performances in the ESC in their specific contexts, using the contest as a means to help us to understand the particular vectors and modalities of gender and sexuality in the cultures and locations identified by researchers.

Over the past two decades the promotion of democracy and respect for human rights – deriving, among other sources, from the 1948 Universal Declaration of Human Rights and the following 1966 UN Covenants on Civil, Political and Economic Rights – were presented as core values shaping the EU's external action in non-EU countries. The recognition of human rights and democracy have also been at the core of the EU enlargement processes of 2004 and 2007, 'when nations from the former socialist bloc succeeded in joining the European "club" not always for tangible political and institutional merits' (Fiaramonti, 2012: 22). However, the EU's actual policies for the promotion of human rights and democracy have also been marked by inconsistencies and double standards due to other more compelling priorities, such as regional stability, economic advantages, and commercial gains. As Joel Peters aptly shows in his introduction to *The European Union and the Arab Spring*, 'Through their silence, and their support of authoritarian regimes in the Middle East, European states became acquiescent in the suppression of human rights and freedoms', which weakened their image in

the eyes of local populations (2012: xiii). Scholars such as Judith Butler (2008), Éric Fassin (2010), and Agnieszka Graff (2010) have linked the EU's stance (but also that of the US) as active promoters of human rights and democracy to a context of instrumentalization of sexual freedom in contemporary Europe (especially vis-à-vis Muslim minorities). Graff, for instance, examines Poland's debates on sexual tolerance and the politicization of homophobia that followed the country's 2004 accession, arguing that the question of sexuality became a boundary marker 'between sexual democracies in the West of Europe and its Eastern "others"' (Graff, 2010: 584). In a similar vein, in his contribution to this volume (Chapter 10), Gluhovic demonstrates how the rhetoric of 'sexual democracy' has become instrumentalized in the processes of cultural othering in the context of the ESC held in Azerbaijan. Thus his and other contributions in this part show that narrations of sexuality and gender, and of sexual liberation, continue to be dominated by unacknowledged but powerful geotemporal biases that place the East as developmentally and civilizationally 'behind' the West.[13]

Many scholars engaged in gendered analysis of the post-1989 transformation in Central and Eastern Europe (CEE) also reveal the full extent of the human costs of post-socialist countries embarking upon a path of freewheeling capitalist development, and the dismantling of socialist relations of production and the infrastructure of social welfare. Their research shows that state-sponsored economic reforms in Eastern Europe have engendered serious social problems, such as high unemployment rates, staggering disparity of income, human rights abuses, rampant corruption, the AIDS pandemic, and environmental degradation. In a universe of less government, greater privatization, and infinite enterprise, these researchers argue, women have largely borne the brunt of these adverse trends (see e.g. Buckley, 1997; Lukić et al., 2006). As industries are privatized, men come to dominate occupations and professions that had been inclusive of women during the socialist era, and women are being relegated to the shrinking public sector and the small-scale service sector. Furthermore, the drastic downscaling of the state sector has resulted in the disproportionate laying-off of female workers, subjecting large segments of the urban female population to the hardships of unemployment or the vagaries of temporary and low-paying jobs.[14]

If women have consistently fared worse than men during Eastern Europe's troubled transition to democracy and free market economy, a string of recent Eurovision victories by women from the east and south of the continent seem to offer an example of empowered and sexualized women who have successfully navigated post-socialist economic and

social transformation. In her contribution, 'Competing Femininities: A "Girl" for Eurovision' (Chapter 8), Elaine Aston explores images of femininity in the 'new' Eurovision focussing on the winning performances of Marie N. (Marija Naumova, Latvia, 2002), Sertab Erener (Turkey, 2003), and Ruslana (Ukraine, 2004). She connects these images to a broader international trend of figuring women's liberation in terms of 'can-do girl power' (167), but also problematizes them by reference to the declining economic and material conditions for women in the 'new' Europe. 'When a nation aspires to become part of Europe (the EU)', Aston argues, 'it does not necessarily follow that this affords a socially progressive experience in regard to gender equality' (170). In the deglamourized self-presentation of the winners Marija Šerifović and Lena (Meyer-Landrut) (2010), however, Aston locates a potential politics of resistance to 'commercially and conventionally produced femininities'.

In 'Taken by a Stranger: How Queerness Haunts Germany at Eurovision' (Chapter 9), Rehberg also makes Lena his focus, arguing that the ESC's status as a celebration of queer culture took a step back with her win and Germany's subsequent hosting, thanks to her mentor Stefan Raab's systematic 'straightening up' of the contest. While, as Rehberg has previously and influentially argued (2007), contemporary Eurovision can be understood as a celebration of (Western) queer identities and sexual otherness, Raab used his considerable status in German entertainment industries to displace the contest's queerness onto the East. Rehberg ties his analysis into the broader dynamics of post-unification German identity, arguing that Raab undertook to de-ironize the relationship between nationalism and Eurovision by, among other means, presenting Lena as an unthreatening *Fräulein* who 'cannot be read as a personification of German military aggressiveness, the memory of which still shapes the national consciousness of Germany's European neighbours' (187). In Lena's second consecutive appearance in 2011, however, Rehberg identifies a *femme fatale* persona in which an exaggerated performance of gender was apparent, thus allowing the queer campness of the ESC to re-emerge in a German context.

Gluhovic tackles the problematic relationship between human rights activism and LGBT activism in the expanded Europe, looking specifically at Azerbaijan's troubled ESC hosting in 2012, complementing this with a narrative of LGBT activism in 2008 host country Serbia. In 'Sing for Democracy: Human Rights and Sexuality Discourse in the Eurovision Song Contest' (Chapter 10), Gluhovic places his analysis in the context

of a wave of scholarship arguing that Western sexual democracy is being used as a means to stigmatize Eastern and Muslim countries portrayed as less advanced and modern because their understandings of gender and sexuality differ from those of the West. Such attitudes were evident in the 'frenzied fixation' (209) of Western media outlets – and some Western LGBT activist organizations – on the repressiveness and sexual intolerance of Azerbaijan in the run-up to, and during, its ESC hosting. Using media accounts, documentation and reports issued by non-governmental organizations (NGOs) and activist groups, and his own observation and interviews, Gluhovic explores the realities of the situation in Azerbaijan, focussing on the notable lack of LGBT activist voices in the 'Sing for Democracy' campaign run by Azeri human rights organizations before and during the 2012 ESC. While a struggle for LGBT rights is still very much under way in Serbia, Azerbaijan, and elsewhere, he argues that winning and hosting the ESC has served to catalyse 'dynamic exchanges linking gender and sexuality with cultural, ethnic and religious identities in contemporary Europe' (215).

Finally in this part, Sieg's contribution 'Conundrums of Post-Socialist Belonging at the Eurovision Song Contest' (Chapter 11) argues that CEE participation in the expanded Eurovision provides a window into those nations' understandings of their access to Europeanness. As she argues, post-socialist countries have been enormously successful in their attempts to use the ESC as 'a stage where they could perform their imagined relationship to Europe as a "return home" or demonstration of friendship': seven ESC winners since 2000 have been from CEE countries. For these nations, however, representing national identity was complicated by the global commodification of ethnic difference as representative of otherness, and by the countries' own internal diversities, thus offering a proscribed range of performance options. What resulted were performances foregrounding conservative images of marriage and family, and presenting exaggerated stereotypes of women as *ingénues* or fallen women, perpetuating historical tropes of the virile West and the feminized, disempowered East. In the 2010 performance of Ukraine's Alyosha, however, Sieg locates the potential for the ESC to be used as a powerful site for an anti-cosmopolitan critique of the inequalities between East and West that persist in 21st-century Europe.

Conclusion

We began this introduction by making reference to the European sociopolitical and cultural context in which we produced this volume

in the second half of 2012, in particular the atmosphere of fiscal and political turmoil caused by the Eurozone crisis. In the last two months of that year, the ESC became implicated in this crisis, when several broadcasters announced that they would not compete in the 2013 contest, most citing the immediate cost of contest participation as the reason for withdrawal. Media commentators noted that ESC participation opens up the possibility of hosting in the following year, and speculated that the possible expense of hosting also lay behind countries' choice to withdraw (see Walker, 2012b). Having taken a £63 million IMF bailout in 2011, and following clashes between riot police and members of the public over austerity measures, Portugal dropped out of the ESC in November, 'cit[ing] financial pressure as the main reason' (ibid.). Poland declined to participate in both ESC 2012 and 2013 because the national broadcaster's resources were focussed on co-hosting the 2012 European Football Cup (ibid.). In December, Slovakia, and Bosnia and Herzegovina also dropped out, with broadcast chiefs indicating that budgets would be best spent elsewhere (Stanton, 2012a, 2012b).[15] In the context of the IMF bailout, austerity, and ongoing public protests, Greek government officials had signalled that they too would withdraw, saying not only that the national broadcaster lacked the funding to participate but also that in the context it would be 'distasteful' and 'morally wrong' to compete (qtd. in Smith, 2012b). However, late in December, both Greece and similarly wavering Cyprus confirmed their ESC participation, along with 37 other countries. The EBU acknowledged that the 'challenging economic situation in Europe' had proved to be a deterrent for some countries, and underlined that it is 'constantly seeking ways to cut costs for both participating broadcasters as well as the host broadcaster and find ways to make hosting the competition more affordable' (Siim, 2012).

In this we see continuing evidence that as Europe goes, so does the ESC. The contest is tied into European economic, political, societal, and cultural life and as such crucial shifts in the European fabric will manifest themselves in the ESC: in the number, variety, location, and histories of countries participating; in the nature of the songs and acts that they present; in the ways in which the contest is received and represented to European and global publics via the media and fans; in the connections made between social and political movements and the contest; and in the moves of contest decision-makers to accommodate these evolutions via innovation of the contest format. The aspiration of this volume is to explore the contest at a particularly pivotal point in its, and Europe's, history; and to generate dialogue and knowledge

around questions of European politics, culture, and representation using the contest as a focal point and test case. At the time of writing there is a strong sense that the EU, as the dominant embodiment of the European project in the early 21st century, has become unsustainable, at least in economic terms. At the same time, dialogue around the ESC increasingly refers to economic containment, and to refocussing the event on a connection between spectators and performers rather than on what the 2013 Swedish organizers deemed a 'technical arms race' between host broadcasters (qtd. in Storvik-Green, 2012). We hope that this project will pave the way for future scholarship exploring the connections between Europe and the ESC as they continue to evolve, together.

Notes

1. Belgium, Denmark, France, Ireland, Italy, Luxembourg, the Netherlands, Norway, Sweden, and the UK were the original members of the CoE. Always a unique institution from the EU and its predecessor organizations, the CoE is based in Strasbourg, as of 2012 has 47 members, and comprises a number of constituent projects and bodies, including the European Court of Human Rights. Belgium, West Germany, France, Italy, Luxembourg, and the Netherlands were the original members of the European Coal and Steel Community and the EEC. Their successor, the EU, as of 2012 has 27 members, becoming 28 when Croatia accedes in July 2013.
2. In the early days of the contest, song titles and country names were listed.
3. Five times in the contest's history (1960, 1963, 1972, 1974, and 1980) the previous year's winner has declined to host because of the expenditure involved or because they lacked a suitable venue. In all instances an alternative host nation was identified. As discussions in this volume indicate, in the contemporary era, hosting has been embraced by broadcasters as an opportunity to showcase and promote the country to the rest of Europe and the world, with governments in some cases offering additional finance to cover high production costs. See Bolin (2006).
4. In terms of geography, the EBU's membership is the broadest among the transnational European organizations being discussed here, extending into the Middle East, North Africa, and Western Asia: Israel, Jordan, Lebanon, Tunisia, and Turkey have been EBU members since the 1950s; the Caucasus nations of Armenia, Azerbaijan, and Georgia joined in the mid-2000s.
5. In 2011 the Big Four became the Big Five when Italy rejoined the ESC after a 14-year absence.
6. Following Ann Cvetkovich's recent intervention in the field of affect theory, we use the term 'affect' here as 'a category that encompasses affect, emotion, and feeling and that includes impulses, desires, and feelings that get historically constructed in a range of ways (whether as distinct specific emotions or as a generic category often contrasted with reason)' (2012: 4). For a detailed discussion of the distinction between affect and emotion, where the former

stands for an immediate, sensory experience and relations to surroundings that precedes emotion, and the latter 'cultural constructs and conscious processes that emerge from them' (Cvetkovich, 2012: 4), see also Clough and Halley (2007); Gorton (2007); Gregg and Seigworth (2010); Liljeström and Paasonen (2010); and a special issue of *Feminist Theory* 13.2 (2012) edited by Carolyn Pedwell and Anne Whitehead. For excellent contributions to this discourse from a theatre and performance studies perspective, see a special issue of *Women and Performance* (19.2, 2009) edited by José Esteban Muñoz; and Dolan (2005).

7. It is in the Québec context that Hurley discusses the affectual qualities of Dion's songs and performances. Dion is also a Eurovision veteran: she won the contest for Switzerland in 1988 with the song *'Ne partez pas sans moi'*.

8. Hartmut Kaelble's article appears in an edited collection by Frank et al. (2010), which deals with the development of the public sphere in Europe. See also Díez Medrano (2009) and Risse (2010) on the same topic.

9. While these chapters explore some of the burning issues under the rubric of European margins and modernities, a number of related strands of inquiry by other authors who joined our workshops enriched our discussions, but unfortunately, due to space limitations these position papers could not be included in this book. Paul Jordan, from the University of Cardiff, for instance, shared with us his research on recent victories in the ESC by Estonia (2001) and Ukraine (2004), which have demonstrated the tremendous significance attached to Eurovision by post-socialist states pursuing the goal of the so-called return to Europe. Drawing upon empirical research, Jordan examined the key identity-political debates surrounding Eurovision in these countries. Vesna Mikić, from the University of Arts in Belgrade, offered a musicological interpretation of the Western Balkans and the 'new' Europe at the ESC. While reflecting on the exclusion of this region from narratives of Europe, European modernity, and European integration, Mikic argued that processes of a new regionalisation and a new 'unification' can be seen in acts created for the Eurovision Song Contest in three former Yugoslav republics (Bosnia and Herzegovina, Serbia, and Croatia).

10. However, as Susan Buck-Morss argues in *Dreamworld and Catastrophe: The Passing of Mass Utopia in East and West*, in which she discusses the concept of modernity in the context of the recent histories of Western and Eastern Europe, 'the cultural forms that that existed in the "East" and "West" (to use the Eurocentric terminology of the Cold War) appear uncannily similar. They may have differed violently in their way of dealing with the problems of modernity, but they shared a faith in the modernizing process developed by the West that for us today has been unbearably shaken' (2000: x).

11. According to James Wolfensohn and George Soros, 'Roma have been among the biggest losers in the transition from communism since 1989. They were often the first to lose their jobs in the early 1990s, and they have been persistently blocked from re-entering the labour force due to their often inadequate skills and pervasive discrimination' (qtd. in Sigona and Trehan, 2009: 3).

12. For the conference call for papers, see http://egsc2013.pt.to.

13. As Robert Kulpa and Joanna Mizielińska argue in their important collection *De-Centring Western Sexualities*, the positive progress of LGBT rights

movements can have the negative knock-on effect of reinforcing negative understandings of the non-West:

> cultural attitudes and legal provisions for lesbian and gay people are becoming important factors in creating and maintaining modern divisions of 'Us' ('West', 'civilised', 'secular', 'liberal', and supposedly 'pro-gay') and 'Them' ('Orient', 'primitive', 'religious', 'fanatical' and consequently 'anti-gay'). (20)

14. Arguments here are developed in more detail in Gluhovic (forthcoming).
15. Turkey also declined to participate, for their part because of concerns about changes to voting rules (Azeri Press Agency, 2012).

Part I

Feeling European: The Eurovision Song Contest and the European Public Sphere

1

'Sharing the Moment': Europe, Affect, and Utopian Performatives in the Eurovision Song Contest

Marilena Zaroulia

Zagreb, 1990: 'Unite, Unite, Europe!'

One of my earliest memories of the Eurovision Song Contest (ESC) is from the 1990 contest in Zagreb, when I first heard Italy's winning song, *'Insieme: 1992'* ('Together: 1992'). The first line was delivered *a capella*: 'Insieme, unite, unite Europe!' Then the first piano notes were heard and Toto Cutugno with eyes closed, tightly holding his hands, sang a ballad pleading for togetherness in a united Europe. As the melody kept building and the backing vocals joined the lead singer, I felt a sudden rush in my body, an incomprehensible and growing feeling of elation, and by the time I heard the chorus lines I was so excited that I found myself singing with tears in my eyes. Listening to the Italian song had deeply affected me: it had caused a bodily, subjective reaction (the rush) that was subsequently transformed into an emotional, socially readable one (the tears).

What might appear as a naïve and embarrassing recollection from my childhood provides an appropriate starting point for this article, which aims to investigate the affective reactions that Eurovision provokes, while probing the politics that underpin such responses. In an attempt to understand the complex interrelation between Europeanness, affect, and politics as manifested in the contest, this chapter sets out to study three Eurovision moments, which coincide with shifts in the politics of the European Union (EU) and experiences of European consciousness since 1989, studying a period that started with the celebration of a united Europe coming into being in the years leading to the 1992 Maastricht Treaty and finishing with the post-2008 socio-political, economic, and institutional crises in the EU. By analysing these

moments – Zagreb, 1990; Oslo, 2010; Düsseldorf, 2011 – I also map my different experiences as a spectator of the ESC, tracing how each moment adds layers to my process of European identification.

The chapter builds on the important work of Italian historian Luisa Passerini, who has historicized representations of Europe and interrogated various aspects of European consciousness and belonging beyond Eurocentric essentialism. She has argued for a critical position towards European heritage, while emphasizing the need for a new approach to the question of Europe, beyond symbols and myths that have historically shaped definitions of Europeanness. I follow her argument that 'one cannot define oneself as European without questioning not only one's cultural heritage, ... but also one's intimate feelings and attitudes' (2002: 27). Hence, a comprehensive analysis of Europe and European identities requires a new conceptualization of the relation between the individual and collectivity: the term 'identity' is replaced with 'identification', and an engagement with subjectivity, intersubjectivity, and their affective dimensions offers further insight into the complex experience of Europeanness.

Passerini's proposition (2007: 98) that processes of identification 'are part of a broader process of subjectivation, by which one becomes the subject of one's life in a given time and place' frames the present analysis. That brief moment of listening to '*Insieme*' added to the shaping of my subjectivity, as I experienced through feeling – possibly for the first time – a sense of belonging to a community larger than the Greek nation, thus making a first step towards identifying myself not only as a Greek but also as a European subject. Thus on that evening of 5 May 1990 in my family's house in Athens, a significant aspect of my subjectivity was coined through an affective interconnection between national and European identification. The present chapter, written between January 2011 and September 2012, a period of tension in Greece–EU relations, questions how this layering of national and European identification has informed ways of watching the contest across the three Eurovision moments as well as critical analysis of such affective reactions.

The chapter does not study in detail specific Greek acts but, particularly in its final part, questions how the socio-political and institutional crises following International Monetary Fund (IMF) and EU interventions and austerity measures introduced by Greek governments since May 2010 have had an impact on my Greek-European identification and subsequent analyses of the ESC. Having grown up in Greece during the 1990s – when the calls for the country's modernization

and Europeanization were widely accepted as necessary steps for its prosperity – but living and working in the UK since the early 2000s, my process of subjectivation has shifted and is defined by an inside/outside sense of belonging. Apart from shaping a different set of 'strategies, alliances and loyalties', this inside/outside notion of belonging further complicates processes of 'affective investment' (Passerini, 2007: 98), which cannot be read as a static condition of nationhood but instead emerges as an intersubjective relation with the national and other communities beyond it. In short, an inside/outside perspective, often precipitated by geographic displacement and shaped by encounters with various identity groups, corresponds to the complex layering of subjectivity, whereby national or European identification is only one of the experiences shaping a subject.

Emotionally rich moments, such as the one that I had at the age of ten, certainly appear in the personal narratives of a number of people who grew up watching the ESC. The feelings that might emerge among audiences – either inside the arena or among the TV viewers – can be easily deconstructed, for they are often permeated by problematic ideological positions about nationhood and might manifest what Michael Billig has defined as 'banal nationalism' (1995). Without dismissing such criticisms of the ideological premises of audiences' feelings, this chapter follows Erin Hurley's argument that affect operates as 'a supplement to meaning that also undoes meaning' (2011: 149) and thus proposes that what might emotionally move us in the context of the Eurovision cannot and should not be ignored. As emotion constitutes 'a form of cultural politics and world making' (Ahmed, 2004: 12), the ESC's affective and ideological dimensions should not be perceived as polar terms of a binary opposition but as complementing perspectives for a comprehensive reading of the contest and its audiences.

Such a methodology is imperative for reading moments when the experience of national belonging, which lies at the heart of the competition, overlaps with or is followed – even momentarily – by an affiliation to a concept broader than the nation, a feeling European sensibility. In those moments of 'emotional labour' (Hurley, 2011: 28), a subject does not 'possess something defined as an identity, but rather it is the subject who is possessed' (Passerini, 2007: 98). Can such moments when one is 'possessed' by strong feelings of belonging to a collectivity capture the possibility of a meaningful European public sphere? If 'our very identification with Europe', as Passerini argues, 'remains to be defined' (2007: 101), since it is constantly reinvented, could an examination of structures of feeling as produced, capitalized, and reflected on the

Eurovision stage provide new insights into what Europe can be in the 21st century, while indicating other forms of European identification beyond institutional bodies such as the EU?

Before I turn to the second historical moment that this chapter studies, I would like to attempt a provisional reading of my childhood memory, acknowledging certain ideological and political factors that might have influenced my reaction in 1990. In doing so I aim to provide a framework for that intense, personal moment: a framework that was shaped by both national and international reasons, which have defined Greece's European identity since 1990 and which are pertinent for an understanding of the emotions that have surfaced in Greece as a consequence of the 2010–2012 crises, which I will discuss in the chapter's third part.

During the 1990 ESC, hosted for the first and last time by Yugoslavia, a number of songs contained overt references to Europe and the European future in the aftermath of the watershed 1989. The Austrian and Norwegian songs were direct responses to the fall of the Iron Curtain, while the Irish song, 'Somewhere in Europe', although ostensibly narrating a love story, presented a journey through a number of landmark places across Europe. Ireland's entry, which finished second, could be read as a celebration of a borderless Europe, an emerging reality or at least an aspiration after 1989. '*Insieme*', a ballad overtly celebrating the post-Cold War united Europe vision, articulated the period's zeitgeist of Europhilia, while 12 European countries were preparing for the Maastricht Treaty.

Hence the 1990 ESC captured a turning point in European history where international relations appeared no longer determined by the intense divisions of the Cold War. As Vuletic explains, this historical moment was broadcast live to Western and Eastern European audiences:

> It was a pleasant coincidence that the only East European country in Eurovision won the Contest in the year that saw the fall of state socialism in eastern Europe, and the Zagreb contest was the first Eurovision that was broadcast directly to the other countries of eastern Europe and the Soviet Union.
>
> (2007: 94)

The shifting international order was bringing about new questions regarding the position of nation states and the reconfiguration of national identities. Eric Hobsbawm, in *Age of Extremes*, provides the

terms for a fuller comprehension of the key elements that defined this landmark period:

> The end of the Cold War proved to be not the end of an international conflict but the end of an era: not only for the East, but for the entire world. There are historic moments, which may be recognized even by contemporaries, as marking the end of an age. The years around 1990 clearly were such a secular turning point. But, while everyone could see that the old had ended, there was utter uncertainty about the nature and prospects of the new.
>
> (1995: 256)

Indeed, what Hobsbawm describes as a volatile background of anticipation defined a number of aspects of the socio-political and cultural milieux in Greece at the turn of the 1990s. The first years following the country's accession as the tenth member of the European Economic Community (EEC) in 1981 were marked by scepticism or hostility towards the EEC, partly because of the country's vexed relations with countries of the European centre since the Second World War. However, by the end of the 1980s and largely due to the EEC's growing economic support of the country, Greek public and political attitudes to European integration changed significantly. Susannah Verney has summarized this radical shift from Euroscepticism to the vision of European integration by juxtaposing two posters of the governing, socialist party for the European elections in 1984 and 1989. While in 1984 the poster depicted two arms – the Greek and the European – wrestling, in 1989 this struggle was replaced by a friendly, welcoming gesture:

> The arm was being held out for a handshake and being used as a bridge for a representative sample of the Greek population to march towards united Europe and 1992 with their heads held high.
>
> (Verney, 1993: 147)

The shifts in the international status quo as well as the positive reactions to these changes in Greece framed my reception of '*Insieme*' and contributed to what I recall as an emotionally intense moment. Since the last months of 1989, I had been fascinated by the media's representation of the fall of the Berlin Wall and its aftermath. Furthermore, the proliferating narratives about Europe as a promise of growth for Greece and the rising public discourses framing 1992 as a magic year had captured my imagination.[1] Such representations and discourses shaped my process of

identification as a Greek subject as bound up with the European vision. This bond between national and European identification was solidified in a spectacular and affective manner on the night I heard '*Insieme*'.

Nonetheless, the Europe that I identified with was incomplete. In problematic ways, official Greek discourses in the early 1990s used the terms 'Europe' and 'EU' as synonymous, although the Maastricht mission of European integration excluded nation states within the borders of the continent which did not participate in the EU mode of governance. At the age of ten I could not realize that the primary focus of the hegemonic EU project was the monetary union or how volatile the transition to the new international order would be for certain European countries, including Greece's neighbours in the Balkans. Instead, the vague notion of an emerging European consciousness had an impact on my imagination, which produced an idealistic version of Europe: a community that inhabited an imagined space of togetherness, beyond geographical borders. My imagination of Europe was similar to that of scholars during the interwar period: like their Europe that became an object of love, a sign 'of identification which go[es] beyond the affective investment for the places where we are born or live' (Passerini, 2007: 109–110), my Europe, the Europe of '*Insieme*', was a utopia, produced through representation and perpetuated through feeling.

Borrowing Sara Ahmed's terms from her important study on what emotions do to the individual and collective body, psyche, and ideology, the feelings of excitement and joy generated by '*Insieme*' did not 'reside positively in the sign'; instead, the emotions associated with the Italian song operated 'as a form of capital' (2004: 45), reproduced through my reception of the performance while feeding back into my fascination for the European utopia, my version of the socioeconomic and political project for a united Europe. In Ahmed's theory, emotions do not reside on a particular object but operate through an 'affective economy' (44); thus, at the turn of the 1990s, the value of a 'European belonging' sentiment grew through the circulation of cultural products, such as the ESC. My European utopia – limited and problematic though it was – was an outcome of this affective economy and exemplifies what Ahmed describes as a process of emotion-working that binds people together, and which is comparable to experiences of temporary community that emerge among audiences during the theatre or performance event.

In *Theatre & Feeling,* Hurley suggests that both affect, as the sensory, subjective reaction, and emotion, as the social manifestation of affect, are relational. In the context of theatre, feeling works by means of the intersubjective relation between performer and audience. This same principle applies to performances on the Eurovision stage. In the

example of '*Insieme*', the chorus lyrics '*L'Europa non è lontana/C' è una canzone Italiana per voi*' ('Europe is not far away/This is an Italian song for you') not only emphasized the intersubjective relation between performer and audience or TV viewer but, more importantly, moved beyond the competition's national aspect, stressing its Europeanness through this direct address to the imagined, European community to which viewers – including me – could have felt that they belonged.

This ideal, European, imagined community appeared to exist beyond the us/them conundrum of national identity, even if this experience could only last for the three minutes of the song. The simultaneous reception of the Italian song by viewers across the continent was bound to instigate a sense of communion among them, an experience through simultaneity that is similar to Benedict Anderson's theorization of the '*kind*' of imagined community that is the nation' (1991: 25). Imagining other people across Europe listening to the song at the same time with me had an impact on my reception of '*Insieme*' and my sense of European belonging. However, this imagining not only indicates that Greece had managed itself to be included in the European integration mission but also suggests the contradictions that defined the unification process. While certain viewers, like me, may have felt part of the community that Cutugno was singing for, other viewers across Europe – in countries that were not yet EU members – may have felt excluded from this future of togetherness, thus being reminded of their status as 'others' in the emerging 'new' Europe of unity despite their desire to be recognized as Europeans. The contrast between my identification through song with other Europeans' exclusion demonstrates the tensions that had marked European history since 1989 and 'the possibility or impossibility of European unification' (Balibar, 2004: 3). The question of who wishes and significantly can identify oneself as European and whether this necessarily implies EU membership has returned to prominence since the eruption of the Eurozone crisis in 2010, challenging hitherto comfortable intersections of national and European – as synonymous with the EU – identifications.

Some 20 years after '*Insieme*' and in a context of emerging crisis, the European imagined community was again articulated through a performance designed to produce a shared, simultaneous, and emotionally intense experience in reception, this time during the non-competitive part of the ESC: in the flash mob dance 'Glow', the interval act of the 2010 Oslo contest, performed by Madcon, a Norwegian hip hop band, made up of Tshawe Baqwa and Yosef Wolde-Mariam. Both '*Insieme*' and 'Glow' attempted to represent a united Europe, particularly through the songs' lyrics. In performance, though, the 1990 song represented

the European community as absent, imagined, listening to the song in 'homogeneous time' (Benjamin qtd. in Anderson, 1991: 24), while the singers portrayed a hegemonic image of an all-white, European, 'authentic' identity. In contrast, Madcon's immigrant identities challenged that dominant representation, allowing for a pluralistic image of Europe. This celebration of difference in Europe through the performers' mixed backgrounds captures aspects of everyday life in contemporary, globalized Europe and a desire for a European consciousness beyond any discrimination. This emphasis on diversity also resonates with principles that permeated the 1997 Amsterdam and 2001 Nice EU treaties and the 'united in diversity' motto, launched in 2000, indicating how often the ESC articulates EU priorities. It is impossible to determine whether the ESC aims to stage the realities, aspirations or institutional directives in contemporary Europe, or indeed who would make such decisions, but, when attempting to read the contest's reception, it is crucial to remember this complex interplay between performance and institutional contexts and how it might have an impact on the audience's feelings.

This chapter's second section discusses the affective and ideological dimensions of 'Glow', focusing particularly on how the flash mob might have contributed to the negotiation of Europe as utopia and the key role of a dramaturgy of feeling, particularly what Jill Dolan (2005) terms the 'utopian performative' – emotionally efficacious moments that invite us to reconsider performance's social potential – in a new stage of the European utopia, in the expanded EU of 27 member states. The chapter further examines the representation of European imagined and existing communities through the flash mob and the potentiality of multiple European public spheres. I ask how the performance worked at an emotional level, proposing that an analysis of the affective dimensions of 'Glow' might allow for a more comprehensive understanding of Europe not as a geographical entity but as an elusive notion, a utopia or, to quote Jacques Derrida, an 'other heading' (1992) with a political impetus. In doing so, I wish to consider the problematics of European belonging and propose that the ESC briefly and in negative terms provides us with insight into how European identification could be experienced through fleeting encounters in the public sphere.

Oslo, 2010: 'Sharing the Moment'

The ESC's promotion is bound up with a discursive triangle of music, sharing, and emotion, which is part of the wider 'affective economy'

that solidifies the contest and the representation of a united Europe through it. As this chapter focuses more on the European unity utopia rather than the construction of national sentiments, it is necessary to examine the interval act as a moment in the contest where pan-European feelings emerge. Furthermore, in recent years, the postcards – short clips that introduce each act – as well as slogans, such as 'Under the Same Sky' (Istanbul, 2004), 'Confluence of Sound' (Belgrade, 2008), 'Share the Moment' (Oslo, 2010) and 'Feel Your Heart Beat' (Düsseldorf, 2011), encapsulate the affective strategies employed to produce a feeling European sensibility.

Interval acts since 1990 can be classified into two groups. The first are those that celebrate the host nation's identity while promoting a version of 'authentic' national culture that can appeal to both national and international audiences. Examples include 'Riverdance' in Dublin (1994), which subsequently became a global sensation, and the appearance of Goran Bregović (Belgrade, 2008), who is famous for his collaborations with other musicians in the Balkans. Furthermore, the interval act in Athens (2006) narrated the history of 5000 years of Greek song, employing dramaturgical strategies reminiscent of the 2004 Athens Olympic Games' opening ceremony, particularly with regard to the spectacular representation of a linear historical narrative of the Greek nation and its music.

The second kind of interval act celebrates a common European identity and a culture of sharing through music. A good example is the 'Musical Journey through Europe' in the 2000 Stockholm contest. The Swedish act, which in some ways is similar to the Norwegian flash mob, attempted to present Europe as a shared space of togetherness by merging live, Swedish music and dance performances in the arena, and recordings of music, dance, and everyday life in various countries across Europe. In other words, the Stockholm act crafted an impression of the local, Swedish culture as part of a larger European community portrayed as a lived, everyday experience.

In this way the interval acts of the ESC share some commonalities with a global spectacle like the Olympic Games. As Helen Gilbert and Jacqueline Lo have observed in their discussion of the 2000 Sydney Olympic Games, the opening ceremony is 'designed not only to capture the imagination of a vast media audience but also to present the nation to itself through popular and allusive iconographies' (2007: 1). By means of sophisticated and carefully orchestrated representations of national narratives and images alongside reflections of cosmopolitanism, the Games' ceremonies advocate a universalist principle of

togetherness, which neglects the existing, material conditions that frequently cause divisions in the contemporary world. The ESC interval act – as the moment in the contest where the national is portrayed as part of the European – can be subject to a similar critique for offering incomplete and romanticized versions of the enlarged, all-inclusive 'new' Europe, ignoring tensions and conflicts in the Continent and, sometimes, reproducing a hegemonic and totalizing narrative of a united Europe that can be consumed by viewers but does not actually exist.

Notwithstanding this valid critique of interval acts as partial representations of contemporary Europe, I would like to investigate the flash mob's affective power, questioning how it staged the European utopia. 'Glow' is significantly different from other interval acts that have attempted to capture Europeanness, for it was not a mere representation of contemporary Europe; as a flash mob, it aspired to present the Eurovision audiences with a possibility of participation in the contest and, metaphorically, Europe.

Flash mobs appeared during the summer of 2003 in the US and soon became a global phenomenon. Balancing between playful attitudes of intervention in public spaces, particularly in urban areas, and 'surfing the line between legality and guerilla-like transgression as a means of calling into question the validity of the former' (Whybrow, 2010: 198–199), flash mobbing has become ubiquitous in performance as well as advertising campaigns. Despite claims to spontaneity, flash mobs are always meticulously planned, as flash mobsters use cyberspace to coordinate their performances. Crucially for this argument, though, flash mobs articulate a new version of the Habermasian public sphere, where the boundaries between performer and spectator become porous. This form of 'surprise theatre' 'both responds to and encourages a culture of perpetual spectatorship' (Muse, 2010: 12) in the digitized age. Flash mobs can be viewed as a celebration of mobilizing people, creating temporary electronic communities as well as different kinds of 'diffused audiences' (Abercrombie and Longhurst, 1998), both of the live and the framed, online performance:

> they use the very technologies that mitigate against the need for live crowds in order to generate, first, temporary live communities, and then long-term virtual ones. They stage a digitally enabled in-your-face revolt against the erosion of face-to-face interaction in a digital nation.
>
> (Muse, 2010: 12)

As in Stockholm, the Oslo act was a composition of live and recorded dance sequences in the arena and other places across Europe. The novelty lay in the inclusion of Eurovision audiences/fans as performers in the act: the 'imagined European community' that Cutugno addressed in 1990 was now actually dancing in various European cities, 'sharing the moment'. Peter Svaar, head of press for the 2010 ESC, suggested that the hosts wanted

> to share the Eurovision Song Contest, rather than just broadcast it. With 18,000 people live on location in Oslo dancing, plus video footage of large flash mob groups from ten major cities, the song, the movements, the arena, and all the cities will share a common musical experience together.

<div align="right">(qtd. in Bakker, 2010)</div>

The Eurovision flash mob, which is reminiscent of widespread volunteering during the Olympic Games, added to the contest's 'affective economies'. Via new technologies, the contest's numerous fans were called to volunteer and perform in an expanded Eurovision stage, in their local contexts (Figure 1.1). 'Glow' enforced the participants' sense of ownership of the contest while, following Ahmed, the more widely

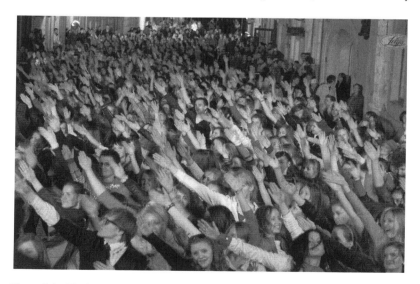

Figure 1.1 Flash mobbers perform 'Glow' as part of the 2010 ESC interval act
Source: EBU.

the dance circulated, the more affective it became and consequently a stronger feeling European sentiment emerged. Participation triggered the emotion-work that binds people together and produced a temporary community. Further, like all performances that 'flash into being for a few short minutes in a particular place [then] often continue to flash on screens around the world for months or years to follow' (Muse, 2010: 9–10), 'Glow' produced a more permanent spectating community potentially beyond European borders, as since the night of the Oslo final the act has been viewed online more than 3 million times.

On the night of the grand final, as the first notes of 'Glow' were heard, the two performers walked across the arena approaching the stage. Madcon's appearance gave a sense of togetherness between performers and the 18,000 spectators, which resonated with the song's lyrics and the promise of 'a world connected'. As the two reached the front rows of the audiences, the wave of 'bow-arrow' moves of the choreography spread across the arena: the first row of audiences started dancing and then gradually the dance rippled across the arena. For eight minutes, footage of Madcon and audiences dancing in the arena were rapidly succeeded by recordings of groups of – predominantly young – dancers in European cities. The recordings from the European cities were cut into performances in the arena as Madcon were asking the audiences to 'put their hands up', not only to celebrate but presumably to participate in the pan-European dance. Five minutes into the act a *coup de théâtre* was staged, as images of Eurovision parties in each of the 39 participant countries appeared on screen: families, couples, and pets were all dancing to 'Glow'.

Two decades after Zagreb, I was watching the ESC at my home in the UK, not on TV but through Eurovision live broadcasting via the internet. This time I was conscious that I was 'sharing the moment', the European utopia of togetherness that I had first encountered in my childhood, not only with other Europeans but also with viewers across the world. This was not simply a carefully crafted image of a united Europe, where the borders between the private, the public, and the spectacular had collapsed; 'Glow' appeared to articulate a cosmopolitan disposition, which was also evident in the song's lyrics, and gestured to a global community of viewers. The ESC was speaking to another layer of my subjectivity, not only as a Greek or a European but also as a 'citizen of the world'. Nonetheless, the Norwegian act's promise of a cosmopolitan Europe vis-à-vis the impact of neoliberal ideologies in shaping (banal) cosmopolitanism as well as models of European governance that limit the space for citizens' participation could only be met with scepticism. For

me, the performance's affective call could not overcome the ideological limitations of a 'cosmopolitan' act on the Eurovision stage.

'Glow' aspired to instigate emotion through the intersubjective moments produced between performers and audiences in the arena, audiences in the various cities and future audiences of the recorded flash mob dance. Hence 'Glow' was produced by a specific European community – Eurovision fans – but was constructed in a way that attempted to reach wider European and global publics. To borrow a term from Dolan's fascinating study of *Utopia in Performance*, 'Glow' could 'ripple out': the dance seemed to literally spread across European cities and households, provoking emotion to the viewers while the dance's affective dimensions could permeate 'other forms of social relations' (Dolan, 2005: 34). Furthermore, the community shaped among the various kinds of performers and audiences of 'Glow' bear the potentiality of 'rippling out', extending into the future.

The concept of potentiality is important for a discussion of the links between Europe as utopia, emotion, and Eurovision dramaturgies. According to José Estaban Muñoz's reading of utopia in queer performance,

> Potentialities have a temporality that is not in the present but, more nearly, in the horizon, which we can understand as futurity. Potentiality is and is not presence, and its ontology cannot be reduced to presentness... It is something like a trace or potential that exists or lingers after a performance.
>
> (Muñoz, 2009: 99)

Potentiality as a critical framework complicates the definition of temporality in Norway's interval act. The flash mob dance and the moment that was shared by performers and audiences transcended clear temporal distinctions of past and present while gesturing towards a future. Thus the 2010 ESC could be approached as an engagement with the notion of Europe not only in the present tense but also in terms of what might happen after the contest, in terms of the acts' potentiality, of what is here but not entirely there until we move to the future. A principle of presence and not presence permeated the flash mob's dramaturgy as it travelled across European cities, living only a trace while progressing to the next location.

A link between the flash mob, potentiality, and the Derridean approach to Europe can be made here. This link, although ostensibly working on philosophical grounds, can offer a valuable position about actual crises in Europe, which are reflective of divisions in the Eurozone,

since certain countries are established as key players in the EU's financial policies while others are perceived as potential contaminators of Europe. These tensions, though, expose a more fundamental rupture in the EU edifice: the failure of plans for a common European constitution during the 2000s and the absence of a European civil society. In short, a united Europe 'sharing the moment' does not exist through EU institutions, which have failed to create an appropriate framework for a meaningful European public sphere.

However, a performance like the flash mob and the feelings it instigated bear the potentiality of indicating another way towards this European unity utopia, which is closer to the Derridean reading of Europe as 'im-possibility'. This 'im-possible' does not signify resignation; instead, it is what gives 'the very movement to desire, action and decision: it is the very figure of the real. It has its hardness, closeness and urgency' (Derrida, 2005: 131). In *The Other Heading* and other writings about Europe since the 1990s, Derrida read Europe as a manifestation of the *à-venir* – as the future and what is yet to come – and an event, which is based on 'a condition of impossibility' (Derrida, 2005: 90). Proposing a radical redefinition of the European beyond Eurocentrism and allowing a true engagement with the 'other', 'which is not, never was, and never will be Europe' (1992: 77), Derrida responded to the European unity promise – that marked my childhood – in deconstructive terms. Although he did not oppose the European utopia *per se*, he radically challenged the homogeneity that the EU integration vision implied and emphasized the distinction between 'the im-possible' and utopia as a term that he was 'wary of', although it 'has critical powers that we should probably never give up on' (2005: 131).

Significant for the purposes of my argument here is that Europe is constantly deferred, at a temporal and geographical distance; it bears the potentiality of a future, which might never emerge, but within this deferral lies its utopian quality. The Derridean Europe, as approached in his talk 'A Europe of Hope' in 2004, shortly before his death, is a 'call' (Naas, 2008: 93) that can shape a direction to the future. Although the flash mob was rehearsed and edited, and 'arrived' on the screens of European audiences on the night of the contest, the experience of European togetherness and participation that it sought to capture can be read in a Derridean fashion, as an experience that is yet to arrive and at the same time incomplete and impossible to arrive. In other words, the flash mob was an appropriate strategy to briefly articulate Europeanness as an im-possible principle while indicating how multiple communities can shape public spheres through shared, embodied

experiences of participation and affective moments of identification, thus paving the way towards that European im-possibility. In this way, the Derridean approach to impossibility offers a framework for analysing the flash mob's performance efficacy while responding to sociological debates (Delanty and Rumford, 2005: 168–183) about the form that a European civil society, beyond the EU, can or might take. Unlike the romanticized European utopia I had imagined in 1990, the 2010 act rejected a static vision of unity misrepresented by institutional bodies, offering instead a passing image of what Europe could be like if more spaces were available for subjects to come together as public in diverse and creative ways.

'Glow' negotiated the relation between present and future, the utopian and the impossible, through emotion, generating 'utopian performatives', which are imbued by a transformative quality for audiences. According to Dolan, utopian performatives are

> small but profound moments in which performance calls the attention of the audience in a way that lifts everyone slightly above the present, into a hopeful feeling of what the world might be like if every moment of our lives were as emotionally voluminous, generous, aesthetically striking and intersubjectively intense.
>
> (2005: 5)

Following Dolan's argument, these intense, emotional experiences of community and intersubjectivity during performance might transform into principles of action in the public sphere. Utopian performatives articulate 'affective and ideological doings... [which] also critically rehearse civic engagement that could be effective in the wider public and political realm' (2005: 7); in this way, the utopian performative momentarily bridges present and future. Certain moments in the performance clearly expressed a desire for an elsewhere: audiences/dancers' hands reached for the sky, while in the London part of the act, three dancers were lifted above the group and reached for the camera, potentially calling viewers across Europe to join them. The heterogeneous groups of people dancing could provoke an emotional reaction, as these embodied communities in the material space that was the Oslo arena and the imaginary (TV) space of Europe gave an image of 'a lived connection', particularly among younger generations in Europe, thus indicating one of the many, existing European communities. The utopian performatives that emerged between audiences and various bodies performing 'Glow' were momentary, grasped only partially. In the same

way that 'utopian performatives spring from a complex alchemy of form and content, context and location, which take shape in moments of utopia as doings, as process, as never finished gestures towards a potentially better future' (Dolan, 2005: 8), the dance and song kept on moving across Europe, challenging any understanding of a European community as transhistorical or essentialist.

However, 'Glow' did not manage to capture the complex image of European communities in their plurality, as only one community that crosses national borders emerged: the community of the Eurovision fans who were recruited to perform. Furthermore, if 'flash mobs envision themselves as a slap in the fact of convention' (Muse, 2010: 20), 'Glow' did not cause – at least visibly – interruption or disruption in the European public spaces or did not conclude with the dispersal of the different groups, thus acknowledging the flash mob's fleeting nature.[2] Although performers' recruitment and planning happened through viral communication, 'Glow' did not appear to react to the realities of contemporary European urban life but instead exemplified how what first appeared as an experimental form of public performance has now largely become mainstream and commodified. All of the recorded footage focused on the dancers, while no audiences in the actual location of the dance appear and their reaction was not visible. In other words, the carefully edited and rehearsed image of Europe 'sharing the moment' did not include anyone who was not officially prepared for the act. This absence of audiences on the location of the flash mob presents 'Glow' more as a spectacle than as a performance of long-lasting 'cracks [that] they [i.e. mobsters] hope to make in people's sense of the stability of everyday life' (Muse, 2010: 14). These cracks can make a flash mob a subversive practice and their lack in the Eurovision example raises questions about the politics of the act.

The synchronized dance produced a naïve understanding of a shared identity and celebrated what can otherwise be perceived as a rather dystopian uniformity that neglects what Gerard Delanty and Chris Rumford (2005: 30) describe as a 'plural conception of Europe' through a 'constellation of civilisations'. The footage from various European households, where families or groups of friends in almost identical living rooms watched the contest, can be read as a representation of a pan-European social class that comprises ESC audiences. The celebratory image of Europe dancing was incomplete: the flash mob articulated a rather totalizing and heteronormative representation of contemporary Europe without clearly contesting it or at least allowing space for difference.

In short, 'Glow' indicated the limits of utopian performatives on the Eurovision stage and raised questions about the ways in which European identities might exist together in the same geographical and imagined space that is Europe, as well as the potentiality of a European public sphere, a space of participation for European citizens. Peter Rehberg has proposed that understanding the paradox of nationality on the Eurovision stage involves an engagement with camp strategies as 'the inevitable articulation of one's endeavor to represent nationality' (2007: 65). Considering how the act could emotionally affect an audience as well as its limitations or failures, 'Glow' is another example of the complex ideologies and dramaturgies that underpin the ESC. It presents a queer strategy of staging Europe by responding to the calls for a European public sphere or civil society question. On the one hand, the flash mob aimed to produce a utopian version of a Europe that is 'not-yet-set' and perhaps will never be, but instead illustrated a rather fixed representation of European identities and communities through the chosen choreography. On the other hand, the impression that 'Glow' through its fleeting dramaturgy of feeling left on certain viewing publics might 'serve the negative purpose of making us more aware of our mental and ideological imprisonment' (Jameson, 2005: xiii) and thus invite us to consider other possibilities of European communities. For Fredric Jameson, 'the best utopias are the ones that fail the most comprehensively' (2005: xiii) and perhaps the utopian quality of the ESC lies precisely in its failing attempts to represent European identities or public spheres, in its 'celebration of Europe *only negatively*' (Rehberg, 2007: 65), thus reminding us that Europe is this impossible task that is yet to arrive but must be pursued, beyond EU politics.

Düsseldorf, 2011: 'Head Up High'

In 1990 my identifications as Greek and European were interconnected because of narratives and images – including '*Insieme*' – that established Greece as a proud member of the vision of European unity; in 2010, the Oslo ESC provoked consideration of the possibility of being a 'citizen of the world' alongside European identification. In May 2011, when I travelled to Düsseldorf alongside other members of the Eurovision and the 'New' Europe Research Network to attend the contest for the first time live, new questions about my Greek/European/cosmopolitan subjectivity were raised. Against a backdrop of failures across the Eurozone that reflected on, or as failures of, Greece, I had to reassess how I identified with Greek and European collectivities, which no longer seemed to

complement each other but instead were in clear opposition.³ On the day of the second semi-final, news of violent clashes that had erupted following a general strike in my home town reached me. The contrast between images of struggle in Athens and the celebratory atmosphere of a Europe united through music in the ESC host city was striking. Inevitably, I remembered *'Insieme'* and the excitement of what now appeared as a void promise of European unity. I reassessed 'Glow' as a naïve articulation of EU hegemony where citizens have access to a controlled public sphere of uniformity, and where illusionary participation in a system governed by the logic of global capitalism is cloaked as liberal democracy.

My experience of the 2011 ESC and particularly my emotional reactions manifested a fundamental shift in my identification as a European subject, whereby my 'I' was attached to a European 'we' which was different from the ideal vision of Cutugno's song, the flash mob's rippling effect and the celebratory communities gathering outside the Düsseldorf arena. Although this was the first time I could experience the contest live, I did not feel that I was 'sharing a moment' alongside the rest of Europe or, rather, I questioned what the Europe was I now belonged to.

A possible reading of the strong alienation that I experienced while in Germany would suggest that my Greekness limited any possibility for a European identification, particularly when considering that since 2010, Greece had offered a spectacle of threat and punishment across Europe. According to such a reading, feelings of anger and shame, and Eurosceptic positions, would limit any possibility of engaging with the contest as a performance of Europeanness. That year was significantly different from the European elections two decades earlier, when Greeks could proudly and 'with their heads held high' – to use the popular expression to which Verney also alludes – be in Europe; like the countries of the Eastern bloc at the turn of the 1990s, Greece is 'othered' in contemporary Europe.

Despite the call for pride in the song's lyrics by means of the same expression, *'το κεφάλι ψηλά και τα χέρια ανοιχτά'* ('head held up high and arms open'), I experienced strong alienation towards the Greek act (Figure 1.2). 'Watch my Dance' was a hybrid of hip-hop dance and traditional *zeibekiko* music, ostensibly attempting to respond to the challenges of post-bailouts Greece. The song narrated a story of betrayal and survival, culminating in a heroic dance performed against a background of ancient ruins; blending allusions to antiquity, reference via *zeibekiko* dance to centuries of Ottoman rule and contemporary rapping, 'Watch my Dance' aptly illustrated contemporary Greek identity as an

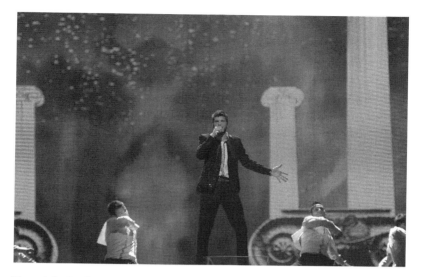

Figure 1.2 Loukas Yiorkas and backup dancers perform 'Watch My Dance', Greece's 2011 ESC entry
Source: Alain Douit.

amalgam of often contradictory cultural references, which indicate the Western/Eastern influences on the country. The act provoked passionate dancing among Greeks in the arena, thus capitalizing on nationalist sentiments which had surfaced in discourses since May 2010 and were reminiscent of attitudes that defined Greek foreign policy and populist antagonism in the 1980s.

Although the song could be read as my generation's allegoric response to the crises, since both performers (Loukas Yiorkas and Stereo Mike) grew up in the same period as me, I felt anger, shame, and frustration, unable to identify with this representation of Greekness and thus relate to other Greeks around me in the arena. 'Watch my Dance' perpetuated the myth of a nation of proud survivors that 'hold heads high', thus transferring the financial and institutional opposition between EU and Greece to the ESC stage, while satisfying an imaginary of national superiority, as it was performed in a German city. In fact, the 2011 Greek entry demonstrated the modernized and Europeanized face of contemporary, Greek popular music – a product of the processes of globalization and late capitalism, elements that led to the crisis that the song's content aspired to critique. In other terms, the Greek song could be read as resisting and responding to the crises, but its spectacular staging and eclectic

borrowings from musical and other cultural influences undermined its efficacy at a political level but strengthened it at an affective one, in either positive or negative terms.[4]

Even in these negative terms, the contest's affective dimensions present an effective way to map moments of national and European identifications, particularly in critical moments of European history. If affect shapes individual and collective bodies, the shared or solitary experience of affect while watching the ESC can shape an experience of Europe as a protean term that exists in the present but gestures to a future. According to Muñoz, utopia is a temporal and spatial stage which moves us beyond the present and expresses 'a politics of emotion' (2009: 97). Examples like the 1990 Italian song, the 2010 Norwegian interval act, and the 2011 Greek representation of Greek-European tension are utopian in the ways that they generated intense feelings while producing views on what is possible or not in Europe, what kinds of communities are visible or not, and how particular forms of identification emerge and are consolidated. These utopian performatives – affective responses that negotiate a sense of what is yet to come – indicate the failure that is inherent in any utopian project, and in negative terms expose what is a disappointing and limiting present; they may not show us what the way to Europe is but they indicate which one is not.

In 2003, in the wake of massive public protests against the Iraq War, Jürgen Habermas and Derrida identified the possibility of a European public sphere, suggesting that 'the power of emotion has brought European citizens jointly to their feet' (2003: 292). Ten years later, in the 2012 context of failure of the official mode of European governance, what emerges is '*a European populism*, a simultaneous movement or a peaceful insurrection of popular masses who will be voicing their anger as victims of the crisis' (Balibar, 2010). This power of emotion might pave the way for a European public sphere, both as a utopian project and as a necessity. In a context where neoliberal rationality is advocated as the only way out of the crisis, a return to emotion as what binds people together can indicate a politics of resistance, beyond national identification, and shape a European civil society where the political is driven by 'passion ... fantasies, desire, and those things that a rationalist approach is unable to understand in the very construction of human subjectivity and identity' (Mouffe, 2001: 40–41).

Janelle Reinelt has offered a critique of Habermas' theory as excluding particular subjects and questioned the role of the public sphere as a space of consensus in a global age. Her proposition is that such forms of expression as affect and emotion should be included in the formation of a public sphere:

the governing geometry of this sphere needs to be envisioned not as a unified field but rather as a network or a rhizome with a plurality of entry points and, indeed, of publics. There is no monolithic sphere.

(Reinelt, 2011: 18)

Reinelt's views are significant for an understanding of the European public sphere, and of the role of the ESC – both in production and reception – in that rhizome of consensus and dissent. In a growing context of anger at the EU's politics as well as hope for rising public movements of resistance, an understanding of affect and emotion as crucial components of ideology and belonging can shed light both into how European politics and identities happen outside Eurovision and into how a new version of the European public sphere might emerge.

The relation between the ESC and European audiences can generate utopian performatives that in their affective potency propose, either positively or negatively, ways of moving beyond the present. Derrida suggests that one can 'feel European *among other things*' (1992: 83). Hence the feeling European sensibility might be an intense, affect-based reaction, the last identification (Passerini, 2007) that emerges only momentarily and is bound to disappear; it is a utopian performative *per se*, which leaves a trace on the history of European identities at large and on the micronarratives of a subject's European identification in specific contexts. In 1999, Étienne Balibar emphasized that it is necessary that 'the project of democratisation and economic construction common to the East and West, the North and South ... will be elaborated and will gain support of its peoples – a project that depends first on them' (2004: 10). In what appears to be a crucial historical juncture which could be 'the end of the EU' (Balibar, 2010), Europeans face the challenge to experience feeling as it is emerging in the actually existing, multiple, and often contradictory European public spheres. This feeling can allow democratic participation across countries, shape new modes of European identification beyond a defined notion of Europe and thus, returning to Balibar, render 'Europe impossible: Europe possible' (2004: 10).

Notes

1. In 1989–1990 the first major scandal in post-dictatorship Greece was revealed: a network of corruption that involved the banking system, press, and leading figures of the governing socialist party, including the prime minister, was exposed. This caused nine months of political instability and three consecutive national elections. The argument about the imperative of the country's modernization and Europeanization that would guarantee the 'cleansing' of

the political system from clientelism and corruption gained momentum during the pre-election period and paved the way for discourses, which claimed that Greece's political future and financial growth could only be guaranteed if European standards were, or at least appeared to be, met.

2. In the spring of 2010 and prior to the night of the live final, recordings of the flash mob dance had taken place in various countries across the continent: Spain, Iceland, Slovenia, Sweden, Lithuania, the UK, Germany, and Ireland. The call for participation was advertised through the official website of the ESC, as well as through fans' websites, pages on *Facebook* and other social media. People who were interested in participating in the flash mob could learn the choreography, using online videos that explained the score in four parts. Although it is possible that a small number of people who had not gone through the process of rehearsal might have joined on the day of recording, the majority of participants were Eurovision fans or at least friends of Eurovision fans who had actively chosen to prepare for and participate in the flash mob. In the case of London, a short advert in the *Evening Standard* (5 May 2010) clearly states that participants 'need to learn the dance before turning up' for the recording.

3. It is impossible and beyond the chapter's scope to engage in detail with the Greek crisis of public debt and its implications for the country and the EU. Since April 2010, Greece has gone through its worst period of recession since 1945, as in order to secure bailout packages from the IMF and the European Central Bank, governments have implemented severe austerity measures, leading to a rise in unemployment and poverty rates as well as extreme ideological positions and practices, primarily from the Far Right party. In Balibar's terms, 'Europe ... imposed on it [i.e. Greece] the coercive rules of the IMF, which protect not the nations, but the banks, and promise deep and endless recession' (2010). Greece, alongside other countries of the European periphery (Portugal, Italy, Ireland, and Spain), seemed to be in a state of emergency, while the possibility of the country's default on its debt was often used – particularly by German government officials – to induce panic among Greek citizens.

4. Providing a reading of the act's relative ESC success – it finished seventh – is complex, for it might have been largely due to diasporic Greeks voting for an act that flattered the nation's ego; on the other hand, it could also have been due to the song's musical references and the growing appeal of hip hop music among the younger generation across Europe.

2
'It's Just Not Funny Any More': Terry Wogan, Melancholy Britain, and the Eurovision Song Contest

Karen Fricker

'It's the Eurovision Song Contest on Saturday, the 57th,' wrote *Guardian* columnist Simon Hoggart on 25 May 2012: 'Wouldn't it be wonderful if it was the last?' He characterizes the contest as 'utterly, horribly grim', full of artists not aware of their lack of talent, and run by organizers who take it seriously as 'a feast of fine music, brought together to bring nations together in harmony, when in fact it's a steaming bowl full of ordure!' Hoggart's expression of strongly negative views about the Eurovision Song Contest (ESC) is not unique in the contemporary British media, and in accounts by writers of British origin. In 2010, the *New Yorker*'s film critic, Englishman Anthony Lane, opined that European pop music 'was all created by the great God of dreck, and Eurovision is his temple' (Lane, 2010: 44). In 2007, *Daily Telegraph* writer Jim White noted the contest's 'utter, jaw-dropping, eye-popping, tooth-grinding, morale-sapping awfulness', while *Radio Times*' David Whitehouse called the ESC 'utterly bloody stupid'. That same year the *Guardian*'s Caroline Sullivan implicitly attributed the recent ESC wins of 'eastern' countries to cheating and collusion: 'you wouldn't go broke betting that representatives of all 15 eligible states are huddled in a conference room in the Carpathians as we speak, discussing tactics.' While other recent winners had hailed from Finland and Greece, Sullivan singled out winners from Estonia, Latvia, Ukraine, and Serbia as uniquely 'eligible' to be part of the conspiratorial eastern 'region' she imagined.[1]

While some media voices in the UK counter this scorn and negativity (see Luscombe, 2005; Greer, 2007; Nelson, 2012) and while sceptical views about Eurovision are sometimes aired elsewhere in Europe (see Constant, 2004; Jørgensen, 2007; Garrigos and Roberts, 2010; Lauwens,

2010; and Gluhovic's discussion of Arsenijević in Chapter 10), the UK has produced insistent, scathingly negative media responses to the contemporary ESC. This chapter argues that this discourse is part of the phenomenon of populist Euroscepticism in the UK that has existed since the 1970s, which reflects the 'crises of collective identity' suffered by the UK in its ongoing, problematic 'reorganisation from imperial state to European Union member state' (Gifford, 2008: 1). A key factor in shaping this discourse were the views of Sir Terry Wogan, who provided official commentary on the contest for nearly four decades, initially on BBC radio and then on BBC TV,[2] and whose was the most influential voice in the UK media about Eurovision as the contest negotiated the emergence of the 'new' Europe. During that time, Wogan cemented his position as 'Britain's best known media figure' (Burrell, 2006), whose morning programme on the corporation's most listened-to station, Radio 2, regularly enjoyed an audience of more than 8 million.[3] His media persona as a middle-class, middle-of-the-road satirist of the vicissitudes of contemporary life was bolstered by his Eurovision commentary, which, initially, positioned the British as bemused participants in, but certainly not fully a part of, what was a distinctly foreign, European spectacle, one in which the UK nonetheless enjoyed success and status. In tracing the changing tone and content of his commentary as the UK, alongside other well-established competing nations, started to fare poorly in the ESC in the late 1990s and 2000s, we can read a larger narrative of the UK's struggle to maintain its exceptionalist self-definition in the context of a rapidly changing Europe.

When UK media figures, including Wogan, trash-talk Eurovision, I contend, they are expressing feelings of unprocessed anger, frustration, and loss about the country's changing relationship to Europe and the rest of the world. Because the ESC has been constructed as being of little value in the UK, broader ideas about cultures and values communicated through negative coverage of the ESC can be shrugged off as inconsequential or not seriously intended, creating a self-perpetuating spiral. These discourses matter, however, because they allow for the recirculation and extension in the public sphere of negative, stereotypical, and often xenophobic views about the rest of Europe and its citizens. They also matter because they have become a means by which the UK continues to incubate internal discourses of Euroscepticism, isolationism, and fear of difference and change. My analysis draws on contemporary scholarship bringing the psychoanalytic concepts of nostalgia and melancholy to bear in the study of post-Second World War Europe. Following Paul Gilroy, I argue that the UK's response to its

declining fortunes in the ESC is a symptom of the country's 'postim-perial melancholia' – that is, its 'inability to face, never mind actually mourn, the profound change in circumstances and moods that followed the end of empire and the consequent loss of imperial prestige' (2005: 90). I bring Svetlana Boym's understanding of nostalgia 'as a defense mechanism in a time of accelerated rhythms of life and historical upheavals' (2001: xiv) to bear on my analysis of Wogan's commentary, arguing that it communicated what she classes 'restorative nostalgia', which 'attempts a transhistorical reconstruction of the lost home' by resisting forward progress and striving for a 'return to origins' (ibid.: xviii). As we will see, Wogan's response to the contest became increas-ingly nostalgic in his final years in the commentator's chair; he became convinced that the contest had lost its way and that he, representing the UK, needed to put it to rights. At the same time, his position as the most valued aspect of the UK's Eurovision presence – 'the only reason for watching the Eurovision' (Henry et al., 2008) for many in the UK – was secured. The still point in this changing world thus became Wogan's commentary: it became the fetish enabling the UK's disavowal of its declining status in the ESC, which brought with it troubling reminders of the country's loss of power and status in Europe, and the world more broadly.

In this chapter I will support these assertions via a close reading of Wogan's ESC commentary at various points throughout his career. I will argue that his celebrated ironic take on the ESC, which for many con-textualized and excused his often extreme statements, itself formed part of his discursive strategies of audience construction that excluded those who did not share his particular points of view on otherness, the UK, and the ESC. This argument takes us through, and beyond, the point at which the ESC became unrecognizable to Wogan, beyond his capacity to ironize it and subject it to nostalgia: 'This is no longer a musical con-test…it's just not funny any more,' he bemoaned in the last moments of the 2008 ESC, as Russia's victory proved to him that 'political voting' had irretrievably corrupted the contest ('The Eurovision Song Contest Final', 2008). As I will argue, however, it was Wogan's own ahistorical and selective reading that turned the contest into the agonistic political standoff that he perceived.

To offset this downbeat scenario, I will end the chapter by proposing a reconsideration of the UK's 2000s-era Eurovision entries through the lens of what Gilroy has termed 'convivial culture' – that is, 'the processes of cohabitation and interaction that have made multi-culture an ordi-nary feature of social life in Britain's urban areas and in postcolonial

cities elsewhere' (2005: xv). Gilroy posits conviviality as a sort of cosmopolitanism from below, which

> finds civic and ethical value in the process of exposure to otherness... [and] glories in the ordinary virtues and ironies – listening, looking, discretion, and friendship – that can be cultivated when mundane encounters with difference become rewarding.
>
> (Ibid.: 67)

While the UK still actively struggles with racism and intolerance, Gilroy and British performance studies scholar Nadine Holdsworth argue that it is crucial to identify and celebrate existing instances of conviviality in contemporary British public life and cultural production that often go unheralded and unacknowledged (see Holdsworth, 2010). The UK's ESC participation since the early 2000s is one such expression of the country's conviviality: the pantheon of ESC acts fielded by the UK since the turn of the 21st century is notable for the ethnic and age diversity of artists represented, and the variety of musical styles and formal approaches essayed. While domestic media accounts have focussed on the relative lack of success of its ESC artists, and have therefore in essence declared the UK an ESC basket case, a reconsideration on Gilroy's and Holdsworth's terms presents a more optimistic picture.

Eurosceptic Britain, melancholic Britain

The UK that entered the ESC in its second year of the contest's running, 1957, was grappling with fundamental shifts in its international position and status, and its demographics and ethnic makeup. Immediately following the end of the Second World War, the British Empire began to break up, and the realignment of the global order into a hostile, bipolar relationship between the USSR and the US left large European nations, including the UK, France, and Germany, jostling for position and attempting to mediate between the superpowers as a means to maintain status. The UK understood itself as having what Winston Churchill dubbed a 'special relationship' (Reynolds, 2006: 2) with the US, thanks to close previous military and political cooperation, but particularly under Prime Minister Margaret Thatcher it attempted to hew out a role as an 'intermediary and facilitator' (Harrison, 2010: 53) between Washington and Moscow. The détente that Thatcher enjoyed taking credit for brokering in the 1980s contributed to reforms in the USSR and eventually the fall of communism, but the end of the Cold

War had the effect of a further decline in British influence in international affairs (White, 1992: 3). Meanwhile, the UK under Thatcher had resisted the growing tide of European integration, regarding the 'special relationship' and the UK's ties to the Commonwealth as a greater priority than multinational relations with the rest of Europe. This reticence led to the UK's belated and fraught entry into the European Economic Community in 1973, a full 16 years after its foundations were laid in the Treaty of Rome.

For political sociologist Chris Gifford, this resistance to European integration became a crucial unifying factor for the fractured and identity-challenged late-20th-century British state. 'Europe' emerged as the 'other' against which the UK attempted to redefine itself following the end of the Second World War, the dissolution of empire, and the reordering of global power during and after the Cold War. These events and processes, Gifford argues, 'ignited crises of collective identity within British political institutions and civil society that finds expression in the rise of contemporary Euroscepticism' (2008: 2). While Euroscepticism was fostered during Thatcher's premiership, it was a populist discourse that extended beyond party politics to become a central element of postimperial British identity, understanding populism as the 'constitution and the mobilisation of "the people" antagonistically conceived in opposition to an oppressive and powerful "other"' (Panizza, 2005: 3). Conflicts within the Conservative Party about its position on Europe resulted in Thatcher's fall from power in 1990, after which Euroscepticism reached 'gale force' (Addison, 2010: 297) in the 1990s under John Major, and extended into the New Labour years. The United Kingdom Independence Party (UKIP) was formed in 1993 with the express purpose of resisting the Maastricht Treaty and eventually removing the UK from the European Union (EU); by 2004 UKIP had 2.6 million votes, 16 per cent of those polled (Turner, 2010: 232).

As does Gifford, Gilroy understands the UK as experiencing a broad crisis of collective identity in the late 20th century, placing his focus on the UK's relationship with the former empire. In similar terms to Gifford, he argues that the UK has been in a period of decline since the end of the Second World War: alongside the breaking-up of empire, the country has experienced a series of internal political and economic crises; internal nationalist movements leading to the devolution of Northern Ireland, Scotland, and Wales; the 'arrival of substantial numbers of postcolonial citizen-migrants' from the former empire; and a sense of 'shock and anxiety that followed from a loss of any sense that the national collective was bound by a coherent and distinctive

culture' (2005: 90). Added into this situation were subsequent revela-
tions of mass violence, torture, and human rights abuses committed
by the British in the colonies, which 'challenge the country's instinc-
tive sense that its imperial ambitions were always good and its political
methods for realising them, morally and legally defensible' (ibid.: 93).
As the reality of empire became ever more apparent, Gilroy contends,
'its complexities and ambiguities were readily set aside. Rather than
work through those feelings, that unsettling history was diminished,
denied, and then, if possible, actively forgotten.' In classing these moves
as evidence of the UK's 'postimperial melancholia', Gilroy hews to the
Freudian/Lacanian understanding of melancholia as a narcissistic and
pathological refusal to face and mourn a traumatic loss (ibid.: 90).

Gilroy's psychoanalytic reading complements a related strand of argu-
ment in political and sociological discourses, which responded to a
growing tendency, in the early days of the 21st century, of British gov-
ernment leaders and revisionist historians to glorify and romanticize
its imperial past. In January 2005, then-Chancellor of the Exchequer
Gordon Brown declared on a visit to Tanzania that 'the days of Britain
having to apologise for its colonial history are over', having proclaimed
several months earlier that 'We should be proud ... of the empire' (qtd.
in Milne, 2012). Journalist Seumas Milne, in a searing article for *Le
Monde Diplomatique*, challenges Brown's 'bizarre' assertion that the UK
has made apologies for empire

> and the crimes committed under it. As with the other European
> former colonial powers, nothing could be further from the
> truth ... Official Britain put decolonisation behind it ... without the
> slightest effort to come to terms with what took place. (2012)

He connects Brown's 'imperial turn' to the work of historians Andrew
Roberts and Niall Ferguson, who argue that empire brought good
not just to the UK but to the colonized themselves, who benefited
from modernization and the civilizing influence of their European
rulers. As postcolonial scholar Robert Spencer further argues, Ferguson's
bestselling volume *Empire: How Britain Made the Modern World* (2003)
positions 'British colonialism [as the] best model for contemporary
global governance'. Such arguments, Milne argues, ignore the fact
that the British Empire was 'built on genocide, vast ethnic cleansing,
slavery, rigorously enforced racial hierarchy, and merciless exploita-
tion'. He points to numerous atrocities throughout the history of the
empire, including, but not limited to, 30 million dead of famine in

turn-of-the-20th-century India; 4 million dead in the Bengal famine of 1943; the deliberate destruction of the Bangladeshi cotton industry; the bloody suppression of the Mau Mau rebellion in 1950s Kenya; and the violence and destruction that accompanied the British army's withdrawal from Aden in 1967 (2012). Milne and Spencer understand this 'imperial nostalgia' as a means of justifying a 'new imperialism' evident in contemporary policies of Western countries, including the US and the UK, that justify foreign interventions, such as the Iraq War, on 'humanitarian' grounds (Milne, 2012). Such feigned altruism is an attempt to justify practices that 'are actually parochial, humanly destructive, and far from uncontested' (Spencer, 2009: 176).

For Gilroy, this resistance to facing the truths of empire has contributed to a resistance in the UK to accepting its increasing diversity as a result of immigration. Pre-Second World War, the UK was, in contemporary terms, a homogeneous place, with a non-white population of some 30,000. The decades after the end of the war led to waves of immigration, initially from the newly independent nations of the former empire, in particular from the West Indies and the Indian subcontinent. Though the UK has controlled immigration since the 1960s, the expansion of the EU in 2004 and 2007 enabled a further influx of new workers and residents; by 2009, some 472,000 Eastern Europeans were working in the UK (Harrison, 2010: 409). By the end of the 20th century, the UK had received more than 3 million immigrants (Hansen, 2000: 3). Under colonization, native populations were given British citizenship and educated to understand themselves as part of the British body politic, and many arrived in the UK after empire in search of employment and improved living conditions. As part of its blocking of the truths of empire, mainstream Britain does not acknowledge its relationship with these newcomers, understanding them as 'unwanted alien intruders without any substantive historical, political, or cultural connections to the collective life of their fellow subjects' (Gilroy, 2005: 90). Gilroy notes a tendency in contemporary Britain to portray immigration as 'being akin to war and invasion', and links this xenophobic response to the denial of repressed knowledge of imperial horrors (ibid.: 94) and to 'what has become a morbid fixation with the fluctuating substance of national culture and identity' (ibid.: 12).

The ESC became a popular institution where this postimperial crisis and resultant Euroscepticism were played out: the UK's falling fortunes in the ESC from the early 1990s onwards turned public and media discourses around the contest into an outlet for anxieties about the nature of British national identity, and for suspicious and negative views about

Europe. The UK's lack of success in the contest became – to follow Gilroy's thinking – a morbid fixation, but the reasons for this were largely displaced onto the European other, as Wogan dismissed performance strategies that confounded his ability to place them within his understood Eurovision norms, and spun increasingly paranoid tales of political voting conspiracies. We turn now to the changing nature of Wogan's commentary in the 'new' Europe era, starting with a brief discussion of his unique place in the UK media landscape.

'The deadpan voice of Middle England'

When he took over Eurovision commentary duties in the 1970s, Michael Terence 'Terry' Wogan was already an established voice on BBC radio, having started his broadcasting career in his native Ireland in the early 1960s and moved to London later that decade to work for the BBC (Figure 2.1). He presented the Radio 2 morning programme from 1972 to 1984; fronted a popular TV chat show on BBC1 in the 1980s and early 1990s; and from 1992 to 2009 returned to the Radio 2 morning slot with 'Wake up to Wogan' (WUTW) (BBC, 'Terry Wogan Biography', 2012). This latter programme became known for Wogan's surreal and improvisatory approach and his high levels of interactivity with listeners via call-ins and the reading out of e-mails. Of his previous TV and radio work, Laurie Taylor and Bob Mullan note

> the degree of collusion that he is said to be able to establish between himself and the audience: the sense that he is somehow sharing a joke with them about some aspect of the [media industry] game ... in which he finds himself enmeshed.
>
> (1987: 75)

We can find evidence of this rapport with his audiences as well as an impression of WUTW's demographic in the existence of the TOGs (Terry's Old Gals or Geezers), a fan community that ran an active website and was a frequent presence on WUTW via call-ins from TOGs using punning and sometimes faintly risqué pseudonyms, such as Mick Sturbs, Palacia Betts, and Lou Smorrels (see Hills, 2009; BBC, 'Wake Up to Wogan', 2012). The lateral, absurdist sensibility of the programme placed it in a tradition of mainstream British humour, cut through with lightly exasperated commentary on 'the absurdity of modern life' (Burrell, 2006), communicating a socially conservative stance advocating the maintenance of traditional values and a resistance to change. For media journalist Ian Burrell, WUTW recalled

the nonsense of classic 1970s Saturday night television such as Morecambe and Wise or The Two Ronnies fused with provincial panto and some why-oh-whery from the op-ed pages of the *Mail* or the *Express*.

(Ibid.)[4]

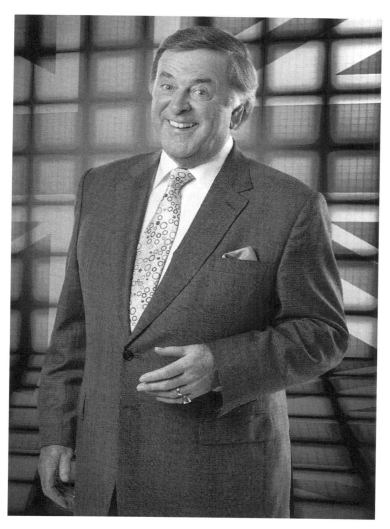

Figure 2.1 BBC commentator Terry Wogan, ca. 2008
Source: BBC.

Thus, by fashioning an approach that resonated with local sensibilities and traditions, Wogan overcame the ostensible difference of his Irishness to be celebrated as 'more than just a radio presenter...[he is] the deadpan voice of Middle England, the gently sardonic lilt that objects in a very British way to too much saccharine, earnestness, or political correctness' (Thynne, 2009).

Many of the aspects of Wogan's approach to radio broadcasting – the use of self-consciously heightened language; the self-positioning as a voice of reason in a silly, shifting world; and the creation of a sense of shared understanding between him and listeners – also became noted features of his take on Eurovision. From the earliest days of his TV commentary, he took a distanced stance from the contest, portraying it as a benignly strange, foreign ritual onto which he and his listener had somehow stumbled and which they can observe from an amused distance. He made clear that he understood his viewer as, like him, Anglophone and unfamiliar with other European cultures, particularly those far away from the UK: having struggled to pronounce the singers' names in the 1982 Yugoslav ESC entry, he asked hypothetically: 'If those pronunciations are wrong, who's going to tell me?' ('The Eurovision Song Contest 1982').[5] A trope established early on was his inability to predict which songs would get votes and which would win, which he portrayed as a product of unpredictable tastes which the UK does not share: comments made during the voting section of the 1981 contest included: 'Were they listening to the same songs as me?', 'You see how subjective popular music can be,' and 'I know nothing about European popular music.' When, during the 1982 contest, he noted that 'whatever you think of the music and whether it reflects musical tastes in Europe or not, somebody out there likes [Eurovision]', he efficiently interpellated a community of listeners who did not see themselves as part of the rest of Europe, nor as sharing its musical traditions and preferences.

A central feature of Wogan's commentary was ironic humour, which political communications scholar Stephen Coleman argues he employed as a means of coping with the inherently 'embarrassing' nature of the ESC – embarrassing because in attempting 'to invoke the imagery of a transcendental European culture...[it actually] draws attention to the reality of European cultural fragmentation' (Coleman, 2008: 131). In the face of this disconnect, Wogan's humour 'establish[ed] a boundary between [himself] and the embarrassment-causing situation'; he 'cringes on behalf of those at home who, without this articulation of embarrassment, would be cringing themselves' (ibid.: 133, 133–134). I would suggest, however, that the reaction which Coleman posits as

universally inevitable to Eurovision – embarrassment – may in fact be culturally specific, as might be his reading of Wogan's use of humour.[6] It is in no way certain that viewers will see the Eurovision contest as a display of fragmentation when it should be presenting a unified ideal: the existence over many decades of mega-events, such as the Olympic Games and, in football the World Cup and European Cup, have normalized the concept of the celebration of unity via a contest of nations. Nor, if viewers do note a disconnect between the ESC's perceived lofty ambitions to unite Europe through song[7] and its tendency to promote national affiliation, is it inevitable that the reaction to this should be an embarrassed cringe. It is exactly this disconnect which is of central interest to a queer scholar such as Peter Rehberg, who argues that the failure of pop songs to represent nation 'opens up the possibility of camp' in the contest, and that 'Eurovision provides a rare occasion for simultaneously celebrating both queerness and national identity' (2007: 64, 60).

The function of Wogan's humour, in my view, is not to gird viewers against inevitable embarrassment but rather to unite them by pointing out aspects of the contest that are inscrutable or seemingly absurd, and offering readings of those aspects, thereby constructing a discursive community that understands itself as perhaps a part of, but certainly different from, the rest of Europe. 'I think that's Johnny Blue standing behind, with the mouth organ,' he said after the performance of the German song 'Johnny Blue' in 1981. The joke, of course, is that Anglophone listeners would not necessarily know what or who the song was about because it was in German, and were therefore probably not even wondering whether a performer represented the title character. Wogan's droll hypothesis points up the relative absurdity (as recognized by Coleman, Rehberg, and others) of the ESC's attempt to communicate across cultures via song, but the reaction comes across much more as detached bemusement than as embarrassed recoil.

A problem with this deployment of humour is that it is expressed via comments about individual acts and performers, a pastime that might also be described as laughing at foreigners. Debbie Lisle's treatment of the humour in Bill Bryson's travel writing and Michael Palin's travel programmes offers a useful model through which to read this aspect of Wogan's commentary. Invoking Simon Critchley's understanding of humour as 'a form of cultural insider-knowledge', Lisle argues that Bryson's and Palin's attempts to forge a cosmopolitan sense of humour that can 'overcome deep cultural differences and reveal shared cultural values' are unsuccessful because they include only 'the author and his

assumed audience', not 'the others being written about' (Lisle, 2006: 105). Thus 20th- and 21st-century travel writers continue in the tradition of their 19th-century antecedents as 'superior Western subjects employing a colonial vision [to] construct inferior "others" in order to justify the continuation of hierarchical global relations' (ibid.: 6). Similarly, Wogan's invitation to his listeners to laugh at Eurovision most often took the form of poking fun at others. He used his commentary to articulate a British 'us' who together understood and could laugh at the wonderful foolishness of the ESC – foolishness embodied by people who were not those speaking or being addressed.

Wogan also tended to comment on the exoticism and difference of acts that deviated from white Western European norms, thus underlining their foreignness from his (and his assumed viewer's) perspective: 'Ah, Istanbul…or is it Constantinople?', he said when the Turkish act appeared in 1982; Greek's song in 1994 was 'the stuff of lost Eurovisions'; Turkey's song in 2003 was 'a breath of the mystic east'; and Cyprus' the same year was 'a tempestuous song, the rhythms of the Mediterranean about it'. In 1981 he pointed out that a black backing singer for Luxembourg 'was an American – I don't know why I point that out, but I feel I should'. Sexist comments also featured prominently. He frequently spoke of women's appearances, making clear his view that attractiveness added positive value to an act. The 1981 Belgian singer had 'the best legs in the contest, and one of the best voices too'; he had a 'quiet fancy' for the 'pretty lady', Anna Vissi, singing for Cyprus in 1982; and it was his view that 'if good looks count for anything, then [the 1991 Swiss number, sung by Sandra Simó] will be in the top three'. Thus Wogan used his commentary to construct an assumed ideal viewer, who shares his identity profile: male (or masculine-identified), white, and British (or British-identified), rather than European.

'Magnificent foolishness'

In the 1990s, many post-socialist countries began to participate in what previously had been Western European-dominated institutions and traditions, including the ESC: 11 new countries joined the contest in that decade, with 15 more joining in the 2000s.[8] New entrant countries and first-time winners came to dominate the top of the scoreboard, while previously successful countries, including the UK, started to score poorly. Only two of the UK's acts have finished in the top ten since 1999, with three finishing last. During this time, Wogan's voice shifted to one

of increasing (presumed) authority, disapproval, and conservatism. He coalesced an overall take on the contest, most clearly expressed in a forward to a British-published ESC companion volume: that the ESC is a 'magnificent foolishness' attempting to 'bring the diverse peoples and cultures of Europe together on one great wing of song, when all it makes manifest is how far apart everybody is'. No one else in Europe seems to 'get' this, in Wogan's view, 'except the man on the Clapham Omnibus, and me' (Wogan, 1998: 7). The latter expression is a British colloquialism referring to 'the average man, especially with regard to his opinions' (OED); the cultural specificity of this expression (as well as its assumption of gender) serves as a further device to self-identify Wogan with a mainstream British male viewpoint, and to isolate the UK as different from the rest of Europe, and unique and superior in its ability to understand (and dismiss) Eurovision. A central reason why Wogan saw the contest as a 'joke', he further wrote, was because he discredited its very premise as an international musical competition: 'How can anybody imagine that a Turkish jury can judge a Swedish song? How does a Croatian assess a Portuguese fado?' (ibid.). This is a remarkably conservative assessment of the viability of cross-cultural exchange that not only dismisses the possible existence of international musical knowledge among jury members or televoters but seems to negate the possibility that any music can be legible or meaningful to someone outside its culture of origin.

A consistent theme in his commentary became the excessive length of the contest, which Wogan portrayed as an endurance test to which he and his listeners were submitting with amused resignation: '26 countries participating – we'll be here 'til Christmas' (2003). He explicitly ties this abnormal length to the contest's expansion, which itself reflects the post-1989 expansion of Europe:

> The Eurovision Song Contest, the show they couldn't kill, the one they love to hate is bigger than ever...the mewling infant of 1956 has assumed the proportions of a sumo wrestler; the newly independent countries of eastern Europe, keen to exercise their vocal chords as well as their franchises, are among the 25 qualifying countries... (1994)

His commentary came regularly to include hyperbolic descriptions of the contest as the site of extraordinary and near-unfathomable goings-on, as if it were a freak show (in 1996: 'you'll laugh, you'll cry, you'll shriek at the lunatic voting of the international juries'; 1997: 'this

is the song contest realm of the undead … where the voting of national juries becomes not just whimsical or eccentric but like something out of the X Files'). Through these discursive gestures, Wogan constructed the evolving ESC – and by application, the expanding Europe – as an aberration and a burden for him and his UK listeners. He increasingly dismissed this emerging ESC/European order as abnormal and corrupt, and enshrined the past era of the ESC as the 'good old times' (1991).

Boym's theorization of the functions of nostalgia can help us to understand this shift in Wogan's discourse. She interprets nostalgia as 'the mourning of displacement and temporal irreversibility' and argues that it is a shared human experience 'at the core of the modern condition' (2001: xvi). Appreciation of the shared experience of nostalgia might promote greater empathy between peoples, she argues, but the nature of 'particular belonging' tends to 'put an end to mutual understanding. *Algia* – longing – is what we share, yet *nostos* – the return home – is what divides us' (ibid.: xv–xvi). Nostalgia, thus understood, tends to flourish in the aftermath of revolution. Despite common perceptions to the contrary, for example, the French Revolution 'produced the *ancien regime*, giving it shape, a sense of closure and a gilded aura', and in post-Soviet Russia the past has been idealized as a 'golden age of stability', or, conversely, critiqued as a 'time of stagnation' (an argument on which Yana Meerzon and Dmitri Priven expand in Chapter 5) (ibid.: xvi). Boym divides nostalgia into two classes – 'restorative', which tries to reconstruct the past; and 'reflective', which cultivates longing – and accepts the inability to recapture the past (ibid.: 41). Restorative nostalgics, into which category we can place Wogan, 'do not think of themselves as nostalgic; they think that their project is about truth' (ibid.).

Wogan in the late 1990s and 2000s became increasingly convinced that Eurovision had lost its way and that only he (and the rest of the UK) could see this truth. Previously, Eurovision was a musical contest, but the expanded ESC had been corrupted by inappropriate considerations and behaviours. In 2009, invited to address the European Broadcasting Union's (EBU's) annual European TV summit, he informed more than 700 broadcasters from 46 countries how they had gone wrong:

> Eurovision … is not about politics or asserting your place in the community, not even about national pride. It is not an opportunity to show your neighbours how much you love them. It is about picking the best popular song in Europe.
>
> (qtd. in Holmwood, 2009)

For Wogan, politics had entered the contest via voting practices in which voters appeared to be bringing non-musical criteria into their selections. Negative observations about 'political', 'bloc', and 'diaspora' voting (i.e. the practice of immigrants voting for their country of origin) came to dominate his commentary, practices he ascribed to unfair favouritism and politicization, but only when non-Western European countries engaged in them.[9] This became a preoccupation of Wogan's commentary, in particular after 1998, when the rules were changed so that votes were cast not by national juries but by the public, via phone-ins and text messaging. In 2003 he declared in his opening monologue that the previous year's contest had been won by Latvia 'in a triumph of Baltic bloc voting', and during the second half of the programme he referenced neighbourly, diasporic, or 'politically correct' voting no less than 11 times. In 2008, his final year as commentator, Wogan mentioned such perceived voting practices no less than 25 times during the broadcast.

Boym has noted that restorative nostalgia tends to adopt 'two main narrative plots', the first of which is 'the restoration of origins' (2001: 43), which she associates with 'national and nationalist revivals all of the world' and their tendency to revive 'national symbols and myths' (ibid.: 41), as well as with the drive to restore major cultural works, such as the ceiling of the Sistene Chapel, in order to efface 'the signs of historical time – patina, ruins, cracks, imperfections' (ibid.: 45). Wogan's hearkening back to a time in which Eurovision voting was fair is evidence of this restorative tendency, though the pure, prelapsarian Eurovision that he idealizes never really existed. Research has shown that regional identities and allegiances have played a role in Eurovision voting since the early days of the contest. While allegiances between some countries shift over time, it is broadly the case that Nordic countries have tended to favour each others' entries, as have Western European countries and Mediterranean countries (see Fenn et al., 2005; Gatherer, 2006; Yair, 1995; Yair and Maiman, 1996). While ESC rules state that juries (and, since 1998, televoters) are expected to vote for their 'favourite' song (European Broadcasting Union, 2012: 2), no criteria or explanation is offered as to what counts as quality, vote-worthy pop; no means is available to determine for what reasons juries or viewers cast votes; and no official instrument exists to determine, censure, or discipline if voting takes on board criteria other than the musical. Wogan himself acknowledged the instability of these voting rules as early as 1981: 'The voting should be done strictly on the merits of each song, but I'm not entirely convinced that a little national prejudice

doesn't creep in.' Even if his memory of his earlier comments was inaccurate, the larger point is Wogan's latter-day invocation of the contest's more virtuous past which, he became convinced, needed to be restored by changes to the voting rules and reducing the number of competing countries (see Holmwood, 2009).

The second characteristic plot of restorative nostalgia is the 'conspiracy theory' (Boym, 2001: 43), a 'paranoic...fantasy of persecution' constructed by communities that understand themselves as under threat, who create a 'scapegoat' as a site of projection, convincing themselves that the scapegoat is persecuting the community (ibid.). We see this played out in Wogan's assertions that the rest of Europe was not voting for the UK's Eurovision entry because it did not approve of the UK's political and military actions. In 2003, for the first time in its ESC history, the UK's act (the duo Jemini) did not score a single point, which Wogan claimed was because 'the United Kingdom is suffering from what we might call post-Iraqi backlash'.[10] While, again, it is impossible to know why individuals across Europe may have voted or not voted for any act, Wogan's argument that the UK received *nul points* because it, alone amongst European countries (along with Poland), supported the US-led invasion of Iraq was widely adopted as truth in the UK media. This argument has the additional effect of identifying Wogan and his listeners as supporters of the Iraq War: bringing external political events into Eurovision discourses had the effect of tethering Wogan and his listeners to a conservative, pro-government stance.

Gilroy has observed contemporary Britain's tendency to commemorate national occasions by recalling military victory, as with fly-bys of vintage aeroplanes at state funerals, weddings and jubilees. Such images are reassuring, Gilroy argues, because they recall the world wars in which the UK played a leading role, and extend narratives of dominance and success: 'Revisiting the feeling of victory in war supplies the best evidence that Britain's endangered civilisation is in progressive motion towards its historic completion' (2005: 88). Wogan similarly constructed Eurovision in martial terms: his closing line in 2003, after Jemini's *nul points* result, was to assure that the UK would be back the following year to 'give them a damn good thrashing', 'them' presumably referring to the rest of Europe. In 2009 he went further, declaring that Eurovision voters were punishing the UK for centuries of military history: 'Britain has attacked nearly every country in Europe and people don't forget' (qtd. in Holmwood, 2009). Thus the deeper nature of Wogan's nostalgia is revealed: while expressed as longing for an uncorrupted Eurovision, he

is actually nostalgic for the UK as a European and global power, aggressively defending its interests on the Continent and around the world. As Gilroy has argued, inviting 'the reassessment of empire' prompts a series of defensive responses, that firstly attempt 'to minimise the extent of the empire, then to deny or justify its brutal character, and, finally, to present the British themselves as the ultimate tragic victims of their extraordinary imperial successes' (2005: 94). This mentality is evident in Wogan's depiction of a defensive UK, once the historic attackers, now being symbolically attacked back via the conspiratorial anti-UK voting agenda he imagines. His comments identify the current moment as one of the UK under siege. Because, as I am arguing, nostalgia for the UK's world-leading past can be understood as nostalgia for a more homogeneous UK, this invocation of a siege mentality cues associations with debates about immigration raging in the country at that time. In 2007 the Labour government introduced a points-based immigration system effectively barring unskilled workers from outside the EU, and the coalition government elected in 2010 extended immigration limitations with the goal of reducing net migration from hundreds of thousands to tens of thousands as a result of its reforms (see Conservative Party, 2012). While these measures were couched as a means to alleviate the welfare burden in the context of economic recession, many commentators in the UK and abroad read them as evidence of a 'Fortress Britain' mentality and an 'increasingly virulent anti-migrant streak' (*The Times of India*, 2012; see also Gardner, 2010; Mitchell, 2010). Wogan's nostalgic invocation of British isolationism and triumphalism fed into these larger public discourses, fostering distrustful relations between the British and others, and ignoring the existence of millions of immigrant British residents who it is difficult to fit into his 'us and them' matrix.

A key feature of most understandings of melancholy is that the subject apprehends at some level that loss has occurred, but blocks this understanding, engaging in various behaviours to perpetuate this blocking; this is the activity of disavowal. One such behaviour is the adoption of a surrogate to take the place of what was lost, which Sigmund Freud named the 'fetish' (see Strachey, 1961). Slavoj Žižek imagines the inner voice of fetishistic disavowal thus: 'I know it, but I refuse to fully assume the consequences of this knowledge, so that I can continue acting as if I don't know it' (2008: 53). It is difficult to believe that viewers across the UK did not register the extremity and anachronism of some of Wogan's statements; and it was a fact that UK acts were struggling to win votes. Despite all this, however, the ESC broadcast continued to be

very popular, which the BBC's Eurovision head of delegation from 2004 to 2007, Dominic Smith, attributes to Wogan's commentary:

> The Eurovision is a success for the BBC in terms of its viewing figures. It does well, with 11 million viewers, and a fair amount of this I think can be attributed to the presence of Sir Terry Wogan.
>
> (qtd. in Roberts, 2009: 153)

Wogan's commentary had become the central feature of the UK's ESC offer; many viewers and media figures said that they tuned into the ESC primarily to listen to him.[11] His take on Eurovision became well known across Europe; he was one of only three commentators to be greeted from the stage by the presenters during the 2008 ESC final. While then-EBU director of TV Bjørn Erichsen let it be known that he disapproved of Wogan's commentary because he made the contest look 'ridiculous' (qtd. in Hastings, 2008), it is notable that the EBU allowed Wogan to continue in his characteristic vein without censure, and even subsequently took some of his critiques on board. As Erichsen's successor, Jørgen Franck, acknowledges (105) a key factor leading to the change back to 50 per cent expert jury voting and 50 per cent televoting in 2009 was Wogan's complaints about voting practices. This is doubtless also evidence of the relative financial power that the UK and the other Big Four (now Big Five) countries wield over the EBU.[12] Wogan was the ESC's biggest star, and via his notoriety, his power, and the BBC's financial contributions, the UK could still claim some form of victory over the contest every year. He was the fetish that continued to enable the UK's melancholic disavowal of its declining status in the ESC, and in Europe and the world more broadly.

None of this, however, could arrest the ongoing tide of change, and so, for Wogan, an exit strategy was required, which he found in a declaration of the ESC as being impossibly compromised. Russia's victory in 2008 with 'Believe', sung by Dima Bilan, was for Wogan the final proof that the ESC was corrupted beyond recognition:

> I can't say that we didn't predict it. Russia were going to be the political winners from the beginning ... you have to say that this is no longer a music contest Western European participants have to decide whether they want to take part from here on in, because their prospects are poor.

In Wogan's unsustainable assessment, nations of the former Soviet Union voted for the Russian entry out of fear of economic/political

retribution. When Ukraine gave Russia 12 points, Wogan commented: 'Ukraine want to make sure the electricity and oil flow through;' and when Latvia also gave Russia top marks, he said: 'Latvia, Estonia, they know where the bread is buttered.' Later he went on to proclaim, by way of exit line: 'we won the Cold War, but we lost Eurovision.' Meerzon and Priven argue convincingly that Bilan's victory was the product of a focussed, well-researched, and well-funded campaign on the part of Russian political and broadcasting élites to master the codes of Eurovision success, in which restorative nostalgia played its part; and they link this to Vladimir Putin's goal of dominance over the Euro-Asian region. Wogan here plays directly into this strategy, by transforming Eurovision into a global struggle of East vs. West paralleling the Cold War, but a struggle that the East had won this time. This allowed him to simultaneously bow out of Eurovision – because it was a lost cause – and, via deft use of the plural pronoun ('We won the Cold War'), write the UK into a central role in the historical victory over communism, a nostalgic flourish that the Iron Lady herself might have approved of. After that year, Wogan departed the commentator's chair, proclaiming that he did not want to 'preside over another debacle' (qtd. in Morris, 2008).

Patriotic, democratic, eccentric

The ESC is one of several high-profile, televized events and competitions in which the UK and other countries perform national identities and affinities. Examining the UK's self-presentation in these events helps us to explore the way the country constructs and understands itself. A focus on Wogan's Eurovision commentary, as I have provided here, presents a troubling image of a country struggling to resolve past and present, blocking acknowledgement of the end of empire and of the reality of its internal diversity. This is only part of a broader picture, however, and I will close by highlighting some moments of convivial self-presentation by the UK that offer a more optimistic vision of the country's possible 'ability to live with alterity without becoming anxious, fearful, or violent' (Gilroy, 2005: xv). As Holdsworth argues, for example, the hit TV programme *Britain's Got Talent* 'exhibits and celebrates many of the values Britain likes to project about itself as a nation: patriotism, democracy, and eccentricity, to name a few' (2010: 2). The variety of acts which the UK has voted into the *Britain's Got Talent* final – including the Scottish singing sensation Susan Boyle; the hip-hop dance group Diversity; and the 2012 winners Ashleigh and Pudsey, a dog

trick act – 'speak volumes about the diverse, multicultural character of Britain', in addition to its propensity for eccentricity (ibid.: 4).

We might also look to the opening ceremony of the London 2012 Olympic Games, themed 'This is for Everyone', in which director Danny Boyle offered a vision of contemporary Britain as quirky, inclusive, diverse, and collective (LOCOG, 2012: 11). This was expressed through Queen Elizabeth II's willingness to play herself in a tongue-in-cheek James Bond skit; inclusion of the traditions and cultures of all four of the UK's constituent nations; performances from artists including mixed race Scottish singer Emeli Sandé, black British rapper Dizzee Rascal, and British Bangladeshi dancer/choreographer Akram Khan, alongside Sir Paul McCartney and the Arctic Monkeys; and a tribute to the National Health Service. In particular, Boyle's choice to have the Olympic cauldron lit not by a singular embodiment of national sporting excellence (as is the tradition) but by seven promising teenage athletes of varying ethnic backgrounds gestured towards a possible future of achievement and excellence for all British youth, offering a positive alternative to the sense of disenfranchisement communicated by the August 2011 urban uprisings in London, Birmingham, and elsewhere.[13]

An even more direct message was sent by the choice of Doreen Lawrence, amongst others, to carry the Olympic Flag. An immigrant from Jamaica, she is the mother of Stephen Lawrence, whose murder in 1993 'at the hands of white racist youth became emblematic of the unaddressed problems of race within the U.K.' (Reinelt, 2006: 73). The campaigning of Stephen's parents, Doreen and Neville, led to an inquiry that concluded that the Metropolitan Police is institutionally racist, and to the eventual conviction of two of their son's murderers. To present Doreen Lawrence as representative of 'our common [human] aspiration to be the best that we can be' (LOCOG, 2012: 35), as is the intended symbolism of Olympic Flag-bearers, is at once to recognize the existence of institutional and cultural racism and violent crime in the UK, and to express a common desire to see them eradicated. It is worth noting, though, that however forward-looking and embracing of diversity some parts of the opening ceremony were, it is hard to fully credit Labour MP and historian Tristram Hunt's assertion that it presented 'the reality of a new Britain unshackled from its imperial past' (Hunt, 2012). Rather, its affirmation of the centrality of geography to the UK's self-identification as indicated in the ceremony's title, 'Isles of Wonder', and its virtual erasure of the historical facts of colonization and empire, save a brief reference to the Windrush generation, are evidence of the UK's continuing refusal to fully face its past.

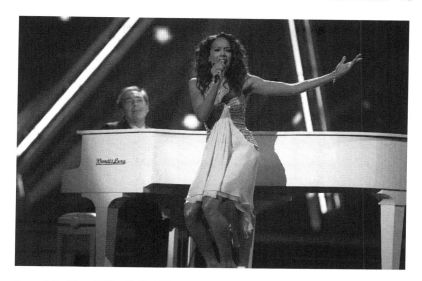

Figure 2.2 The UK's 2009 ESC entry, 'It's My Time', sung by Jade Ewen, accompanied by composer Andrew Lloyd Webber
Source: Indrek Galetin.

Finally, if we look to the UK's Eurovision acts since 1997, the ESC provides evidence of a more open, diverse, and convivial UK than Wogan's commentary and mainstream media coverage suggest (Figure 2.2). The entries since that time have been stylistically varied, and the country has been represented by a notably diverse group of artists. The lead singer of the UK's last winning act, in 1997, Katrina Leskinach, is an American immigrant to the UK. Her immediate successor, the black British singer Imaani, placed second with the soul-inflected up-tempo ballad 'Say It Again'. Since that time no fewer than seven of the UK's entries have been sung by solo artists who are of colour or mixed race (Javine Hylton, 2005; Andy Abraham, 2008; Jade Ewen, 2009; Englebert Humperdinck, 2012), or by groups featuring artists of varied ethnic backgrounds (Precious, 1999; Lindsay Dracass, 2001; Blue, 2010). The musical styles represented have ranged from R&B (Javine's 'Touch My Fire'; Welsh singer Jessica Garlick's 'Come Back', which placed third in 2002) through upbeat soul (Abraham's 'Even If') and upbeat pop with rap elements (Dracass's 'No Dream Impossible') to urban dance music (Daz Sampson's 'Teenage Life', 2006). The performers' ages have ranged from 19 (Josh Dubovie, 2010) to 76 (Humperdinck). British eccentricity found a particular outlet in 2007's 'Flying the Flag', which

saw four-member group Scooch dressed as airline hosts and hostesses performing a dance pop number laced through with bawdy entendre. Underlining that the song had been chosen for competition via a public vote, the BBC's then-head of delegation Smith noted that Scooch's song

> summed up, in three minutes, what BBC viewers think works at Eurovision. And they selected a song which was nostalgic, colourful, and a bit silly. I thought it might [have scored] higher at the actual contest but I don't think the Europeans really ever connected with the very British seaside humour feel of the entry.
>
> (qtd. in Roberts, 2009: 160)

Indeed, 'Flying the Flag' did not score well, achieving 25th out of 26th that year, but it nonetheless was a game attempt by the UK to express itself in culturally specific terms.

These Eurovision entries offer a portrait of a lively and diverse society attempting to adapt to a cultural showcase whose codes and conventions are rapidly changing. The mainstream UK media's narrow focus on contest results has not allowed for a sufficient celebration of the breadth and variety of the UK's contemporary Eurovision self-presentation. The Eurovision stage is itself, slowly but discernibly, becoming a more

Figure 2.3 Swedish 2012 ESC winner Loreen performs 'Euphoria' with dancer Ausben Jordan
Source: Andres Putting.

diverse place (Figure 2.3). While celebrated as performing one of the most commercially successful Eurovision songs in many years, the 2012 winner, Loreen, is also notable for her background and her performance choices: she was born in Sweden to parents of Moroccan Berber descent, and she danced on stage with a black man. Other 2012 entrants of colour included Ukraine's Gaitana, who is Congolese-Ukranian, and France's Anggun, who was born in Indonesia. While Anggun's entry did not fare well with voters, it is part of what seems to be a concerted effort on behalf of the French delegation to diversify its ESC presence: the 2011 French entry was sung in the regional language of Corsican, while the 2010 entry was a zouk-inflected dance number performed by Zaire-born Jessy Matador. The presence of these acts on Eurovision stages represents positive progress towards a contest that more accurately reflects the mingling of nationalities, ethnicities, and cultural traditions that is the reality of today's Europe. Were it to shift its perspective away from nostalgia towards one of cosmopolitan conviviality, the UK might perceive that, in this, it is already leading the way.

Notes

1. As Joanna Mizielińska and Robert Kulpa argue, to represent 'the former communist bloc' as one entity is to efface considerable historical, cultural, and political diversity: 'there were significant differences between the USSR, Poland, Hungary, Romania, Yugoslavia, and East Germany; and...there are equally significant differences between what they have become now' (2010: 21).
2. Wogan was BBC radio commentator in 1971, 1974–1977, and 1979; and BBC TV commentator in 1973, 1978, and 1980–2008. My analysis here is based on viewings of various of the ESCs for which he provided TV commentary from 1981 to 2008.
3. Radio 2's overall listenership in a June 2012 RAJAR/Ipsos MORI/RSMB poll was 14,457,000 adults per week. See Rajar.co.uk, 2012.
4. The *Daily Mail* and the *Daily Express* are British tabloid newspapers known for their conservative stance.
5. All citations from Wogan's commentary are taken from archival recordings of BBC broadcasts. For the purposes of space and ease of reading, from this point I will only indicate the year of the comment, either in the body of the text or as the in-text citation.
6. Coleman's analysis is also limited by his small research sample: only Wogan's 2006 and 2007 commentaries are cited in his article.
7. It is worth noting that the ESC, initially, was not tied to ideals of European unification but rather was created for utilitarian and instrumental reasons: to supply content to the then-nascent European Broadcasting Union and to test the capacity of its new transnational broadcasting links, as the panel discussion with ESC broadcasters in this volume attests. This being said, since that time the ESC has become widely understood as an occasion for the

performance of European unity, and its recurrent and ritualistic character add to the sense of cultural import and gravity around it.

8. Included in this list of post-2000 entries, as three distinct entities, are Serbia and Montenegro, which joined as one country in 2004, and the individual countries of Montenegro and Serbia, which joined in 2007.

9. See, for example, these statements from 1994: when Slovakia gave 12 points to Croatia: 'I wonder if there is any partiality there? I wouldn't like to suggest anything;' when Greece and Cyprus exchanged 12 point scores: 'a joke'; when Spain gave Portugal 12 points: no comment. Similarly, in 1997: when Greece and Cyprus exchanged 12 point scores: 'pathetic'; when Ireland gave 12 points to the (eventual winner), the UK: 'good voting from Ireland – let's hope we can do the same for them, but not if they are too close.'

10. While I am attempting throughout this article to bracket out aesthetic judgements, it is important to note that several authors of books about Eurovision have since acknowledged that Jemini gave a poor performance, and that this seems likely to have contributed to their scoring result. According to John Kennedy O'Connor, author of *The Eurovision Song Contest: The Official History*, Jemini's was a 'tuneless and uninspired effort' (2005: 174), while Andy Roberts in *Flying the Flag: The UK in Eurovision* writes that Jemini had little chance of success after '[singer Gemma] Abbey plunged into the song resoundingly off-key' (2010: 107).

11. See, for example, online reader comments in Holmwood (2009) – by mestizo: 'Wogan IS the contest'; by erp77: 'Terry was the only reason I watched Eurovision.' Cheryl Baker, a member of Buck's Fizz, the British group that won the ESC in 1981, comments in Hastings (2008) that 'If it wasn't for Terry I don't think people would tune in in the numbers they do.' In the same article, broadcaster Paul Gambaccini says that 'Terry Wogan's commentary is inseparable from the British public's consumption of Eurovision. We have a particular way of enjoying it'.

12. As of the late 2000s, France, Germany, Spain, and the UK, referred to colloquially as the Big Four, contributed 40 per cent of contest participation fees. BBC ESC executive producer Kevin Bishop portrayed this as enabling the very existence of the expanded contest: 'Without that contribution there would not be an ESC for the less-wealthy contributing countries to enjoy and be a part of' (qtd. in Roberts, 2009: 151). This seems debatable – former ESC executive supervisor Svante Stockselius argues, for example, that were the Big Four to cease participation, their contribution could be 'carried by the other participants' (qtd. in ibid.: 152); but the financial contribution of the Big Four (now the Big Five since Italy rejoined the contest in 2011) has undoubtedly bought them considerable privilege in the contest, most obviously in the form of automatic qualification into the final.

13. This reading, linking the choice of cauldron-lighters to the 2011 uprisings, stemmed from a conversation with Chris Megson, for which many thanks.

3
Europe, with Feeling: The Eurovision Song Contest as Entertainment

Mari Pajala

No other programme in the history of international TV in Europe can match the nearly 60-year-long unbroken tradition of the Eurovision Song Contest (ESC). Many factors have contributed to the contest's longevity: the members of the European Broadcasting Union (EBU) have been committed to producing a flagship programme for their Eurovision network; the organizers have developed the contest to keep up with changes in media culture; and individual broadcasting companies have been eager to participate, in some cases partly because of the symbolic value that the contest has gained as a sign of European belonging. Another important reason for the ESC's survival is that it has worked as media entertainment, inspiring a wealth of feelings: viewers have been moved by singers' powerful performances and uplifted by energetic choreographies, empathized with winners' emotions, laughed at failed performances, enjoyed an ironic distance from the whole spectacle, celebrated their country's victory and been outraged by 'unfair' results and other controversies. Often these feelings draw strength from national loyalties, but they also construct different kinds of relations to Europe.

This chapter discusses the affective qualities of the contemporary ESC, asking what kind of relations to Europe emerge in the affective intensities generated by the contest. My starting point comes from Sara Ahmed's work on the cultural politics of emotion, which has drawn attention to the role that affect plays in the process where individual and collective bodies take shape. She argues that the boundaries of 'us' as a collective are shaped in contact with others. Naming others as a cause of 'our' emotion forms a boundary between us and them, shaping both as

separate categories (Ahmed, 2004: 1, 10). Ahmed's theorizing provides a basis for considering how boundaries outside and within Europe are formed in affective relations with the ESC. In order to study these relations, I focus on the ESC as entertainment. As film scholar Richard Dyer (1992: 2–3) points out, studies on entertainment have often been concerned with showing that entertainment is actually about something else, such as important historical or social issues. Likewise, ESC research has concentrated on questions of national representation, European belonging and sexual politics, which the contest arguably foregrounds (e.g. Raykoff and Tobin, 2007; Tuhkanen and Vänskä, 2007; Georgiou and Sandvoss, 2008). However, if we focus solely on these issues, we may not learn much about how entertainment works and how it affects us (Dyer, 1992: 3). Following recent work on affects and media, my focus here is on significance more than signification (Skeggs and Wood, 2012: 41; see also e.g. Kavka, 2008; Paasonen, 2011). I hope to contribute to existing research on the ESC's role in the cultural politics of Europe but move the emphasis from representations and discourses to feelings.

Research on the ESC has studied the contest as an occasion for the strategic representation of the nation (Bolin, 2006; Baker, 2008; Mitrović, 2010; Jordan, 2011) and analysed understandings concerning nationality in the audience and media reception of the contest (Pajala, 2006; Christensen and Christensen, 2008; Coleman, 2008; Georgiou, 2008). This has made an important contribution to the study of the cultural politics of contemporary Europe. However, some studies discuss the ESC as if it were a strand of state cultural diplomacy with the result that the contest's specificity as popular media entertainment is in danger of getting lost. For example, Marijana Mitrović's article about the construction of Serbian national identity in the ESC analyses the contest as an event where nation states put themselves on display (2010: 172–173). Yet the ESC is not organized by states but by broadcasting companies. While in rare instances the state may have a say in the choice of the Eurovision entry, in most countries, broadcasters enjoy considerable autonomy from the state. Viewers often interpret Eurovision performances in relation to national stereotypes (see Georgiou, 2008), but nationality does not exhaust their meanings or attractions.

My discussion of the affective intensities of the ESC draws on Dyer's ideas about feelings and entertainment (1992: 17–34). He stresses the sensuous and non-representational qualities of feelings as well as their culturally constructed nature. Feelings may then be difficult to capture in words, but they are not outside culture. Building on Gilles Deleuze and Baruch Spinoza, Beverley Skeggs and Helen Wood emphasize the

power of affect to move us and make us do things, defining affect as 'the feelings that produce an effect' (2012: 5–6). Like them, I am interested in 'the resonances and intensities produced between the TV and the viewer that make us do things and do nothing, creating connections as well as refusals' (Skeggs and Wood, 2012: 135). In this chapter I focus on three kinds of situation where feelings engendered by the ESC result in action: voting, complaining, and singing along. These actions relate to different aspects of the ESC as a TV programme. Voting is a response to a performance, a moment of live TV. Complaining follows the dramatic structure of the ESC, when the results are experienced as unsatisfying. And, finally, singing along is enabled by the repetition of Eurovision songs as recordings that carry with them the memory of their performance on TV. The chapter is based on textual analysis rather than audience research, but the starting point for my discussion comes from observing reactions to the ESC: voting results, public complaints, and Eurovision parties. I will begin by considering how a TV programme like the ESC may contribute to producing a sense of Europeanness.

Feeling European through transnational TV?

The possibility that transnational TV programmes such as the ESC might contribute to a sense of European belonging has been a point of some debate. Writing about the history of the EBU, Jérôme Bourdon argues that international broadcasts 'have repeatedly failed to promote, let alone create, a sense of belonging to a common Europe' (2007: 263). He recounts the history of international broadcasts, news exchange, and attempts to launch European TV channels, suggesting that they have represented a conscious attempt to promote European identity but have failed to create a truly European audience.[1] Bourdon considers the ESC to be an example of this failure, as the programme is domesticated by local commentators for national TV audiences and does not attract viewers equally all over Europe (2007: 266). While it is true that the ESC has been a different show for viewers in different countries, his argument is made problematic by its underlying assumption of a uniformly shared European culture. Bourdon (2007: 263) seems to posit the nation state as a model for European identity, asserting that pro-Europeans have failed 'where their 19th-century "nationalist" predecessors succeeded'. As a result, he describes Europe as an entity with clear (yet undefined) boundaries between insiders and outsiders.[2] He considers it worrying that enthusiasm for the ESC comes 'mostly from outside Europe', arguing that outsider participants, such as Israel and Russia,

share 'an aspiration to be part of "the West"' rather than 'a common European culture' (Bourdon, 2007: 266). In Bourdon's argument, feeling European is tied to a shared European culture and, accordingly, remains an impossibility.

An assumption of a shared European culture is a problematic starting point for an analysis of the ESC. As Gerard Delanty points out in his historical study of the idea of Europe, the region is a kind of constantly redefined 'discursive strategy' (1995: 8). Europe has been constructed through appeals to shared culture and community but also through exclusions and the negative evaluation of difference. While the constitutive outsides of Europe have changed over time, the question of where to draw its eastern boundaries has remained central (Delanty: 1995). In a later study (2005), Delanty and Chris Rumford attempt to offer an alternative vision of Europe that would not be based on an assumption of shared identity or strictly defined boundaries but instead on Europeanization as a process of becoming that is built on encounters rather than shared culture. In Delanty and Rumford's formulation, the essence of Europeanization lies in cosmopolitanism as 'the transformation of cultural and political subjectivities in the context of the encounter of the local or national with the global' (2005: 22). This view of Europeanization is normative, perhaps even utopian. Delanty and Rumford's ideas are valuable in separating the idea of Europe from a demand for an already existing shared culture. However, their idealization of cosmopolitanism does not adequately describe contemporary reality in Europe. (For a critical discussion of cosmopolitanism see Katrin Sieg's contribution [Chapter 11].) Rather than seeing Europe or Europeanization as a value in itself, I am here interested in the different ways in which the contemporary ESC imagines Europe.

Following Jostein Gripsrud's discussion of transnational TV, the ESC could be seen as an occasion for feeling momentarily European. Gripsrud criticizes Bourdon for setting unrealistic expectations for a sense of European belonging by predicting that European identity would become as strong as national identities in a few decades. Rather, people may begin to see themselves as European in addition to their national and other identities (Gripsrud, 2007: 489–490; see also Passerini, 2007: 97–103). He argues that transnational TV – such as Eurovision news exchange and programme activities, international cable and satellite channels, and the habit of watching TV from neighbouring countries – has contributed significantly towards establishing a European public sphere, 'albeit multilingual and seriously limited in many ways' (2007: 491). Gripsrud suggests that 'a sense of belonging somewhere' is created

by habit, 'the experience of the usual and the well-known over time'. He concludes that TV's main contribution to the development of a European public sphere is 'as a source of such feelings of belonging to this continent and not others' (Gripsrud, 2007: 491). While I am not specifically working with the concept of the public sphere here, I find his emphasis on habit useful for describing the ESC's potential for creating a sense of Europeanness. However, the contest often emphasizes boundaries and conflicts in Europe (see e.g. Pajala, 2006: 134–139) and as such does not create a sense of uncomplicated belonging.

The ESC has been organized annually since 1956 and, as such, while it has not been televized in every participating country for this length of time, it is an unusually long-lived European media event. It has been associated with the concept of Europe through its name, Eurovision; and through explicit references, such as the habitual greeting, 'Good evening, Europe'. As conceptualized in the ESC, Europe does not have clear external boundaries, and the contest's image of Europe has grown wider over the years, greatly surpassing the boundaries of the EU, for example. In the contemporary ESC, Europe covers the same area as the Council of Europe (with the addition of Israel), although it may extend further in the future. The regular, annual pattern of the ESC has enabled it to become a habitual part of the European media landscape in the spring. The experience of the ESC varies as a result of differences in nationality, gender, sexuality, generation, histories of migration, musical preferences, and many other factors. Yet watching or hearing about the ESC can become a habit that creates a sense of belonging in Europe or feelings associated with Europe. These feelings can be positive, hurtful, and mixed.

Eurovision performance and utopian feeling

The ESC has traditionally been live TV entertainment for Saturday night, now extended to a short serial format with semifinals during the week. Throughout its history the contest has also been a media event that spreads outside TV, attracting intensive press interest in many countries. The contemporary ESC has a large online presence, which lengthens the duration of the event, as official and unofficial Eurovision websites report from the rehearsals weeks before the final. In the contemporary media environment, live TV entertainment is geared towards the production of moments that will be talked about, remembered, and circulated elsewhere in the media (see Evans, 2011: 117–119). In the ESC, these moments are typically standout performances or spectacular

victories, such as monster metal band Lordi (Finnish winners in 2006), the Russian grandmothers Buranovskiye Babushki (second-place finishers in 2012), and Dima Bilan's performance with the figure skating champion Yevgeni Plushchenko (the 2008 winner for Russia).

Dyer provides a framework for thinking about the role of feeling in entertainment in his classic article 'Entertainment and Utopia' (originally published in 1977). He identifies utopianism as a central feature of entertainment. Entertainment offers a more attractive alternative to everyday life, not by representing an ideal world but by suggesting 'what utopia would feel like' (Dyer, 1992: 18). Utopianism is produced by both representational and non-representational signs, such as colour, rhythm, movement, melody, and camerawork. Dyer stresses that non-representational signs are in no way less structured or historically specific than representational signs. Rather, non-representational signs are part of an affective code that is specific to a particular mode of cultural production. He identifies five categories of utopianism: energy (power, activity, potential), abundance (enjoyment of material plenty), intensity (authentic and unambiguous emotions), transparency (a quality of relationships between fictional characters, and between performers and audience), and community (a sense of togetherness and belonging). These are not universal categories but responses that commercial entertainment offers to real problems in capitalist societies, such as unequal distribution of resources (vs. abundance), exhausting work (vs. energy), and social fragmentation (vs. community) (Dyer, 1002: 18–26). Dyer's discussion of entertainment is based on the analysis of Hollywood musicals where musical numbers are central in the production of utopian feeling. As such, it provides a good model for studying the ESC as entertainment.

The contemporary ESC is very much geared towards producing a feeling of community and abundance. It has always addressed an international audience sharing a live TV event, but the formal audiences of the past did not produce a particularly affective image of community on TV. Since the late 1990s the focus on the fan audience on site has provided a much more tangible vision of community (Singleton et al., 2007: 15, 19; see also the discussion of the 'Share the moment' slogan in Marilena Zaroulia's contribution [Chapter 1]). The feeling of abundance comes from the extravagant staging and TV technology. At the 2000 ESC in Stockholm it became possible to customize the setting for each performance, and the staging has become ever more elaborate since then. Multiple screens, a wealth of camera angles, and huge audiences provide a feeling of plenty. The cost of arranging the ESC has

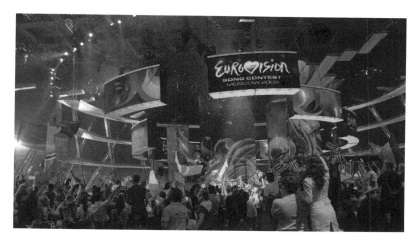

Figure 3.1 The lavish and electronically sophisticated stage presentation of the 2009 ESC in Moscow
Source: Alain Douit.

soared at the same time as reports of an economic crisis have dominated European news (Figure 3.1). The 2009 contest in Moscow broke previous records, reportedly costing €30 million (Jordan, 2012). Norwegian TV scaled down the production of the following year's contest, but the 2011 show in Düsseldorf was a more extravagant affair again, held in a huge football stadium. At a time when countries such as Ireland, Greece, and Portugal were undergoing severe economic problems, the lavishly staged 2011 contest underlined German economic power. Azerbaijan seems to have broken all previous records with reported government funding of €48 million and a newly built arena for 2012 (ibid.). During an economic downturn, the increasingly lavish ESC productions associate Europe with limitless material abundance, offering a capitalist solution to capitalism's problems. At the same time, the spectacular productions emphasize economic inequalities between European countries, as all participating broadcasters might not be able to take on arranging the ESC in its present form.[3]

Successful Eurovision performances able to attract votes from all over the Eurovision area are often characterized by a utopian sensibility (Figure 3.2). As an example, we can look at Alexander Rybak's 'Fairytale', the winner with the most points in Eurovision history. Of Dyer's categories of utopian sensibility, Rybak's performance embodied energy and intensity in particular. While 'Fairytale' as a title already suggests a

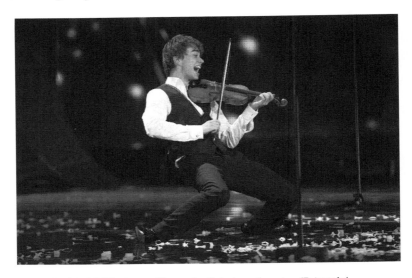

Figure 3.2 2009 ESC winner Alexander Rybak performing 'Fairytale'
Source: Indrek Galetin.

certain utopianism, the utopian feeling of the performance came mainly from non-representational elements. His performance produced a powerful sense of energy. The rhythm of the song is clear and strong, and the broken hairs of his bow (ripped before the performance, for the effect) drew attention to Rybak's emphatic style of violin playing. Three male dancers contributed to the feeling of energy with their physically demanding and masculine performance. Intensity, on the other hand, came from Rybak's style of singing and playing. 'Fairytale' draws stylistically on folk music, which already carries with it connotations of authenticity. In the chorus in particular, Rybak's voice had a very open quality. His violin playing similarly produced an open sound, owing to the use of open strings, the lack of vibrato, and vigorous use of the bow. The performance style emphasized the meaning of the lyrics: he put his hand to his chest as he sang about liking a girl, touched his head as he sang about hurting, and threw his arms open as he declared: 'I'm in love with a fairytale.' As a result, the performance and the lyrics supported each other, with no sense of ambiguity or contradiction. These qualities produced a sense of unambiguous emotion expressed 'without holding back', which characterizes Dyer's category of intensity (1992: 21).

Runaway victories such as 'Fairytale' can produce a utopian feeling of European community when seemingly everybody agrees to celebrate

a common favourite. Unusually, 'Fairytale' received points from every participating country, ending up with 387 points, almost 100 more than the previous record. If, as Dyer argues, entertainment responds to real problems in society, the ESC could be characterized as a response to the many conflicts and divisions in Europe, such as symbolic divisions between East and West, conflicts between some neighbouring countries, and economic tensions within the EU. While these conflicts are played out in the ESC, there are also utopian moments when they fade to the background. Runaway victories, when viewers in every country appear to be in agreement, produce a utopian image of momentary European unity.

Dealing with disappointment

Even the most overwhelming victory will never please everybody. Consequently, ESC results always leave many people disappointed. For the avid follower, the Eurovision season offers the potential for a whole string of disappointments: wrong songs are selected for the ESC, the performance of your favourite song fails to live up to its potential, your country does not advance to the final, and your favourite entry ends up at the bottom of the scoreboard whilst some horrid performance wins the whole thing. The voting is an important part of the ESC entertainment, providing suspense, surprises, and an emotional celebration of the winner. The results also offer material for media controversies. Complaints by artists and viewers, for example, in the popular press are a conventional part of Eurovision entertainment in many countries (see Pajala, 2007a: 76–80).

Disappointment occurs when experiences do not live up to prior expectations. Accordingly, if you do not expect anything, you cannot be disappointed. A feeling of disappointment requires that you have affectively invested in an object – in the case of the ESC, a participating song, performer or country. The strength of disappointment as an affective state can be seen in the reactions it engenders, as disappointment is often expressed through conspiracy theories. In the moment of disappointment, it seems to be hard to believe that other people have different tastes than you do; hence the speculation about voting scams that frequently occur not only around the ESC but also programme formats such as *Pop Idol* and *Big Brother*. These kinds of programme invite audience engagement by asking viewers to perform judgements of taste or morality. As such they also encourage outrage at perceived failures of judgement.

The most famous conspiracy theories in the contemporary ESC concern bloc voting and exchanging votes. Following the successes of new participating countries from the former East, accusations of neighbourly voting have been rampant in countries of the former West (see e.g. Björnberg, 2007: 17–18; Coleman, 2008: 135–136; Vidmar-Horvat, 2010: 35–36).[4] The 2007 contest in Helsinki was particularly controversial. Apart from Turkey, the ten countries that qualified from the semifinal were all from the former East.[5] In the final, the top ten was made up of Greece, Turkey, and eight countries from the former East. Many would argue that the highest-scoring entries deserved their place with strong songs and professional performances. However, the absence of former West European countries at the top of the scoreboard led to intense complaints.

The reactions to Eurovision results are particularly strong on site, where people have invested a great deal in the ESC as travelling fans or members of delegations, materially as well as affectually. These reactions also filter through to the wider audience through TV, press reports and internet fan sites. Booing was audible in the 2007 semifinal as the results were announced. Keith Mills of *All Kinds of Everything*, a well-known Irish fan blog that follows Eurovision rehearsals on site, described a sense of shock after the semifinal:

> Once I heard the dreadful result I decided to avoid the Winners' Press Conference. I'd seen enough Eastern European back slapping for one day. There's really only one story in town and that's the Eastern European walkover. The majority of them may have deserved to qualify and I think Latvia and Hungary may well have made it on Western rather than Eastern votes, but this result stinks.
>
> No one can tell me that the best ten songs or performances made it. Neighbourly voting ... has always been a problem in the contest, but it has now gone beyond a joke.
>
> (Mills, 2007)

Here we can see how emotions construct boundaries between self and other (Ahmed, 2004), as the writer reads others as a cause of his own disappointment. Even though Mills acknowledges that the majority of deserving songs qualified, he describes the results as an 'Eastern European walkover', imagining a coherent Eastern European bloc that is able to dominate Western Europe. Controversies over voting construct an image of Europe as divided into separate blocs with little sympathy for each other.

These kinds of reaction tell us less about actual bloc voting practices than about the workings of affect in watching televized competitions. In their study about audiences' affective reactions to reality TV, Skeggs and Wood note a movement between immediate affective reactions and later judgements based on cognitive rationalization (2012: 154, 209–210). Complaints about neighbourly voting are typically immediate reactions that follow a strong affect. In the moment of affect, a stereotypical notion of Eastern European bloc voting provides a quick explanation for the disappointing results. Following Spinoza's observation about how affect becomes attached to ideas, Skeggs and Wood point out that affect is 'often speedily connected to passing moral judgement' (2012: 150). Similarly, in the ESC the success of 'undeserving' entries quickly surfaces suspicions of corruption, but these accusations are not supported by rational consideration. Analysis of ESC voting patterns has shown that voting blocs where countries favour each other have existed long before the arrival of participants from the former East (Yair and Maman, 1996). Consequently, the arrival of new participants has not made the ESC less fair than it was, but it has undermined the hegemonic position of Western Europe (see Estonian Human Development Report, 2000: 66–69). Succeeding in the ESC is not as easy for countries in the former West as it once was, which can lead to frustrated expectations and intense disappointment.

Following complaints caused by the 2007 contest, the ESC reference group reintroduced 'expert' juries to the contest in 2009 so that half of the result is now made up of audience votes, the other half of jury votes. Among the reasons given for this move was that juries would reduce the role of neighbourly and diaspora voting, making the contest fairer. The juries were also supposed to make the contest more entertaining by guaranteeing less predictable results (Bakker, 2009). These justifications are questionable, as voting blocs existed in the ESC even before the introduction of televoting, when juries alone decided the results (Yair and Maiman, 1996). In her discussion of the politics of happiness, Ahmed draws attention to the unequal access to happiness:

> If certain people come first, we might say those who are already in place (such as parents, hosts, or citizens), then their happiness comes first. For those who are positioned as coming after, happiness means following somebody else's goods.

> (2010: 578)

In a similar way, the organization of the ESC prioritizes the happiness of the 'old' participants in bringing back juries in response to

complaints from the former West. Culturally, this reflects a hierarchical view of Europe, where Western Europe is prioritized over Eastern Europe (Vidmar-Horvat, 2010: 35–36). The importance given to the concerns of the former West also follows on from economic inequalities in Europe. The large and wealthy broadcasters in Western Europe must be kept happy, as their continuing participation in the contest is important for the EBU.

Complaints about bloc voting are a paranoid way of dealing with disappointment. They posit a grand theory where relations between countries explain Eurovision results, regardless of the actual quality of performances each year (Sedgwick, 1997: 23–24). Following Eve Kosofsky Sedgwick's differentiation between paranoid and reparative ways of knowing, it is also possible to find reparative ways of dealing with Eurovision disappointments, especially in fan culture. A reparative position does not look for grand theories or evidence of what it already knows but seeks to turn threatening objects into sources of sustenance and comfort (Sedgwick, 1997). As a reparative reaction to disappointment, Finnish fans offered comforting hugs to people whose favourites had failed to make it to the final at the post-semifinal 'recovery afternoon' during the 2007 ESC. Fan polls and alternative song contests, such as the OGAE Second Chance Contest,[6] offer a chance for fan favourites to come out on top even if they did not succeed in the actual ESC. These kinds of fan practices show that even disappointment can be turned into something productive.

Singing along

The fan experience of the ESC differs from the experience of casual viewers, as the relationship with the contest is cultivated over a long period of time. A popular opinion in Eurovision fan culture is that fan favourites often do not do well in the ESC (see Jordan, 2011; Spence, 2011). This discrepancy between fan favourites and Eurovision successes is partly explained by the longer relationship that fans have with Eurovision entries. Whereas casual ESC viewers hear the entries for the first time while watching the show, fans are already familiar with them and have firm favourites among the entries. A song may keep its position as a fan favourite even if the performance in the ESC does not live up to expectations. Each contest produces some songs that remain in circulation in fan contexts after the contest is over. The following discussion of fandom is based on observations of Finnish Eurovision culture.

The 2011 Finnish Eurovision final was held in my home town, Turku. After the show I went with friends to an after-party where the DJ played a wide selection of Eurovision tunes, ranging from well-known classics to more obscure songs from national finals, especially the Swedish Melodifestivalen. My favourite moment of the evening came when the DJ played the 2010 Serbian entry '*Ovo je Balkan*', with the full dancefloor singing along with '*Beograd, Beograd, ja bezobrazan*' in a language that few of them understood. It reminded me of the last time the Finnish Eurovision final had been in Turku a few years earlier. For me the most memorable moment of the after-party then was when people sang together to '*Neka mi ne svane*', the Croatian ballad from 1998. It seemed like everybody knew the lyrics although, again, few probably knew the language. Certainly it felt like everybody understood the emotion in the song.

In moments like these the ESC provides a basis for a sense of community that is based not on identity categories but on familiarity with a set of songs, built through repetition over the years. In the fan reception of Eurovision songs, language recedes in importance – it is not necessary to understand the lyrics in order to sing along with feeling. The singalong moments seem to be filled with shared emotion, although, as Ahmed reminds us, you cannot actually know what other people feel. She suggests that shared feelings are not actually shared; we do not know if other people are really feeling the same emotion that we are or what their relation to the emotion is. Emotions do not circulate among people; objects of emotion do (Ahmed, 2004: 10–11). Popular Eurovision songs are objects of emotion that circulate in fan culture, providing a basis for a momentary sense of community. On the dancefloor, recognizing these songs, knowing the lyrics, and perhaps borrowing some moves from the original choreography can become the basis for a sense of shared feeling.

Various musical genres can be popular in Eurovision fan culture, but uplifting dance tracks and emotional ballads tend to be favoured, whereas middle-of-the-road, radio-friendly pop songs and ironic comedy acts are generally not as popular (see Vranis, 2011; OGAE, 2012). In Dyer's terms, then, Eurovision fan culture favours performances that offer a sense of energy, intensity, and transparency. A sense of authentic feeling does not require a stripped-down, untheatrical performance as in some versions of rock music culture. Rather, the sense of intensity comes from performing a carefully choreographed show with conviction. '*Neka mi ne svane*' is an example of a classic Eurovision performance, so defined. The song is a ballad that starts quietly and builds to a powerful

crescendo. The singer, Danijela, a small blond woman dressed in a black cape-like dress, began the performance in an introspective manner, holding her hands close to her chest and at times closing her eyes. She stood in the same place for the duration of the song, moving only her hands and arms in graceful movements. At the culmination of the song, Danijela's cape fell off to reveal a figure-hugging white dress. As she belted out the last choruses, her gaze was frank and her gestures had lost their initial tentative quality. The performance formed a narrative of overcoming emotional hardships that was understandable beyond language barriers. The emotional drama of the performance stuck to the song and can be relived on hearing it again (on the 'stickiness' of emotions, see Ahmed, 2004).

Fan parties show that the ESC has created a European popular culture that some people experience as very significant. This culture is not homogenous but has local variations. For example, in the spring of 2010 I attended Eurovision events in the Netherlands and in Norway where the set of popular songs was somewhat different from that in Finland, featuring more Western European material. Factors such as geographical and cultural proximity, language, and access to foreign TV channels contribute to defining which Eurovision songs become popular in a local fan culture. For example, the Swedish Melodifestivalen is familiar to Finnish Eurovision fans because Swedish is taught at school, Swedish TV has been available on the Finnish west coast for decades, and nowadays Melodifestivalen is even shown on a Finnish TV channel. Geographical and cultural proximity do not, of course, completely determine the popularity of Eurovision songs. On the discussion forum of *Viisukuppila*, the main Finnish Eurovision fan site, the entries from some neighbouring countries (Sweden and Estonia in particular) attract more than average attention. The amount of discussion generated by other countries' entries varies annually depending on the song and artist.[7] For fan audiences, songs from all Eurovision countries are potentially equally interesting, which makes the ESC an exceptional event.

The ESC's internationalism has always been one of its attractions for fan audiences. The programme has been a chance to see European countries come together and to hear music from different regions performed in a variety of languages (Moser, 1999: 59–60; Singleton et al., 2007: 18). This aspect was particularly rare before the arrival of cable and satellite TV, and the internet. Brian Singleton, Karen Fricker, and Elena Moreo characterize the ESC of this era as a 'spectacle of otherness' (2007: 15). The expanded Europe of the contemporary ESC means that the variety of languages and musical styles on show has grown, even if many

choose to sing in English. At the same time the internet has made it easier than before for fans to follow other countries' Eurovision finals and to familiarize themselves with the careers of the performers. Instead of a 'spectacle of otherness', the ESC may become a context where the geographically distant can become intimately familiar. Whereas the old ESC was dominated by Western Europe (see Yair and Maman, 1996), this is no longer the case. Many new participating countries, such as Ukraine, Romania, Serbia, and Azerbaijan, have put a great deal of effort into their entries, which makes them more interesting from a fan culture perspective than lacklustre, older participants, such as the Netherlands or Belgium. Thus I would suggest that local Eurovision fan cultures produce changing maps of Europe where different areas emerge as significant: neighbouring countries; some large and formerly dominant Western countries such as the UK; and countries, often from the former East, that seem to take Eurovision seriously and produce interesting entries. In the context of fan cultures, Europe in the ESC does not have one hegemonic region or centre but, rather, many.

Conclusion

This chapter has discussed three types of situation where the ESC may engender strong feelings in the audience. These are, of course, not the only possible affective relations to the ESC but they relate to central features of ESC entertainment – winning, losing, and reliving favourite performances. The case studies show that the ESC can engender ambivalent feelings in relation to the expanded vision of Europe that it represents. As a media spectacle, the contemporary ESC presents Europe in terms of material abundance, giving precedence to economically powerful countries. Although the contest provides a context for playing out tensions within Europe, at times it also creates utopian moments of European community. On the other hand, disappointed reactions to ESC results in the former West typically make use of hierarchical divisions between East and West, creating an image of Europe that is separated into two rigidly separated areas. Local Eurovision fan cultures often pay special attention to entries from neighbouring countries, but it is also possible to become intimately familiar with entries and performers across geographical and linguistic distance. In fan cultures, the map of Europe evolves as new areas produce strong Eurovision participants. In conclusion, then, the contemporary ESC both reproduces historical divisions and tensions in Europe and provides opportunities for new connections and affinities.

In this chapter I have foregrounded a reparative instead of a paranoid reading of the ESC, although elements of both are present. In this way I have attempted to make room for a discussion of the ESC that is not wholly structured by the category of nationality. For example, my own previous work on the ESC analysed the construction of nationality in the ESC and its Finnish media reception, outlining the repetition of certain articulations of nationality over the years (Pajala, 2006, 2007a, 2007b, 2011). While this sort of analysis describes an important aspect of the ESC, I have also felt that it misses much of what is significant about the contest. Eurovision performances or fan experiences of the ESC are only very partially explained by an analysis focussing on nationality as the main structuring category. As Dyer notes, contradictions in entertainment forms are also a source of ideological ambivalence. For example, in film musicals, musical numbers often contradict the narrative (Dyer, 1992: 25), and the ESC is equally ambiguous. The structure of the contest is based on the category of nationality: songs are presented as national representatives, and national juries and televoters give points to countries ('Norway, 12 points'), not songs. However, this rigid structure is contradicted at the level of performance. For instance, while Rybak's violin playing draws on Norwegian folk music, the appeal of the performance of 'Fairytale' is not limited to a sense of 'Norwegianness'. A reparative reading of the ESC risks appearing naïve. We can probably find reasons to criticize any Eurovision performance as stereotypical, exoticizing, or sexist if we try. However, the risk of naïvety is at times worth taking as it can draw attention to qualities that a more paranoid critical reading overlooks. In order to grasp the full significance of the ESC, research needs to pay attention both to institutions, structures, and repetition, and to microlevel exceptions and experiences.

Notes

1. As Jostein Gripsrud (2007: 489) points out, Bourdon seems to exaggerate the hopes that EBU founders and EU politicians had for TV in this regard.
2. Bourdon does not explicitly define the concept of Europe, making no clear distinction between Europe, the EU and the EBU. This conceptual slippage is problematic because the EU is not synonymous with Europe and the EBU's membership has always been wider than that of the EU, or its predecessor, the European Communities.
3. The EBU promised in 2012 to address this problem, suggesting changes that would enable all broadcasters to stage the contest, such as smaller venues and less rehearsal time (see the Introduction and the panel discussion with ESC broadcasters [Chapter 4]). Swedish TV network SVT's decision to host the 2013 ESC at Malmö Arena (capacity 15,000) instead of the newly constructed

Friends Arena (maximum capacity 65,000, although for the ESC it would have been around half this number) near Stockholm may be a step in this direction. Executive producer Martin Österdahl commented in the newspaper *Dagens Nyheter* that he could not understand how Russian and German organizers had been able to inflate their respective budgets on the ESC. Instead of competing with huge arenas and LED walls, SVT declared an interest in spending resources on developing the ESC in other ways. Österdahl argued that the recent emphasis on scale had made the ESC cold, whereas SVT wanted to make the contest 'more engaging' (see Lindström, 2012).

4. As 'Western Europe' and 'Eastern Europe' are contentious terms, I talk about the 'former West' and 'former East' to reference the historical legacy of the era when Europe was divided between communist and non-communist countries.
5. These were Bulgaria, Belarus, Georgia, Hungary, Latvia, Macedonia, Moldova, Serbia, Slovenia, and Turkey. In fact, Serbia, Slovenia, and Macedonia had been participating in the ESC since the early 1960s as part of Yugoslavia, which had distanced itself from the Eastern bloc in the late 1940s. Such differences among the new Eurovision countries are not taken into account in the simplifying division between 'Eastern' and 'Western' Europe.
6. OGAE, the Organisation Générale des Amateurs de l'Eurovision, is the leading Eurovision fan club.
7. Thus in 2012, popular topics included the entries from Albania (an arty ballad that earned the country its best ESC result so far) and Russia (represented by the grandmothers from Buranovo who received extensive media attention before the contest).

4

'The Song Contest Is a Battlefield': Panel Discussion with Eurovision Song Contest Broadcasters, 18 February 2011

This panel discussion took place at Royal Holloway, University of London, during the first meeting of the Eurovision and the 'New' Europe Research Network. Brian Singleton chaired a panel of four broadcast executives from across Europe, who were invited to share points of view about the Eurovision Song Contest (ESC) with scholars: Kjell Ekholm from YLE (Finland's national public broadcaster); Jørgen Franck, then interim director of TV for the European Broadcasting Union (EBU);[1] Steve Hocking from the BBC/UK; and Mariana Rusen from TVR (the Romanian national public broadcaster). The editors have abridged the discussion in order to focus on issues of direct relevance to this volume.

A key theme is the increasing size and scale of the ESC since the mid-2000s. As becomes clear, the amount of resource a host broadcaster can commit to the contest is not subject to limitation by the EBU, leading to what Yana Meerzon and Dmitri Priven characterize as something of a 'logistics competition' between some host broadcasters to stage ever-more elaborate and expensive spectacles (119). Despite strong concerns expressed here by Franck, no apparent spending limits were put in place and the trend continued with the 2012 contest in Azerbaijan, direct costs of which were understood to be at least £47 million, with estimates of indirect costs ranging between £171 million and £446 million (*The Economist*, 2012a).

At a press conference during the 2012 ESC, executive supervisor Jon Ola Sand said that the EBU remained concerned about the expanding size of the contest, referring not only to expenditure but also to the logistical and organizational challenges of staging a two-week-long rehearsal and performance period. In late 2012, amid announcements that some

countries had withdrawn from participation in the 2013 contest citing economic constraints (see Introduction), the EBU underlined that it was 'constantly seeking ways to cut costs for both participating broadcasters as well as the host broadcaster and find ways to make hosting the competition more affordable' (Siim, 2012).

Readers may be interested to read the discussion here of the 'Glow' flash mob in the 2010 Oslo contest alongside Marilena Zaroulia's analysis (Chapter 1); similarly, comments here about the BBC's relationship to the contest and Terry Wogan's role in prompting a voting rules change dovetail with Karen Fricker's discussions (Chapter 2).

Brian Singleton: I'll start by asking each of the panellists individually who they are and what they do in relation to the Eurovision Song Contest.

Kjell Ekholm: My connection to the song contest is a bit odd because, in the 1970s when I was a teenager, everyone was watching it, me and all my mates, but nobody said that they were watching. We were all fans of Deep Purple, Led Zeppelin and so on – but some of my very favourite songs from the song contest are from the 1970s when the big orchestra was there. I still listen to these records and the sound is amazing with the orchestra blasting through.

Before I went into broadcasting I had done lots of different things, including being a rock musician for a while. Since I started at YLE in 1987 I've been involved in many programmes, but ended up as head of features in 2001; and in 2002 I became a member of the EBU Eurovision reference group,[2] which was probably the most interesting journey I've made in my working life.

When Finland won [in 2006] I was the head of our delegation... during the encore, I was standing there thinking: 'Oh no.' I knew what was in front of me because I had been involved in the reference group for four years. I knew all the problems all the broadcasters had, because internally there is a big jealousy about who will be executive producer, who will be director, and so forth. All these problems were going through my head then, so I couldn't really enjoy that time because it was already starting to spin for me... It is very, very hard to arrange the song contest because it's such a special event. You can't compare it to anything else.

Anyway, I started working on it immediately; for one year, from June 2006 until July 2007 I was working more or less day and night on that project. As a public broadcaster with no sponsorship department, doing this show was like somebody throwing us

in to the lion's cage... Another thing that was crucial was to deal with the City of Helsinki, and we had a very, very good partnership with them.

During that year, many commercial channels in Finland, who are together with the newspapers, started to say things like: 'YLE can't arrange this. It's going to be a disaster and all of Europe will laugh at us.' That was another kind of pressure on us. All the time there were questions about what kind of image of Finland will we give to Europe, with the postcards [video segments between competing songs] and so on.

It was really a hard thing but we believed in what we were doing, and we stuck to all the decisions we made. After the semifinal – it was just one semifinal in 2007 – everything started changing. Everyone in Finland said: 'Wow! This is great. This is the right picture we want Europeans to have about Finland.'

BS: Can I ask you – and could you answer this as a television producer, not as a Finnish person – would you do it all over again? Would you like to win?

KE: I forgot to tell you that the Finnish had two traumas in their lives. Two big things we couldn't live with. The first one we got rid of in 1995 when we won the World Championship in ice hockey – and we won it in Sweden. The second one was the Eurovision Song Contest. We had been taking part over 40 times. It was kind of: 'When are we going to win? When will it happen?'

So would I like to do it all over again? Of course, but the feeling wouldn't be the same. It could be more professional – but the feeling wouldn't be the same.

BS: We move now to the BBC and Steve Hocking.

Steve Hocking: I'm an executive producer at the BBC and I've had a similarly long career to Kjell's. I started at the BBC in 1986 and have been the exec of a whole range of things from children's programmes to lots of live TV. Most recently I've been the executive producer of some of the big state occasions in the UK, like the state opening of Parliament, Trooping the Colour, things like this. The Queen is the star of many of things I've done.

... I am also a vice-chair of the television committee of the EBU, which is a board of advisors, really, to Jørgen Franck and his department. I don't have any operational responsibility for the BBC's approach to the song contest, but I sit here as somebody who is often the go-between between the BBC producers, the EBU, and the contest organizers, sharing the impact of rule changes and likely

rule changes, trying to resolve minor issues that emerge out of an enormously complex international event which takes place over a few short weeks and days in a location which may be very familiar to the producers, or may be a country that the BBC has not worked in very regularly in the past.

My personal connection to the song contest is much like yours, Kjell. We were a family that knew nothing about the media, and never would have dreamt for a moment that I would have had anything to do with people who made the song contest. But we'd sit, like British people do, rooting for whomever it was, trying to persuade yourself that Mary Hopkin really was a better singer with a better song than Dana, or whatever; simply wanting your team to win.

For the BBC audience the attraction of the song contest is that it's a one-off massive, live event. Like a football match, the excitement starts when the anthem starts playing. The lead-up to the song contest for the UK audience is nothing like as significant as it is for other broadcasters. [The BBC] doesn't build an audience for the show.

... The year that I first joined the EBU TV committee was the year that [UK act] Jemini had received *nul points*, and I was introduced to the world of the EBU where people commiserated with me. They said: 'That must be very difficult for you. I'm really very sorry that the UK performed so badly.' I was thinking that I don't think anybody in the UK really cares. It's kind of funny when it all goes horribly wrong and you come last. It's better to do that than come a miserable 12th or something.

Now, would the BBC like to win the Eurovision Song Contest? Nobody I've ever spoken to in our entertainment department wouldn't fight – just like they would have fought in Finland – to be the executive producer of the Eurovision Song Contest. I've spoken to camera supervisors, I've spoken to lighting directors, who would kill to have the opportunity to put on the best TV show I've ever been to – which was certainly my experience watching live in Helsinki.

BS: Romania has come third twice in the contest the last five years, and has hosted the Junior Eurovision Song Contest. Can you tell us your relationship with these events?

Mariana Rusen: I work in Romanian television, not as a producer but as a PR manager. I am responsible for the promotion of the artists. Whether the song is good or lame, I have to push it. I have to make people like it, like it or not. So it's a challenge. Also, being part of the

delegation I run the press side, which means I relate to all the other delegations, as well as members of the press, fans, and organizers – I am a contact point for everyone. So it's fun. It's a lot of work but it's really fun.

My colleagues in TVR were really thrilled to show what they could do when they hosted the Junior Eurovision – which is Eurovision on a much smaller scale, definitely. The fun is so much more, because there isn't pressure put on the kids to win. All the kids must have fun, must enjoy. They are already winners of the national selection in their own countries. So basically what they have is a fantastic one week, playing together, making friends, showing their songs, their performances.

As far as our results in the main Eurovision Song Contest, yes, we were lucky to finish in third place last year, and it would be really nice to be in second position – but to win, I don't know.

BS: Seriously, you wouldn't want to win?

MR: Well, come on, we hardly have the money to participate. Every year we try to find sponsors and funds to present ourselves at the best quality level, but still this means a huge financial effort for us. Winning would already be too much. I don't think our government would be very happy if we would bring them the trophy, and the obligation to organize the Eurovision the next year.

BS: So national pride would soon wear off?

MR: National pride is one thing, but when it comes down to money it's a totally different approach.

BS: I am detecting fear here throughout many broadcasters... the fear of winning and the impact that would have.

MR: It's good to be good – but not that good!

BS: Now we are going to turn to Jørgen Franck, who is the interim director of television at the EBU. He's the boss of all things Eurovision.

Jørgen Franck: I was a professional classical musician for 25 years. I played at my first concert in the Danish Radio Symphony Orchestra in 1969; I ended this in 1984 having taken, on the side, a master's degree in law. I quit the orchestra and got a job as a legal advisor in the Danish broadcaster [DR], and after a year or two I ended up as boss of the legal department – so I had a bit of luck there. I spent a number of years in DR, until in 2002 I left Denmark to take a job in the TV department of the EBU. Basically I was second in command, and since January 2010 I am director interim.

So, as you might understand, as a classical musician, the Eurovision Song Contest was something you didn't touch – but we

watched it anyway. There were decades when I think people did not love the song contest; they loved to hate it. Seen from an EBU point of view, which I can do now, this didn't matter – because we watched it anyway.

That was also before I realized that the song contest in fact has a mission in Europe. I think it's not about the music; or rather, the music is a tool that we use to bring the broadcasters and the populations of Europe together. Without that tool it wouldn't happen. To me, the song contest is a battlefield where you can allow yourself to be a patriot. You can even allow yourself to be a nationalist, which is a word you don't want to attach very much to people these days. You can support your own country. You can say the others stink. It's harmless but it's very significant. If we didn't have that battlefield, we might have more battles. It's a little like football was, before hooligans started demolishing cities. Football cannot do this job any more, but the song contest can.

This is actually one of the basic things to know about the song contest now, and at the EBU we are thinking a lot about this. We have made some changes recently. [Executive supervisor] Svante Stockselius has left his position, having served well for seven years in the service of the EBU. It was about time for him to find new things to do, and also for us to find new blood, new energy for this. So we have employed Jon Ola Sand, who did, in my opinion, a brilliant job in organizing the contest [in Oslo] in 2010. He is now based with me in Geneva, which is also a big step forward; before we were scattered all over Europe. In modern times this shouldn't matter, but it does. You don't spend time together, you don't have the layer that can nurture the creativity.

I am glad you have asked me to be at this research meeting, because it is important for studies like this to know from the inside what the deliberations are behind what we actually do. There must be a reason for all the silly things that the Eurovision Song Contest undertakes.

BS: As researchers, we don't generally have access to producers' deliberations and decisions. So that's why the focus of our research is more on representation, because that's what we can see. But as we move forward in research, that's something we would like to profit from our contacts here, to understand more the thinking behind the scenes.

Audience comment (Katrin Sieg): I think scholars' focus on the spectators' experience and on representation is not just because we don't know what the true authors of the contest think. Two years ago,

when I first joined the network, I realized that it was difficult to get access to information from the EBU; but it is also the case that we don't think there is such thing as an author. It was not my understanding that you were invited because you're the true authors of this, so we need to pick your brains to tell us what your intentions are. I think there's legitimacy that is essentially academically motivated.

BS: Of course, I've worked in reading the contest as representation myself. But I do think that it's important to bring executive decision-makers here to give a more complete perspective.

JF: In my opinion the song contest has undergone a change recently. Oslo marked a change, at least as I see it. The song contest has just grown and grown and grown and grown: in Moscow, which was a brilliant show, we had a 100-metre LED wall; we had swimming pools being hoisted down from the ceiling. You can do a lot with money (Figure 4.1). This is not putting blame on Russia, but then there was a problem because Norway could not afford such a big show. It couldn't follow that path anymore. So we discussed it, and

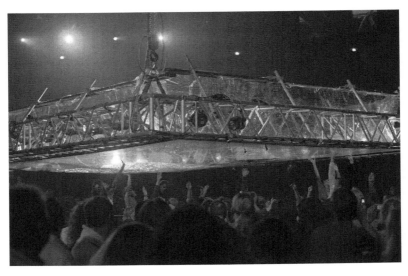

Figure 4.1 Argentinean troupe De La Guarda perform during the interval act of the 2009 ESC in swimming pools flown down from the ceiling of the Olympiysky Arena
Source: Indrek Galetin.

Norway came up with the 'Share the Moment' idea, simply to focus on the fact that there were 70 million viewers in Europe watching the same programme on the television screen at the same time. They wanted to illustrate that in the programme, which I think they did brilliantly well.

The flash mob was very significant for this... [there were] the images they added to the flash mob, recorded in homes all over Europe, and then the direct link to Hamburg where they had thousands of people dancing at the same time. It was a brilliant illustration of the fact that 70 million people were actually occupied by the same thing in this moment.

MR: Even the postcards were showing families getting together in front of the television set, just preparing to watch their entry.

JF: So finally, I think we have, in European public service broadcasting, an entertainment programme with a message. That is not very normal in entertainment. Now, I think that your analysis of what you see could be a help for us. The broadcasters send something out with a message for the big European audience. You sit out here amongst these people and you ask what message you received. If that message is understood in a different way than what we wanted to send, we have a problem. A miscommunication is always the problem of the transmitter, not the recipient.

Audience comment (Katrin Sieg): I know what message you want to send, but I don't know if I agree with it.

JF: OK, but you see, that's where this connection can help us.

Audience comment (Phil Jackson): From my perspective I don't think there's one universal reading of Eurovision every year. With the flash mob, the best point for me, as a lifelong fan, was the opening sequence, with the series of screens and people saying 'My name's Paul and I'm from the UK', and so forth – introductions of people from all over Europe. It gave us that sense of a Eurovision family. The EBU are very clever at underlining the history and the significance of the Eurovision, particularly post the new branding in 2004. There is a sense in which, yes, we are sharing a moment and we are perhaps being manoeuvred into a position where we do feel nostalgic for all those yesterdays of the contest.

Audience comment (Peter Devine): Touching upon a point that Mariana made, but I'd like to address this question to Steve... can the BBC afford to win at Eurovision?

SH: Why would you think it couldn't?

(Audience laughter)

Audience comment (Peter Devine): ... In Moscow they spent $42 million on it. I am asking you, given the climate, could the BBC actually afford to win?

SH: Yes.

Audience comment (Peter Devine): Even in an Olympic year?

(Audience laughter)

SH: I have no access to anything that would suggest that the BBC wouldn't take its responsibility seriously if it won.

... To come back to a previous point, as a member of the EBU television committee I think it would be a terribly sad thing if the song contest couldn't be won by a country like Romania, or indeed any of the Eastern European countries. By comparison, the BBC is the richest member of the club and it would be scandalous if the BBC claimed it couldn't afford to win the Eurovision Song Contest. There are many members of the club who would really struggle as public service broadcasters to deliver. In the time I've sat on the TV committee, which is the last seven or eight years, an active conversation has gone on about how you would support smaller, less wealthy public service broadcasters to deliver the song contest were they to win it. We've not yet been in a position where we've had to make huge decisions about this. Often there has been state funding intervention that has supported [host broadcasters]. Going back to Jørgen's point about the principles behind the song contest, if Romania was to find itself in a position of winning, it would be the committee's job – the other public service broadcasters' jobs – to come up with some solution to the funding problem, whatever that might be....

Certainly when people [initially] got together to test the technical network, and came up with the notion of a song competition to do that, that is something that the BBC has always been interested in. The song contest has led technical innovation around mass texting. In an internet, TV-connected world, what the song contest could pilot for European broadcasters, and indeed for the industry, is something which we are very interested in at the BBC, as I am sure other broadcasters are too. In Eurovision, public service broadcasters have this amazing live television event which is truly popular, which allows you to play with flash mobs, for example, in a way that it would be impossible for any one broadcaster to do themselves.

KE: Within YLE when we hosted, we had some knowledge to arrange. We had cameramen who were very good; we had some technical

equipment. And we had a managing director at the time who was doing very many stupid things – but he was very clever at this point because on the Monday after winning he said publicly: 'YLE can't arrange this on our own. We have some knowledge and equipment and so on, but the government has to come in with €15 million – or it will go to Tallinn or Stockholm.' It took one hour and the prime minister said: 'No, no, no, no, no! Not to Sweden, no! We will give the money to YLE.'

(Audience laughter)

JF: We're touching on a big problem here. On the BBC issue, I don't think the BBC could afford not to host it if they win. That would be one of the major disasters in this part of the world if that happened... the price paid by NRK [to host in 2009] was a double-digit million amount in Euros, and now we have learned about the $42 to 48 million that Russia spent [in 2008].... In Copenhagen in 2001, it balanced, and that was a huge show.... Why did it balance in 2001, and it cost a double-digit million Euro figure for Oslo in 2010? [The EBU] are not in control of that. The broadcasters have chosen that this event should grow so much, because every broadcaster wants to do better than the previous one. How can you do better? You buy an extra LED wall, or whatever – that's the way it's been handled.

So we are facing a big problem. We have centralized commercial incomes for sponsorship for televoting, redistributed to the participating broadcasters every year. Is that the right way of doing it? It was a necessary way, because eight or nine years ago the funding was much more local; each and every broadcaster could find their own sponsors. The televoting arrangement was made with the local telecom operator by each broadcaster so the money stayed in the countries. When my predecessor [Bjørn Erichsen] got the job of TV director of the EBU in 2002, he centralized it. He said: 'It must be possible to accumulate more money on commercial revenues for the Eurovision Song Contest. It must be a commercial gold mine, reaching 70 million viewers'.... We employed a marketing company, T.E.A.M., known for football, based in Lucerne, Switzerland, to find international sponsorship... There is [now] a significant amount of commercial income connected to the song contest – I won't reveal the figures. In order not to disappoint the participating broadcasters, we made a rule that it would be redistributed to them according to the exposure of the sponsorships... The televoting is based on a direct report of the call intensity in each country.

So you could ask, if Norway paid a double digit million Euro figure for the song contest, is it fair that the commercial income goes back to the participating broadcasters – which in many cases means that they pay very little for getting these three big shows of up to three-and-a-half hours? Some even get it for free, because they get more than 100 per cent reimbursement. On average the reimbursement has been between 50 per cent and 70 per cent, meaning that the participating broadcasters get a big show, or three big shows, for very little money. Even [head of delegation] Phil Parsons from the BBC [which cannot accept commercial income from sponsorship] admits that the price for the shows is fair.

It's really about time that we discussed changing that financial model so that the commercial income goes back to the host broadcaster. And this is not the only measure that needs to be taken. We need to go further along the road of downsizing. It's not only size that counts.

Audience comment (Paul Jordan): I have a question for Mariana. There is a certain amount of cynicism about Eurovision from the UK perspective. How is the contest received in Romania; do people see it as a serious musical event? Is it something that attracts mainstream stars?

MR: Definitely Eurovision is an event that some love, some hate, but no one ignores. No one in Romania ignores Eurovision. Some are looking only for the scandal, only for the juicy stuff. Others are just criticizing: nothing is good, nothing is appealing to them. The song is not good, the fact that we changed the rules again is not good, TVR is not a good organization, and so on. Whatever... but they are discussing, they are making enquiries, they are watching, they are involved even in criticizing. This is a sign that they are interested.

We also have a lot of support from the press in the last two years. They were very supportive of our artists, not just for Paula and Ovi, who came third [in 2010], but also a year before with Elena Gheorghe and her 'Balkan Girls', which didn't place very well. No one criticized her performance. We were surprised, and kind of suspicious. Why are you being so nice to us?

Definitely in Romania, Eurovision is a brand linked to the national broadcaster. Still it somehow involves all the other commercial television channels, because they invite the artists, they discuss the selection, they discuss the competitors, they invite different composers to say their opinion. They organize special shows to discuss all this, which is amazing. We're very happy about this.

... I want to come back now to something that came up in a presentation we heard today [by Paul Jordan] about Estonia winning in 2001. Estonians interviewed as part of the research were complaining that there were two Russians in the band [as backing singers] and that no one spoke about them. This was automatically considered to have political implications [because there is a sizeable Russian minority in Estonia, which is subject to marginalization].

Let me tell you about this from the promotional point of view. No promoter, no PR manager, no person in my shoes will ever dilute the attention away from the lead singers towards all the team, and especially not towards the backing singers. My window of opportunity is three minutes on the stage, full stop, to reach an audience of 70 million. I have to prepare the attention of that audience for those three minutes, so all the attention goes to the lead singer. There is nothing political in this. Of course, the large audience doesn't know that, it's something very technical; but I think you should have access to this technical information in order to present both sides.

Audience comment (Katrin Sieg): I have a question about the voting procedure. For many years the trend was to have more and more televoting, to have audiences be the ones to decide what the outcome of the contest would be. What kind of complaints were voiced inside the EBU or among Eurovision decision-makers to return to the system of joint jury and televoting?

JF: We finally gave in to a lot of criticism of the sole televoting-based decision-making. [BBC commentator] Terry Wogan was a big factor in this, because he always complained that there was something wrong with the voting, that it was probably bribed or rigged. I think, basically, the problem is that the UK had no friends ... Other countries have lots of friends and they vote for them. You cannot vote for your own country, and that's a handicap if you don't have any friends.

That was one of the biggest problems, so we said: 'OK, let's have a test of the public vote by an expert vote by an expert jury. Let's see if that actually changes the result.' We already had these juries as backup if there something wrong with the televoting. We had the suspicion that [switching to 50/50 voting] wouldn't change very much. To make that very clear and open we said: 'OK, finally we are in favour of public vote here. We are in favour of a decision not made by experts, because it should not be the elite deciding on the winner of the song contest. It should be the peoples of Europe.'

And we said: 'OK, let's incorporate that test. Let's make it 50/50.' So 50 per cent is experts and 50 per cent is the popular vote. The analysis so far has shown that it doesn't change a lot, really just on the marginals. There is an order here and there that is moved around, but it is not a significantly different result – it is actually quite comfortable for us to know that. It means that both elements must be reliable.

BS: I'm aware we're running out of time. I would like to ask each of the panellists to address the future. Where do you see Eurovision going, if you can look into a crystal ball?

SH: I go back to something I said earlier. The song contest in its origins was a creative response to technical innovation, and I think that exciting transformations of the contest for me always in some way respond to technical opportunity. That was what was fantastic about the flash mob: even though it couldn't be fully live and simultaneous, it spoke to a world in which things *could be* live and simultaneous, in which the ubiquity of technologies across the different broadcasters would enable a kind of live interaction with the event which would be a step change from people being able to all vote in the same time window for it. I think that's where the future of it lies. The future of blockbuster entertainment broadcasting is a live future. Live sporting events are massive for all our broadcasters. It's a remarkable thing that European public service broadcasting has in its gift one of the biggest live entertainment events in the world. I think there are potential excitements around applying new technologies that could have an impact similar to 2004, where a new technology opened up possibilities of mass televoting.

MR: Definitely I don't envy the new Eurovision managing team at the EBU, because I realize that you will probably have the most difficult task, to keep this contest from expanding too much. At a certain moment you [addressing Jørgen Franck] said you could feel the need to downsize – I can't see how you could do that without starting a war. At the same time it's obvious that too much is too much. You will have to keep the balance between overexpanding and excessive costs, and causing frustration among participants by downsizing. Keeping that in balance with creativity and new technologies – it's not going to be easy.

KE: In the old days, people talked about the contest at their first coffee break at work on Monday morning. Then people started chatting on the web about what happened during the contest and after; now it's *Facebook*... and we don't know yet what the next thing will be.

The contest is very close to the audience, and the live thing is very important. What that next thing is going to be, that's going to be interesting to watch – something has to come after *Facebook*.

Another thing is that I think we have to face is, the competition from the commercial side is there, with the *Pop Idols* and other formats. There has to be a change to a bigger drama in the contest, in one way or another – the drama is part of the entertainment.

The third thing is that the Eurovision Song Contest is a very high-tech programme. I am looking forward to seeing the song contest in a cinema with 3D. That would be nice.

JF: ...What makes the Eurovision Song Contest survive is that you never know what the next one will look like Now we just need to ask ourselves: 'What will we do with it?'... I have outlined a little here what I think it could be. I don't know if I'll be in charge of this for a long time, but if I can have a say I know roughly where I want to take it.

3D is actually an idea that has been put forward and that we wanted to do, because we treat the song contest as a big playground for new technology. Our technical department wanted to establish a 3D production in parallel to the song contest and broadcast it live in cinemas across Europe. But [in 2009] the host broadcaster did not dare to do it because they thought it would jeopardize the security of the show [meaning the ability of the host broadcaster to reliably deliver the television broadcast signal] We had [3D] offered for free from a company who wanted to put this technology at our disposal, but the people in NDR didn't dare to do it. We won't get it this year, unfortunately, and I suspect that by the following year it will be probably too late because somebody else will have done it.

BS: It would be wonderful to see 70 million people all wearing 3D glasses at the same time.

JF: Imagine the parties you could have in the cinemas. It would be really thrilling.

Notes

1. As of late 2012, Franck is the EBU television director.
2. The reference group is the committee of European television executives overseeing the ESC. It includes the ESC executive supervisor, an EBU employee.

Part II
European Margins and Multiple Modernities

5
Back to the Future: Imagining a New Russia at the Eurovision Song Contest

Yana Meerzon and Dmitri Priven

A *Washington Post* journalist once wrote: 'Russia and the European Union are neighbours geographically. But geopolitically they live in different centuries... Europe sees the answer to its problems... in transcending the nation-state and power. For Russians, the solution is in restoring them' (Kagan, 2008). In spite of the seeming incongruity between the economic and cultural politics of the European Union (EU) and those of Russia, it seems that for both geopolitical entities the Eurovision Song Contest (ESC) has become a venue to test the changing cultural, political, and economic values that both Europe and Russia began to experience after the fall of Berlin Wall in 1989. Looking at Russia's eager participation in the ESC, this chapter examines the creative, administrative, funding, and media systems behind Russia's ESC output. It views Russia's growing interest in the ESC as an indicator of the country's negotiation of its position as a separate geopolitical entity vis-à-vis the EU.

However, in considering the musical and performative output that Russia has fielded at the ESC, we choose not to look at Russia's recent involvement in the contest in terms of its relation to the geopolitical, cultural, or aesthetic sensibilities endemic to the expanding EU; we argue instead that the ESC served Russia's ruling regime in the 2000s as an ideological tool and a nation-building device. Furthermore, this study suggests that Russia's participation in the ESC is indicative of the country's leading role within the emerging Euro-Asian economic bloc and the related geopolitical discourse actively explored by Russia's government. This discourse around the ESC, abundant in the state-run media, speaks to the governing regime's desire to re-establish a

post-Soviet cultural space that would include not only its current political and economic partners, such as Belarus, Ukraine, and Kazakhstan, but also the Baltic states and Georgia, all of which have decidedly European political, economic, and cultural leanings. In this respect, this study proposes to deconstruct Russia's vision of the ESC's artistic, musical, and performative norms and expectations in light of how the country's dominant ideologies position Russia vis-à-vis the post-1989 EU and in the world. We suggest that by making a targeted effort to compete in and win the ESC, including increasingly substantial monetary and artistic investment, Russia's authorities reify a particular national mythology for both domestic and external consumption.

To this effect, this chapter analyses several Russian ESC entries of the 2000s, Dima Bilan's 2008 victory in Belgrade, and Russia's subsequent hosting of the ESC in 2009. Using methodologies of critical discourse analysis and performance theory, we argue that the ESC is one in a series of events that the current political regime is using to demonstrate to the West that the country can create musical and performative products compatible with the standards of Western showbusiness. Russian political and media authorities employ what one could call an ESC formula of success, a combination of artistic and economic efforts, as a strategy not only to win the contest but also to re-establish the pre-Perestroika image of the country (both on the home front and abroad) as a competitive, progressive, and wealthy Euro-Asian nation. Accordingly, this study recognizes the 2009 ESC held in Moscow and its official media coverage as a stepping stone for Russia's subsequent successful bids for and implementation of the University Games in 2013, the Winter Olympic Games in 2014, and the FIFA World Cup in 2018.

Setting the context: On a politics of (re)mapping a post-Soviet cultural space

The 1991 collapse of the Soviet Union instigated post-communist Russia's search for the country's new identity, and for marketing strategies to promote this identity internally and internationally. The continuity of the Soviet zeitgeist within the country had been disrupted in the early 1990s, when ideologists of the new Russia were trying to relinquish 70 years of Soviet history and create temporal and cultural bridges (at least in the people's collective consciousness) with pre-Soviet Russia. The 1990s search for Russia's new sociopolitical and cultural image began – top down – with resurrecting and glorifying the pre-Soviet 'golden age', especially the period between 1861 and 1917.

More specifically, 1996 saw Boris Yeltsin, in a quest to improve his chances to win a second presidential term, announce the need for a new Russian idea, one that would ideologically unite the post-Soviet nation. Thinking of Russia's future, his cabinet 'implicitly acknowledged that seeking "normality" patterned after the achievements of wealthy Western nations had not sufficed as a guiding principle for authority-building in Russia' (Smith, 2002: 159). Russia would choose its own way. Accordingly, in 1996 the cabinet turned its gaze to the country's history to shape an image of its future. It was time once again to rethink or, rather, retell Russia's history, and for some pro-Western politicians to 'embrac[e] the idea of having a set of positive memories [and thus to invoke them] as markers of a shared political identity' (ibid.). After Yeltsin's success in the 1996 election, *Rossiiskaia gazeta* (a major state newspaper) started a contest to articulate a new 'all-national progressive idea' that would be capable of 'binding together and energising [the] society' (ibid.: 162). Although the state apparatus did not openly outline the search criteria, the suitable 'national idea' was in the end to be 'civic, not "political, ethnic, or confessional". At the same time, however, [the idea] needed to be national and patriotic – an idea not just for ethnic Russians... but for all citizens of the Russian Federation' (ibid.: 163). Specifically, the new ideological discourse was intended to fix 'the time that is out of joint' – that is, to re-establish the lost continuity of the collective zeitgeist of the Soviet era. Accordingly, in the 1990s, many artists, singers, political activists, and media authorities turned their nostalgic gaze to the pre-1917 Russian past and its unity of orthodoxy, autocracy, and nationality.[1] This discourse was meant to create an image of a new Russia as an ideologically and culturally solid country able to position itself independently but in dialogue with its Western neighbours, the countries of the EU. At the same time, it foregrounded another image of Russia – a strong state capable of supporting and controlling (if necessary) its Eastern neighbours and former constituents. This dual positioning of Russia as a Euro-Asian state was therefore intended to reinforce its historical status as a buffer zone between West and East, with a tinge of 19th-century nationalist romanticism.

The Putin–Medvedev rule of the 2000s started out much in the same socio-political vein, with a view to regaining domestic economic stability and to ensuring Russia's return to the European and global stage as an economically, militarily, and culturally competitive power. However, the decade witnessed the ideologists of the post-communist state gradually capitalizing on the population's 'hypochondria of the heart' (see Boym, 2001) – that is, its nostalgia for Soviet myths of a guaranteed perfect

future, or at least of a stable present, underlaid by an 'as-long-as-it-does-not-get-any-worse' mentality. The government's internal politics then aimed to address a 'widespread sense of insecurity and loss' (Remington, 2008: 249) using economic and cultural mechanisms. By 2012, the year Putin returned as president, the country found itself in a cultural zeitgeist that many speak of as similar to the 1970s, Brezhnev-era 'stagnation'. In the 2000s, 'the worldwide increase in the price of oil [had] strengthened Putin's hand' (Remington, 2008: 249), whereas employment of mass communications, namely of TV, had helped his new economic and cultural politics.

Russian TV, a progressive national idea, and the ESC

Once the new 'progressive national idea' had been rediscovered in the ideological practices of the Soviet past, the government could not overestimate the leading role of Russian TV in its reinforcement. The authorities eagerly embraced the power of national TV, notably two of its genres – episodic series and music shows (MacFayden, 2008). Governmental use of popular music for ideological purposes has a long history in Russia: leading Russian rock critic Artemy Troitsky (2010a) claims that 'Russia's state ideology in music has always been and remains...music for popular entertainment and for the peace of mind of the government'. In the 1960s, the communist regime appropriated Western mainstream popular music styles to create the so-called VIA ('vocal-instrumental ensembles') – expanded and sterilized versions of rock groups. In the late 1990s, in order to re-emphasize the discourse of continuity in post-communist Russia, Channel 1 Russia aired a three-part project entitled *Starye pesni o glavnom* ('Old songs about what's important') on New Year's night, which presented a corpus of recognizable Soviet pop songs about love, sung and restaged by pop stars of the mid-1990s. Today, David-Emil Wickström and Yngvar Steinholt see this appropriation of pop music's appeal (including the ESC) for ideological purposes as a manifestation of what Svetlana Boym (2001) terms 'restorative nostalgia', which 'attempts a transhistorical construction of the lost home' (2009: 325).[2] The outcome of such politics is a newly established, state-approved, multigenerational group of TV personalities (including popular singers, composers, and TV hosts) who repeatedly appear in Channel 1 Russia's programming. Just as in the 1970s, in today's Russia this common core of state-approved popular TV stars functions as a symbol of economic stability, and underscores the idea that new Russia has left the unpredictability of the 1990s free market of

pop music behind. Hosting the 2009 ESC was very much in line with Channel 1 Russia's longstanding mandate to build the country's 'democratic' identity by capitalizing on old sentiments. It is not surprising in this context that t.A.T.u, who competed for Russia in the 2003 ESC, performed their hit 'Not Gonna Get Us' (note the title's symbolism) in the opening act of the 2009 semifinal along with the Alexandrov Red Army Choir and Dance Ensemble, with a Russian fighter jet in the background.

Russia's participation in the ESC

Starting from its first ESC appearance in 1994, Russia has continuously worked on its winning strategies – on a product in line with what is expected at the contest. Although never articulated as a fully fledged recipe, Russia's ESC formula of success revolves around four performative and musical axes. The song's musicality (i) means that a new song must be 'danceable, catchy, so that the audience would be able to sing along' (Eurovision Song Contest, 2009). The contestant's performative presence and complexity (ii) refers to the singer's performative choices, acting technique, musical ability, and delivery. The contestant's 'youth, naiveté, energy and truthfulness' (iii) (Breitburg, 2010) alludes to his/her appearance, sex appeal, and age (the younger the better), and to flashy and revealing costumes and makeup. Lastly, there is the song's language and lyrics (iv): with no language restrictions after 1999, the so-called Populenglish, the Esperanto of world popular music, has become a staple of ESC performative aesthetics. We suggest that these four tenets reflect the transnational nature of the contest's expectations and output, something that 'conceives the poetic imagination as ... a nation-crossing force that exceeds the limits of the territorial and juridical norm' (Ramazani, 2009: 2). Over the past 15 years, Russia has attempted to conform to the aesthetic and musical norms of the ESC, while exhibiting uniquely Russian sensibilities – the duality of Russian cultural politics that, as we have been arguing, reflects Russia's self-positioning as a new Euro-Asian entity, a strategy that paid off in 2008 with Bilan's victory.

Russia first appeared at the ESC in 1994 with the song '*Vyechniy strannik*' ['Eternal wonderer'] , performed by aspiring singer Youddiph, and took ninth place. The choice of singer was as emblematic as it was misguided: Youddiph's quirky, jazz-tinged song was intended to show off the new Russia's musical sensibilities but failed to impress voters. Russia then fielded the heavy artillery of the king and queen of the Russian pop stage, Philip Kirkorov and Alla Pugacheva, in 1995 and

1997, respectively, but to little avail. Success finally arrived in 2000, when Russia was represented by 16-year old Alsou (daughter of Lukoil top executive Ralif Safin and widely known as 'the Oil Princess'), singing 'Solo' by Andrew Lane and Brandon Barnes – a catchy number with English lyrics. The performer was young, attractive, and naïve enough to believe that 'what helped was that it was the first contest in [her] life, and [she] wasn't quite aware of the responsibility so [she] didn't have much stage fright' (qtd. in Mikheev et al., 2000). The mise-en-scène of her act was in line with the European audience's expectations; her pink, sexy outfit was designed by the London couturier Maria Grachvogel, then the Spice Girls' regular designer and stylist. Arguably, Alsou took second place that year because her producers had for the first time succeeded in offering a Russian version of the ESC formula of success: the four performative qualities of a ESC act, along with heavy media coverage and strong financial support. Her success marked the beginning of Russia's more focused and concerted pursuit of Eurovision gold, which involved, in the words of the director of the 2009 Moscow ESC, getting advice from 'everybody who was or is somebody' in Eurovision and European TV (qtd. in Eurovision Song Contest, 2009), and consciously modelling their singers and musical material on Europop.

After Alsou's 2000 performance, Russia's ascent to the ESC summit continued with t.A.T.u's third place with *'Ne ver', ne boisya, ne prosi'* in 2003; Bilan's second place with 'Never Let You Go' in 2006; and Serebro's third place with 'Song no. 1' in 2007. Bilan's 2008 number, 'Believe', composed by Jim Beanz (James Washington) and Bilan, received 272 votes with the maximum 12 points from many former Soviet states, such as Estonia, Latvia, Lithuania, Ukraine, Belarus, and Armenia (along with Israel), and it brought Russia the long-awaited Eurovision gold. The song's lyrics, such as 'I believe: I can do it all/Open every door/Turn unthinkable to reality/You'll see – I can do it all and more' (The Eurovision Song Contest Final, 2008), brought Bilan personal recognition and congratulations from both President Medvedev and Prime Minister Putin. Bilan's post-contest comments aligned his success with official state endeavours: 'We continued the string of beautiful victories taking place one after another... In sports, this is basketball, soccer, hockey and the chance to host the 2014 Olympics in Sochi' (qtd. in Kishkovsky, 2008).

Dressed in a white shirt and matching trousers, the colour of youth and innocence (and the colour of Eurovision victory) Bilan started his song alone, sitting at the tip of a thrust stage surrounded by the audience, cultivating a sense of intimacy with his listeners. He sang in 'nearly

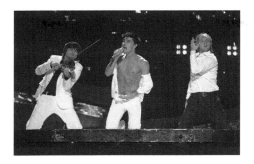

Figure 5.1 2008 ESC winner Dima Bilan (centre) performing 'Believe' with Edvin
Marton (left) and Yevgeni Plushchenko
Source: Indrek Galetin.

flawless English', 'frequently flashed his bare chest' (Kishkovsky, 2008)
and alternated sitting, lying, and kneeling, all of which added to the
sex appeal of his number. With the second part of the act and the lyrics
'Nothing else can stop me if I just believe/And I believe in me', Bilan
stood up and moved centre stage, where Olympic champion ice skater
Yevgeni Plushchenko, dressed in a white shirt and black trousers, twirled
around Bilan, while the Ukrainian/Hungarian virtuoso violinist Edvin
Marton,[3] also dressed in white, supported the singer's determination to
believe in his own powers with a musical intervention on his magical
Stradivarius. The act reached a crescendo with the lines 'nothing else
can stop me if I just believe', as the trio lined up on their knees across
the platform gesturing towards the audience, and triumphantly finished
with Bilan singing: 'and we believe in you' (Figure 5.1). The gesture and
the song suggested the self-assurance of the singer and the country that
he represented, as well as their openness to the new audiences and the
new markets of the West.

By combining the talents of Bilan (a classically trained singer capa-
ble of performing 18th-century opera), Plushchenko, and Marton, the
Russian ESC producers offered not only a strong artistic bid but also
an ideological statement targeted at domestic and international audi-
ences. The Bilan–Plushchenko–Marton combo signified the newly rising
power of the post-communist Russia. It generously contributed to the
longstanding image of 'Russianness' that the country has been selling
to the West during the communist period by re-enforcing the masculine
authority and power that was associated with the militarist and some-
what aggressive Soviet Russia. At the same time, it capitalized on another
stereotype of Russia's cultural superiority dating back to Soviet times: the

talented singer was backed up by the Olympic champion figure skater and the virtuoso violinist, all products of Russia's excellent training system in arts and sports. More specifically for the contest itself, the victory demonstrated, as 2009 ESC producer Konstantin Ernst suggests, that by that point the Russian TV authorities had not only learned lessons about ESC aesthetics (by creating an act that did not necessarily promote the country's musical distinctness) but also proved themselves able to create a performative product that could win the ESC battle of national prides and sensibilities (qtd. in Eurovision Song Contest, 2009), because for Russia, 'Eurovision [is] not just a song contest. It is an opportunity to show off, and ... to defend the face of the homeland' (qtd. in Eurovision Song Contest, 2012).

The subsequent, triumphant staging of the ESC in Moscow reflected the then-current tenets of Medvedev–Putin's domestic politics: taming Russian private business; merging the structures of power with those of financial, industrial, and media oligarchies; making oil industries and profits serve the building of a national idea; and manipulating the population's votes. As with many other projects aired on Channel 1 Russia, the 2009 ESC served the Medvedev–Putin government as a tool to market a post-Soviet, open, tolerant, and democratic new Russia to both domestic and foreign audiences. In Ernst's view, it was mainly the 'external political effect' that the organizers were after (qtd. in *The Economist*, 2009). The 2009 ESC, like any other international event hosted by Russia, including the 1980 Olympic Games, was perceived by the Russian authorities as an opportunity for self-affirmation through massive spending: hosting the ESC cost £26 million, at that point the largest ESC budget in the contest's history. Writing about the finances involved, as well as Putin's personal engagement in monitoring preparations for the contest, the witty *Economist* suggests: 'In the past Kremlinologists monitored Soviet leaders by their line-up above Lenin's mausoleum. Now it is by their appearance at Eurovision' (ibid.).

The 2009 Russian ESC performative endeavour

According to Vladimir Aksyuta, artistic director of the 2009 ESC, the Russian organizers raised the technology bar so high that any subsequent host nation had a hard act to follow (Eurovision Song Contest, 2009). They made a serious point of hiring world-class lighting, sound, and stage designers, and brought in 30 per cent of all the LED screens available in Europe. The 2009 ESC had the largest audience and the widest media coverage of any contest to date; Moscow's Olympiysky Arena became, for the duration of the contest week, Europe's biggest

concert venue. Hence, the general perception in the media was as if this had been not only a musical but also a logistics competition.

The opening ceremony took place in the Manege, adjacent to the Kremlin and Red Square. It began with a dance act performed by a military dance troupe, followed by a potpourri of ESC-winning songs from the past performed by the children's ensemble Neposedy, and a variety of ESC songs mixed with Russian folk music performed by famed Russian balalaika player Aleksey Arkhipovsky. The ceremony also featured several past Eurovision performers, the choice of whom exemplified Russia's tendency to create a transgenerational and transgeographical continuity of memory from the Soviet period to the present, from Western Europe to Russia. Notably, Moscow welcomed the first ESC winner, Lys Assia, who performed her 1956 winning song, 'Refrain'. The German act Tschenghis Khan (ESC winners in 1979) and the Dutch group Teach-In (the 1975 contest winners), who enjoyed immense popularity in the Soviet Union during the disco era, also appeared among the invited artists. Hence, the opening show and the Moscow ESC in general were intended to evoke the imaginary temporal space, along the lines of restorative nostalgia, that Russian state TV creates for its citizens and, now, for international audiences.

Emblematically, it was the firebird from Russian folktales – the bird that brings good fortune – that reigned over the 2009 contest. The first semifinal opened with a fairy tale about two little girls (played by Masha and Nastya Tolmachev, the winners of the 2006 Junior ESC), who sought advice about how to fly from plants and magic horses. The fairy tale continued accompanied by projections of creatures from other Russian fairy tales, including the firebird itself, which eventually materialized and flew 30 metres above the audience. The bird brought the two girls onto the stage to discover a magic tree capable of granting the girls' – and thus the Eurovision contestants' – wishes, because it is only the song that 'can give people wings' (Eurovision Song Contest, 2009). The choice of this symbol and the fairy-tale narrative exemplified the tendencies of Russian culture and music to cater to European tastes and standards, while enriching the country's creative output with its folk traditions. The firebird allowed the 2009 ESC producers to exploit a 'folk' vision of Russianness familiar to the Western gaze: the symbol spoke equally well to both domestic and foreign audiences.

At the same time, the design choices and the many international performers in the opening gala symbolized the Russian hosts' European tastes and high level of cultural awareness. The contest stage was designed by New York-based scenographer John Casey, who had worked on the 1997 ESC in Dublin. Creating his stage fantasy in Moscow, he

pursued a longstanding interest in Russian constructivism and avant-garde theatre design: he managed to introduce 'Russian avant-garde art into a contemporary setting, almost entirely made up of different types of LED screens' (Sandberg, 2009). This design involved a particular positioning of screens and mirrors over the performance area, allowing for unusual colour and image combinations that were evocative of El Lissitsky's and Kandinsky's paintings, and Rodchenko's photographs. This combination of historical imagery with advanced technological performance added a special visual flavour to the Moscow contest (see Figure 3.1). It both spoke to the nation-building desires of the Russian authorities and catered to Europeans' expectations of Russianness. Invited to participate in the opening of the final, Cirque de Soleil served this purpose too. It performed *Enfant Prodigue/Prodigal Son*, which featured, among other images, flying *matryoshka* dolls, and midgets descending from the sky in hot air balloons. Both of these images were curiously reminiscent of the flying bear from the 1980 Olympic Games. The number ended with Bilan being flown in to reprise the previous year's winning song.

The 2009 ESC also spoke to the official ideology positioning Russia as a buffer state between Europe and Asia, via, for example, the song it chose for the competition.[4] Russia fielded the Ukranian singer Anastasia Prikhodko with the much-publicized song '*Mamo*' (Mother). Beyond the iconicity of choosing not to sing in English at home, the fact that the song was performed in Russian and Ukrainian was in line with political tendencies towards rapprochement between the two countries after a decade and a half of political and economic animosity.[5] As Ernst explains, the choice of Prikhodko to represent Russia 'personifies our [Russia's] pan-European approach to ESC, because Anastasia's father is Russian, her mother Ukrainian, she gained fame in Russia, the music was written by an ethnic Georgian, and the original lyrics are by an Estonian. All this fits well with our international vision of this contest' (qtd. in Eurovision Song Contest, 2009). Interesting to note here is Ernst's interpretation of the phrase 'pan-European'. All of the geographical references in relation to Prikhodko and her song happen to be as post-Soviet as they are European, again in line with Russia's desire to build a new post-Soviet space that is pan-Slavic and pan-Asian; or, in other words, to restore the cultural-economic and ideological hegemony of Russia within the territory of the former Soviet Union – an interesting statement on the country's vision of Europeanness coming from a person in charge of televized state ideology.

However, after the 2009 ESC, the interests of the Russian government and, therefore, the executive management of Channel 1 Russia shifted towards different nation-building projects. The 2010 Russian ESC contestant, Petr Nalich, was selected and supported by Rossiya 1, a smaller state-controlled TV channel. Asked whether he was ready to fight a Russian victory at the 2010 ESC after the country's unfortunate performance at the 2010 Winter Olympics in Vancouver, Nalich said: 'I don't think we should treat a song contest as the Olympic Games, because music is not sport. If you treat music as a competitive sport and demand that a singer win at all cost, the music only gets worse' (2010).[6]

Conclusion: The Buranovo Grannies, ESC 2012

Many Russian show-business personalities consider Russia's 15-year-long effort to win the ESC as evidence of several inferiority complexes. Besides the most obvious complex related to the country's loss of superpower status, there is also an inferiority complex in the area of pop music. The popular sentiment – if Russia wins Eurovision, it will prove that it has become a world leader in pop music – should be taken with a grain of salt, according to Troitsky (2005). The closest Russian pop music has ever come to European, let alone world, pop music standards and markets was with t.A.T.u. Russian popular singers' target audiences have been, and remain, in Russia proper, the Russian-speaking population of the former member states of the Soviet Union, and the Russian-speaking diasporas of Europe, Israel, North America, and Australia (Breitburg, 2010).[7] As a result, Russia's participation in the ESC can serve as a performative mirror on the country's economic and geopolitical processes over the past two decades. Back in 2000, Alsou's second-place finish reflected important political and economic changes happening in Russia at the beginning of Putin's presidency, specifically in terms of the state reclaiming control of the energy sector. It was not a coincidence that Ralif Safin, a top executive at Lukoil at the time, decided to sponsor his daughter, Alsou, to perform in the ESC. It seems no less a coincidence that it was with Alsou that Russia's serious financial and artistic investment in Eurovision began. Accordingly, to speak of the Russian government's ideological influence over the country's ESC choices, and the strategy that finally brought the competition to Moscow in 2009, is also to speak of the continuous merger of money (i.e. significant private businesses, such as Lukoil) with state power. The lavish 2009 contest budget exemplifies the outcomes of the process. In this context, one can state that Bilan's 2008 performance was a currency much more stable and attractive than the ruble.

Geopolitically speaking, Russia's participation in the ESC reflects a certain stand that the state-run media (and through it the ruling United Russia party of Putin–Medvedev) have taken in terms of how they position Russia in the post-Soviet space. The unique geopolitical position that Russia sees itself occupying in today's balance of world power – a uniquely Euro-Asian position that serves as a sociocultural bridge and economic buffer zone between Europe and the Asia-Pacific region – is also reflected in the choice of performers and acts representing Russia over the past decade, and in the performative choices in contest programming during the 2009 ESC in Moscow.

Ultimately, this chapter argues that for Russia its involvement in the ESC has become increasingly more important as a national reaffirmation device, both in economic and cultural terms, and for both internal and external use (Figure 5.2). It was not surprising in this context to see the folk band Buranovskiye Babushki (the Buranovo Grannies) as the country's 2012 official ESC entry. The group lives in the village of Buranovo in the Malopurginsky district of Udmurtia (an autonomous republic in the Volga region) and sings Udmurt folk songs in its native language. The fact that it was selected to represent Russia at the ESC 2012 is indicative of the country's attempts to build the image of a strong state that is sensitive to its ethnic

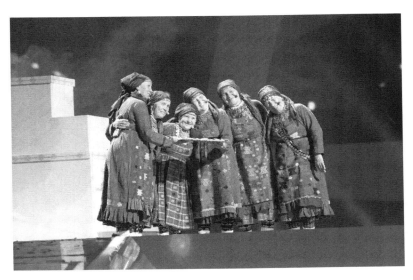

Figure 5.2 2012 Russian ESC entry, the Buranovskiye Babushki
Source: Thomas Hanses.

minorities. It is also in line, although paradoxically, with the Russian ESC formula of success. 'Party for Everybody', the group's ESC number was a new song composed by Viktor Drobysh and Timofey Leont'ev, with lyrics by Ol'ga Tukhtareva (one of the group's vocalists) and the American poet Mary Susan Applegate, who has also worked with Kylie Minogue and the German synthpop duo Modern Talking. The new song is danceable and catchy, and it is sung in two languages – Udmurt and English. An invitation to sing and dance, the song presents the grannies happily setting tables while waiting for guests to arrive and sing together 'really loud', so 'the boredom will go away' (Radio Golos Rossii, 2012).

Dressed in somewhat stylized Udmurt national costumes, the Buranovo Grannies impress their audiences with their performative appeal, energy, simplicity, and openness. Although some music critics saw the duo of former winner Bilan and Julia Volkova, with their mega-hit 'Back to Her Future', as a more mainstream option for Russia in ESC 2012, the final round of the national competition brought them only 29.25 votes, whereas the Buranovo Grannies received 38.51 votes (Gasparyan, 2012). What contributed to their national victory was, it seems, the third factor of the ESC formula of success: the contestant's 'naiveté, energy and truthfulness', their charm and ability to act 'not quite mainstream', to be 'original and very sincere' (Breitburg, 2010). Moreover, for many people who voted for the Grannies, the group's seeming disengagement with current Russian politics, and the (also seeming) absence of strong producers who can dictate their own politics in the world of pop music, played a particular role.

The Buranovo Grannies came second in ESC 2012. Their stay, while in Baku, was at the villa of Emin Agalarov, the son-in-law of Azerbaijan's president Ilham Aliyev – himself a businessman and a pop singer. Although this may have started some rumours of nepotism, the sincerity and wholesomeness of the group were seen by the contest's winner, Loreen, as a major contributing factor towards their success (Vovk, 2012). While they were dancing and singing in Baku, their importance to their local community was affirmed: they were awarded the title of People's Artists of Udmurtia; and Aleksandr Volkov, President of Udmurtia, promised to allocate 1 million rubles (around £20,000) to restore the Church of St. Trinity in the village of Buranovo, which had been destroyed in the 1930s (Vovk, 2012). Ultimately, the participation of the Buranovo Grannies in ESC 2012 may once again be indicative of a desire of Russia's leadership to position the country in a certain light both domestically and internationally, this time as a strong but tolerant and friendly state.

Notes

1. This unity was the cornerstone of a nationalist manifesto written in 1832 by Sergey Uvarov, minister of education for Tsar Nicholas I, and is still flaunted by several cultural icons in today's Russia (notably filmmaker Nikita Mikhalkov).
2. A disconnect evident in the 1970s and 1980s, between state-sanctioned pop music and the semi-underground rock music scene, has now been completely glossed over by aged representatives from both camps being invited to perform in Channel 1 programmes; everyone is now equally part of the country's cultural legacy, with nostalgia being the great cultural and social equalizer.
3. Marton was born in an area of Ukraine largely populated by ethnic Hungarians. He trained at the Tchaikovsky Central Music School in Moscow.
4. Today's dominant political discourse in Russia, marked by calls to recognize the uniqueness of Russia's geopolitical position (see Kratochvíl, 2008; White et al., 2010), re-enforces the government's preoccupation with a neo-Euro-Asian idea. Putin has frequently voiced the country's desire to be perceived as a Euro-Asian rather than a European nation (see Laruelle, 2008: 7–8). This position, according to Marlène Laruelle (2008) and Mark Mazawer (2011), is conditioned by Russia's tendency to seek the support of, and influence on, its former Soviet co-constituents in order to create an alliance that might serve as an economic link between the economies of the EU and the Asia-Pacific region. Moreover, today the government's policy 'is far from seeking to isolate Russia from the international capitalist economy, as the Soviet regime did. Nor is it intending to compete with the US as a global power. However, it does seek to become … a "regional superpower" ' (Remington, 2008: 249). Thus, the government would recognize 'a united Eurasia in opposition to the transatlantic West' as the mechanism to assure 'protection from external threats and increasing global competition', something made possible by the Commonwealth of Independent States' 'common intellectual potential and united efforts' (Putin ctd. in Torbakov, 2004).
5. A pan-Slavic discourse has recently reappeared in Russian TV shows, with 1960s–1980s Soviet TV personalities reminiscing about the good old days when Ukraine was still part of the USSR (read Russia); we can read Prihodko's presence as Russia's representative at the 2009 ESC as part of this wave of nostalgia.
6. Despite his less-than-ambitious take on the contest, Nalich was placed a respectable 11th in the 2010 ESC.
7. As an example, 2009 ESC winner Alexander Rybak, who was born in Belarus and is now a Norwegian national, was embraced by Russian-speaking audiences in Russia and in the diaspora.

6

'Playing with Fire' and Playing It Safe: With(out) Roma at the Eurovision Song Contest?

Ioana Szeman

Often dismissed as light entertainment and kitsch, the Eurovision Song Contest (ESC) provides fertile ground for studying images of Europeanness by showcasing the self-representations of participating nations and the hierarchies that exist between them. The starting point here is the participation of Florin Salam,[1] a Romani-Romanian manele performer, in the Romanian national selection competition for the 2010 ESC. His involvement sent shock waves through a section of the Romanian public and media who feared the prospect of a manele singer, a Țigan,[2] representing the nation at the ESC. In Romania, pop music is regarded as inherently better, more modern, and more highbrow than manele, a version of which can be found in other Balkan countries under such names as turbo folk and chalga.[3] Manele is mainly performed by Romani musicians in Romania, and, as a very divisive genre, has a bad reputation among many Romanians, including pop and rock music fans. Despite being one of the most popular singers in Romania, Salam was unsuccessful and did not even make it to the national final. His rejection restored order for those who feared the worst. The Romanian 2010 ESC final was won by the duo of Paula and Ovi (Paula Selig and Ovidiu Cernăuțeanu) with 'Playing with Fire', a song that emulated an unspecified and generic pop; they came third in that year's ESC final, held in Oslo.

In this chapter, I argue that Salam's failure at the 2010 ESC competition and the media scandal surrounding his participation illustrate the identity anxieties that manele and manele singers, identified with Roma or Țigani and perceived as inadequate for the international stage of the ESC, cause in Romania. I discuss Romania's ESC entries over the last

five years as performances that aimed to avoid the stigma of Gypsies or Ţigani and to change the reputation of Romania abroad, which was perceived as having been damaged by the identification of Roma with Romania, which reached extreme levels in 2010. I link media reactions around Salam's participation in the 2010 national competition to the expulsions of thousands of Romani-Romanian and Romani-Bulgarian citizens from France that same year in an unprecedented campaign that was condemned by the European Commission. Roma, the largest transnational minority in Europe, have been largely absent from the ESC – and not only among Romania's entries – despite a strong trend in ethnic music at the ESC over the last decade and a resurgence of so-called Gypsy music on the international music scene. I argue that, despite the absence of Roma at the competition, stereotypes of Gypsies and Ţigani become tropes for romanticization and stigmatization at the ESC in relationships of nesting marginalization, with Romania and Roma occupying marginal positions in Europe and Romania, respectively. The absence of Roma and local music in Romania's entries reflects tensions that resurface despite their silencing: Roma's lack of actual citizenship in Romania and the EU, the racialized hierarchies of musical genres, and the power differentials between 'Eastern' and 'Western' nations that have persisted despite EU expansion into East Central Europe. My analysis is based on media reactions and public controversies around Romania's ESC entries in the last five years as well as Salam's 2010 participation in the national song-selection process.

Roma, citizenship, and Europe

In East Central Europe, where the largest populations of Roma live, most Roma are settled and many live in poverty at the margins of society, while Romani children continue to experience segregation in the school system (European Roma Rights Center). The improvement of the situation of the Romani minority was high on the EU accession agenda for countries from East Central Europe, and one of the key conditions for Romania's EU accession and membership in 2007.[4] In Romania, which has the largest number of Roma of any European country, Roma were officially recognized as a minority after 1989. The EU-supported National Strategy for Improving the Situation of Roma (2001–2010), which the Romanian government contributed to and implemented, led to legislative and political changes in Romania, including social programmes, anti-discrimination campaigns, and funding for Romani cultural performances. However, the superficial application of this

strategy fostered the commodification of Romani culture while failing to eradicate poverty among and discrimination against Roma. Caught between the retreat of the state from supporting its impoverished citizens and a new paradigm of culture defining their identity, many Roma have become cultural producers without, however, obtaining equal access to and success within the culture, while many remain impoverished and ignored by the state.

The dichotomy between the illiberal East and the liberal West with regard to Roma, reinforced during EU negotiations, was exposed as false after 2007 through the repeated expulsions of Romani citizens – and thus EU citizens – from Western Europe. A few dozen Roma from Romania were forced to leave Ireland in 2007, hundreds were fingerprinted and expelled from Italy in 2008, and thousands of Romani-Romanian and Romani-Bulgarian EU citizens met the same fate in France in 2010 (Brooks, 2010; Fassin, 2010). The French government's virulent campaign against Roma targeted over 300 settlements, which their inhabitants were forced to leave after being offered €300 per person for the trip back to their home country. Numerous international non-governmental organizations, both Romani and non-Romani and including the United Nations, condemned these actions, while the Italian government, the initiator of a similar campaign in 2008, endorsed them. The European Parliament voted against and condemned the mass expulsions from France, and Viviane Reding, the European commissioner for justice, accused the French government of bypassing EU law and inciting racism against Roma. The commissioner's main objection concerned a stipulation in a French government circular that was made public, which referred directly to Roma as targets of the expulsions, thus contradicting an EU directive from 2000 on racial equality and non-discrimination (Emerson, 2011). While this was a landmark vote and condemnation, the expulsions continued once the direct reference to Roma was removed from the circular without further protest from the European commissioner. Furthermore, the Romanian government assisted its French counterpart in policing the Romanian citizens' forced return.

The expulsions made apparent the dependence of EU citizenship on national citizenship and the marginalization of Roma across Europe. Many Roma in Romania are formally Romanian citizens and hold Romanian ID, but they do not benefit from most of their rights as citizens; their substantive citizenship does not match their formal citizenship, a situation faced by many Roma. Gerard Delanty outlines the difference between formal citizenship (based on rights) and de

facto, substantive citizenship, based on the actual implementation of these rights. In itself, the gap between formal and actual citizenship is performative, in that formal citizenship needs to be enacted to be realized. Through what I call the politics of performative citizenship, many Roma fail to performatively fill the gap between formal and substantive citizenship and are racialized as Ţigani (Szeman, forthcoming). Romania defines itself as a nation state and Romanian citizenship is synonymous with the Romanian ethnic majority. In Romania, Roma are both highly visible and marked as Ţigani, and invisible as citizens. Those who pass as citizens are assimilated, while those who do not are marked as abject Ţigani, or exotic 'others'. Some Roma may pass as Romanian and citizens, and have their professional and artistic contributions appropriated by the nation. Poor Roma are often equated with the Ţigan stereotype, due to the association of Roma with a lower class, which can be dodged in certain circumstances through displays of status, wealth, or social capital. Yet even if some individuals are able to avoid its spectre, the abject Ţigan haunts the very foundations of the nation. Roma fail to count as citizens all across Europe. Étienne Balibar makes a useful distinction between 'demos', the 'collective subject of representation, decision making and rights, and 'ethnos', the historical communities formed based on ethnic belonging (2004: 8). Roma find themselves in the gap between 'ethnos' and 'demos', even in countries that claim a more inclusive definition of the 'demos'.

The current situation of Roma in Romania needs to be seen through the historical relationships between Roma, ethnic Romanians, and the Romanian nation, and in relation to Europe. In parts of Romania's current territories, Roma were slaves until the second half of the 19th century, and the term Ţigan literally meant 'slave'.[5] During the five decades of socialism in Romania, Roma were treated as a social problem: their culture was not recognized or even mentioned in official documents, and they were the target of assimilation campaigns that aimed to turn them into socialist citizens by erasing their ethnic and cultural identities. Since the Romani ethnicity was not officially recognized, the term Ţigan became a synonym for the 'underclass'. Moreover, nationalism flourished in Romania during its socialist period (see Verdery, 1991), and as most Roma failed to assimilate, for all the alleged benefits they received, they became scapegoats for the nation. Stereotypes of Ţigani being thieves, criminals, and outcasts proliferated despite the socialist government's official suppression of Romani identity, as did stereotypes of Ţigani being extremely rich. Due to the complete erasure of Romani culture in Romania during socialism, Roma were not

recognized as contributors to national culture and their values were appropriated as Romanian. As Ţigani, Roma were outside both high culture and folklore; Romani musicians were used to epitomize the genius of Romanian folklore, but they were deemed to possess no culture themselves. If romantic Gypsies are fashionable in Western Europe, North America, and elsewhere, this trend is only incipient in Romania, having commenced with the spread of consumer culture. Salam's failure at Eurovision is an example of the politics of performative citizenship, where the double stigma of Ţigani and manele made his performance unacceptable and impossible to assimilate, and symbolically remaining outside national culture.

Starting with the 19th century, constructions of the Romanian nation emulated Western European models. Katherine Verdery discusses the formation of the independent Romanian state as a mobilization of Western allies, where 'those intellectuals who argued about the national essence were constructing the means for ideological subjection of their countrymen, Romanian and non-Romanian, within the new state' (1996: 46). Furthermore, the Romanian nation has always been exposed to and dominated by the larger empires surrounding it, a position that has given rise to what (in a different context) Nelson Maldonado-Torres calls the coloniality of being, which refers to attitudes and mentalities related to colonialism that exist without the institution of colonialism (2007). Scholars of South East Europe have theorized the relationship of the region to the West by reworking Edward Said's *Orientalism* (1978): Maria Todorova's notion of 'Balkanism' captures the proximity and perceived temporal distance between the West and the Balkan region (1997); while Milica Bakić-Hayden's concept of 'nesting Orientalisms' reflects the nested hierarchies that such divisions engender, specifically referring to one nationality's projection of Orientalist stereotypes onto other nationalities of the former Yugoslavia (1995).

The expulsions of Romanian EU citizens from Western Europe reveal that power differentials between the East and the West have not disappeared with the extension of EU membership to several countries from East Central Europe in 2004 and 2007. They have been reconfigured, but the so-called lag between West and East persists at both the rhetorical and the political level. These power differentials become apparent in the rhetorical deployment of Balkanism; the 'othering' and distancing in time of otherwise geographically close Balkan identities; and the recurrence of 'nesting Orientalisms' at work in both the current European configuration and the conflation between Roma and Romanians, which are visible in the media and at the ESC. The conflation between

Roma and Romanians is an example of Balkanism that manifests itself linguistically through popular etymology, where the phonetic similarities between the two words and their appearance together result in their conflation in popular culture. Anthropologist Susan Gal has analysed the fractal recurring of the East–West dichotomy within Europe and the role that Europe plays as an ideological concept whose meaning and location shifts (1991). Following Gal, Romania represents the East in relation, or in opposition, to Europe, whereas within Romania, Țigani stand for the East – the Orient within Romania – while Romania itself stands for Europe, in contrast with Țigani. At the ESC, Romania's entries attempted to shed any association with Roma, while on the Western music scene, where 'Gypsy music' is increasingly popular, any music from the Balkans is associated with Gypsies and is coded as exotic through an erasure of ethnic and national differences in the region.

'Gypsy Music', nationalisms, and the ESC

At the same time as Romanian and Bulgarian Roma were being expelled from Western Europe, romantic stereotypes about Roma flourished and played a central role in the international success of Gypsy music. Apparently positive stereotypes of Roma as talented and natural performers go hand in hand with blatantly negative ones, which present Roma as duplicitous liars and thieves in most countries across Western Europe and some countries in the former Eastern bloc. The underbelly of the romantic stereotypes is always present, as attested by new waves of racism against Roma across Europe, in parallel with the growing success of the Gypsy brand of music. The popularity of Gypsy music performances in the West has resulted in a range of events that take place across continents, from large international festivals featuring Romani bands from the Balkans, to 'Gypsy nights' in clubs where audiences sport Gypsy costumes. Western DJs such as Shantel and Gypsy Sound System, and Western bands such as Beirut and Balkan Beat Box, feature or sample music from South East Europe (see Silverman, 2007; Szeman, 2009). The international festival scene encourages broad distinctions and divisions between Roma and non-Roma, mostly falling along Romani/Balkan and non-Romani/Western lines. This version of Balkanism places all 'native' artists from the Balkans within the same category, disregarding not only the different nationalities in the Balkans but also the differences among Roma from different countries, as well as those that are present even within the same country.

As a transnational ethnic minority, Roma represent a potential ethnicizing element at the ESC, where the resurgence of so-called ethnic music represented by music with ethnic-sounding elements and/or performers from ethnic minorities both parallels and differs considerably from the commercial music scene, as outlined above. Alf Björnberg identifies two major representational strategies at the ESC: one in which any local flavour is erased from the nation's entry, and the opposite one of emphasizing such ethnic elements (2007: 20–21). The success of 'ethnic' performances is based on their becoming 'free-floating signifiers representing an unspecified cultural anchorage' (ibid.: 23). While his focus is on Western European countries, countries from East Central Europe have followed similar trends. The inclusion of ethnic-sounding music and ethnic-minority performers in the ESC entries from East Central European countries follows their function as exotic additions that enhance local flavour, or transport the audience into a distant exotic space. These performances are open to multiple readings, but they are also heavily grounded in their local contexts and may offer visibility to minorities in some cases, but not to Roma. Winning songs from this category included Ruslana's 'Wild Dances', which represented Ukraine in 2004, and Sertab Erener's 'Every Way that I Can', from Turkey, in 2003.

In the case of Romania's entries, racial and ethnic hierarchies were maintained, despite the multiple readings that the entries may have allowed. Since its first participation at the ESC in 1994, Romania's performances have tended to emulate an unspecified European pop, with several ballad-style songs and a few entries that emphasized the local flavour of folk or 'ethnic' music: 'Liubi, liubi, I love you' by Todomondo in 2007, the 'Balkan Girls' of 2009, and Mandinga's *Zaleilah* in 2012, which I discuss in detail in the following section. Unlike Romania, Moldova, for example, mobilized the 'ethnic' element in their entries, using both the 'Balkan' sound and the folk sound, as in Zdob si Zdub's performance in 2011 and Nelly Ciobanu's in 2009. Ciobanu's song *Hora din Moldova* ('Line Dancing from Moldova') was a combination of brass and percussion instruments, a sound similar to Zdob si Zdub's song 'So Lucky.' However, for Zdob si Zdub the brass sound and surrealist/parodic performance evoked 'Gypsy music', while Ciobanu and her accompanying four male dancers referenced folk costumes and local line dancing. These performances show that, depending on its framing, a similar sound may reference national folklores, Balkan music, or Gypsy music. The national folklores of the Balkan region have served to define nations as ethnically homogenous by denying or

instrumentalizing the Roma. Ethnic music – the sound of brass instruments and other popular music identified in the commercial scene as Gypsy or Balkan[6] – is redeployed at the ESC as national folklore, without directly referencing Roma and without Romani artists. In the Western context of the success of Gypsy music, Roma remain hidden in plain sight, and, as Gypsies, function as projective mechanisms – a way of reaching the wild, passionate, and unpredictable place that the Balkans are supposed to be (Szeman, 2009).

National folklores in countries of East Central Europe and the Balkans exclude Roma, who are not recognized as having a culture of their own, but they are nevertheless used to help to define the nation. In Romania, Romani musicians have been part of the entertainment scene for centuries, but they were not credited with music of their own. The post-1989 phenomenon of manele, seen as the opposite of culture, is exclusively credited to Roma. In Romania, music labelled as folklore is seen as Romanian, but contemporary music such as manele is not, because it is seen as kitsch and therefore associated with Ţigani. While there are diverse repertoires that are played exclusively among Roma, popular music in multiethnic countries like Romania reflects multiple cross-influences. Given this complex history, the lack of visibility of Roma at the ESC is reinforced by the competition's nation-based format.[7] Supported and organized by the state, the national selection competition and the final performances are supposed to represent the nation for the rest of Europe.

Some examples of Romani performers at the ESC international final include Romani rap band Gipsy.cz, who sang for the Czech Republic in 2009; Serbia's winning entry in the 2007 competition, with Marija Šerifović, a singer of Romani descent; and the chalga singer Azis, who represented Bulgaria as a backup singer in 2006. The Czech band's name explicitly stated their ethnicity, with the performers claiming both their Romani and their Czech identities. In the other cases, the performers' ethnicity may have been known to spectators who were already familiar with them. Such was the case with bleached-blond, gay Romani chalga king Azis, whose excess was tempered at the ESC by his position in the background of a slow pop song by Bulgarian singer Mariana Popova. TV viewers could have missed out on his presence completely as he only appeared for several seconds in the televized footage. The Romani pop singer Nico performed in the Romanian ESC entry for 2008, but her presence reinforced the nation as 'ethnos' while erasing Roma. Singing in Italian with another pop artist, Nico's presence reflected a process that has been ongoing for centuries in Romania – that is, the appropriation

of elements of Romani culture and some Romani performers. Nico's performance is another example of the politics of performative citizenship, but in the opposite direction from Salam's performance. In Nico's case, because neither the pop song nor the performer was marked as Ţigan(ca), the performance was acceptable as Romanian. The blending in of Romani performers with the majority in these examples does not represent a proof of integration and acceptance; on the contrary, it shows that successful individuals, performers in these cases, can pass as the majority and/or be accepted as exotic without any changes to the prevailing negative stereotypes about Roma.

The ESC provides a very different setting from the commercial music scene in the West, which is orchestrated by Western managers and producers even when the musicians hail from the Balkans. In the commercial music scene, the Gypsy element is considered marketable and is thus sought after, and the presence of Romani musicians is desired as a sign of authenticity (see Szeman, 2009). The ESC represents an opportunity for the smaller countries of East Central Europe and the Balkans to assert and represent themselves against the more powerful Western nations. Roma serve as tropes in the rhetorical and musical battles among participating nations, but their voices remain unheard. While the ESC is not known for being a forum for political statements, the relative absence and invisibility of Romani musicians on its stage are noteworthy, given their popularity across Europe. While some Romani musicians, such as Gipsy.cz, participate in the Eurovision as Roma, and while countries like the Czech Republic present themselves as embracing diversity and the Roma, Romania has vigorously avoided association with Roma. For many non-Romani Romanians, Romania's participation in the ESC represents an opportunity to correct the persistent conflation of Romania with Roma in foreign media, which was especially prevalent during fingerprinting campaigns in 2008 in Italy and the 2010 expulsions of Roma from France.

From 'Gypsy frenzy' to manele: What they talk about when they talk about Gypsies

Greeted at the airport upon her return from Oslo following the 2010 ESC final like an athlete bringing home an Olympic medal (a bronze one in this case), Seling, who was placed third along with Ovi for 'Playing with Fire', (Figure 6.1) declared: 'I wish with all my soul that we could convince the world that Romania is a little different than what Europe has become accustomed to. It is a pity for them to believe we

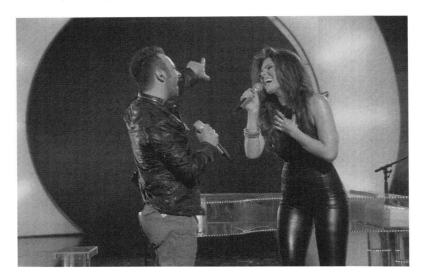

Figure 6.1 Romania's 2010 Eurovision entry Paula and Ovi (Paula Seling and Ovidiu Cernăuțeanu) performing 'Playing with Fire'
Source: Aurel Baboi.

are all the way they think we are'[8] (qtd. in Arsenie, 2010). She seemed to be speaking in riddles here, since she did not directly mention any of the infamous episodes relating to the treatment of Romanian citizens internationally. Rather, she metonymically named only the effect of these developments – Romania's bad reputation abroad. Her statement reproduced, on a smaller scale, the reactions that these events provoked in Romania: what was reported as reprehensible in Romania was not the expulsion of Romanian citizens but the further deterioration of the nation's reputation. Many non-Roma protested against the mention of Romania with regard to the expulsions, and some politicians even plotted to replace the name of the Romani ethnicity with Țigani in order to further distance them from ethnic Romanians.[9]

In the wider European context, Romania's marginal geopolitical position and the continued mistaking of ethnic Romanian and Romani identities, especially in foreign media, have caused frustration among Romanians who aspire to be European, only to feel cast as abject when identified with Roma. The anxiety around this identification has led to legal changes in the past: for example, the abbreviation of the country's name on Romanian passports was recently changed from 'Rom' to 'Rou' in order to avoid foreigners' mistaken association of the 'Rom' abbreviation with Roma. This anxiety is also reflected in the choice of

performances for the ESC, as illustrated by Salam's participation in the national competition in 2010. Even though he took part in the ESC pre-selection campaign with two pop songs, he was unmistakably perceived as a manelist – that is, Ţigan, in Romania, and continued to inhabit the ideologically negative 'other' of Romanian identity. The stigma attached to Roma and Romania made a manelist like Salam into an unaccept-able subject for representing the nation, for he was doubly marked as a Ţigan – first as a Rom, and second as a manelist. In Romania, segregation along musical genres prevents engagement with Romani realities and perpetuates the abject Ţigani stereotypes through the vilification and trashing of the manele style. Manele detractors see the musicians who play this music as agents of '*ţiganizaţie*', where Ţigani embody the nega-tive pole of the East–West dichotomy.[10] The verbs *a se ţigăni* ('to gypsy') and *a se ţiganiza* ('to gypsify'), similar in kind to the phrase 'to jew' (see Gilman, 1991), are most often used offensively, and carry linguistic traces of racism that is present in the Romanian culture. Even though not all Roma may take offence, the words 'Ţigan' and '*a se ţigăni/za*' are derogatory.

As previously mentioned, the success of Gypsy music performed by Romani musicians at international festivals is very different from the ESC. Within the framework of the ESC, the performance chosen to rep-resent each nation is often selected by a national jury,[11] a process that, as of 2012, occurs in conjunction with a public vote in Romania. The success of Romani bands abroad and the recent success of manele per-formers, including Salam, in the West do not make these performers more palatable or acceptable as representatives of Romania in the eyes of its citizens or the jury. While exports featuring Romani musicians are marketed as Gypsy music in the West, Romania is not yet part of the Gypsy music scene. Romani culture was officially non-existent for over five decades during communism and, as a result, romantic Gypsy stereo-types that can be found in both the West and East of Europe have been mostly absent in Romania and have only started to resurface recently. Festivals and international tours that bring together Romani musicians from across the Balkans erase the very different reception of these musi-cians in their respective countries. For example, the Romani singer Esma Redžepova from Macedonia has always advertised herself as a Romani performer and has enjoyed great success at home, unlike some of the Romanian Romani bands, who are successful in the West but return home to near anonymity.[12]

The 'us' and 'them' of the Romanian nation, where Roma are posited as the abject 'other', are repeated in the abjection of the manele genre; both of these abject poles are fractally identified with the East, the

Orient, and more specifically the geographical Middle East. Romani musicians, as epitomes of manele, find themselves at the crux of debates about identity, Europe, and the 'Orient', modernity and tradition – epitomized in critiques or praise for manele. National juries represent the filter that establishes and maintains acceptable representations of the nation through their choices of musical styles and performers.

The absence of minorities and ethnic music markers among Romania's ESC entries reflects a reaction of non-Romani Romanians to representations of Romania in foreign media and the frequent conflation of Roma and Romanians. When the Romanian entry Todomondo addressed diversity in 2007, it did so in a European context, with the performers singing in English, French, Italian, Spanish, Russian, and Romanian. Romania was thus placed in a 'family' of Latin nations rather than in a Balkan context, with Russia as the 'other', non-Latin nation. The 2009 entry 'The Balkan Girls' indexed the term Balkan, but the song had Latin American overtones rather than characteristics of Balkan music. The non-Romani Romanian dancers and singer performed a short routine vaguely reminiscent of line dancing in Romania, which was compared to the Irish *Riverdance* by a reviewer. The song was allegedly inspired by the local legend of *iele* – fairies that lure unsuspecting men – but these references were almost impossible to read in the ESC final performance, which featured scantily dressed women, and a sound that did not resemble manele. Nevertheless, Romanian audiences initially accused the song of being a manea, though its final musical arrangement clearly distanced it from the unwanted manele genre.

Associations with Roma or Gypsies can surface even when they are not present, just as the suspicion that someone is a Ṭigan may hang over anyone in Romania. While avoiding local flavour, Romania's entries occasionally employ outside 'others', a frequent ESC strategy, as happened in 2012 with the Romanian-Cuban group Mandinga (Figure 6.2). In the case of countries from East Central Europe, the presence of distant 'others' at the ESC offers a promise of exotic escape and a diversion from the sizeable populations of other ethnic minorities. Ethnic music and foreign, ethnic-minority performers have appeared in the entries of new European countries – for example, Estonia's winning entry in 2001 featured a black singer originally from Aruba, Dave Benton. In the 2012 Romanian entry, Afro-Cuban musicians and a Latin American sound featured in a song composed by Costi Ioniță, a non-Romani Romanian musician, who at one stage in his career composed and sang manele. Foreign media identified parts of this fusion song and performance with Gypsy music due to the brass sound. While the song did not resemble

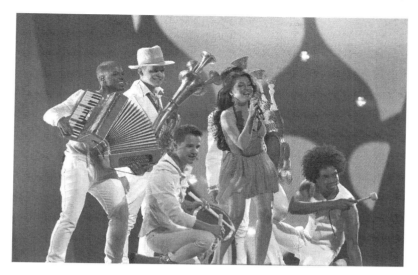

Figure 6.2 The Romanian-Cuban band Mandinga performs at the 2012 ESC
Source: Andres Putting.

manele, some of its brass sounds made it similar to the Balkan sound identified in the music scene with Gypsy music. The Associated Press described the song as 'a global mishmash: Cuban horns, lashings of salsa, a generous dollop of Gypsy frenzy, and even a smattering of bagpipes', as highlighted online in the *Bucharest Herald* (2012). The description was translated in Romanian media as '*muzica ţigănească*'. In order to explain what was perceived as a poor outcome – Mandinga placed 12th in the final – some even disparagingly called the song a 'manea', a combined effect of the Associated Press' description and the fact that its composer had previously dipped into the manele genre.

Given the strong reactions that manele provoke in Romania, it is not surprising that Salam's participation in the 2010 Romanian ESC competition caused a huge stir in the national media; his failure to reach the national final caused yet another set of controversies. The composer of the songs he performed accused the Romanian public TV channel that organized the competition of racism in the online version of national newspaper *Libertatea* (2010): 'I have a few friends at the Romanian television. They told me the Eurovision jury would not let him [Salam] compete because he is a Ţigan. They have not even listened to his songs and say that it would be shameful to go to Oslo with a Ţigan.' A week later the organizer of the ESC from Romanian TV declared in the same

publication that she would have supported Salam's presence as 'a touch of colour' in the competition, but that the jury members gave him very low marks (Libertatea, 2010b). Other media outlets rejoiced that he did not make it into the national final:

> Let the whole Eurovision be a huge salami. If until now there have always been scandals when the results were announced, this time there will certainly be 'ţigănie.'... Seriously this time: we need someone serious to represent us in Oslo, Norway. Let Salam take care of weddings and christenings. Let him play at a different table.
>
> (Mişcarea de rezistenţă, 2010)

Salam publicly deplored the contempt in which many in Romania hold manele. In 2008 he sang with Seling and a symphonic orchestra from Bucharest in order to bridge the gap between the two genres. He appealed for his music to stop being treated as garbage, and showed that he could sing with a whole symphonic orchestra and match Seling's voice. This performance and its reception provide a telling illustration of the perceived gap between pop and manele in Romania. The presenter at the concert introduced the purpose of the event to the audience in the following way:

> to show the whole world that for us the word 'discrimination' does not exist, and to prove that there can be a fusion between these two musical genres, which, it's true, clash: manele and the extraordinarily beautiful music of Paula Seling, pop... Listen very carefully to the song that follows, with Paula Seling and Florin Salam, because it is something else.
>
> (Florin Salam and Paula Seling Live, 2008)

The deferential introduction of Seling and her 'extraordinarily beautiful music' contrasts with the dismissive mention of manele. The presenter patronizingly asks the audience to listen as if they might otherwise miss the momentous occasion that brought Seling to them. According to this introduction, the Seling–Salam duo brought together two genres that clashed – pop and manele – but their clash is purely ideological in Romania, since manele, just like any form of music, can mix very well with pop. National ideologies, as reflected in highbrow and lowbrow divisions between pop and manele in Romania, diverge from global trends in commercial music.

After performing with Salam, Seling came under fire from her fans for mingling with uncultivated manele fans. Questioned on the talk show *Happy Hour* on the ProTv channel as to why she attended a concert with manelists, she corrected the moderator by pointing out that they were Roma, and in turn asked: 'Don't you want them to listen to something else?' (Happy Hour, 2008). She declared that she went to cultivate the audience, in order to offer them something different, and that she refused the honorarium in order to avoid accusations that she did it for the money. Asked about how she had helped Roma by singing three songs at Sala Palatului, Seling explained:

> By showing the world that it is possible, that if you reach out your hand to people who need culture, and to be cultivated ... I gave an example, a very good example. I showed that, if Roma are exposed to artists who sing something else than just manele, they listen and participate.
>
> (Happy Hour, 2008)

Like the presenter quoted above, Seling's attitude reflects how popular musical genres in Romania are ideologically divided, aligned not only with highbrow and lowbrow culture, but also along West and East vectors, and valued – or devalued – accordingly, in relationships of nesting Orientalisms that are accentuated by the conflation between Roma and Romanians abroad. Although Seling identified the audience at this concert as Roma, manele is equally popular with non-Roma in Romania. Unlike in the other countries in South East Europe where similar genres exist, however, in Romania the association of manele with Roma is automatic.

Salam's failure to make the final national stage of the ESC, and the perceived constant threat in Romania of 'Gypsifying' and 'manelizing' its ESC entry, reflect national tensions that were exacerbated with the expulsions of Roma from France and the continued mistaking of Romanian and Romani identities. These tensions have deep roots in the history of Romania as a marginal nation in Europe and the ongoing marginalization of Roma across Europe. The blandness of most Romanian ESC entries in the last decade, or their converse exoticism, work to dissociate Romanians from Roma and to erase uncomfortable reminders of racism against Roma at both European and national scales. In eschewing local specificity, Romania's entries, including the few examples that engaged with ethnic diversity, reflect an existing

trend of projecting a generic diversity through the use of external others at the ESC, or otherwise promoting a generic pop that attempts to be as unspecific as possible. The Roma haunt Romania's entries, but they resurface at the ESC as exotic tropes or negative stereotypes displayed in both foreign and local media, which further divert public attention from any engagement with the deeply concerning rise of racism against Roma across Europe.

Notes

1. His real name is Florin Stoian, and his nickname 'Sala(a)m' comes from the Arabic word for peace. In Romanian, however, 'salam' means 'salami', a coincidence that has been the pretext for numerous jokes and jibes about the singer.
2. I use the terms Rom/Roma (singular/plural) to refer to members of this ethnic minority, and the terms Ţigan(ca)/Ţigani(ci) (singular-masculine-feminine/plural-masculine-feminine) to refer to stereotypes about them in Romania. I also employ the term 'Gypsy' to refer to stereotypes about Roma outside Romania, such as in the Gypsy music scene in the West.
3. Manele in Romania, chalga in Bulgaria, and turbo folk in Serbia are related popular musical genres in these post-socialist countries. The 'oriental' specificity of manele lies in the rhythm, called *kifteteli*, or *chifteteli*. Manele/manea (plural/singular) are characterized by 'syncopated Arab rhythms' and 'elaborately ornamented, virtuosic, and often improvisational' melodic passages (Beissinger, 2007). Manele's favourite topics include money, cars, love, and women – all signs of status for the newly rich. Most manele singers are men, often accompanied by scantily dressed belly dancers. The most common instruments employed are the accordion, synthesizer or keyboard, drums, clarinet, electric guitar, saxophone, and string bass. Western music, from rock and pop to rap and hip-hop, has influenced manele and given birth to fusion styles in Romania, and Western DJs have also recently started to mix electronic beats with manele sounds.
4. Roma, the self-ascription of most individuals that speak the Romani language, as well as other groups identifying as Ţigani, Rudara, Sinti, and so on across Europe, all share a common ancestry in tribes that migrated from India during the 12th century. The Romani language, which is derived from old Sanskrit and shares similarities with today's South Asian languages, offers the strongest evidence for this migration. Even though Roma are mentioned in official documents from the territories of today's Romania that originate as far back as the 13th century, many non-Roma in Romania see Roma as foreigners.
5. In the regions of Moldavia and Wallachia, which fell under the influence of the Ottoman Empire for centuries, Roma were slaves until 1856; in Transylvania, which belonged to the Austro-Hungarian Empire until 1918, Roma were slaves for only a short period of time.
6. Terms such as 'Balkan' and 'Gypsy' music are used in the commercial music scene to market any music from the Balkans, including Romania. For

example, brass sounds are often identified as Balkan or Gypsy. These identifications do not correspond to how the music is seen locally. Music played by and for Roma and national folklore in Romania, which locally is seen to exclude Roma, can be found advertised as Gypsy music in the West (see Szeman, 2009).

7. At the Venice Biennale, an event structured similarly to the nation-based format of the ESC, a Roma Pavilion was added to represent Roma from all countries across Europe as a transnational minority (Szeman, 2010).

8. All translations from Romanian are mine, unless otherwise noted.

9. While the near homonymy between Romanian and Roma is arbitrary, and could have been the case with any other nation in the region, it would not have happened with any of the 'established' Western nations. For example, another arbitrary near homonymy is that between 'Roma' and the Italian capital 'Rome' ('Roma' in Italian), yet it is rare for Roma and Romans to be mistaken for each other.

10. Marin Marian-Bălaşa discusses anti-manele websites and an anti-manele protest in Romania (2006).

11. In some cases, broadcasters choose the country's entrant without the public's participation.

12. As this book went to press, it was announced that the duo of Redžepova and pop singer Vlatko Lozanoski would represent the Former Yugoslav Republic of Macedonia in the 2013 ESC.

7
From Dana to Dustin: The Reputation of Old/New Ireland and the Eurovision Song Contest

Brian Singleton

On 20 May 2008 in the Belgrade Arena during the first semifinal of the Eurovision Song Contest (ESC), the Irish entry was booed unceremoniously off the stage. At the end of the evening, Ireland failed to qualify for the final. This marked the absolute nadir of Ireland's participation in a contest that it had dominated in previous decades. At the same time, despite government denials, the Irish economy, the wonder of the economic world since 1997, went into freefall as access to capital for Irish banks and businesses dried up, the overheated property market came to a standstill, and unemployment rose on a steep curve. By September 2008, Ireland had officially entered a recession; by 2010 it needed a European Union (EU)/International Monetary Fund (IMF) bail-out, and by 2011 its credit rating had been declared junk. To compound the media assault on its economic reputation, a second 'I' for Ireland was added to the pejorative use by economic analysts of the acronym PI(I)GS, once formerly reserved for the comparatively depressed economies in the southern half of the Eurozone (Portugal, Italy, Greece, and Spain). It was wholly appropriate then for Ireland's worst achievement ever in the history of the contest (in 2008) to have been performed by a turkey puppet in a shopping trolley!

How had it come to pass that Ireland's Eurovision reputation so quickly could have achieved junk status after a record-breaking run of success in the previous decade and millennium? The markers of that

An earlier version of this chapter was delivered as part of my inaugural lecture as Samuel Beckett Professor of Drama and Theatre at Trinity College Dublin, November 2011.

reputation of the ESC's most successful country needs detailed analysis since the argument put forward here is that Eurovision success in the popular cultural medium of TV is bound up with a wider political strategy of hinging national reputation on cultural prowess, in the absence of heretofore economic markers of success. Ireland's small size, population, and location on the western periphery of Europe, away from the political centre of Brussels, always sought allegiance with its massive diasporic outreach community, particularly in the US. Ireland's relationship with Europe (it did not join the European Economic Community [EEC] until 1973) was at best tenuous. However, with an economic boom in the late 1990s and the adoption of the European single currency in 2002, it had an enviable political and economic reputation in, and closely tied to, Europe. While benefiting enormously from infrastructural grants from the EEC/EU over three decades, Ireland repaid with loyalty, and for the most part unquestioning adoption of EU directives on protean federalist integration. Up to 2008, therefore, Ireland was a reputable European nation.

Reputation is a measure of trust with regard to the value of the performance of a past behaviour that enables the prediction of a future performative behaviour. Rather than simply reflecting the past, a reputation is a shadow of the future, operating in the present. The three tenses of past, present, and future coexist in a national reputation, in the same way as the operation of nostalgia: a present remembering of a lost past for a possible future (see Stewart, 1993). But just how does an artist gain a reputation? Is it something conferred upon him or her, or does the artist have some agency in the building of a reputation? The art itself is not necessarily responsible for the survival of a reputation or the building of a reputation into the status of renown. According to sociologists Gladys and Kurt Lang, 'Renown represents a more cosmopolitan form of recognition, measured by how well the artist is known beyond the network of professional peers. For this, artistic achievement does not suffice' (Lang and Lang, 2001: 6). The artists' own agency while alive in their performative engagement with their art is crucial, I would argue, to the remembrance of the artist in posterity. And that performative engagement to a large degree is determined by the artists' performance in various social, cultural, and political networks, outside the specific arena of his or her individual discipline, and often in the networks of social and cultural cosmopolitan elites. The move from one network to another, while operating in both, propels the artist into recognition beyond artistic circles. What relationship does an artist's reputation have with that of a nation, and to what extent is the artist–nation binary

interdependent? By its very nature the ESC conjoins temporarily an artist's identity with a nation state, which allows for what Michael Tomz calls 'repeated interactions' (Tomz, 2007: 4) of the two as co-artists (artist and nation) on stage performing further repeated actions on the various media platforms of the ESC. Choosing the co-artist for the nation's performance is the crux of perceived national identity in performance. The nation invariably remains the same (unless it breaks up to form new ones) while the reputation of artists is aligned to reflect the currency of the nation in international terms. By linking performance and culture to the social and cultural politics of a national reputation, it is plain to see how reputation is a national marketing tool of an existing past image of a nation operating in the present for future economic or collective cultural benefit, and how it acts as a platform for a desired transnational and cosmopolitan outcome of the repeated actions of performing a reputation: renown – a consolidated or sedimented reputation over time.

Ireland came comparatively late to the ESC, in 1965, even four years after former 'Eastern' Yugoslavia made its debut. The first contestants came from Ireland's 'showband' culture, in which semiprofessional bands of musicians toured the dance and parish halls, largely performing cover versions of the chart hits of foreign others. To a wider European audience, the contribution seemed outdated set against other highly contemporary sounds and looks that referenced the wider sphere of popular music. From the outset, Ireland never threatened to emulate the contemporary, but offered the first of many slow ballads that would become its hallmark (Figure 7.1). Unexpectedly, however, Ireland won in 1970 with 'All Kinds of Everything' sung by Dana, an 18 year-old girl from the Bogside in Derry, the location of some of the worst violence and social unrest in 20th-century Irish history. But Derry was in Northern Ireland, and therefore Dana was technically British, and, as was revealed much later, she was actually born in London, contesting her chosen Irish nationality even further. Nevertheless, her beauty, simplicity, and ingenuousness of performance won the hearts of the judges and transcended the politically negative images emanating from her home city for the previous 10 months. Dana and Ireland's win was a political triumph, made the sweeter by beating the hot favourite, the UK's Mary Hopkin. As British troops had marched in to 'occupy' Northern Ireland (though at the time the rationale for their deployment was for the defence of the Catholic population), Dana had stormed to victory in their stead on the popular cultural stage.[1] This seminal Eurovision moment was one of cultural transcendence over political strife that

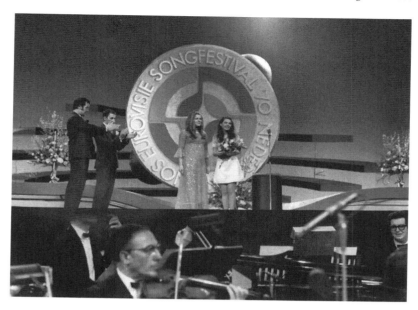

Figure 7.1 Dana (with flowers) winning the 1970 ESC for Ireland
Source: EBU.

heralded many similar moments in the future after the break-up of the former Yugoslavia. Dana's Eurovision win captured the spirit of the age of embattlement against the colonial oppressor by a cultural triumph from what some might term an insider insurgent. It was an iconic moment in Ireland's cultural history and was indelibly linked to a wider political and nationalist movement. Ireland imagined itself as a nation while the nationalist population of Ireland, north and south of a very real border, could imagine through Dana, if only momentarily, reunification on a cultural scale. Here was Ireland's first use of the ESC as a cultural marker for a wider political battle on the stages of the nation and its international interactions.

Replicating the currency of simplicity as a hallmark for previous Eurovision winners in the late 1960s, Ireland's Eurovision image of ingenuous youthfulness was a marker of its sense of what it meant to be European in cultural terms. Dana, from the outside, was also outside history; while she wore a dress of emblematic Celtic embroidery, marking her as national, she sang a simple song of a world only of beauty, transcending national borders. Her song joined the gallery of winners of transnational simplicity: *'Poupée de Cire, Poupée de Son'* (France Gall,

France, 1965), 'Puppet on a String' (Sandie Shaw, UK, 1968), 'Boom Bang a Bang' (Lulu, UK, 1969). This transnational linguistic simplicity, emotional purity, and youthful innocence was the central tenet of what we might call an 'Old European' notion of a collective European identity, as performed by the UK and France in particular. The notion of Europeanness in the contest in 1970 was situated very much in the vision of the nations that controlled the axis of power in Europe. While the early years of the contest were dominated by France and the Netherlands with a particular vision of light entertainment, the UK's dominant popular music scene began to exert an influence by the end of the 1960s, but, I would argue, only within the mould of that already established 'light Europeanness'. French opposition to the UK's entry into the EEC would also be reversed. Ireland won the ESC at a time when the country had entered negotiations to accede to the EEC. Learning the cultural performance markers of Europeanness ran concomitantly with joining Europe politico-economically.

Ireland eventually succeeded in joining the EEC in 1973, and throughout the 1970s it continued to score well in the ESC, always ending up on the top half of the scoreboard. Economically, Ireland benefited greatly from accession. The political inwardness of its early leaders with a new national imaginary at the forefront of their thinking served to close off Ireland's borders from imported investment. With a small population and a largely agrarian economy, the country spent most of the 20th century in economic stagnation with its greatest export being its people who could find no prospects at home. European economic accession in 1973 was the first indication of a change in direction from Ireland's self-glorification of being on the periphery, and in return for large-scale infrastructural investment from its rich European neighbours, it became a dutiful though peripheral servant of the European economic centre. With its non-manufacturing economy, it had little but its culture as a marker of an international reputation. One aspect of that culture (sport) was primarily national and nationalist and thus did not have an outlet for its internationalization. Ireland was good at national sports because no other country played them. Its literary artists, however, and its theatres were very much operating at the matrix of modernism and were circulating among their transnational cosmopolitan counterparts. Ireland's music had Celtic comparators from Spain to Norway and was firmly located within the realm of the popular. From Horslips (in the 1970s) to U2 (in the 1980s and beyond), Irish 'cultural sounds' intersected with international pop and rock music, and achieved a degree of international centrality that helped to garner a musical reputation for

the country. Though the success was down to the talents of the bands themselves, their unmistakably Celtic sounds marked them as Irish and helped to conjoin personal Irish success with the country's national reputation. On Eurovision stages, however, success eventually came when national markers were abandoned to internationally appealing 'light' ballads.

In 1980, Johnny Logan, a young Australia-born singer, took the country to a second victory in the Hague, singing a slow ballad, 'What's Another Year?' (Figure 7.2) But he was a temporary success in a decade of failure. In the early 1980s the country fared badly, and in 1983 did not even participate because of a financial crisis at the national broadcaster RTÉ. It was only in 1987 when Logan returned to represent the country with his self-penned 'Hold Me Now' that fortunes were revived and national pride restored. But his career had gone nowhere in the intervening period. He had been embroiled in a legal battle and needed the ESC to relaunch his career. This it did, of course, but it did not mean he charted throughout Europe. He did achieve modest success and a stable career thereafter, but his relationship with Eurovision was indelible by this stage, and particularly since he penned a third winning entry, 'Why Me?', for Linda Martin in 1992. Like Dana before him, Eurovision

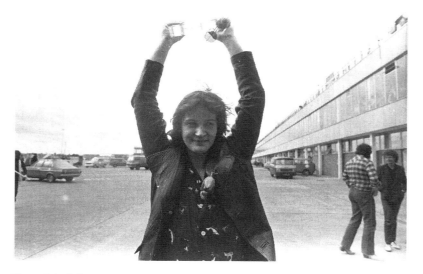

Figure 7.2 Johnny Logan at Dublin Airport after winning the ESC for Ireland in 1980
Source: The Irish Times.

mythologized a reputation for Logan that had not been earned by a sustained presence in the record sales' charts. For Martin, too, this was a triumphant return after a second placing in 1984, with the song 'Terminal Three', also penned by Logan. By the time of his third win, Logan had become known as Mr Eurovision. His regular appearances on the annual show and the media interest in his words of wisdom cemented this status. In terms of reputation, this is what Lang and Lang call a 'satellite effect' (2001: 331), in which a person of current renown in a particular field brings into his or her ambit renowned associates, or interpreters. The conjoining of this particular artist and nation towards victory in a European competition transcended any shadow that might have been cast by the artist's faltering early career, or the nation's then peripheral economy.

But what really was Ireland's reputation at Eurovision and what was the reputation of the contest at that time? Though Dana and Logan began and ended a decade with songs that ignored popular trends in music, in the intervening period the contest enjoyed unprecedented levels of popularity in terms of its audience figures. Of course, this was in no small part due to the dominance of national broadcasters and their normal mononational fare at the time. The contest was an unusual, exotic form of light entertainment that had national pride as its key jeopardy factor. It was an early form of reality entertainment that had a host of national spin-offs. In the 1970s it had featured the contemporary sounds of ABBA, as well as established and respected UK pop artists such as Olivia Newton-John, Cliff Richard, The New Seekers, and The Shadows. In 1973 it was estimated that half the population of the UK tuned in to the live broadcast. In Ireland its popularity was no different. Throughout the 1980s the cultural capital of the ESC throughout Europe remained strong despite the critical opprobrium that faced the surprise 1989 winner, 'Rock Me', sung by the Yugoslavian band Riva. The 'satellite effect' of the ESC's increasingly negative reputation, however, was reversed in 1988 with the winning song for Switzerland, '*Ne partez pas sans moi*'. While the song failed to have any chart appeal, however, its singer, Québécoise Céline Dion, would go on to have a long career at the top of the charts in many world markets. The contest subsequently would come into Dion's reflected ambit of renown, being the most successful winning act since ABBA in 1974. And it is within this context of the 1980s that Logan's success is situated. While Logan was successful in a particular balladeer style, and though his songs did not reflect any recognizable brand of Irishness, in the contest the ballad became synonymous with Ireland and its reputation, and the nexus

of 'Logan-ballad-Ireland' became a Eurovision brand in its own right. Logan's lack of success in the industry between his two wins might have initially cast doubt on his reputation, but it was subsequently restored and survives to this day, not simply because of his record-breaking statistics in the contest but because of the national statistic of recording the most wins ever (seven). But that was yet to come.

Three successive wins for Ireland from 1992 to 1994, a final win in 1996, and a recognizable claim to a win in 1995, since one half of the group Secret Garden, which won for Norway with the instrumental piece 'Nocturne', was Irish.[2] That particular song was very similar to Ireland's 1996 winning song, 'The Voice', and both reflected one of Ireland's greatest global exports in popular music, Enya, who had dominated the charts since the late 1980s in many countries with her distinctive Celtic instrumental and vocals. What is more, *Riverdance*, the hugely popular interval act of the 1994 contest, went on to become a global touring phenomenon and created for Ireland a popular cultural status on the international stage of mythic proportions. These two non-wins (the interval act and the Secret Garden performance) arguably contributed most to Ireland's international cultural reputation. The actual wins at the contest paled into international insignificance given the worldwide euphoria that greeted the post-Eurovision careers of both sets of artists. Nevertheless, the country's final win in 1996 with 'The Voice', which abandoned the earlier transnational light love-ballad formula for a more recognizable national flavour, coincided with the peak of Ireland's dominance of popular music with globalized Celtic sounds. Sound markers of the ethnonational would emerge a decade later as a winning formula (Turkey, 2003; Ukraine, 2004; Greece, 2005; Serbia, 2007; Norway, 2009), but for Ireland in 1996, the Celticization of both the ESC and global music markets was complete.

Looking back now on the period of Ireland's wins and off-stage success, with the hindsight of anniversary events and subsequent failures of performance, it is easy to see how the cumulative effect of so many wins and successes at the contest in such a short period of time countered the lack of international success outside the ESC by the winning artists, though they would go on to enjoy a long-lasting national reputation. What has happened to restore the international reputation of Ireland in the contest is that the spin-off successes in the context of more than half a century of performances have engendered a satellite effect for Ireland's Eurovision reputation that has helped to bolster the memory of the record-breaking statistics secured by Ireland in the 1990s. Ireland's runner-up position in 1997 (Marc Roberts singing 'Mysterious

Woman') while hosts of the contest for the record seventh time was to be its highest placing facing forward. While the Irish public's love of Eurovision would endure in terms of TV audience figures for the next two decades, new economic narratives of reputation would overshadow the much-vaunted notion of Eurovision being synonymous with Ireland's international reputation.

The miraculous performance of the Irish economy proved to be a new national narrative from 1997 onwards. The country's future cultural self-promotion would be tied to its 'Celtic Tiger' economy. Its economic restoration and reputation drove it to international prominence concurrently with the Celticization of popular cultural markets (music, theatre, and dance). Ireland as a successful national economy had no further direct need to invest in a European contest in which all but one of the songs ultimately fail. Further, viewers no longer needed to look to the national broadcaster for entertainment, and the proliferation of alternative light entertainment opportunities left the ESC in its shadow. The contest had to respond and, by the time Ireland hosted its final contest in 1997, five of the competing nations had introduced televoting, which was an attempt by the European Broadcasting Union to turn the contest into a participatory media experience. At the same contest, artists were permitted to use prerecorded backing tracks, signalling the eventual demise of the live orchestra two years later, a feature that Ireland had exploited in its power ballads to glorious effect.

In some senses the international success of *Riverdance* and its Celtic spin-offs, beyond the borders of Europe, meant that Ireland no longer had any need for Eurovision as a platform for the exhibition of Irish popular culture. The simplistic narrative of *Riverdance* (the show) heralds Ireland's dance tradition as the world's most eminent that competes and wins against other national dance traditions. It places Irish step dancing alongside internationally renowned traditional dances, from jazz tap to flamenco, and thereby embues Irish step dance with the renown of other world dances in, some might say, a bucolic Celtic twilight of nostalgia. Eurovision or, indeed, Europe was no longer a big enough stage for Irish popular cultural ambition. Concomitantly, Irish economic aspirations took a similar stance. The so-called Celtic Tiger bubble economy (1997–2007) was a temporary blip in Ireland's historically poor record. Record international direct investment fuelled an international property boom that pushed up the gross domestic product but also public spending. At the time, Ireland's politicians, who had nothing but good news to tell the electorate, believed that the economic miracle was a reality of sound foreign investment, not a myth fuelled by international speculation.

For a time, as Ingo Schmidt has pointed out, 'Ireland seemed to prove neoliberal claims according to which free trade within the EU would allow poor countries to catch up with the rich countries' (Schmidt, 2011: 74). This apparent conjoining of Ireland with the European centre happened at the same time as the centre of Eurovision (the so-called Big Four – France, Germany, Spain, and the UK – because they subsidize the ESC so heavily) would fall out of favour with the European tele-electorate from 1998 for the next decade or so. Ireland's successes at Eurovision by this stage had not only caught up with central European victories but actually overtaken them. Like the Celtic Tiger economy, Ireland's Eurovision performance in the mid-1990s was a Eurobubble created by a jury system of voting, like the foreign direct investment that had fuelled Ireland's apparent economic success. But joining the centre would have disastrous consequences for Ireland when the foreign direct investment pulled out of the economy and the foreign cultural approbation of Ireland at the ESC was wiped out by popular vote. Ireland's ESC successes had shifted the country away from the periphery of Eurovision power to its very centre so that by the time the new countries of Eastern Europe and beyond joined the voting equation, Ireland's centrality was shored up even more. But Ireland as a nation altered dramatically during the economic boom years. Its successful economy made it an attractive place of inward migration, either for work or for refuge. The East to West and South to North trajectories of migration brought with them large communities of migrants from Poland, Lithuania, China, and Nigeria. Similar migration patterns were happening all over Europe and, particularly for the European migrants, the ESC offered a moment of connection to their home country. Throughout the first decade of the new millennium, Ireland's national televote consistently placed Poland and Lithuania in top positions. It seems plausible that inward migration had a large part to play in this voting pattern. Irish emigration, on the other hand, beyond that to the UK, could never contribute to voting for its own nation.

At the turn of the millennium, as televoting was universally deployed by national broadcasters, contemporary sounds proved popular among voters, and Ireland's ballad entries began to slide down the scoreboards. The contest was won and hosted by countries in the eastern half of Europe for eight successive years. And for several years Ireland used a reality show format to find its Eurovision entrants. But its voting patterns for those shows proved just as controversial as the neighbourly and diasporic voting patterns of the contest itself – in Ireland, parochial campaigns by the competitors' families and friends ensured that talent on

an international scale mattered not, to the point where in the national contest *You're a Star* presenters and panels of judges would repeatedly instruct viewers to vote for the song with the most chance of winning Eurovision and not for their local singer (2003–2005). The Irish TV public had forsaken the global potential of the contest for the sake of local allegiances of self-interest. Shunning the ESC in this way, however inadvertently, was to prove fatal, as inexperienced performers were chosen to represent the country. Meanwhile, the impact of Terry Wogan's BBC commentary had a detrimental effect on the Irish national commentary as well. Since Wogan was Irish, and his scathing and biting wit, sense of humour, and occasional xenophobic outrage, made for great TV viewing and listening, Ireland's national broadcaster had to compete for viewing figures for the readily available British channel.[3] Their answer lay in Marty Whelan, who has commentated for RTÉ since 2000. Though he has been much more measured in his approach to the success of the Eastern countries, he too developed a soft form of sarcastic wit that further eroded the reputation of the contest *per se*. Both Wogan and Whelan (in effect to a lesser degree) upstaged the contest by none other than their own performances. And as the cult of the personality replaced that of the serious commentator, the ESC had to compete against hours of ribald remarks, year after year. It was no surprise therefore that the foul-mouthed puppet, Dustin the Turkey, should represent the country in 2008, shamelessly reciting the names of many countries to secure for the song its eponymous 12 points (the song was called '*Irelande [sic] Douze Pointe [sic]*'), jibes at Terry Wogan, and recycling Ireland's former Eurovision glory.[4] No one was impressed outside the country. The viewers of Europe remained impassive, while many fans in the Belgrade Arena vented their opprobrium. Four months later the country entered a recession, the economy went into freefall, and unemployment rose inexorably. The cultural joke of Irish Eurovision was overtaken by the swift onset of an economic disaster.

So what happened to Ireland's ESC entries thereafter? An uptempo song, '*Et Cetera*', in 2009 failed to qualify for the final for the second year in a row. In 2010, 1993's winner Niamh Kavanagh won the national contest and represented Ireland in Oslo. In the run-up to the contest, an *Irish Times* article penned by Karen Fricker screamed: 'Could You Sing Us out of Recession Again, Niamh?'. It was a clear signal that Irish economic hopes were being pinned on a popular cultural revival of fortune. This nostalgia was misplaced, however. Kavanagh was too old for the new voting public's taste and the retro-ballad 'It's For You' insufficiently modern. She only scraped into the final and finished a

very disappointing 23rd place. Nostalgia had no place in a modern Eurovision. It appealed only to a fan group and to an age group who were not necessarily the most avid text voters. As of the previous year, jury voting had been reinstated to provide 50 per cent of the results alongside 50 per cent public voting, but in this case the return of the judges offered little help to the Irish song. Industry representatives on the juries were also not persuaded by such a nostalgic approach that had no popular appeal. And so in quick succession neither approach, the one contemporary, the second a nostalgic ballad sung by one of the oldest contestants that year, proved to be a winning formula.

In 2011, RTÉ decided to keep the same national contest formula but this time invited leading music industry promoters to find songs and match them to singers. Arguably Ireland's most successful music promoter, Caroline Downey Desmond, matched teenage twins Jedward (John and Edward Grimes) with a hugely energetic song 'Lipstick' (Figure 7.3). Jedward had been the surprise stars of the UK's reality TV show *X Factor* in 2009. Though they were only placed sixth in that competition they quickly developed a large fan base in Ireland and the UK, mostly of pre-teenage girls. But the caustic comments of some of the judges in that show week after week slated the duo for their

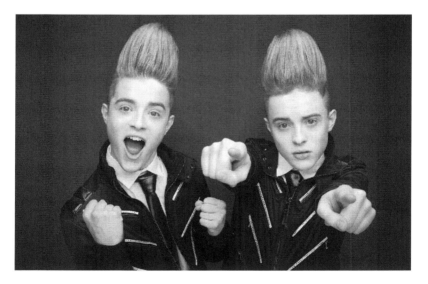

Figure 7.3 Jedward (John and Edward Grimes), who performed for Ireland in the 2011 and 2012 ESC

lack of timing and their inability to sing. However, their manic energy and polite refusal to be cowed by such a barrage of criticism swiftly made them the show's underdogs, therefore eliciting public opinion in support. Since leaving *X Factor* they have released several singles that charted, and hosted their own TV reality show. Their good looks, bizarre trademark pineapple-shaped hair, and crazed personalities made them TV stars, and in Ireland they quickly became A-list celebrities, making sure that anything they do is headline news. Performing on the national final live on primetime TV, however, was not as straightforward as it seemed. 'Lipstick' had inadvertently been prereleased and thus for the national final the song was penalized from the outset, making a sure victory suddenly improbable. And while screaming pre-teen fans camped outside the studios on the day of the broadcast, inside, veteran official fan club supporters in the audience made clear their intentions to support, not Jedward, but Nikki Kavanagh, a backing singer from the previous year's entry who had become a firm fan favourite with her song, voice, and personality. That song was another ballad, however. Jedward won by a slim margin, given the penalty they had incurred. It did not seem auspicious for the success of the song that the majority of Irish Eurovision fans were displeased with the choice. After all, it is the fans who accompany the contestants to the contest itself and generate interest in the national song, as well as provide a national spectacle in support during the live show. As a musical act, Jedward was not taken at all seriously by music critics and the fans feared that their less than salubrious reputation for talent might make Ireland another national joke entry.

The 2011 contest in Düsseldorf, however, provided Jedward and Ireland with an opportunity to restore their respective reputations. Jedward worked the assembled 2000 journalists with ease. Their looks, hair, costume, and pre-pubescent behaviour on screen had wide European appeal and they were much sought after for photo opportunities and TV appearances. On stage during rehearsals, they surprised everyone. Desmond had commissioned a hugely attractive and expensive video for projection on the LED wall behind them, while the boys performed their song and dance routine more than competently, aided by superb backing singers. Jedward suddenly became contenders both with the fans and with the external pollsters. By the time the contest began, they were tipped to win their semifinal, and Google predicted they would win the contest outright. Eventually, Jedward came eighth in the final – the second highest place achieved since Ireland hosted in 1997.[5] The twins were the talk of the contest, their song climbed high in

several European charts, and they recorded several of the famed 'douze points' from the UK, Denmark, and Sweden. Throughout the week, as the European media had warmed to the song and the singers, the Irish media realized that Ireland was popular once again in Eurovision. Jedward's national popularity among a pre-teen demographic became more widespread as the possibility of doing exceptionally well in the contest was a reality. The national mood as depicted in the media was lifted from the morass of stories of banking corruption, bailouts, austerity, and joblessness. Ireland's Eurovision entry provided light-hearted and yet fully committed performers, making the nation proud once again on the international stage. Jedward, not renowned for their attention to performance detail, performed in tune and with near-perfect dance routines, restoring their credibility as a musical act and garnering support throughout Europe for their efforts. While previously Ireland's financial status and reputation had been declared junk along with its cultural contributions to Eurovision to the point where it entered the perjorative acronym PIIGS, Ireland did not do so in Eurovision terms. The PIIGS may have been the disgraced of Europe, but their Eurovision success was a counterpoint narrative of popular proportions. Three of the five PIIGS scored top-ten places with various strategies of song content. Ireland's strategy was to shake off its light-ballad legacy from its successful 1990s entries, and buy into the Eurovision upbeat pop formula with a narrative of youthful optimism that transcended the national, much in the formula of ABBA of old (see Frith, 1989). But if Ireland had won in 2011, and had the money to stage the contest in 2012, what image of the nation could the national broadcaster have projected to counteract the widely known reputation of national economic failure? Would popular cultural success and youthful positivity be enough to remove the second 'I' from the PIIGS acronym?

At the time when Ireland and its media came to love Eurovision again, they did so because they needed it. There was no other narrative of optimism available. During the Celtic Tiger years, Ireland did not need Eurovision. It also did not need Europe and, when asked for the first time to ratify the Lisbon Treaty in 2008, the electorate refused to do so. Subsequently, it was revealed that members of the parliamentary cabinet in Ireland had never even read the treaty document. Since its accession in 1973, Ireland had benefited enormously from being part of the European family of the EEC/EU, particularly in respect of development grants for infrastructure projects. In return, using the EU as a means to bypass the UK was a political act of contestation of the domination of the colonial power. This was a very strategic allegiance with greater

Europe in return for investment in the domestic economy. Since then, Ireland has been a very good member of the family. Though it was constitutionally obliged to go to the electorate with any European directive, it had until 2008 always ratified what the central powers in Europe had wished. Until that time, however, successive Irish governments could herald the EU as part of the engine of a successful domestic economy so the electorate saw no need to challenge the relationship. However, with the economy in freefall in 2008, Ireland for the first time called a halt to the cosy relationship. The rejection on the political field coincided with the snub entry to the ESC. While Ireland was humiliated instantly by failing to attract support inside and outside the Belgrade Arena for the ESC, it would have to wait two more years before the snub was overtaken by politico-economic humiliation, with the arrival of the troika of EU/European Central Bank/IMF in the country offering a financial bailout on terms that would affect the nation not just economically but also by effectively losing economic sovereignty. Ireland was now legally bound to a wide economic European federalism whose provision of a bailout would ensure the country's peripheral status for the foreseeable future.

New narratives of nationalism emerged in Ireland in the wake of the perceived loss of sovereignty and the sudden faltering economy. By the time credit agency Moody's had downgraded Ireland's debt rating, no national narrative could emerge other than that of failure, retraction, and humiliation. Though there were street protests and political dissent, the Irish public by and large responded fatalistically to the bailout and its conditions. However, in the cultural sphere, Ireland still retained an internationally successful image, particularly in literature, theatre, and music. Its Nobel Prize winners, ESC winners, and theatre exports contributed hugely to that successful image. A National Campaign for the Arts (NCA) was launched and vociferously lobbied political representatives to retain the arts at the centre of economic recovery. The global music industry continued to feature prominent Irish musicians, Hollywood had a plethora of young Irish talent, and Ireland was making inroads into the online gaming industry. Such was Ireland's myopic political focus on economic recovery that the NCA was inadvertently advocating a neoliberal notion of a 'creative class' where a state's economy could be driven to a significant extent by the creative industries (see Florida, 2002).

It is within the context of Ireland buying into the notion of a creative economy that Jedward's relative success should be seen. Though their early musical reputation was suspect, their media reputation was huge by the time they were selected to represent the country at the ESC.

Their youth and lack of placement within a context of economic failure permitted them to transcend those contextual narratives and communicate directly with a younger European TV public. Their youthfulness coalesced with the ESC's desired apolitical approach. Young people in and out of love is the central narrative of popular music, and while the ballads might reflect the hurt of lost love, the Eurovision trope is one of transcending adversity. Before they had ever sung one note on the Eurovision stage, Jedward had already transcended severe media criticism and pressure. Their mocked status on a British reality show was transcended by a seemingly inexhaustible ability to rise above criticism. Though their song was electro bubblepop, Jedward's presentation was not too dissimilar from what Ireland offered through Dana and Johnny Logan; young, beautiful people with international appeal. Infectious positivity and optimism is another of the twins' key performance strategies, as well as an ability to appeal across an age and gender spectrum. Crucially, the twins went to Düsseldorf with a love for Eurovision and were well briefed on how the ESC works from a media perspective. Their presence, friendliness, and occasional zany behaviour offered the Irish entry a large number of opportunities for encountering foreign media.

Though scholars and pundits fail to agree on the importance of pre-contest publicity as a recipe for success, the direction of national media, and more specifically of the live commentators who mediate the contest, the singers, and their songs for national tastes are undoubtedly crucial to national perception. The production surrounding Jedward, and in particular the pre-prepared video for the LCD wall on the stage, was declared by assembled media and fans to be one of the highlights of the live show. The performance of their song ended with an explosion of glitter raining down on the spectators (more akin to a reprise than an initial singing of a song). This complemented another of Ireland's marketing strategies, namely the distribution to the audience of thousands of Jedheads, cardboard cut-outs of the twins' famous hair, which everyone could wear. Everyone could be an Irish person for the evening. This marketing of inclusion and inclusiveness despite the marked difference of the performers' highly unusual hair and stage costumes meant that the audience was also encountering difference as sameness. Accepting to wear a Jedhead, one accepted to be marked as different, as celebratory, and, by extension, as Irish. So, though they may not have won the contest outright, their highly inclusive performance both on and off stage marked Ireland once more as a serious participant in the ESC. Crucially, Ireland did not seek to reclaim its heritage through a single man or woman perched on a stool singing a slow ballad. For Ireland to reinvent itself after the balladeer image had been tainted by the seemingly

endless and improbable run of good luck in the 1990s, courtesy of an exclusive jury voting system, a completely different act had to be performed. And after the perceived lack of a serious attempt at participation in the contest through a succession of weak entries in the first decade of the millennium, culminating in Dustin's appearance in 2008, Ireland needed to have a song that could place well in the charts.

Jedward's 'Lipstick' reached no. 1 in the Irish charts but also charted well in Germany, Denmark, and Sweden, thus giving Ireland a participating act in Eurovision that could transcend the song contest in the music industry. Unlike Ireland's previous entries, and particularly unlike its winners, its 2011 entry had a currency beyond the Eurovision stage. Further, Jedward's ingenuousness was not that of the simple and innocent Irish entrants of the early wins; they are artists of the US company Universal Music Group (whose stable includes the likes of Madonna, Lady Gaga, and Rihanna). Their sound is contemporaneous with an international (and not just Euro-regional) youth culture and therein lies the possibility of a redemptive approach to the contest for Ireland and a restoration of a reputation, one that has been used to good effect by Russia (Dima Bilan, 2008), Germany (Lena Meyer-Landrut, 2010), Azerbaijan (Ell & Nikki, 2011), and Sweden (Loreen, 2012) – namely their choice of local artists for songs written by internationally renowned writers and musicians largely competing in the US market. Until 2011, like the foreign direct investment from European banks to the Irish economy, Eurovision had never given Irish popular music 'any significant share in world markets' or any real possibility 'to climb up in the international hierarchy of states' (Schmidt, 2011: 82). In fact it had created a mythologized reputation bubble for the country in the contest centring a former peripheral country only for it to be cast adrift thereafter. Jedward, on the other hand, transcended the centre/periphery divide with their emplacement within the international music industry. It has taken a very long time for Ireland's appeal to the juries in the 1990s to be translated to the viewing public thereafter. The return from junk status in the contest in 2008 was not achieved through a nostalgic return to a past reputation but through the reinvention of a new one based on musical contemporariness, and a choice of artist situated once more within youth culture. This transnational appeal also ran counter to perceived notions of 'multinational coalitions' (Ingvoldstad, 2007: 108) of reciprocal allegiances in voting. Appealing across old political divides of the former communist East and capitalist West is no longer the marker of a new Eurovision. The appeal of Ireland's Jedward transcended the new divide beyond Eurovision that separates the financially prudent

from the profligate in economic terms not by playing a Europeanness configured in national terms but rather by appealing to a universal cultural image of youth and youthfulness that had been the early marker of Eurovision success for Ireland in 1970. In Eurovision terms, Ireland's successful 2011 entry was the first to be a truly commercial success, and one that was reported to have turned a small profit for the national broadcaster, RTÉ (escdaily.com). Now that Ireland's national reputation has declined economically, it has reverted to its former size – a size that, as Greg Clark has argued, makes it possible once again to use the ESC 'for gentle political purposes in terms of redefining a country's image' (Clark, 2008: 94).[6]

Notes

1. The song charted well thereafter throughout Europe and Dana's career looked set to triumph, particularly in the UK. But it was a career stalled by illness and a return to family. Though she was able to revive a career for the domestic market, her profound religious beliefs seemed at odds with the social contestation of contemporary popular music. Decades later, after a spell of hosting an evangelical TV series in the US, Dana returned to Ireland with an ultra-Catholic pro-life agenda and turned to politics, successfully being elected as a Member of the European Parliament but unsuccessfully defending her seat (2004) and unsuccessfully running for the presidency of Ireland (2011).
2. Fionnuala Sweeney was playing in the RTÉ concert orchestra for the 1994 contest when she met Norwegian composer Rolf Lovland. She was the star of Secret Garden's 'Nocturne', as the song was largely a violin solo by her and traded clearly on Celtic traditions in the style of Enya and *Riverdance*.
3. See Karen Fricker (Chapter 2) for an extended discussion of Wogan's commentary.
4. Dustin was already a well-known figure in Irish popular culture when he made his Eurovision appearance. The creation of Dublin comedian John Morrison, Dustin is an 18-inch tall puppet that offers satiric (and frequently irreverent and profane) social commentary about contemporary Ireland. He appears frequently on Irish TV and radio. Part of the conceit of Dustin's act is that Morrison never reveals himself and the public is invited to accept the absurd reality of a talking (and, in the case of Eurovision, singing and rapping), turkey.
5. Ireland came 2nd in 1997, 6th in 2000, and 10th in 2006.
6. Jedward returned to represent Ireland in 2012 with a legion of new fans across Europe. While they were placed 4th in their semifinal and 10th in the final televote, a poor performance in the jury final failed to persuade the national juries and so their final overall placing was 19th.

Part III

Gender Identities and Sexualities in the Eurovision Song Contest

8
Competing Femininities: A 'Girl' for Eurovision

Elaine Aston

In the days after the 2007 Eurovision Song Contest, the internationally acclaimed feminist Germaine Greer wrote in the *Guardian* about '*Molitva*' ('Prayer'), Serbia's contest entry, sung by Marija Šerifović (Figure 8.1):

> It was wonderful enough that a solid plain girl in glasses won [Eurovision] for Serbia with an old fashioned torch-song; that she should have sung it in passionate earnest as a lover of her own sex is what made this viewer switch off the iron and start praying that the gods might let her win.

> (Greer, 2007: 28)

As she puts down her iron to watch Šerifović's performance, Greer's feminist gaze is drawn to the absence of spectacular femininity: 'the presentation was so subdued, no high kicks, no pelvic thrusts' (ibid.). Greer's attention to the 2007 contest is exceptional. If there are other commentaries by celebrity feminists on Eurovision, I have not yet found them. Moreover, despite the strong field of feminist media and cultural studies in the UK, I have been unable to discover a significant interest in the contest from this quarter. Perhaps all of this points to the fact that this annual contest reputed, as Greer suggests, for its 'high kicks' and 'pelvic thrusts' is antithetical to feminist interests and that feminists might be better off retreating behind their ironing boards rather than watching Eurovision.

However, in this contribution I want to buck the trend by offering a series of reflections on the competition from feminist perspectives: to think how femininities compete as a 'girl' for Eurovision, 'new' Europe, contest. This is a complicated task, complicated that is by

Figure 8.1 2007 ESC winner Marija Šerifović

different geographies of femininities and feminisms, and by different national stakes in the international Eurovision gaze. Working out of a contextualization of Western feminisms juxtaposed with questions of women's citizenship and agency in CEE (Central and Eastern European) contexts, I move to address these complexities in two ways. Firstly, I look to identify and analyse the contest's millennial trend of 'girling' women's empowerment, drawing on the winning performances by Marie N. (Marija Naumova, Latvia, 2002), Serteb Erener (Turkey, 2003), and Ruslana (Ukraine, 2004). Here I am seeking to understand how 'girl-powering' the nation in the contest makes legible questions of women's social advancement (or lack thereof). Secondly, I complement this by coming back to the eschewal of spectacular femininity as exemplified by Šerifović, and thereafter by Lena (Meyer-Landrut) (winning the contest for Germany in 2010), in order to posit the politicizing potential of 'alternative' femininities styled for Eurovision.

Feminisms in perspective and context

From a Western feminist perspective, to 'enter' the contest with regard to its post-1989 'new' Europe configuration is to pick up the Eurovision

story at the point where 'old'-styled, second-wave feminism, variously invested in liberal, radical, and socialist feminist ideas of women's equality and/or liberation, had been severely dented by the rise of identity politics. Coupled with the 1980s backlash against feminism at large, this made it increasingly hard to achieve a 'unification' of women across socially, ethnically, and sexually configured sites of differences. For an ESC reminder of the 1980s backlash, one need look no further than the iconic sexist, skirt-stripping choreography of the UK's 1981 winning entry 'Making Your Mind Up' by Buck's Fizz. The retrosexist, 1950s look of the two-boy, two-girl band, complemented by their limp rock without a lot of roll choreography, slipstreamed back into a disempowering vision of femininity pre-women's modern liberation. The gender stereotyping of this act appeared in stark contrast with the mid-1980s surveys conducted by the European Economic Community (EEC) that evidenced 'two-thirds of people questioned... believ[ing] it was time to break down the strict stereotypes of women's and men's social roles' (Taylor, 1985: 83). Further, these EEC surveys recorded a changing attitude to women and politics: surveyed as to whether people 'thought politics should be left to men, 41 per cent disagreed in 1975. Eight years later 71 per cent disagreed' (ibid.). It is hard to reconcile these figures endorsing the 'breakdown of gender stereotyping' with the retrosexist imaging of femininity stripping feminism of its claims to women's social empowerment. All of this does not add up, or rather it makes visible the 1980s move to push the feminist clock backwards rather than forwards. In short, even while Western Europe in that decade had apparently been making up its mind in favour of breaking down the 'stereotypes of women's and men's social roles', to look back from my UK-based, feminist perspective is to see an increasingly retrogressive rather than progressive gender outlook towards the century's close.

While Western feminisms ran their troubled, late 20th-century course, post-1989 women's lives in CEE countries were undergoing radical social transformations. 'Active citizenship and the revival of civil society was what the upheavals of 1989 seemed to promise for the former state socialist countries of East Central Europe', wrote Barbara Einhorn in the conclusion to *Cinderella Goes to Market* (1993: 256). However, her study shows that the promise of a more socially progressive future in CEE countries was undermined in the early 1990s by high unemployment, falling levels in women's political representation, and the curbing of women's reproductive rights (ibid.). As these nations were caught between the state socialism of the past and the 'newly democratic societies' of the 1990s, Einhorn instead detected a deterioration rather than

an amelioration of women's social conditions: 'In the past rights were given, from above, now they are taken away by market and "new" ideological pressures' (1993: 257).

Since then, matters pertaining to women's capacity to participate in the public sphere, questions of women's agency, and active citizenship in CEE countries have remained seminal to feminist activism and scholarship. In particular, as Lukić et al. outline, core to the 'new citizenship model' have been the attempts made between local women's activism and non-governmental organizations (NGOs) to create 'alternative spaces' for the improvement of women's lives 'beyond the state and [the new, neoliberal] market' (2006: 3). Here too, however, difficulties have arisen. Reporting, for instance, on what she describes as the hybrid feminisms emerging between the work of NGOs and local women's activism in Ukraine post-1991 after the dissolution of the Soviet Union, Alexandra Hrycak is critical of the ways in which this has served in fact to erode rather than strengthen the grassroots activities of local groups of Ukrainian women (2006; see also Lukić et al., 2006: 4, and later discussion here with respect to Ruslana).

Trying to make sense of what she perceived to be feminism's lost, 20th-century ground, French writer and critic Nicole Ward Jouve asked:

> Is it just that the pendulum will swing, or that the public appetite for what's new will make it tire of anything, regardless of its relevance? Are things so much improved? Do three hundred women sit in Parliament? What is fascinating is how, through what process, do people go back?
>
> (1991: 107)

In part, the process of going backwards rather than forwards has been shaped by the idea that the gender wars have been fought and won; that women have gained their rights to social equality, or that the neoliberal markets and democracies in CEE countries have been successful in making women more equal-righted.[1] More recently, British feminist and cultural studies scholar Angela McRobbie cautioned that the increasingly globalized economies and markets in Europe and other parts of the world have created

> an array of political and cultural forces, to re-shape notions of womanhood so that they fit with new or merging (neo-liberalised) social and economic arrangements. And, within a context where in many parts of Europe and in the US there has been a decisive shift to

the right, this might also be seen as a way of re-stabilising gender relations against the disruptive threat posed by feminism. It is not so much turning the clock back, as turning it forward to secure a post-feminist gender settlement, a new sexual contract.

(McRobbie, 2009 57)

McRobbie elaborates that the idea of 'a new sexual contract' figures a sense of social and sexual empowerment: '[t]he dynamics of regulation and control are less about what young women ought not to do, and more about what they can do' (ibid.). While she is primarily concerned with a 'post-feminist gender settlement' in a Western (mainly British) context, in the section that follows I come back to the ESC to examine how styling 'can do' girl power in acts representing CEE countries works to settle and/or unsettle questions pertaining to women's empowerment.

Girl power from West to East/East to West

After the 1990s were dominated by an unprecedented number of winning entries from Ireland, including three female vocalists (Linda Martin, 1992; Niamh Kavanagh, 1993; Eimear Quinn, 1996),[2] the ESC went into the 21st century with a veritable explosion of successful girl-power performances. Two of these were from CEE countries relatively new to Eurovision: Latvia ('I Wanna' performed by Marie N., 2002) and Ukraine ('Wild Dances', Ruslana, 2004).[3] A third came from Turkey ('Every Way That I Can', Erener, 2003), the country's first win since joining the ESC in the mid-1970s (Solomon, 2007: 135). In these acts, 'can do' girl power is detectable, for instance, in the Madonna-like play of feminized cross-dressing that strips back to the ultrafeminine in Naumova's performance of 'I Wanna'; Erener's equally Madonna-derived, harem-corseted figure; and Ruslana's 'wild girl' sporting the iconic warrior-princess look of Zena, eponymous heroine of the fantasy, action-adventure TV series (Gold, 2004; Adams, 2010). Quite straightforwardly one might decide to decode this uncontested, winning girl-power formula as a specific instance of what Paul Allatson argues as the kitsch-driven contest's 'appeal to the familiarised-exotic taste of the audience' (2007: 93) and as an endorsement of a millennial 'material girl'. However, what this occludes is how and why this kind of sexually assertive femininity might be strategically useful for 'new' nation branding at the turn of the millennium and, in turn, how, as signalled above, girl-powering the nation through the global broadcasting

of the ESC reveals and/or conceals matters pertaining to local questions of female empowerment, agency, or citizenship.

To win and consequently host the ESC creates the opportunity to showcase and broadcast the winning country to 'Europe'. For CEE countries in particular, this can occasion the desire to revise the image of the nation as an unfamiliar, exotic 'other' in the gaze of 'old' Europe. Around the time of Naumova's 2002 success in Tallinn, the capital of Baltic neighbour Estonia (winners of the 2001 ESC), Latvia was under intense EU scrutiny with respect to the accession process to full EU membership. Membership requires confirmation that the terms of the EU *acquis*, along with the criteria related to democracy and to economic viability, are met (Novikova, 2006: 103). Understanding Latvia's aspirations with regard to the EU informs how one sees the 'blond ambition' of Naumova's act. Figured as exotically global rather than ethnically local, the performance is hard to 'place'. With lyrics sung entirely in English, a composition and choreography of salsa rhythms and routines, the world music effect that this creates transcends national identity. Although this is not an unusual tactic for ESC acts (see Allatson, 2007: 94), in this particular instance the worlding of Latvia rehearses the nation as a global player: performs a sense of entitlement to be part of a bigger, international (EU) picture. That sense of entitlement is played out through the cross-dressing, girl-power display of Naumova's white-suited assertiveness as she takes an energetic stance in relation to the complicated 'rules' of her 'crazy' lover. The performance flirts with sexual politics: a girl can dress like a man, dance with another girl. But ultimately this 'artful game' means accepting the woman's part: stripped of her suit by the boy dancers, Naumova's body is revealed sheathed in a pink satin dress tugged seductively down to her ankles – femininity emerges as spectacular and triumphant.

Strictly speaking, playing by EU rules requires that gender equality is taken into account, though in reality this can prove to be little more than a masquerade as Irina Novikova (2006) reveals in her persuasive account of how, despite the terms of the EU accession, gender equality remains marginal rather than central to Latvian policy-making in ways detrimental to women's lives economically, socially, and culturally. From my Western feminist perspective and albeit limited understanding of the Latvian situation, it would be implausible to argue a radical edge to Naumova's cross-dressed, girl-power play. Rather, it mirrors the social realities in which gender relations fold back into persistent inequalities. On the other hand, her figuration of a Latvia looking away from its Soviet past and forward to its integration into the EU is complicated

by her Russian descent. This makes resonant the historical remnants of the Soviet occupation as it gestures to a Latvia where citizenship is modelled along an ethnic divide of 'citizens' and 'aliens' (Novikova, 2006: 103).[4] Opportunities to 'increase the visibility of "alien" women' are rare, Novikova argues (ibid.: 108), and while Naumova prefers to sidestep 'the politics of ethnicity' (Straumanis, 2002), her iconic status in Latvia since the ESC success is arguably productively significant in this regard.

In contrast with Naumova's unplaced or displaced global girl, Erener's 'Every Way That I Can', which won the Latvian-hosted contest in 2003, hybridizes East and West in ways that several scholars have come to regard as an act of Turkish self-orientalization. Songül Karahasnoglu and Gabriel Skoog, for instance, explain how Erener's music label, Sony, directed her to drop her former European style and opt for 'a more Turkish-derived format [that] might be read as an act of self-orientalizating, a change based upon internalized foreign expectation of authentic Turkishness' (2009: 67). Similarly, Matthew Gumpert analyses her ESC performance as one of 'auto-Orientalism' (2007). Asking what it meant for Turkey to want to project its image through the 'harem girl', he answers this with an account of Turkey's internalization of the East performed back to a Western gaze. In the hybridization of East and West, the Oriental and the Occidental, he summarizes that what this produces is 'a musical version of an EU summit: state orientalism, offensive to no one' (2007: 151).

Viewed as a strategic platform for Turkey's interests in Europe, what tends to fall out of the discussion of Erener's ESC performance is a feminist gaze on the Turkish pop diva's harem girl. From a Western feminist perspective her performance appears to constellate the conflicting strains of a self-orientalization that casts femininity back into a site/sight of female objectification designed to please and a self-occidentalization as the song sung in English (a controversial decision in some Turkish quarters [see Solomon, 2007: 136–137]) asserts a Western brand of 'come on' girl power. So, for instance, the rap section played to the repeated line 'Nothing in the world can stop me, no sir' on the one hand resounds as a grrrl-power anthem, and on the other is expressive of a subjugated female subject determined 'every which way' to please her 'sultan'/Turkish master.

Histories of modern women's movements in Turkey (from the inception of the Turkish Republic) reveal, as Marella Bodur and Susan Franceschet explain, that women's interests were 'subordinated to the needs and interests of the [new, secular] nation' and recognize the

contradictory tension that existed in the dual requirement that women's role should be 'to signify modernity, and to guard and transmit Turkish national culture' (2003: 120). Hence, what has characterized women's activism in more recent years is how the 'struggles for redefining [women's] identities' map with those of 'empowerment' (ibid.: 126). Erener's strategic mix of the familiar, exotic stereotype of the harem girl with the empowering sensibilities of an assertive femininity is evocative of identities yet to 'be' found in and out of the struggles between modernity and tradition, secular and Muslim, the nation's interests and women's self-interests.

This is by no means easy given the differences between women, differences rooted in ethnicities (Kurdish and Turkish), or in secular and religious divides, which make it difficult 'to reconcile women's diversity in order to challenge and transform the prevailing gender discourse' (Bodur and Franceschet, 2003: 126). Here, too, Erener's performance has resonance. It is an all-girl performance, but these are not women 'banded' together. At the centre of the group, Erener is also at the centre of antagonistic relations with the other women – rival lovers rather than 'sisters' whom she has to beat off and push away, just as hard as they try to undo her solo, star position, pulling on the four trains of pink fabric attached to her body that they wind and whirl about her in gestures of constraint.[5]

Further, looking ahead by thinking back for a moment to Naumova's performance and the Latvian/EU accession context is to be reminded that when a nation aspires to become part of Europe (the EU), it does not necessarily follow that this affords a socially progressive experience with respect to gender equality. In other words, to be enslaved to the nation that looks to please Europe is no guarantee of a release from the harem (figuratively speaking) at some future date. However, the love of the 'sultan' that Erener's harem girl declares herself willing to die for ('I'll cry/ I'll die') also asserts a determination to make her lover love her. As women in Turkey persist in aspiring beyond identities based on the needs of the nation, so the need for the nation to love/recognize their interests remains paramount.

From a feminist-political perspective, of the three ESC girl-power performances I consider here, Ruslana's 'Wild Dances', which won the contest in 2004 in Istanbul, is arguably the most radically charged of the 'can-do' girls. While, like Erener's harem girl, Ruslana's 'wild girl' undoubtedly and strategically is designed to appeal to a Western (masculinist) imagination and, as previously noted, connotes the globally mediatized warrior-princess look, it also reminds of Ukraine's

Amazon ancestry of warrior women (see Webster Wilde, 1999: Ch. 2). Figuring that ancestry, Ruslana's 'wild girl' has designs on women's empowerment woven through local and national Ukrainian interests.

As touched on earlier, Hrycak's account of women's issues in post-socialist Ukraine draws critical (in both senses) attention to what she perceives as the schism between locally configured sites or informal networks of women's activism and the activities of Western NGOs. The latter she regards as producing hybrid feminisms on account of their blending of the foreign and the local though ultimately, she maintains, in ways detrimental to women's interests given their double failure – either to support local women's activism or 'to resemble Western feminist models of grassroots women's empowerment' (2006: 71–72). This failure is consequent, Hrycak argues, largely upon a refusal of women's NGOs to negotiate and to value ' "traditional" gender relations', primarily those that 'embrace a "maternalist" discourse', which remain important to local women's groups (ibid.: 74–75). In brief, a sense of tradition is therefore seen as inferior and detrimental to modern (Western) formations of women's empowerment.

Ruslana's hybrid 'wild girl' does not resolve the divide that Hyrcak observes by reclaiming 'traditional' gender values in an 'old'-style, maternally marked discourse and ideology, but it finds a way to bridge the gap by constellating sensibilities of young women's freedom and independence with a revaluation of cultural tradition and heritage. Her Amazonian persona (that she has continued to adopt and adapt in her concerts and concept albums) fuses the archaic and the contemporary; her music mixes Ukranian folk traditions into popular music, branded and delivered in a youthful style of Western feminist/feminine empowerment.

To amplify: as many commentators on her ESC act have observed, sung in English and Ukrainian, 'Wild Dances' resonates with the ethnically encoded strains of music derived from the folk traditions of the Hutsul people in the Carpathian Mountains in Western Ukraine. The opening, for example, was performed as a musical sequence on *trembitas* (long horns used by Hutsul shepherds; see Solomon, 2007: 142–143), while Hutsul dance steps were also incorporated into the uptempo, energetic choreography (Pavlyshyn, 2006: 479). In short, visually and aurally, the 'ethnographic quotations' created a sense 'of the archaic and the pre-civilizational, underscoring the positive value of "wildness" as an expression of the natural, on the one hand, and the heady, liberating quality of the dance on the other' (Pavlyshyn, 2006: 475). Overall, purposefully incorporated into Ruslana's self-exoticized 'wild girl' appeal

to a 'Euro-vision' is an acknowledgement of a local, Ukrainian heritage that has sociocultural value both within the country (Hutsul culture was suppressed under the Soviet regime) and with respect to refreshing and re-energizing an image of Ukraine, looking West to Europe (rather than East to Russia). As Ruslana declared on winning the ESC, this created an opportunity to represent Ukraine to foreign audiences in a way that invited them 'to forget about Chernobyl' (qtd. in Williams, 2004).

As a self-styled Amazonion ecowarrior (her subsequent *Wild Energy* show and album conceptualizes the crisis in global energy), Ruslana also represents renewable feminine/feminist energies for younger, Ukrainian generations. She is the most socially and politically engaged artist of those ESC performers discussed here: she was a prominent figure in the Orange Revolution in the autumn following Eurovision and was briefly a member of parliament for the 'Our Ukraine' party after the revolution. She campaigns on behalf of those affected by the Chernobyl disaster, and to raise social awareness of human trafficking and global warming.

At the same time, Ruslana's post-ESC, 'pop idol' status at home and in Europe has also been courted by the beauty industry: she is the 'face' of youthful women's empowerment and of the cosmetic firm L'Oréal in Ukraine. Her endorsement of commercial femininities and women's independence, or the way in which femininities compete with feminist interests, is very much to the point of the discussion thus far. This directs us back to the ways in which girl-power branding can be deployed tactically as a means to open up questions of social inequalities and disempowerment – a tactic not lost, for instance, on Ukraine's recently formed, controversial 'Femen' organization, whose young women organize topless protests over sex tourism and female trafficking. Hence, if, on the one hand, hypersexualized, hyperfeminized girl power troubles and contests an older style of Western feminism, on the other hand, as evidenced in these ESC acts and CEE contexts, it can also press on different geographies of feminism, localizing and locating questions of women's empowerment and citizenship.

'This dress is not for me': Alternative 'girls' for Eurovision

However, the ESC's glamour and glitz appeal to 'the familiarised-exotic taste of the audience', or the camp fun and cheese factor that characterize the contest (Savodnik, 2011), can more often than not work to conceal rather than reveal feminist and gender politics as I have excavated them here. So in this final part of my discussion I turn to the more recent signs of femininities defamiliarized and de-exoticized in the

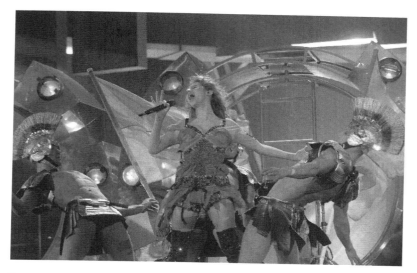

Figure 8.2 Ukraine's Svetlana Loboda and her backup dancers performing 'Be My Valentine (Anti-Crisis Girl)' in the 2009 ESC
Source: Indrek Galetin.

contest to consider how these might make visible feminist concerns – work to resist the idea of 'a new sexual contract' by encoding politicizing sensibilities of disempowerment.

Occasionally artists have used their participation in the ESC explicitly to showcase a social issue. This occurred, for example, with Ukraine's Svetlana Loboda and her 'Be My Valentine (Anti-Crisis Girl)' act in Moscow (2009; see Figure 8.2) when she used pre-final publicity opportunities to promote an anti-domestic violence campaign. In photographs and a video, she posed semi-nude, her model's body made up with bruises and scars to protest against domestic violence as a global issue.[6] From a cynical point of view this might appear little more than a vote-winning ESC tactic – her 'anti-crisis girl' mission to rescue women (if not the world) resounding hubristically as a promotional stunt rather than the promise of serious social commitment and activism. Yet at the same time the artifice of her 'violated' glamour look, captioned by the title 'This Dress is Not for Me', produces an uncanny space resistant to concealing domestically inflicted 'wounds': it announces a need to keep on looking at questions of women's oppression and disempowerment, rather than fashioning empowerment as necessarily attainable, achievable, or already dealt with.

On the other hand, keeping the social 'wounds' open or making them visible is hard to achieve, and this not least, as noted in the girl-power discussion, when they are produced through glamorous bodies in the fashion, music, or entertainment industries. As Imelda Whelehan observes, 'we [feminists] are, perhaps, harder on women in industries such as popular music and entertainment, who tend to fit the glamour mould and whose success can only really be measured in material terms and in terms of the breadth of their fame' (2000: 45). And this is why, to come back to the citation that headlines this essay, the politicizing strains and possibilities of Šerifović's deglamourized ESC appearance, in both senses of the word, caught Greer's feminist attention.

Performed in the 'European Year of Equal Opportunities for All', Šerifović's winning entry figured the idea that equal opportunities were not as yet available to all. Unlike Naumova's heteronormatively marked cross-dressing, Šerifović's butch, black-suited figure surrounded by her femme/female backing group was strategically designed as queer, 'to be read as gay' (Mitrović, 2010: 174), thereby creating an 'alternative', 'other' kind of 'girl' for Eurovision. Playfully if not parodically, the act defamiliarized and de-exoticized the ESC's endorsement of glamorous femininity. Styled as a kind of Brechtian *gestus,* the backing singers who surrounded Šerifović with their robotic, Stepford-Wives-styled choreography, bouffant hairstyles that had the look of a recently groomed Barbie Doll, and kitsch red heart brooches pinned onto their black suits, estranged spectacular femininity as an 'accessory' to social and sexual inequalities. In short, in ways antithetical to the glamour of the girl-power performances, Šerifović authenticated a politicizing sense of disenchantment and disidentification with commercially and conventionally produced femininities.

In the British press, Šerifović's tactical foregrounding of a queer/butch identity, in conjunction with her Romany background, was 'read', as Greer's commentary evidences, as 'outing' Serbia's poor record on LGBT rights and voicing the social injustices and inequalities of Roma people throughout Europe.[7] At the same time, however, as Marijana Mitrović points out, Šerifović's performance, notably in a Serbian context, was interpreted and laid claim to in contradictory, competing ways, as political parties of all kinds appropriated her success to promote their own interests (Mitrović, 2009: 12). In particular, as the singer asserted her Eurovision victory as a victory for 'the new Serbia' (qtd. in Zimonjic, 2007), and made her 'post-show winner's podium' appearance 'draped' in the Serbian flag (Mitrović, 2009: 12), she oscillated between a signification of 'otherness' and the nation whose receptivity to that 'otherness' was by no means (if at all) certain. Further, Šerifović's apparent support

of the nationalist Serbian Radical Party sparked debate as to where her political allegiances really lay, while uncertainties over her sexuality (gay or straight?) provoked animated, prurient debates in the media.

All of this Mitrović concludes as problematic: assisting with 'the strengthening of [the] national unity of Serbia' and conflating the performance of the 'other' as standing in for, or 'as if' this answers, the lack of, or at best limited, social progress for gay and/or Roma communities (2009: 14–16). While not disputing these difficulties, I would, however, posit the 'what if' pleasures of Šerifović's performance as one that pleads for a more heterogeneous sense of belonging. Put simply, whatever the political tensions and sexual political debates surrounding the singer, queering Eurovision with her camp performance (see Vänskä, 2007) and Roma 'identity', Šerifović voices the love of and longing for a politics of inclusivity.

Ironically, such a view is supported by the way in which Šerifović's 'difference' has impacted on her post-Eurovision music career. Despite being feted internationally as a gay icon, unlike Ruslana, her 'status [as a] national symbol' has been short-lived, precisely because, as Mitrović explains, she fails to conform to the nationalist, gendered image of the 'ethnically', 'racially pure', 'sexually straight oriented' woman (2009: 15). Underlining this point is also the way in which after the ESC her female backing group achieved success by forming their own glamorous girl band, the 'Beauty Queens', while in October 2007 at the Miss International beauty contest hosted in Tokyo, the singer's crossdressed look was glammed up and sexily refashioned by Miss Serbia (Teodora Marčić).[8]

Back in Eurovision, however, a taste for the de-exoticized reappeared in Lena's win for Germany in Oslo, or rather it was the singer's average-girl-on-the-street look that appealed to European Broadcasting Area (EBA) viewers. As one journalist observed, 'Lena Meyer-Landrut looks like what she is: a teenager plucked from the streets of Hannover who's done most of her singing in the shower' (Wroe, 2010). Perceived as 'authentic' with a 'homemade English accent' (*Spiegel Online*, 2010), visually and musically, Lena styled a trash-feminine aesthetic. Love orbited lyrically in a mundane round of hair-doing, toenail painting, and blue underwear. And, as Mark Savage commented for the BBC, there was 'no complicated choreography, no inexplicable backing dancers and she wore a simple black dress – the sort of thing you could pick up tomorrow in any high street store' (2010).

With her off-the-peg, off-the-street look and sound, replete with visible tattoo and the Lily Allen-like strains of an affected English working-class accent mixed into a medley of Euro-urban-street-speak,

Lena's performance enchanted on account of its appeal to a sense of teen disenchantment. As *Spiegel Online* insightfully observed and reported, 'the European community is growing closer and there are cities like Hanover all over this continent and further afield'. If pop music is, as always, 'about desires and dreams', then what Lena represents 'are not the dreams of the cool kids sitting in the cool clubs of New York, London and Berlin. These are the dreams dreamt in the bedrooms of children everywhere from Hanover to Dubrovnik' (2010). In support of this view, while researching this essay I came across numerous clips from young girls posted on *YouTube* – recordings of their own, home-made, Lena-look-alike acts, recordings that were clearly attracting large numbers of viewings.[9] These kind of dream-teen-virtual-lives played out in cyberspace city collide, perhaps, with the social realities of ordinary, 'uncool' city lives – and this at a time of global recession when the economic downturn makes it less rather than more likely that questions of social justice and inequality will be addressed or redressed.

Watching and rewatching Lena's performance on the internet, there is a part of me that feels we have been here before. The girl-off or from-the-street feel was what characterized the UK's Sandie Shaw's countercultural performance of sexual liberation back in the 1960s. I was a child in (rather than of) the 1960s, and Shaw's winning performance back in 1967 is my earliest personal recollection of Eurovision. It is her working-class edginess (her Eurovision/BBC glamour notwithstanding) that Lena puts me a little in mind of. A former employee at the Ford factory in Dagenham, Shaw is hailed as the 'Dagenham Diva' (a role she reprised in recording the soundtrack for the 2010 British movie *Dagenham Girls*).[10] Looking back at the Dagenham diva and forward to the Hanover diva leaves me wondering whether, perhaps, there is a more hopeful sign that the feminist pendulum is swinging back through younger generations of women coming from different parts of Europe, Central, East and West? Is there a sense, possibly, that rather than seeing themselves in the image of the already (falsely) enfranchised, younger generations of women may yet be feeling the need to compete for their rights to be more equal-righted?

Notes

1. For a fuller account of feminist gains and losses than I have the space to offer here, see Aston and Harris (2006).
2. Raykoff writes: 'Many fans considered this winning streak to be Europe's rebuke to Britain and a sign that Ireland's future would come through its ties to the continent beyond the British Isles' (2007: 4).

3. Latvia first entered the ESC in 2000; the Ukraine in 2003.
4. Post-1991 Latvia decreed that 'only those who were born in Latvia before 1940, the year of the annexation of the Baltic countries by the USSR, and their offspring, became citizens of Latvia' (Novikova, 2006: 103).
5. By contrast, the harem setting of the promotional video stages a stronger sense of female bonding, while the choreography and filming are clearly designed to appeal to a masculinist gaze.
6. See Brey (2009).
7. Similarly, a columnist in the *Independent* explained how 'Šerifović clearly demonstrated her rejection of the traditional guise and repertoire of Serbian women singers, traditionally seen as standard-bearers of the nationalist right. No sign on her all-women team of the obligatory lavish make-up, long nails, rocks and low-cut dress. No sign, either, of the singer's equally obligatory accompaniment – a muscle-bound boyfriend or husband, preferably a gangster or war criminal' (2007).
8. For information about the Serbian girl band, see http://www.beautyqueens.org/. Images of Miss Serbia can be found at http://www.pbase.com/selsadek10/image/87442500.
9. Social networking sites are favoured for these kinds of DIY self-promotional tactic and there are instances of this helping to launch singing careers, Allen's early recordings on *Myspace* being a case in point.
10. Ford's historically major car manufacturing plant is sited in the East London suburb of Dagenham. *Made in Dagenham* is based on the 1968 strike by women workers at the factory in the struggle to win equal pay.

9
Taken by a Stranger: How Queerness Haunts Germany at Eurovision

Peter Rehberg

Introduction

Eurovision, with its camp aesthetics, gay fan culture, and European audience, certainly provides the opportunity for queer people to experience a feeling of belonging on both the national and the transnational level, which is rendered more complicated or foreclosed in other cultural mainstream contexts and the public sphere in general. Lena's victory for Germany in 2010, however, was experienced by many gay fans in Germany – including myself – as somewhat of a disappointment. Unlike Dana International's victory for Israel in 1998, Germany's success was not celebrated as an instance that pushed minority rights and sexual liberalism – one possible message of camp aesthetics in the realm of pop culture – momentarily to the forefront of a national or transnational agenda. It did not offer an encounter of gay, lesbian, and transgender politics with national state or European politics that would not only bring queerness into the public sphere but might also have touched the concept of the nation state or transnational union (Rehberg, 2007). It was not only that Lena with her perky girlishness was not a queer diva like the glamorous transsexual Dana International, but, moreover, it seemed that Lena's mentor, Stefan Raab, as the person responsible for the national selection in Germany, did everything possible to straighten up the event as a whole. After having participated in the Eurovision Song Contest (ESC) both as performer and songwriter, Raab became Germany's self-proclaimed Eurovision expert during the 2000s in a media discourse on the ESC otherwise dominated by openly gay men.[1] The imagined Germany of 2010 – and with Germany as the

178

winner of the ESC the imagined Europe of 2010 – was not a queer one, as opposed to the imagined Israel and Europe of 1998, for instance.[2]

In this chapter I will show how, in the case of Germany's victory, national self-assertion at the ESC worked via a decamping and thus a dequeering of the contest.[3] Raab's rhetoric during the national selection clearly testifies to a barely hidden homophobic perspective on the contest's camp aesthetics – a standard straight response that reacts to the evident campiness of the event and its presumed implications for sexual politics with homosexual panic: How queer am I if I enjoy Eurovision? Given its reliance on publicly funded institutions – namely European TV stations – straightness at Eurovision as prominently allegorized by the gender-mixed couples that usually present the show is always possible, and it would be naïve and misleading to perceive the ESC as an uncontested celebration of queer culture. While much important work has been done on Eurovision's camp aesthetics and its fan culture (Raykoff and Tobin, 2007; Rehberg and Tuhkanen, 2007; Singleton et al., 2007), here I am more interested in the opposite phenomenon: straight culture's investment in the ESC. My question is why Raab so decidedly posited his engagement with the contest in an anti-queer way during the 2000s, culminating, I assert, in Lena's victory in 2010. I am raising this question in the context of the ESC's history over the past 15 years, the time since Raab first took an interest in the competition. These years also overlap with the emergence of Eastern Europe as a cultural power to reckon with at Eurovision, most evidently demonstrated by the impressive Eastern European placement record of the 2000s. I argue that while constructing Lena as an authentically feminine and thus non-queer German and European candidate for the ESC, Raab was never shy to locate the 'queerness' of the show – in his perspective an expression of sexual otherness which he certainly enjoys ridiculing – within Eastern Europe. By projecting the 'queerness' of the ESC onto the East, he was able to reappropriate it as a straight event from a German and Western European perspective.

This gesture – shared to an extent by other straight (at least when judged by their rhetorical performance) guys involved with Eurovision, such as former British commentator Terry Wogan – raises questions about the intersection of camp aesthetics and European identities: What are the ways in which the contest's pop culture produces meaning, if the production of such a link between sexuality and nationality is possible, and on what historically generated structure would this signifying process rely, especially with respect to the juxtaposition between Western and Eastern Europe? What does it mean to establish a difference

between Western and Eastern Europe in terms of straight pop versus 'queer' camp? How stable and effective can such instrumentalization of the ESC be for a national interest and beyond? Did Raab succeed in turning Eurovision into a straight event?

Curiously, Lena's second appearance at the ESC in 2011, after her victory in Oslo in 2010, tells a different story. 'Taken by a stranger', although unusual for the show as a musical piece, was, as a performance, much closer to its aesthetic archive. Her act was almost camp. Most importantly, its obvious construction of femininity as masquerade was clearly opposed to Germany's previous strategy, namely to link the national interest of winning Eurovision to a construction of hetero-sexual femininity as authentic. To put it polemically: Was the straight backlash of 2010 responded to by a queer counterattack in 2011?

The conceptualization of Eurovision's queerness also leads back to a reconsideration of the construction of Europe at the ESC: In what ways can we understand the contest aesthetic as a queer text in a critical sense that resists strategies which aim to construct non-queer national and European identities? Beyond mobilizing Eurovision's queerness as a ges-ture of critical intervention against national political appropriations of the contest, is there also a possibility of describing Europe affirmatively in queer terms? Does the ESC present Europe as a queer nation?

German nationality and straightness

I will begin by describing how over the past couple of years, Eurovision culture in Germany has become straight. As arguably the contest's most faithful fans, gay men take care of the song contest when no one else wants it – as did the openly gay host of the German national selec-tion programme, Thomas Hermanns, during a period of the first decade of the 21st century, when the public German broadcaster ARD did not make a particularly strong effort to be successful at the contest, and for a couple of years Germany finished in the lower third of the chart. Yet when openly straight and financially powerful Raab took over and named Germany's participation in the ESC a 'national mission' after a number of relative failures, he triggered not just an increase in inter-est for his new national selection show *Unser Star für Oslo* ('Our Star for Oslo'), but eventually succeeded Europe-wide when German singer Lena won the contest with her Song 'Satellite' in 2010 (Mehlig, 2010).

Raab has been a controversial figure in the context of German enter-tainment for some time, and as a five-time participant in Eurovision over the past 15 years, as songwriter, performer, or producer of a German

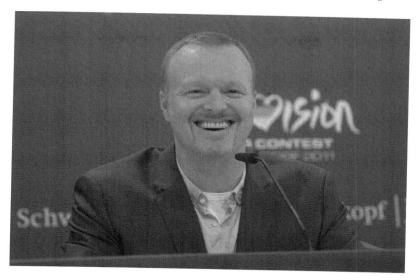

Figure 9.1 Stefan Raab at a press conference during the 2011 ESC
Source: Elke Roels.

entry, he represents in some ways a successor to Ralph Siegel, whose songs were performed in the ESC final a staggering 18 times, mostly for Germany, including the 1982 winning song by Nicole, '*Ein bisschen Frieden*' ('A little bit of peace') (Figure 9.1). Raab started his Eurovision career by writing Guildo Horn's '*Guildo hat euch lieb*' ('Guildo loves you') in 1998, which announced the arrival of German straight camp at the contest. It continued two years later with '*Waddehaddedudeda*' (baby speech for 'What is it that you have there?'), a shiny 1970s retro-performance by Raab. Although more stylish and less excessively funny than Horn's performance – he wasn't climbing up the stage as Horn had in Birmingham – the act worked along similar lines of retro-kitsch. But whereas Horn's grotesquely funny incarnation of the ugly German offered some material for a queering of nationality, the highly heterosexual performance of '*Waddehaddedudeda*', with an Elvis-like, macho Raab and sparsely clad female backing singers, demonstrates clearly that Raab's camp had nothing in common with queer in the sense of destabilizing essentialist notions of gender and sexuality. Soon after, Raab simply left all camp appeal – straight or queer – of Eurovision behind in order to prove his skills as a serious musician. In 2004 he wrote 'Can't wait until tonight', a soulful ballad sung by Max Mutzke, before he became host of the German national final in 2010.

While Hermanns' national ESC selection shows were full of allusions to the campiness of Eurovision, Raab was very cautious about coming across as camp at all. Rather, in his remarks at press conferences and on his own daily TV show, he compared the ESC repeatedly to football, a discipline whose fan culture is stubbornly homophobic, and in which Germany generally performs well internationally. With his rhetoric, Raab tried to mobilize a repressed sense of Germanness, which, especially after the 2006 World Cup was held in Germany, allowed itself to be publicly celebrated again in a carnivalesque fashion, and broke the German taboo of demonstrating national belonging (Warburg, 2010). The 2006 World Cup witnessed a display of the German national flag and its colours in all kinds of variations like never before in postwar Germany; this has become an established phenomenon in German public life and media representation ever since (Figure 9.2). It is no coincidence, then, that in 2010, when leaving the aircraft together with Lena at Hannover Airport after her victory the previous day in Oslo, the first thing that Raab did was wave a German flag (as Lena already had when performing the reprise of her winning song in Oslo).

Although Lena's and Raab's pop-cultural appropriations of nationality were certainly far from the sternness of its officially political or

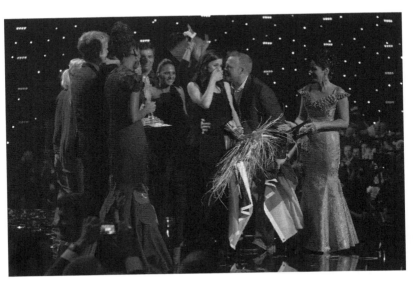

Figure 9.2 Lena accepting the 2010 ESC winner's trophy, with her manager Stefan Raab
Source: Indrek Galetin.

militaristic use, the irony in talking about the German Eurovision entry as a national mission (as Raab had a tendency to do) or in holding a press conference in the Reichstag not so much mocked the significance of national symbols but rather took pop culture as a pretext that allowed the rearticulation of national identity.

It is the very undecidability inherent in irony – whether something is meant seriously or not – that allows for an articulation of a constitutively problematic German nationality, since one can always claim: 'I didn't really mean it.' But in this form of a restricted irony – as opposed to its much more excessive romantic articulation and the de Manian reading of it (de Man, 1996) – the possibility of establishing meaning (i.e. the representation of nationality) must remain intact. In order to defend the signifier of nationality, especially since it had to be camouflaged as ironic, it also at the same time had to be secured with a different strategy. Nationality could only be performed as significant in the realm of entertainment if it was otherwise stabilized, or else the signifier would simply collapse altogether, as in romantic irony. The strategy of referring to nationality ironically, consequently, came at the cost of the queerness of the event. Raab's Eurovision irony mirrors a straight appropriation of the contest.

This took place as a first step by juxtaposing the ESC's tradition of camp with the attempt to promote Raab's protégées as serious. Repeatedly, during the national final to select the German Eurovision entry for 2010, he stressed the artistic ambitions of the German contestants up to the point where the show was criticized for being boring. Secondly, to establish the newly discovered national German interest in the contest as serious, Raab, both in 2010 and 2011, was not shy to publicly dismiss the more campy entries of other countries, as he had already done in previous years. This dismissal, however, was not simply anti-kitsch, as comments on Eurovision quite often are; he decidedly referred to the sexual 'queerness' of the event, in a gesture that naturalizes heterosexuality, by not mentioning it but instead repeatedly pointing out the sexual 'other' in order to establish a hierarchical opposition.

Commenting on the 2010 Bulgarian entry, Raab referred to the group as 'Nero and his cute oil-boys', thus reading homosexuality, homophobically, as paedophile decadence ('TV Total', 2010). In the same show he described the female Serbian winner from 2007, Marija Šerifović, as 'this little, fat Serbian boy', concluding: 'Previously, one had to go to a video store in order to see East European lesbians.' He pointed out Eastern European entries as sexually exotic, and in the case of Serbia denied the female gender to a singer whose stage performance was coded as lesbian. Raab's anti-queer attitude, which made room for homophobic and

sexist jokes, was not simply an individual characteristic but also initiated a new discourse on the ESC in Germany. Matthias Opdenhövel, co-host and Raab's protégé in the German Eurovision TV events in 2010 and 2011, followed in his mentor's footsteps when he expressed half-hearted regret about Dana International's failure to qualify for the 2011 final in Düsseldorf with her song 'Ding Dong'. Without much subtlety he took the song's title as a metaphor for the transsexual's (missing?) phallus: 'Although, honestly, I don't really want to know anything about Dana's Ding Dong' ('TV Total', 2011).

Pop hegemony

Raab's trashing of Eurovision can be read as a strategy of a heterosexualization of the contest that equates the aesthetically questionable with the sexual other, 'the queer', thus mobilizing the original insulting quality of the term to evoke the idea of a 'queer' panopticon in contrast with Lena's artistically serious performance of authentic femininity. But not only that: 'queerness' according to Raab is predominantly understood as being located in Eastern Europe. The trashing of Eurovision as 'queer' takes place as a trashing of Eastern Europe.

To offer another example of this strategy, his previous comments culminated in a remark about Verka Serduchka, the 2007 Ukrainian representative. Raab described the female impersonator Andriy Mykhailovych Danylko (aka Verka) as 'the after-effects of Chernobyl' ('TV Total', 2007). He dismisses a camp cross-dressing performance, which self-consciously plays with moments of European history and combines them in a hybrid disco show, as a freakish monstrosity and as such the result of a nuclear catastrophe. Evoking with his rhetoric the trauma of the meltdown of a nuclear power plant in 1986 also functions as a trope for Western European defencelessness when faced with a threat from Eastern Europe. Moreover, it recalls the final years of the Cold War when still-fixed frontiers between East and West existed. The fall of the Berlin Wall, usually unequivocally understood as the most potent symbol of not just German but European unification and as political progress on the Continent, also provoked a crisis of identity in both Eastern and Western Europe (McAdams, 2010). Germany's dequeering of its entry while simultaneously 'queering' the East was clearly a defence against the Eastern European threat at Eurovision in the national interest, and, moreover, done in the name of Western Europe.

An understanding of the ESC as 'queer' in the sense of failing to fulfil international standards of pop culture defined predominantly by

Anglo-American youth culture has everything to do with a hierarchy between West and East. In comparison with international pop and rock as a Western Anglo-American format, the contest was a 'lesser' form of pop, 'Eastern', and as such, in 'missing' the coolness and hipness attached to pop, it was 'queer'. Eurovision's Eastern pop was Eurotrash.[4]

This aesthetic failure from the perspective of a hegemonic Anglo-American pop history, which understands pop culture as a Western product, of course simultaneously represents the very reason which enabled a subculture around Eurovision that celebrated the so-called culturally mediocre from a perspective of sexual minorities through a gesture of re-evaluation, thus destabilizing any attempt to establish a hierarchy between West and East. Under the condition that Eurovision represented the unprivileged term, it offered itself as a celebration of queerness. Queer culture has a long tradition of turning failure into cultural capital, as Judith Halberstam has recently argued (Halberstam, 2011).

If in this narrative of pop hegemony Eurovision was historically a bad copy of international Anglo-American pop, since the Eastern extension of Eurovision in the 1990s, Eastern European countries have taken the Eurovision formula as a standard for their entries and thus become a copy of the copy or the East of the East,[5] and in so doing they have mirrored back to Western Europe the (from a hegemonic perspective unwelcome) image of Eurovision as a 'queer' spectacle. 'Bad Eastern European entries' (as they are made fun of by Raab), when successful at Eurovision – and thus representative of all of Europe – threaten in this context a Western European identity. Countries such as Germany, which defines itself as Western European, distanced themselves from such affirmation of queer aesthetics and phobically projected 'queerness' back onto Eastern Europe.

For a country like Germany the stakes in this situation seem particularly high. In previous decades Germany used Eurovision as a site to prove how much it belonged to Europe (much as Eastern European countries do now), culminating in Nicole's victory in 1982. Claiming its place in Europe by means of a pop song seemed especially precarious for a country whose popular culture in particular has been instrumentalized by the propaganda machinery of fascism. Eastern Europe's approach to the ESC represents an uncomfortable reminder of Germany's own campaign to be accepted within the European community. Moreover, the issue of finding its place within Europe arose for Germany once again after its reunification in 1990. After all, from the perspective presented by Raab of associating the East with 'queer', a Germany

that reunites former East and West Germany would be at least partly 'queer'. A projection of the 'queer' onto Eastern Europe in this context works towards stabilizing a reunified Germany's position as a non-queer Western European country.[6]

If one reads Lena in the context of the construction of Germany, her performance was in fact a repetition of Nicole's success in 1982 and achieved the same effect: demonstrating a non-aggressive German culture by means of a 'cute' female body, a demonstration whose audience this time included Eastern European countries which had especially suffered from Germany's militaristic and racial violence in the 20th century.

Naturalized femininity

So who is Lena? The construction of her persona by herself, Raab, and by German Eurovision culture can be read as an answer to Germany's precarious status at the ESC. Let's begin by comparing her with more conventional forms of femininity at the contest. She is far from the depth and darkness of the traditional Eurovision diva (Singleton et al., 2007), and she lacks the unapologetic sexual promise of the porno pop diva.[7] This already becomes apparent through her voice: it is the voice of a girl, almost a non-voice, like her non-dancing. When in 2010 the *New Yorker* finally took notice of the ESC for the first time, it ungenerously stated that Lena's dancing was a movement similar to dancing in your own kitchen (Lane, 2010). Her non-voice was much more a direct expression of her teenage sex appeal than any big, trained voice could ever be. It kept the promise of physical proximity, as if she were whispering directly into your ear, or, at least, humming next to you in the kitchen.

Lena's persona fitted into the discursive frame that Raab's take on Eurovision had established by mobilizing the discourse of pop hegemony along the oppositions of quality/trash, authentic/fake, straight/queer, and German/non-German. Her perhaps charming amateurishness was quickly translated into a discourse on authenticity and became linked to issues of both heterosexism and nationalism. The decamping of the ESC in the national interest went hand in hand with a newly discovered heterosexist politics that manifested itself, eventually, in the persona of Lena, whose Lolita-like sex appeal was presented cleverly as the classical mixture of innocence and the sexual market value of a female teenage body. Her sexiness was not openly addressed; rather, she was posited as an alternative to aggressively sexualized representations of femininity at the ESC.

Lena's erotic appeal was immediately translated into an issue of being romantically in love, confirmed by the Norwegian winner of 2009, Alexander Rybak, when he tried to kiss her on stage while handing her the winner's trophy after her victory in Oslo. By means of this shift from sexuality to romance, she could, at the same time, serve as a role model for a new German middle-class youth and its respectability, powerfully presented when Lower Saxony's former minister-president and German federal president, Christian Wulff, welcomed her at Hannover Airport after her victory in Oslo.

The strategies described so far can explain how Raab managed to raise an interest in Eurovision on the national level, by framing Lena's persona as a respectable pop performer for Germany. However, Lena was appreciated not just by a German audience and was not just commercially successful on a national level: she in fact won the contest. How, then, was her appeal translated for an international public?

Princess, *Fräulein*, European girl

Although female stars are generally more successful in the ESC than men, it might not be a coincidence that it takes a teenage girl for Germany to win the contest, as in both cases with 17-year-old Nicole in 1982 and 19-year-old Lena in 2010. For the sexually (supposedly) innocent teenage female body (or, more precisely, its sexual appeal lies in its 'innocence') cannot be read as a personification of German military aggressiveness, the memory of which still shapes the national consciousness of Germany's European neighbours in particular. Rather, she is a princess, maybe a princess undercover like Cinderella, or a teenage Snow White with her pale complexion and super-red lipstick. In some sense, Lena really was the heroine of a fairy tale. This was not just because this theme was already set the previous year, when Rybak won the contest with a song called 'Fairytale', and Lena just had to fill in this narrative frame. It was also because German victories in football (the analogy Raab loves to use for Eurovision) are continually referred to as wonders or fairy tales, events that make the impossible happen – as in Söhnke Wortmann's movie about the 1954 World Cup, entitled '*Das Wunder von Bern*' ('The Wonder of Bern'), or in references to the World Cup 2006, in which Germany finished third, as a '*Sommermärchen*' ('Summer Fairy Tale'). Referring to the successful participation in and celebration of the World Cup as a fairy tale, a story that as a survivor's tale has a guaranteed happy ending, functions here as a reconciliatory narrative for Germany's troubled history: the peaceful, quasi-non-intentional (wonder-like) regaining of a sense of German nationality (Warburg,

2010). Winning the ESC, like winning the World Cup, with this rhetorical strategy, turns into a fairy-tale-like happy ending for Germany. Fashioning Lena as a character from one of the Grimms' Tales marks her to an extent already as German.

If we read Lena beyond the fairy-tale narrative in the context of German post-war femininity, with her 2010 winning song 'Satellite', and her simplistic, almost shabby H&M-style of clothing, she represented not so much a princess as – quite the opposite – an updated version of the image of a post-war *Fräulein*. Historically apt (and for once funny and indeed in the camp tradition of Eurovision), Raab called himself and his team for the show *Unser Star für Oslo* 'The women of the rubble of the Grand Prix', thus referring to the German women who cleaned up the war debris in German cities after the Second World War (Khunkham, 2010). The post-war *Fräulein*, however, is rather the younger sister or daughter of the *Trümmerfrau* ('rubble woman') (which makes Raab himself in relation to Lena indeed the *Trümmerfrau*). She is poor and uncorrupted by German history through age and gender. As a potential reward and bride for allied soldiers, the *Fräulein*, historically, was always already much more cosmopolitan than her male compatriots of the time, who were more directly implicated in Germany's political and militaristic crimes.[8]

In that sense the German *Fräulein* was potentially a European girl who by 'sleeping with the enemy' pointed towards a post-nationalistic future for Germany, one that reached across borders not through militaristic aggressiveness but by means of a position that was passive yet powerfully seductive – like Lena with her Eurovision performance. And this is precisely how the European commentators reacted to Lena's winning performance in Oslo. When giving her the highest scores, the TV presenters announcing the national votes made remarks such as 'lovely Lena' or 'Lena, we love you too' in an affectionate way that ESC winners rarely get to see.

While Lena's performance relied on historically familiar forms of German femininity, it also stressed this staging of straight femininity as a European position. More than being a star, she seemed to be a groupie, as the lyrics of 'Satellite' told us, and thus perhaps the first Eurovision winner who should be understood as an internet phenomenon. There is no categorical difference between Lena and her *YouTube* lookalikes. Her appeal was rather that she could be anybody, anywhere. Europe-wide, this might be the most obvious reason for her success, and although it transcends her construction in the national context, nonetheless her persona as a European girl was enabled precisely because she was

German in a specific way. Consequently, Lena's groupie girl persona for a European audience oscillated seductively between the signifiers German and European.

Lena as *femme fatale*

After Lena's victory in Oslo in 2010, Raab announced quite spontaneously and obviously without consulting ARD officials that Lena would represent Germany at the ESC again the following year. It became clear quite soon after the victory in Oslo that her success could not easily be reproduced – especially since it was precisely Lena's poorly trained 'charming clumsiness' on stage, her 'authenticity', that won her a lot of fans. The 2011 national final was a presentation of all 12 songs of Lena's second CD, 'Good News'. The show suggested that it was presenting an individual Eurovision star.

When the question came up of how to package the song for the purpose of the contest, the proto-sexual Lolita image of 'Satellite' was replaced by a more consciously fashioned femme fatale persona (Figure 9.3). In contrast with the previous year, Raab and his team mobilized and stylized Lena's teenage sex appeal and turned her into Frank

Figure 9.3 Lena performing 'Taken by a Stranger' in the 2011 ESC
Source: Pieter Van der Berghe.

Wedekind's Lulu. The sexual ingredient that had been part of the Lena phenomenon all along was now openly addressed. For her Eurovision performance of 'Taken by a stranger', she decided to dress in long, tight pants, with more perfect makeup, and she presented a more skilled stage performance. She was staged as a somewhat cool, constrained *femme fatale* who represented femininity as a sexual enigma.

The *femme fatale* Lena was a classic case of femininity as a masquerade, as feminist film critics have read Hollywood and pop stars from Marlene Dietrich to Hitchcock's women or Madonna (Mulvey, 2009). The performance also illustrated Butler's concept of gender performativity in an exemplary fashion (1999). Her newly stylized stage persona offered itself more for a camp reading that is invested in the constructedness of gender and sexuality than the Lolita version of Lena from the previous year.

The oppositions governing Raab's discourse of Eurovision as a national project until then had been challenged by his own strategy the second time round. Lena's song willingly gave in to the principles of the masquerade that were more common for the contest, and openly displayed the artificiality of its own construction. In the context of her first performance, which linked authenticity to nationalism, the inauthenticity towards deliberate camp appeared as non-nationalist. In this sense the dazzling style of 'Taken by a stranger' undermined Germany's self-assertion as a Western European nation by means of 'authentic femininity' and pushed it back towards the queer campiness of Eurovision.

Queer Europe?

In the case of the history of the German entries of 2010 and 2011, both performed by Lena, the ESC appears to be not only a site of national self-assertion but also an occasion when the campness of pop continually returns. While the success of Lena's first performance as a German girl groupie shattered my belief in Eurovision's queerness, her second appearance reminded me that there is something indestructibly queer about the contest. With Germany 2010 and 2011 as examples, the contest appears to be conditioned by the dialectic between straight and queer. Both the massive defence against its queer tradition and the involuntary return of it suggest that queerness must be located beyond individual performances and their readings. Where, then, should we locate such a force, and in what ways could we call the contest a queer text (Doty, 1993: xi)?

One of the answers I can offer in the context of this article is, as I have shown, the dependency of Eurovision's queerness on a narrative of pop hegemony. In relation to Anglo-American pop, the contest as a 'bad copy' is constitutively queer, a structural condition that can be repressed, projected onto the 'other', or celebrated as Eurovision's true asset. Many individual performers and performances that we call queer can be related to the ESC's precarious status as a pop event in the context of this narrative.[9] While Lena's first performance, especially in the German national context, can be read as a defence mechanism against Eurovision's queer impact, her second was clearly more affected by it.

I have been using the term 'queer' in this analysis less as an umbrella term for gay, lesbian, and other sexual minorities, but rather as an analytical term that describes non-identitarian politics of representation as, for instance, in camp. As such it represents a reappropriation of its historically pejorative meaning – 'queer' as an insult – which, as I show in this chapter, has been remobilized in various ways by Raab. I finally want to come back now to the question about a queer Europe that I posed at the beginning.

In the context of the ESC it is possible to mobilize queer as a strategic intervention against hegemonic ramifications such as national or Western European self-assertion. This is what Lena's second performance did involuntarily. That is not to say, however, that the contest offers a trajectory for a queer Europe in any unproblematic way. I argued previously that 'Europe' is the name for the failure of individual European national assertions (Rehberg, 2007). In that sense, Europe is indeed queer. But what is the relationship between Europe as the collapse of national self-assertions through camp aesthetics and a social reality we can understand as queer? While queer representations certainly enable queer lifeworlds, they are by no means identical with them. The disjunction between queer representation and queer politics echoes the discussion of the political use of camp about which, for instance, both Andrew Ross and Susan Sontag have been rather sceptical (Ross, 1989; Sontag, 1990). I am less pessimistic about the politics of camp, but how queer aesthetics are able to prepare the change of social lifeworlds is a question one cannot answer *a priori*. In this chapter I have tried to understand the straight backlash against Eurovision primarily as a national project in relation to the queer tradition of the ESC. For the case of Germany in 2010 and 2011, one can say at least this much: the heterosexual agenda promoted by Raab was haunted by the queerness of the Eurovision archive.

Notes

1. Raab solidified this position through his daily TV show, *TV Total*, which paid attention to the ESC in the 2000s like no other programme in Germany. Moreover, in 2005 he started the so-called *Bundesvisionscontest*, a successful TV show which imitated the ESC format at the national level by having the 16 federal states of Germany compete against each other. The *Bundesvisionscontest* did not, however, serve as a national selection for Eurovision. For the 2010 ESC final in Norway, the German public broadcaster ARD cooperated with Raab's employer, the private TV station Pro7, so that Raab could host the national selection. His own company, Brainpool, produced the show for Pro7 and ARD, and was production partner of the German broadcaster NDR for the ESC in Düsseldorf in the following year, and of the Azerbaijan broadcaster Ictimai for the 2012 ESC in Baku.

2. Within the disciplinary context of queer studies the term 'queer' has been the subject of debate and redefined several times. I understand 'queer' here in two different ways: as a descriptive term, which encompasses diverse sexual minorities, and as an analytical term, which challenges essentialist assumptions of heteronormativity. This potential relies on the historical use of 'queer' as an insult, a meaning that Raab repeatedly activated in his comments about Eastern European Eurovision entries (without necessarily using the term 'queer'). That is why I put 'queer' in quotation marks when I speak of Raab's strategies. 'Gay' is sometimes used instead of 'queer' as a descriptive term when it seems empirically more accurate than the more vague umbrella term 'queer'.

3. I use the term 'camp' here to refer to the aesthetic of performances whose camp value can be constructed through either production or reception. However, 'camp' does designate a form of anti-essentialist criticism only when heterosexist notions of sexuality are being shattered.

4. An analysis of the Anglo-American discourse on European pop could support this claim. See, for instance, Anthony Lane's ungenerous article on Eurovision in the *New Yorker* (Lane, 2010).

5. I am focusing here on Raab's application of the construction of the 'East' from a hegemonic perspective. An analysis of Eastern European entries would, of course, show that their adaptation of Western pop formulas is just one possible strategy; another would be, for instance, promoting national folklore, or combining the two.

6. Historian Dagmar Herzog discusses how after 1989 relations between East and West Germany were represented in terms of sexual hierarchy (Herzog, 2010).

7. With 'porno pop diva' I refer to a sexualized stage performance by a female star, which has been popularized mainly by American female singers since the 1980s. Initially, this strategy was celebrated by feminists as sexual self-assertion and girl power – for instance, in the case of early Madonna. In the course of the 1990s, however, such highly sexualized performance of femininity in pop seemed to have collapsed again into traditional forms of objectifying the female body (Metelmann, 2005). The political status of porno pop is thus ambivalent and its application in the context of Eurovision complicated and contradictory. As far as I can see, it started with the harem-style performance of Turkish singer Sertab Erener in 2003, followed by Ruslana,

Helena Paparizou, Safura and others in the 2000s. While this display of feminine sexuality from Eastern, Southern Eastern European, or Asian countries appears as a copy of the sexual aggressiveness of US pop in particular (Britney Spears, Rihanna, Lady Gaga), it combines this formula in various ways with regional folklore and mythology specific to Eastern and Southern Europe and the Middle East. The question is whether these entries offer themselves simply as an objectification of the female body or whether they self-consciously play with this history. In the context of this chapter I am using porno pop not as moral or political but simply as a descriptive term that designates the display of sexual aggressiveness. For a critical discussion of, for instance, Turkey's 'Auto-Orientalism', see Gumpert (2007).
8. An internationally well-known example of this kind of narrative is Rainer Werner Fassbinder's *The Marriage of Maria Braun* from 1979 with Hanna Schygulla as the pragmatic post-war heroine.
9. This question needs further exploration to understand Eurovision's queer potential structurally beyond individual phenomena. I would, for instance, also agree with Alexander Doty's psychoanalytically informed reading of pop culture and apply it to Eurovision: queerness in pop understood as a manifestation of fantasies is always already there. His psychoanalytical understanding of pop could therefore be another useful tool to deconstruct the Anglo-American pop hegemony (see Doty, 1993: xiii).

10

Sing for Democracy: Human Rights and Sexuality Discourse in the Eurovision Song Contest

Milija Gluhovic

In the run up to the 2012 Eurovision Song Contest (ESC) finale in Baku, Berlin's *Tageszeitung* published an article entitled '*Galaxie des Eurokitsch*' by Vladimir Arsenijević, a Serbian novelist and columnist. Later translated into Serbian as 'Godzilla vs. King Kong', the article offers a number of critical parallels between Serbia and Azerbaijan: both have won the contest and gained the right to host it; both are former socialist countries in search of a new, modern identity; both have corrupt political elites; and both have shown a significant disregard for basic human rights and are deeply homophobic societies. Arsenijević portrays the ESC as an 'anti-European festival' of the worst kind of music, a 'hysterical competition that stirs the most basic instincts in the peoples of Europe'. He notes that as the contest's popularity grows exponentially as we move from the putative 'centre' of Europe towards its margins, what we call 'European values' fade unavoidably, and he stresses that this 'grand-parade of all kinds of European trash by all means does not belong to "European values"'. He also mentions the contest's popularity with gay audiences, recalling a 'veritable invasion of gays from all Europe' when Belgrade hosted the event in May 2008. While during the ESC in Belgrade no significant acts of violence against lesbian, gay, bisexual, and transgender (LGBT) people were recorded, giving an impression that the city may not be as homophobic as reputed, he recalls that only a year later, the Belgrade Gay Pride parade had to be cancelled for security reasons. And while some argued that Azerbaijan should not be allowed to host the event because of its poor human rights record, Arsenijević argued that Serbia is no better than this south-Caucasian country. If Serbia was allowed to host the contest, he continued, so

should Azerbaijan, concluding that what we were bound to witness in Baku in May 2012 was an 'encounter between two equal monsters, just from two different climates, something like an encounter between Godzilla and King Kong' (Arsenijević, 2012; my translation).

The newspaper article invokes some of the key issues that concern me in this chapter: the discourse about human rights – especially LGBT rights – that accompanied the ESC in Belgrade and grew exponentially in the run-up to Eurovision in Baku; the discourse on 'sexual democracy' that became enmeshed with extending Western values abroad; the ways in which 'the question of sexuality became a boundary marker' between sexual democracies in the West of Europe and its Eastern 'others' (Graff, 2010: 584), such as Serbia and Azerbaijan; and (good intentions notwithstanding) alignments between (white) queerness and normative nationalist and imperial interests. After elaborating on some of the key notions important for my analysis, such as 'sexual democracy' and 'homonationalism', I address briefly the popular appeal of the ESC for gay audiences in order to examine the highly charged discourse on human rights, and LGBT rights in particular, that enveloped the ESC contest in Baku as never before in the history of this festival of popular European music. Focussing in particular (but not exclusively) on the ESC in Baku, I examine the complex ways in which national and sexual identities are acted out, reconfigured and re-evaluated in this cultural performance involving the European Broadcasting Union and national organizers, participants, the media, police, local and national politicians, and international activists. Along the way I question some assumptions voiced by the media (but sometimes also by human rights activists and politicians) about homophobia as an intrinsic feature of certain geographies – the kinds of assumption that in turn may lead to all kinds of instrumentalization.[1] In trying to chart relations between sex, race, nationality, and ethnicity, the frameworks for discussing them, and the ESC, I traverse a range of discourses such as media reports, human rights reports, press releases, and political resolutions. Ultimately I argue that this European cultural performance can serve as a productive locus of tension over gender/sexuality versus cultural/religious identity in the service of a more progressive image of Europe.

According to Éric Fassin, the so-called clash of civilisations, which marked the geopolitical landscape of the 1990s, has evolved into a 'sexual clash of civilisations' in which gender and sexual politics matter in crucial ways (2010: 509). To this French sociologist, today 'we are witnessing a racialisation of the rhetoric of sexual democracy', which is employed 'not as an instrument to question the normative foundations

of the sexual order, but rather as a weapon to stigmatize "undemocratic" others in the name of sexual modernity' (2011: 8–9). Fassin shows how the language of gender equality and freedom can function today as a marker that distinguishes so-called advanced Western democracies in opposition to their 'others', in particular the Islamic 'other', and become instrumentalized in the current Euro-American nationalist and imperial projects. He posits that the rejection of the European Union (EU) Constitutional Treaty in both France and the Netherlands in 2005 led to a 'reformulation of the European project, from a supranational federal ideal to a federation of nationalist ideologies', whereby immigration became 'the new, negative cement of Europe' (2010: 515). In a French context, writes Fassin, 'Sexual democracy – or at least the rhetoric of sexual democracy – may thus be the price that many conservatives are willing to pay so as to provide a modern justification to anti-immigration politics that could otherwise appear merely as reactionary xenophobia' (2010: 513). Here, as well as in many other Western European countries, a new sexual nationalism appeared in controversies about the Islamic veil, polygamy, forced marriage, sexual violence, and virginity. In the Netherlands – the country that first opened up marriage to same-sex couples in 2001 – as well as in much of Western Europe, the rhetoric of sexual democracy, in the form of LGBT rights and freedoms, is increasingly taken up by both liberal and conservative forces as a sign of modern civility against the other's allegedly backward culture (see e.g. Butler, 2009). Some have argued that gay marriage reform in Europe is 'less about gay rights and more about codifying an ideal of European values' against Islam and various Third-World 'Others' (Roy, 2005). This racialization of progressive sexual politics and its role in the process of cultural othering (whether in the Middle East or within Europe) comes not only from far-right political parties, such as the Belgian Flemish Interest (*Vlaamse Belang*), the Dutch Party for Freedom (*Partij voor de Vrijheid*), and the British National Party, but also from local grass-roots LGBT organizers, such as the British group OutRage!, as we shall see later.[2]

By contrast with Europe, in the US the racialized rhetoric of sexual democracy is pushed to the forefront in relation to the war on terror in order to bring legitimacy to military operations abroad. Addressing this phenomenon in her award-winning book *Terrorist Assemblages*, Jasbir Puar explores the effects and implications of the '*convivial* relations' between a new form of 'homonormativity' that has emerged in liberal-capitalist societies (but especially the US) and racialized, militant nationalism, a configuration that she calls 'homonationalism' (2007:

xiv). Puar defines homonationalism as a form of sexual normalization that accepts particular forms of homosexuality in order to continue the project of US imperial expansion: 'this brand of homosexuality operates as a regulatory script not only of normative gayness, queerness, or homosexuality, but also of racial and national norms that reinforce these subjects' (ibid.: 2). Exploring the allegiances between contemporary queer politics and racism, empire, and the war on terror, Puar draws our attention to the imperialist and patriotic discourses in LGBT campaigns. She suggests that by supporting or enabling interpretations of developing and Muslim nations as homophobic in orientalizing ways, in tandem with conservative anti-Muslim rhetoric that infuses Western foreign policy, these campaigns may contribute to national neo-imperialist projects. For instance, she starts her book by examining the work of the UK's premier queer human rights organization, OutRage!, which has profiled the treatment of gays in Islamic states and has helped to sensationalize the execution of two Iranian teenagers in July 2005 after they had been convicted of raping a 13-year-old boy.[3] According to Puar, campaigns like this have facilitated the demonization of Middle Eastern cultures and the proliferation of Orientalist narratives about their sexual backwardness, which, under the pretext of saving the lives of the victims of such savagery, justify Western states' lawless interventions. As we shall soon see, her acute observations bear directly upon some human rights and LBGT rights campaigns that accompanied recent ESC events.

To be sure, these justifications have a history. In her important article entitled 'Can the Subaltern Speak', Gayatri Spivak demonstrates how British imperialism was justified in the following terms: 'white men saving brown women from brown men' (1988: 297). More recently, as many commentators have noted, the need to liberate Muslim and Arab women from their misogynist cultural backgrounds and religious traditions has been central to establishing the moral grounds for the war on terror (see e.g. Abu-Lughod, 2002). And while the 'saving gays' narratives that inform civilizational modes of gay politics today are a relatively new phenomenon, this does not mean that discourses on homosexuality were absent from 19th- and 20th-century European colonial discourse. Rather, as Sarah Bracke aptly puts it, 'homosexuality has switched sides in the familiar dichotomy: from a sign of uncivilisation, homosexuality or at least the "tolerance" and "acceptance" of (certain modes of) it, has become a marker of civilization' (2012: 249). President Obama's foreign policies, which increasingly rely on his rhetorical commitment to international human rights agendas, represent a case in point. He recently

stated that 'The struggle to end discrimination against LGBT persons is a global challenge, and one that is central to the United States' commitment to promoting human rights', while in a speech given in Geneva in 2011 on the occasion of the celebration of Human Rights Day, the US secretary of state, Hilary Clinton, declared that securing the human rights of LGBT people 'is now one of the remaining human rights challenges of our time' (qtd. in Sabsay, 2012: 609). We should remain wary of an uncritical acceptance of this language of freedom, including sexual freedom, considering the paradox that human rights and humanitarianism can be seen to operate as tools and strategies of contemporary imperialism (see Douzinas, 2007; Sabsay, 2012).

Some influential scholars, such as Joseph Massad, simply dismiss such struggles and concerns as Western neo-imperialist impositions that have very little (or nothing) to do with realities in the Middle East, North Africa, and some other parts of the world. His argument requires a short detour in order to understand it, which is all the more necessary because it encapsulates well the kind of claim that are readily co-opted by a right-wing strategy for discrediting LGBT activism. In his recent study *Desiring Arabs*, Massad describes how hegemonic colonial cultural discourses on putatively Muslim and Arab sexual mores and practices came to shape writings on sex and sexuality by Arab scholars from the end of the 19th century to the early 21st century. At the same time, he takes account of sexual practices and identities from medieval Arab texts to map changes in Arab sexual attitudes that came about as a result of colonialism and cultural imperialism.[4] As Frances Hasso aptly puts it, 'Massad contends that western accounts since the nineteenth century have invested sexual subjectivities and practices with cultural and civilisational value along an evolutionary schema within larger colonial and imperialist contexts that constitute the West as advanced and modernized and the East as backward and undeveloped' (2011: 652). In one of his chapters he focusses on an array of international organizations and gay activist groups, such as the International Lesbian and Gay Association (ILGA), the International Gay and Lesbian Human Rights Commission, Human Rights Watch and Amnesty International, which he heuristically labels the Gay International, arguing that they advocate a human rights agenda based on Western social/cultural norms that often reproduce Orientalist missionary impulses seeking to homogenize the world in the image of the West. Denying the existence of Arabs who identify as homosexuals, he contends that Arab sexuality is organized along radically different logic than the Western identitarian model. According to him, 'it is the very

discourse of the Gay International, which both produces homosexuals, as well as gays and lesbians, where they do not exist, and represses same-sex desires and practices that refuse to be assimilated into its sexual epistemology' (2007: 162–163). Reducing queer politics to Western imperialism, Massad argues that Arab anti-colonial nationalists and Islamists are correct in perceiving such campaigns 'as part of Western encroachment on Arab and Muslim cultures' (ibid.: 175). He blames the increased repression of homosexuality in the Arab world, including the criminalization of homosexual sociality, on internationally hegemonic gay organizations' politics of citizenship rights and their insistence on a universalist identity on the bases of gayness (ibid.: 188–189).

As Hasso asserts, Massad is right in pointing out how 'campaigns to save others become mechanisms through which a range of violent and subordinating projects are legitimated' (2011: 65). Scholars such as Puar (2007, 2011) have shown, for instance, how Western gay activists sometimes erase indigenous voices and political agency, and how a particular version of LGBT identity is equated with democracy and justice in human rights discourse (Waites, 2009; Rahman, 2010). Yet these and other scholars also show that 'a multivalent conversation between East and West, North and South … cannot be reduced to mere influence or importation of Western science and social attitudes' (Deeb and Al Kassim, 2011: 2). Furthermore, as Samar Habib observes, while it is important to recognize the diversity of culturally specific sexual practices and to challenge the hegemony of a Western mode of understanding the sexual subject, 'it is deleterious to deny the existence of exclusive and near-exclusive homosexual proclivities in the Muslim world and to dismiss individuals identifying this way as Westernised people' (2010: lvii). What is more, argues Habib, the critiques that challenge the homogenizing attempts of Western universalisms often overlook 'the very real struggles of homosexual people in the Arab world (regardless of whether such a term is universally identified with, these individuals are in the least aware of their inherent difference and exclusion from the socially sanctified sexual currencies or marriage and children)' (ibid.: xiii). While it is, of course, true that some versions of queer politics have become complicit with the current Euro-American nationalist and imperial projects, it is also true that persons of non-normative genders and sexualities in countries such as Malaysia, Nigeria, Iran, and Saudi Arabia live in a constant and very clear danger. 'We cannot ignore the plight of these individuals for the sake of theoretical convenience or simply because we seek to launch a justified criticism of the Western propaganda machine that denigrates

Muslim nations as inferior and civilised' (ibid.: xxv). Finally, these scholars argue that queer politics should not be identified with the West, and a wide array of emancipatory impulses, tactics, and modalities of sexual dissent in non-Western societies could not be read as assimilating to the West, as Massad would have it. As Sara Ahmed puts it cogently – referencing Massad's book – 'Just as we should not make Muslim "foreign" to queer, we also should not make queer "foreign" to Muslim: either strategy makes Muslims who identify as queer into foreigners' (2011: 131).

Therefore, contra Massad, I would argue that the 'Western' model of sexual modernity and the sexual conservatism of Azerbaijan, as well as those of countries such as Serbia and Russia (whose societal attitudes toward gays and lesbians recently came under scrutiny in conjunction with their roles as the host countries for the ESC in 2008 and 2009, respectively), need to be understood as engaged in a dynamic relation to each other, and that this dynamism has significant implications for how we think about LGBT politics. I also contend that in recent years the ESC has offered an arena for advancing demands for the recognition and social inclusion of LGBT people in Europe, especially countries such as Serbia, Russia, and Azerbaijan, where the position of these sexual minorities remains precarious. (I will also show briefly how the ESC in Baku served as a springboard for local and foreign non-governmental organizations (NGOs) to challenge forms of state-authored domination and control, and human rights violations in Azerbaijan.)

Recent scholarship has already addressed the increased visibility of queer culture at the ESC, such as openly gay and transgendered performers, self-consciously camp entries, and the contest's strong following among gay audiences. Mikko Tuhkanen even goes so far as to argue that 'the song contest, at least since the 1970s, has implicitly but undeniably constituted an annual gay event unchallenged in its scope and significance' (2007: 8). According to Peter Rehberg, it has been so popular among gay audiences, particularly gay men, that 'Eurovision fandom has in itself been read as a metonymical secret code for being gay, much like one's excitement for opera or Hollywood melodrama in pre-Stonewall times' (2007: 60; see also Singleton et al., 2007). In Rehberg's view, the celebration of queerness at the ESC does not necessarily transcend traditional national distinctions; rather, 'Eurovision provides a rare occasion for simultaneously celebrating both queerness and national identity' (2007: 60). Analysing the performances of Israel's Dana International, Finland's Lordi, and Ukraine's Verka Serduchka, he

shows how 'nationality is produced in an unconventional way by being camped up' on ESC stages (ibid.: 63).

While Rehberg employs camp as the primary critical tool to analyse the contest's queerness in relation to the separate nation states comprising Europe, Robert Tobin examines the ESC as the potential site where European cultural citizenship and belonging can be claimed. He argues that the ESC embodies and expresses a unique 'model of European citizenship that is particularly amenable to the needs that are present in queer populations and communities' (2007: 25). According to him, the efforts made by European institutions such as the European Parliament and the European Court of Human Rights to advocate for the rights of sexual minorities and to challenge discriminating legislations in the EU member states have turned Europeanness into a form of identification particularly attractive for queer people. He further observes that upholding the rights of sexual minorities has become one of the touchstones of the European supranational consensus in the 1990s, which has also had a direct bearing on the ESC. Like many scholars and journalists before him, Tobin also recognizes the celebrity and gay icon status of Dana International, a transgendered performer from Israel who won the contest in 1998, showing how her ESC appearance came to 'assert Israel's membership in the sexually liberal West' (ibid.: 33). This and a few other examples lead Tobin to conclude that the ESC offers a model of queer European citizenship, and that through its reliance on camp aesthetics, the contest also 'allows performers and fans alike simultaneously to claim and disavow regional, national, and continental identities', enabling them to 'to maintain a sense of cultural identity while critiquing essentialism' (ibid.: 34).[5]

While I appreciate the affirmative bent of Tobin's argument, I would like to expand on his, and other critics', reading of Dana International's victory in light of the complex relations between sexual politics and national politics in Israel, which will also offer a segue into my discussion of the ESC in Baku and the LGBT human rights discourse and controversy that marked the 2012 contest so visibly (Figure 10.1). In her essay 'Viva la Diva: Post Zionism and Gay Rights', Alisa Solomon examines Dana International's victory against the backdrop of the nationalization of the discourse of gay rights and the assimilation of the gay rights movement in Israel. Commenting on how the advancement of gay rights for Israelis has resulted in rivalries and divisions between orthodox and secular Israeli Jews, she states: 'in today's Israeli culture war, queerness – or at least the tolerance of queerness – has acquired

Figure 10.1 1998 ESC winner Dana International

a new rhetorical value for mainstream Zionism: standing against the imposition of fundamentalist religious law, it has come to stand for democratic liberalism' (2004: 636). To Solomon, Dana International's emergence as the queer symbol of the liberal Israeli state 'throws light upon the way in which Zionism redeploys queerness as a trope precisely at a moment when the meaning of Zionism is being vigorously contested' (ibid.: 151). However, as Amal Amireh notes, despite these divisions inside Israel, 'the positive rhetorical function of queerness... goes beyond those internal cultural wars (between secular Jews and religious Jews) into the wider culture war between Israelis and Palestinians, where it functions to consolidate a fractured Zionist consensus' (2010: 637).

Amireh's essay illuminates the complex ways in which queerness and nationalism are entangled in the Middle East, especially in the context of the Palestine–Israel conflict. Elaborating on some of these entanglements, Gil Hochberg argues that in the Palestinian context, 'Palestinians who self-identify as queer (or gay or homosexual) are often seen as Arabs who have given up their Arabness in favour of queerness and who by the same token become less Palestinian and more Western or Israeli' (2010: 507–508). This association of homosexuality with national and cultural betrayal facilitates the perception of gays as

threats to national security, which results 'in devastating consequences for Palestinian LGBTQ, including social isolation, physical threats, and in extreme cases even death' (ibid.: 508).[6] On the other hand, Israel's co-optation of gay rights for nationalist purposes has been criticized extensively in Israel and internationally. In order to redirect focus away from critiques of its repressive actions towards and discrimination against Palestinians in the West Bank and Gaza, Israel has attempted to utilize its relative 'gay-friendly' status (when compared with neighbouring countries) as an example of its commitment to sexual equality and 'Western' and 'European' values. Puar, for instance, has offered a critique of Israel's public relations campaigns, such as 'Brand Israel', that work to establish Israel's reputation within the US and Europe as a modern, progressive, tolerant, and democratic state, while decrying the ruthlessness of legislated homophobia in the Islamic countries that surround it in the Middle East. According to her, while consolidating a positive, democratic image of Israel, this so-called practice of 'pinkwashing' simultaneously denies 'Israeli homophobic oppression of its own gays and lesbians' as well as 'the impact of colonial occupation on the degradation and containment of Palestinian cultural norms and values' (2011: 138).[7]

Dana International's Eurovision success and its use in various PR campaigns to improve the international image of Israel have been effectively emulated by former communist countries. Recognizing that the ESC has 'become a discursive tool in the definitions of Europeanness and political strategies of Europeanisation' (Bolin, 2006: 191), countries such as Estonia, Ukraine, and, most recently, Azerbaijan have mobilized significant resources to win and then host the contest, and to use the competition as a vehicle to construct and represent themselves to the rest of Europe and the world. And while the Azerbaijani government was keen to use the competition to portray the country as a modern, secular, multicultural state and raise its international image, international human rights groups and local civil society activists hoped that the song contest would help to focus worldwide attention on human rights abuses there. In fact, as soon as the country earned the right to host the contest by winning the 2011 competition in Düsseldorf, the international media and human rights organizations started reporting on alleged abuses by President Aliyev's regime (Figure 10.2). Two days after singers Eldar Gasimov and Nigar Jamal, who form the act Ell & Nikki, won the contest in Düsseldorf, *Pink News*, Europe's largest gay news service, reported that 'broadcasters, fans and human rights groups are concerned that the country's record on gay rights makes it

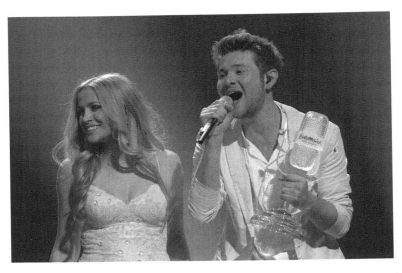

Figure 10.2 2011 ESC winners Ell & Nikki (Eldar Gasimov and Nigar Jamal) perform the winners' reprise of 'Running Scared'
Source: Alain Douit.

deeply unsuitable to hold the contest' (Geen, 2011). The most prominent OutRage! member, Peter Tatchell, also immediately issued a public statement about human rights abuses in Azerbaijan, declaring that the country 'is not a welcoming or safe country for LGBT people', insisting that the EBU 'must seek guarantees from the Azerbaijani government that it will respect human rights, that visitors to next year's competition will not be victimised and that domestic and foreign media covering the event will be able to report freely, without harassment' (2011). He accused the EBU of colluding with the government of Azerbaijan in instrumentalizing Eurovision to 'project a modern, liberal image to the outside world' (2012), while urging ESC contestants 'to stand up against President Aliyev and his dictatorial regime in Azerbaijan' (qtd. in Spencer, 2012).

While space here prevents an extensive commentary on the current sociopolitical situation in Azerbaijan, I will make a brief excursus into this area in order to provide some necessary contextualization for my discussion of the ESC in Baku. As postcolonial scholar Walter Mignolo observes, until the collapse of the Soviet Union the Central Asian states – Kazakhstan, the Kyrgyz Republic, Tajikistan, Turkmenistan, and Uzbekistan – were 'marginal to the Western map tracing the march of

history', and have only gained visibility in the West in the context of the post-1989 international order and the ongoing war on terror, thanks to their vast oil reserves, vital for the energy-intensive economies of the West (2006: 283, 295). This could also be said of Azerbaijan, although, like Georgia and Armenia (the other two South Caucasian countries), the country distinguishes itself from Central Asian states by its European identities and aspirations. Azerbaijan gained its independence from the Soviet Union in 1991, and since then it has received much international attention because of its strategic position as an exporter of hydrocarbon resources and as 'a potential hub for energy trade between Central Asia and Western Europe, the US and Turkey' (Fischer, 2012: 38). The war with Armenia that broke out in 1991 over Azerbaijan's autonomous region of Nagorno-Karabakh, which ended with an uneasy armistice in 1994, aided the return to power of the Soviet-era leader Heydar Aliyev, who transferred his power to his son, Ilham, in 2003. Over the following decade, this new leader consolidated an authoritarian political system with strong democratic flaws. Multinational oil companies which started operating in Azerbaijan from the early 1990s brought investments which, combined with oil revenues, only strengthened his position.

According to Mary Kaldor, professor of global governance at the London School of Economics, material conditions for most Azeris are much worse than in communist times: 'inequality, increases in mortality, unemployment, and lack of public services are all visible aspects of everyday life' in Azerbaijan (2007: 166). Discussing the country alongside Armenia, however, Kaldor asserts that the regimes in these two countries 'are not totalitarian', and even though 'governments, ruling parties, and security services try to control all aspects of social life, increased openness, international liberalisation and outside pressure for democratisation, mean that NGOs, independent media and critical intellectuals survive, albeit precariously' (ibid.: 166). However, Azerbaijan's status as a resource exporter to the West means that the country attracts much international attention and is sensitive to international opinion. Thus, as Kaldor argues, 'the behaviour of outside players – states, companies and international organisations – can influence the evolution of Azerbaijan's internal development' (ibid.: 171). The country is embedded in a highly complex regional environment, where Russia and the US play key roles, while Iran and Turkey are also significant players. International institutions like the International Monetary Fund, the World Bank, and the United Nations Development Programme, and political/security institutions such as the Organization

for Security and Co-operation in Europe (OSCE), the EU, the Council of Europe, and NATO also play important roles. According to Kaldor, political institutions in particular could 'act as surrogates for democracy – a way of counter-balancing and putting pressure on the ruling circles' and, through their links with the nascent civil society, 'offer an alternative mechanism for accountability' (ibid.: 176).

However, the problem is that international institutions such as the EU have been very weak. EU policies such as the European Neighbourhood Policy and the Eastern Partnership have not been very successful in influencing the consolidation of democracy, the rule of law, human rights, and the market economy in Azerbaijan and other neighbours in the post-Soviet space. Some critics argue that the EU uses these values 'to gloss over its geostrategic and geo-economic interests' in this geographical region (Fischer, 2012: 39; Engel-Di Mauro, 2006), while others point out how some of the recent activities of international organizations have had a detrimental effect on the public perception of them in Azerbaijan. Leila Alieva, director of the Centre for National and International Studies in Baku, notes that the EU's weak reaction to the strongly flawed presidential elections in 2003 and 2005, and the referendum on lifting the two-term limit on the presidential mandate, which caused much concern and protest from the opposition and civil society in the country, 'were all seen as compromise positions for the sake of the energy agenda' (2009: 54). The OSCE's attempts to find a solution for the unresolved dispute with Armenia over Nagorno-Karabakh and to encourage democratization have also been flawed and had a negative impact on the public perception of this organization in Azerbaijan. Furthermore, the country's rich oil revenues mean that it is not in much need of EU funds, which 'weaken[s] the conditionality of the EU's financial instruments' (ibid.). Ruling elites can use their resource-derived wealth to weaken opposition ranks, suppress public unrest, 'buy off social and political support in the country, and strengthen political patronage' (ibid.). Finally, Azerbaijan's large petrochemical deposits present a temptation for the EU 'to reduce or replace real cooperation with the country with self-interest based relations at the level of bureaucracies and ruling elites' (ibid.: 54–55).

In the run-up to and during the ESC, the most vocal criticism of Azerbaijan's democratization record came from Germany, whose TV stations and newspapers reported extensively on human rights abuses in Azerbaijan. In May 2012, *Spiegel Online* reported that the country 'is rife with corruption and comparisons to European feudalism in the Middle Ages are hardly a stretch' (2012b). The same paper also

related that 'homophobia is rampant in Azerbaijan, where many people consider the word "gay" to be an insult and the government uses accusations of homosexuality to discredit members of the opposition, regardless of their sexuality' (Langer, 2012). Reporting for Radio Free Europe (RFE), Daisy Sindelar argued that the social stigma attached to homosexuality in Azerbaijan comes from 'a conservative mix of Muslim faith and Soviet-style squeamishness', adding that 'discrimination and harassment remain day-to-day facts of life for many members of Azerbaijan's gay community, who have no legal protection and almost no representation in civil society' (2012).

While European and US politicians are often muted in their criticism of Azerbaijan's human rights violations and democratic deficiencies – not least because their countries are partly dependent on Azerbaijan for their energy needs – German government officials joined journalists offering pointed criticism of the Aliyev administration. Ahead of his visit to the Caucasus region in March 2012, German foreign minister Guido Westerwelle endorsed the idea of using Eurovision to put pressure on Azerbaijan to democratize: 'We should use these events to create a critical public forum in order to talk to people and promote our democratic values' (qtd. in *Spiegel Online*, 2012a). (However, as *Azernews* reports, these human rights concerns did not stop the German politician from concluding his visit to Azerbaijan by signing 'a memorandum on establishing an Azerbaijani-German chamber of commerce and industry' (2012a)).

The ESC in Baku not only put Azerbaijan's authoritarian government and its human rights record under the international spotlight but also drew attention to EU relations with Azerbaijan. Until this point the EU countries seemed more concerned about their energy interests and security in Azerbaijan than human rights violations in the country. Seemingly putting democracy back at the heart of the EU's relationship with Baku, on 24 May 2012 the European Parliament issued a resolution on the human rights situation in Azerbaijan, strongly condemning recent breaches and violations of the principles of democracy, freedom of speech, and the rule of law in Azerbaijan. In its press release, it stated that Azerbaijan's hosting of the contest 'should be an opportunity for it to show its commitment to democracy and human rights'. The resolution cites reported incidents involving attacks, harassment, and intimidation of journalists, calling on the Azerbaijani authorities to guarantee media freedom, stop suppressing freedom of expression and assembly, and bring its legislation in these areas into line with international standards. The resolution also criticized forced evictions, and

the expropriation and demolition of properties in Baku, in the name of development projects partly linked to Eurovision, and showed support for the promoters of Sing for Democracy – a human rights campaign launched ahead of the ESC – hoping that 'their action can contribute to bringing about the indispensable democratic reforms and a substantial improvement of the human rights situation in the country' (2012: 4).[8]

The EU resolution was at least in part a result of active lobbying by human rights activists in Azerbaijan, who after Ell & Nikki's victory in Düsseldorf quickly realized that the following year's competition in Baku could provide an excellent platform for raising awareness about the democratic challenges that the country faces and could serve as a catalyst for Europe to change its relationship with Baku. Sing for Democracy was launched by several human rights organizations based in Baku, including the Alliance for Defence of Political Freedoms (ADPF), the Institute for Peace and Democracy (IPD), the Institute for Reporters' Freedom and Safety (IRFS), and the Human Rights Club (HRC), and it was funded by the US-based National Endowment for Democracy. In mid-May, just as the international press corps was arriving in Baku, the campaign held an international conference on human rights in Azerbaijan, addressing issues such as freedom of expression, journalists' safety, transparency of broadcasting, economic and political freedoms, legal and political restrictions on sociopolitical activities, and local and international mechanisms for human rights protection. I attended a number of the events that the campaign organized during Eurovision week, including a press conference on 22 May for international journalists, where the campaign leaders presented their democratic platform and called for the immediate release of political prisoners, freedom of expression and assembly, protection of property rights, and the independence of courts. Earlier that week Rasul Jafarov of the HRC, Emin Huseynov of the IRFS, and other campaigners had met, at her instigation, with Loreen, the singer representing Sweden at the contest (and its eventual winner), in the offices of the IRFS, where they briefed her about human rights violations in Azerbaijan. The event took place with the support of the Swedish Civil Rights Defenders organization and the Norwegian Human Rights House foundation, and it was widely covered by the media. Although many in Europe hoped that the Eurovision spotlight would prompt the government in Baku to moderate its actions in order to avoid negative publicity, and the stakes for Azerbaijan in hosting the ESC were high, the regime did not always react to the international attention and pressures with demonstrative openness and ease. For instance, Sing for Democracy campaigners planned to organize a

large music festival in an outdoor public setting, but in the end they could only hold a much smaller event in a bar. While a protest march they organized on 23 May unfolded peacefully, other opposition rallies on 21, 24, and 25 May were broken up violently, and many protestors were assaulted and detained by the police. Witnessed by local residents, tourists, and journalists, these arrests did little to suggest that the government might be loosening its grip in the wake of the Arab Spring.[9] While Azerbaijan wanted to look its best and to show that it is a part of Europe (the fact that it hosted the contest suggested this proximity), this was a strong indicator that for the Azerbaijani government it was more important to make a tough impression on audiences in the domestic arena than to impress those abroad.

LGBT activists in Azerbaijan did not take part in the Sing for Democracy campaign, and the precarious situation in which LGBT men and women in Azerbaijan find themselves was not addressed at any of the campaign's events. Rather, in response to foreign journalists' frenzied fixation on homophobia in Azerbaijan, Gender and Development, the only NGO in Azerbaijan dealing with LGBT issues in the country, issued a statement on 22 May 2012 by which they intended to counteract what they saw as largely inaccurate international press coverage about the predicament of the LGBT community in the country. After reminding the foreign press that a law which required prosecution of homosexuality in Azerbaijan was abolished in 2001, which, they claimed, has allowed the LGBT community to lead a more active public life, the statement enumerated some of the main initiatives that the activists from this NGO have carried out in the country in the last few years. In partnerships with other NGOs, they have provided legal, medical, and psychological support to LGBT communities in the country and have collaborated with the Ministry of Health and the State AIDS centre on HIV AIDS prevention. In an article published by *News.Az* several months ahead of the competition, the chairman of Gender and Development, Kamran Rzayev, stated that discrimination against gay people is not very common and that there are no recorded cases of discrimination at work or physical violence against LGBT persons in Azerbaijan. He dismissed rumours that a Gay Pride parade would take place in Baku during Eurovision, stating that 'Neither our community nor majority representatives of the sexual minorities in Azerbaijan are ready for it (*News.Az*, 2012). The article also cites Ruslan Balukhin, the creator in 2011 of *gay.az*, the first gay website in Azerbaijan, and Rauf Mardiyev, the general secretary of the IRELI Public Union, the country's major youth organization, both of whom state that Azeri society is

tolerant towards sexual minorities. In an interview I conducted, Rzayev and Bagirov both insisted that Azeri society is very tolerant towards gays, much more than any of the former Soviet republics in the region.

In the press statement issued on 22 May, Gender and Development also provided web links to video interviews with public figures and human rights activists concerning LGBT rights in Azerbaijan – clearly with the objective of informing the foreign press about the extent to which homosexuality is tolerated in the country. By and large, the persons interviewed suggest that homosexuality in Azerbaijan may be accommodated as long as it stays out of sight. That is, they suggest that, like many individuals with non-normative sexuality living in the Arab-Muslim world, Azeri homosexuals are to live in a culturally unique closet in which homosexuality may be accommodated if it does not obstruct the standard obligations of marriage and reproduction. However, none of the interviewees offered a serious consideration of further enfranchisement of gays and lesbians in public domains or advocated the implementation of new juridical frames that would recognize sexual diversity and include gendered and sexual 'others' in citizenship.

The Gender and Development activists were right to point out that in the run-up to and during the ESC in Baku, the Western media focussed largely on the persecution of homosexuality in Azerbaijan and that some of this coverage was clearly Islamophobic and tainted with a racial and colonialist undertone. It is also true that Azerbaijan is relatively gay friendly when compared with neighbouring states such as Iran and that gay rights in Azerbaijan should be understood in all their complexity. While insisting that same-sex object choices have become accepted and acceptable in Azerbaijan, they remained silent about the ongoing realities of discrimination, non-recognition, and violence against gays in the country. However, 'The Violations of the Rights of Lesbian, Gay, Bisexual, Transgender Persons in Azerbaijan', a report prepared by the same NGO in collaboration with ILGA-Europe and Global Rights published in 2009, states:

> There are still a number of serious threats to the rights and protections of LGBT citizens in Azerbaijan. Police brutality and harassment permeate the lives of LGBT citizens in the forms of physical violence, blackmail, intimidation, invasions into homes, raids on public establishments, interference with personal privacy, and manipulations of the court system. These types of abuses stem from a number of sources, including insufficient training and education on

LGBT people, homophobia, transphobia, and public attitudes and misrepresentations of LGBT Azerbaijani people.

<div align="right">(Bagirov et al., 2009: 2)</div>

The report further states that 'harassment, violence and abuses against LGBT people in Azerbaijan are systemic problems', making a number of recommendations to the Azerbaijan government (ibid.: 9). In its 2011 annual review of Azerbaijan, ILGA-Europe also mentioned several cases of homophobic and transphobic violence that took place that year, and reported on regular harassment and blackmailing of gay men and trans-sexual sex workers (2011: 42). The US State Department's 2010 human rights report on Azerbaijan mentioned many 'incidents of police brutality against individuals based on sexual orientation', including the killing of two members of the LGBT community (2011: 45). It also stated that in 2010, members of the LGBT community in Azerbaijan 'continued to refuse to lodge formal complaints with law enforcement bodies out of fear of reprisal or retaliatory persecution' (ibid.).

While the ESC helped to bring new visibility and legitimacy to the issue of sexual rights in Azerbaijan, my impression was that Gender and Development activists decided at that point to remain silent about homophobia and homophobic violence there. Fear and intimidation as well as their tenuous links with Azerbaijan's nascent civil society may go some way in explaining why LGBT activists in the country did not campaign more actively during the ESC to gain visibility, to address the pain of not being recognized, or to question the conditions of recognition. (Issues such as the legal status of same-sex couples, inheritance, or the possibility of some form of legal union do not feature as immediate concerns in any of the Gender and Development agendas or the Azeri public sphere.) Many people in and outside Azerbaijan involved in Sing for Democracy showed concern that a new wave of repression would start after the contest finished. Many predicted that government crackdowns would resume against outspokenly critical human rights activists and journalists. On 19 June 2012, in an article entitled 'After the Curtain Call, a Crackdown Begins', Shahla Sultanova reported that Mehman Huseynov, a well-known photographer with the Institute for Reporters' Freedom and Safety, was arrested in the aftermath of the ESC.[10] She also reported that more than 15 activists who took part in the Sing for Democracy campaign march during the Eurovision week were summoned by police and intimidated (2012). However, as Vugar Gojayev, a human rights activist based in Baku, relates, the campaign also brought some gains: nine political prisoners arrested for participation in the

opposition's protest actions in spring 2011 were given amnesty by President Aliyev, though more than 60 political prisoners, among them journalists, remain in prison (Goyajev and Jafarov, 2012). Rasul Jafarov, one of the key organizers of Sing for Democracy, also stated that 'The support for human rights and democracy in Azerbaijan, mobilized around the Eurovision Song Contest, showed the potential for change when supporters at home and abroad come together' (ibid.). To this activist, the events during the Eurovision week proved that 'change is inevitable' (ibid.).

However, as mentioned earlier, none of the Sing for Democracy public events or statements have so far addressed the limits of sexual freedom or sexual democracy in Azerbaijan. In this regard, Rabab Abdulhadi's reflections on the challenges one faces when seeking to discuss the rights of LGBT persons in the Muslim world is instructive here. According to this author, the women's movement or movements for the rights of sexual and gender minorities are marginalized and sidelined to the periphery of more urgent concerns, such as the sovereignty of the nation or human rights abuses inflicted by tyrannical rulers. She makes a strong claim that the struggles for protecting the rights of individuals of non-normative genders and sexualities in the Muslim world have to be fought alongside other movements for justice:

> Sexual freedom cannot be unlinked from other aspects of human liberation, nor can such rights be guaranteed in the absence of the social setting in which all other rights are respected. To achieve such vision, people in the Arab and Muslim communities must be freed from colonial legacy, neo-colonial interventions, foreign occupation, socio-economic hierarchies, and dictatorial and monarchical authority. Furthermore, for LGBTIQ people in Arab and Muslim communities – as more such identities emerge – the solution lies not in building alliances with those who denigrate their communities and their religion, but rather, they must build ties with forces struggling for a comprehensive social change, first on a regional level, and then internationally.
>
> (2010: 482)

In other words, like Alieva, Abdulhadi reiterates the importance of a healthy and boisterous civil society for any kind of progressive social change.

The protestors who burst into the streets and squares of Baku on several occasions during the ESC were essentially seeking political freedom in place of local despotism. On the whole, these groups did not include

the poorest members of society. Workers have still to mount any sustained general strike. To a great extent this societal disjuncture could be seen as a result of the ideological limbo in which that society has been left since 1991, the year of independence, and of state repression and election manipulation stamping out collective organization among the dispossessed. I contend that only when the re-emergent political left (represented, for instance, by poorly resourced grass-roots groups, NGOs, independent media, and professional organizations) reconnects with the deeper social springs in the country will its demands for political freedom and social justice find optimal political expression and create evolutionary change in the future. And perhaps only in that framework could calls for greater LGBT rights hope to find any realization.

Whether the ESC will leave a positive legacy in Azerbaijan's public sphere and provide an impetus for democratization and the advancement of human rights – especially LGBT rights – in the country remains to be seen. Looking across Europe, LGBT organization and advocacy over the past three decades have advanced the rights of LGBT people, including the decriminalization of homosexuality, the enfranchisement of LGBT people in public domains, the constitutionalization of gender equality, the enabling of public celebrations of 'pride', the domestication and normalization of queer families, and so on. However, manifestations of homophobia and heterosexism, among others, continue to target LGBT people as an identifiable subject in Europe and the rest of the world. As the former European commissioner for human rights, Thomas Hammarberg, notes, even though 'the pathologization and criminalization of homosexuality in Europe' are a thing of the past, millions of Europeans are still 'discriminated, stigmatised and even victims of violence because of their actual or perceived sexual orientation and gender identity' (Council of Europe, 2011a). In a report entitled 'Discrimination on Grounds of Sexual Orientation and Gender Identity in Europe' that he prepared for the Council of Europe, he provides an analysis of the situation of LGBT people in the 47 council member states.[11] It shows that despite progress made over recent decades concerning attitudes and practices toward LGBT people, homophobic and transphobic attitudes still exist in all countries covered by the review, 'though attitudes vary significantly among and within the countries' (Council of Europe, 2011b: 7). While the report does not name any specific countries, it still makes it clear that some of the key problems that the LGBT community in Azerbaijan faces today are also recurring problems across the continent (gays' invisibility; the lack of access to

214 Gender Identities & Sexualities in the ESC

marriage or registered partnership; no access to the adoption of children; and difficulties faced by transgender persons in the process of legal gender recognition).

Finishing this chapter in Belgrade in early October of 2012, I witnessed public debates in the Serbian media in response to Serbian gay activists' plans to organize a Gay Pride march in the city centre as part of Belgrade Pride week (2–7 October 2012). On 3 October, a few days before the scheduled march, the Serbian authorities banned the event, offering the same reasons as when they cancelled the 2011 Belgrade Gay Pride parade (see Blagojević, 2011).[12] Activists then instead held a rally dubbed 'A Parade within Four Walls' which ended with a minute-long protest in front of Belgrade's Media Centre, where some 20 activists gathered, holding rainbow flags and pledging to stage the next march in September 2013. A Swedish art exhibition held at the Centre for Cultural Decontamination in Belgrade to coincide with Gay Pride week also caused much controversy and was heavily guarded by the police. Entitled 'Ecce Homo', it featured photographs which depict Jesus Christ among gay people. The Belgrade Pride Week Organisation also organized an International Pride Forum, which took place over a few days and involved human rights activists, politicians, journalists, and representatives of LGBT communities from Serbia and abroad.

EU politicians expressed their concern that Belgrade banned a Gay Pride event for the second year running. The secretary general of the Council of Europe, Thorbjorn Jagland, voiced his surprise and disappointment; the European Commission warned that the decision went against fundamental human rights upheld by the EU; while Bridget Olsen, the Swedish minister for European affairs, demanded that the Serbian government should show 'a commitment to respect human and minority rights' if it wants to enter the European Union (qtd. in RFE/RL's Balkan Service, 2012). Despite this voicing of disapproval by EU elites, the Serbian prime minister, Ivica Dačić, described the ban as a victory for Serbia stating that 'he would rather accept criticism for the decision to ban the parade than to see any victims on that day in Belgrade' (B92, 2012). In response to concerns voiced by EU politicians and human rights activists, he was also quoted as saying that 'nobody will be telling anyone what should happen in Belgrade, be it the EU or any of the countries of the world, or any extremist or radical organization' (ibid.). He also condemned the Swedish art exhibition, comparing it to a video mocking the Prophet Muhammad that caused a global uproar in the autumn of 2012. The head of the Serbian Orthodox Church, Patriarch Irinej, also condemned the march, calling it a 'parade of shame' that is

'foreign to our history, tradition and culture', while the ultranationalist group Obraz ('Honour') called the ban a 'victory for Serb patriots' (qtd. in Gec, 2012). Goran Miletić from the Belgrade 2012 Gay Pride organizing committee expressed his regret that the authorities were intimidated by the threats of violence and did not do enough to safeguard the event. 'Pride is not a circus that will leave this city', he stated defiantly. 'We are staying here, this is where we live' (qtd. in *Guardian*, 2012). Miletić's comment could also be seen as a metacommentary on Arsenijević's article 'Godzilla vs. King Kong' cited earlier, specifically to Arsenijević's assertion that the city of Belgrade, faced with a ESC-induced 'gay invasion' in May 2008, 'shrugged its shoulders, closed its eyes, clenched its teeth and pretended that nothing out of ordinary was going on' (*E-novine*). In Arsenijević's vision, Eurovision, deemed 'gay', became closely linked to Europe and the 'European' model of sexual modernity, which arrived in Serbia with a fleeting promise of tolerance towards sexual minorities, creating a temporary presence of sexual otherness that Belgradians decided to tolerate. The famous Balkan hospitality, as it were, assumed a straight form, positioning (Eurovision) gays as guests in the city, reliant on their continuous goodwill. As Ahmed writes, 'To be a guest is to experience a moral obligation to be on your best behaviour, such as to refuse to fulfil this obligation would threaten your right to coexistence' (2010a: 206). And, indeed, a leaflet distributed by the EBU to the accredited press and fans at the Belgrade Arena was only one of the warnings circulating during the ESC in Belgrade advising appropriate discretion in public when it came to expressing affection between members of the same sex. However, as the 2010 Belgrade Gay Pride parade and the two subsequent attempts to hold Gay Pride parades made clear, LGBT people also live here and belong to this city and this country, and they are here to stay. I would venture to say that even though the majority of citizens of Serbia failed to identify, or declare solidarity, with the Serbian LGBT community, and even though this community still finds itself in a precarious condition, in recent years Serbian gays have made significant progress in the struggle for recognition and a bearable life in their country. If Eurovision has been discursively constructed as a gay event promoting sexual progressiveness repeatedly associated with 'European standards', that is, with sexual democracy in Western Europe, public deliberations about LGBT rights and freedoms in countries such as Serbia and Azerbaijan during and in the aftermath of the ESC testify that this kind of cultural performance could also be seen as a catalyser of dynamic exchanges linking gender and sexuality with cultural, ethnic, and religious identities in contemporary Europe.

Notes

1. Perhaps one of the most extreme instances of this instrumentalization in recent years is the use of sexual torture in Abu Ghraib, performed by US army personnel against Iraqi prisoners, which was informed by certain cultural assumptions about Muslim and Arab sexualities and sexual taboos (see e.g. Puar, 2007).
2. A conference entitled Sexual Nationalisms: Gender, Sexuality, and the Politics of Belonging in the New Europe (University of Amsterdam, 27–28 January 2011) addressed various ways in which gender and sexuality are played out in national debates about national identity, immigration, multiculturalism, and Islam in Europe.
3. I use the term 'gay' as a shorthand for persons of non-normative gender and sexuality.
4. He writes that his intention is not to argue in favour of a 'non-Western nativism, of some blissful existence prior to the epistemic, ethical, and political violence unleashed on the non-West' (2007: 42) but rather to oppose 'a Western nativism armed with a Rousseauesque zeal bent on forcing people into "freedom", or a Western nativism that considers assimilating the world into its own norms as ipso facto "liberation" and "progress," a step toward universalizing a superior notion of the human' (2007: 42).
5. Other scholars offer less celebratory accounts of the contest's queer potential. Mari Pajala, for instance, points out that even though recent years have witnessed an increasing number of queer performances, heteronormative images of gender and sexuality still dominate the ESC stages (2007b: 26). See also the contributions by Elaine Aston (Chapter 8), Rehberg (Chapter 9), and Katrin Sieg (Chapter 11).
6. In this acronym, the letter Q stands for those who identify as queer.
7. However, Dana International's statement published in *Inquirer* in 1998 that 'it is easier to be a transsexual in Israel than an Arab' (qtd. in Amireh, 2010: 643) underscores, as Amireh aptly argues, 'the irreducible difference between two forms of oppression' in the state of Israel (2010: 643).
8. The situation of the LGBT community in Azerbaijan was not directly addressed in this document. In response to this diplomatic pressure, the Azerbaijani government went on the defence, calling the resolution 'unjust and biased' while the Azerbaijani parliament issued a formal protest (*Azernews*, 2012b).
9. A month later, on 23 June, a number of the activists who took part in these protests held a press conference in Baku, speaking about the physical assaults they had undergone and continued harassment by the police. See *Obyektiv.tv* YouTube clip from 23 June 2012.
10. Huseynov's photographs and videos had been used by the Sing for Democracy campaign to show police behaviour during the pre-Eurovision protests and evictions, and they were picked up by the international media. Mehman Huseynov is the younger brother of Emin Huseynov, one of the key activists involved in this democracy platform, and many suspect that the criminal case launched against him is based on fabricated hooliganism charges.
11. The report examines the attitudes and perceptions towards LGBT people; legal standards and their implementation; protection from violence and

access to asylum; freedoms of assembly, expression and association; gender recognition and family life; and access to health care, education, and employment.

12. On 24 May 2012, the European Parliament adopted a resolution strongly condemning recent laws or proposals in EU countries (Lithuania, Latvia, and Hungary) and Council of Europe member states (Russia, Ukraine, and Moldova) which make it a penal or criminal offence to talk positively about homosexuality in public. As the press release issued by the European Parliament states, these laws have already been used in Ukraine and Russia to arrest and fine citizens. The parliament called on the Council of Europe to investigate these human rights violations and take appropriate measures. For some excellent reflections on Gay Pride parade controversies in Eastern Europe, see the special issue of *Sextures* edited by Anna Gruszczynska (2012).

11
Conundrums of Post-Socialist Belonging at the Eurovision Song Contest

Katrin Sieg

In May 2011, the male-female duo Ell & Nikki won the Eurovision Song Contest (ESC) for Azerbaijan, a relative newcomer to the giant media event, with the romantic R&B ballad 'Running Scared'. The government of this small, oil-rich nation in the Caucasus region had spared no expense in hiring world-class composers, choreographers, designers, and dancers, resulting in a pleasing confection of a pop song that even had a bit of a commercial afterlife.[1] Azerbaijan's hosting of the contest in its capital, Baku, in 2012 set off massive infrastructure projects to prepare the ancient port city on the Caspian Sea for the arrival of performers and their entourages, along with thousands of fans for whom attending the live show was the highpoint of the year. The construction of a 25,000 seat arena named Crystal Hall especially for the contest required the eviction and resettling of more than 10,000 residents. Added to the £38.7 million it cost to produce the show, the Baku contest was the most expensive ever.[2] While the nation sought to showcase its recently refurbished historic capital, a UNESCO world heritage site, along with the luxury shops and hotels that had sprouted as a consequence of oil and gas revenues, the majority of the population were living in impoverished and politically repressive conditions. Although Azerbaijan has received millions of euros under the European Union's (EU's) Neighbourhood Policy programme to aid its 'democratic development and good governance', its record of respecting its citizens' political rights and civil liberties is poor: the non-governmental organization Freedom House gives it low scores of six and five, respectively (out of seven), and bluntly characterizes its status as 'not free' ('Azerbaijan', 2010).[3] Yet the EU's interest in maintaining good business relations with

the country, already a significant supplier of fossil fuels to continental Europe and soon a major contributor to the planned Nabucco pipeline, has led it to keep tactfully quiet about its political record. But international news media took the opportunity to scrutinize the country's human rights abuses, and widely reported the government's curtailing of public protests in the week preceding the contest and the arrest of 60 demonstrators.[4] This coverage confirmed Europeans' perceptions of Muslim intolerance and authoritarianism rather than broadening their conception of Europeanness.[5] Whether such reports added up to 'a vision of hell, or just a few sour notes', as the Australian *Sunday Age* phrased it, the ESC did not unequivocally demonstrate Azerbaijan's cultural affinity with Europe as a prerequisite of political recognition and economic partnership, but tarnished the image that media consultants had so carefully and expensively burnished (Elder, 2012: 1). After Ell & Nikki's victory successfully converted economic capital into cultural cachet, it has proved more difficult to convert cultural cachet back into social and economic capital.

This chapter will examine the endeavours of Central and Eastern European (CEE) countries, which have flocked to the ESC in the past 15 years, to demonstrate belonging to and partnership with Europe, and ask whether and how they position themselves as stakeholders in a common project to define the meaning, values, and norms that are attached to Europeanness. The ESC, broadcast on TV and live-streamed on the internet in May each year, offers the most widely accessible public venue where such struggles over European identity and its boundaries are carried out – struggles that are fought in cultural terms, but that, as my opening anecdote suggests, have material consequences in the realm of political economy. In the past two decades the ESC has swelled tremendously in terms of participating countries, viewers, budget, and broadcast slots. Viewing venues have proliferated, from internet forums to urban clubs, parties, and public screenings. Greater exposure and procedural changes have fuelled public excitement about the ESC, and forged deep and broad attachments to Europe in a way that the architects of EU cultural policy could only dream of.

Another reason for the tremendous reinvigoration of the ESC over the past 15 years has been the application of many new states from the former Eastern bloc to the European Broadcasting Union (EBU) – the network of public broadcasters that organizes the contest. They have infused the contest with new energy and capital.[6] The profound reconstruction of CEE economies and political systems, applications for EU membership, and eventual joining of the EU in two waves

of enlargement in 2004 and 2007, paralleled their entrance onto the Eurovision stage and informed their performances. In 1994, Estonia, Hungary, Lithuania, Romania, Slovakia, and Russia competed for the first time. Since then, Latvia (2000), Ukraine (2003), Albania and Belarus (2004), Moldova and Bulgaria (2005), Georgia and the Czech Republic (2007), and Armenia (2008) have joined the ESC.[7] For many post-socialist countries, whose relation to Europeanness was ideologically, culturally, or geographically tenuous, the ESC became a stage where they could perform their imagined relationship to Europe as a 'return home' or demonstration of friendship. Their efforts have been extraordinarily successful: in the last 10 years, seven of the winners have come from CEE countries.[8]

The eastward expansion of the ESC has coincided with stylistic changes that Swedish musicologist Alf Björnberg (2007) characterized as a 'return to ethnicity'. Both oldtimers and newcomers have adopted 'ethnic' music styles and genres, from turbo folk and new-age Celtic to oriental hip hop. Björnberg regards these changes as welcome diversions in a global pop-musical landscape marked by increasing homogeneity, and concludes that they constitute a 'representational multiculturalism' that 'celebrates cultural diversity and cultural connections to others' (Björnberg, 2007: 23). The embrace of more diverse musical genres has undoubtedly enriched the contest, and opened up spaces for the inclusion of ethnic sounds and artists of colour that revised the myth of a homogenous European culture undergirded by Europop.[9] Yet other scholars have come to a more ambivalent appraisal of the 'return to ethnicity': anthropologists John and Jean Comaroff, for instance, observe the neoliberal commodification of identity and cultural heritage in *Ethnicity, Inc.* (2009), which 'while it opens up some populations to new sources of value [it] also may subject them to new, more intricate forms of control, even dispossession' (59). Kien Nghi Ha, a German cultural theorist, comes to a rather damning appraisal of the ESC as emblematic of a postmodern valuation of cultural difference that is commensurate with traditional nationalism; worse, its flaunting of model immigrants 'reinforces sexist and racist stereotypes', and ultimately reduces exoticized others to fetishes of difference (Ha, 2005: 107).[10] Similarly, Aniko Imre, a scholar of East European film and media, has noted the opportunities that the global music industry and visual media have created for Roma music and musicians at the ESC, and in global popular culture at large, without ameliorating the severe discrimination of this ethnic group (see also Chapter 6). Moreover, she shows that the empowerment of some minority artists is only available to men, and 'consolidates

an alliance between the men of national majorities and minorities' (Imre, 2009: 118). In sum, these critics diagnose a paradigm shift from nationalist exclusion to differentiated inclusion of previously deni-grated others, whose troubling consequences for ethnic minorities, and for women of colour in particular, renders Björnberg's celebration of diversity naïve.

The question that arises from the simultaneous expansion of the EU and the EBU, and the fetishizing of ethnic performance in the European (if not global) context, is what options this leaves for ESC participants from CEE countries, which not only have ethnic minorities but also have historically been positioned as 'ethnic' in the Western European imagination. How, then, can ethnicity be performed in ways that do not reinscribe colonial power hierarchies? Are there any alternatives to figuring cosmopolitanism, aside from multiracial bodies?

Many CEE countries have framed their claims to belonging through organic tropes of romance and family. Nevertheless, these tropes, because they eroticize difference in the allegorical bonds between nations, trail behind them imperialist fantasies and colonial histo-ries, which historically enshrined patriarchal and racialized hierar-chies. My close examination of the Polish band Ich Troje's '*Keine Grenzen/Żadnich granic*', presented in 2003 on the eve of the first wave of Eastern enlargement, explores whether and how the metaphor of the European family can be adapted to the purpose of signifying post-imperialist relations. Moreover, I track male–female relations in songs by CEE countries over several years to examine the payoffs and costs of the intensely gendered and sexualized musical scenarios for which the ESC has become famous. Finally, my close reading of Alyosha's song 'Sweet People' (Ukraine 2010) in the last section of this chapter considers the possibility that kinship and 'home' are reconfigured for an alterna-tive discourse of cosmopolitanism, namely one that emphasizes civic participation, social and environmental sustainability, and democratic sovereignty, rather than the 'natural' order of the family.

Cosmopolitan empire

Since restructuring their economies and political systems in the 1990s, CEE states have become heavily dependent on Western Europe. In 2004 and 2007, 12 countries joined the EU, yet economic and political con-vergence have, for the most part, eluded the new member states.[11] Cultural scholars, historians, and social scientists on the left noted eco-nomic decline and widespread immiseration that followed neoliberal

restructuring, the weakness of civil society organizations that could actively participate in this process, and the isolation of political elites who, even in the judgement of moderate-to-conservative observers, pillaged the state in the name of privatization schemes.[12] To date, mass political disillusionment has been evidenced by the fact that not a single incumbent government has been re-elected in a CEE country.[13] Moderate political economists, such as EU enlargement expert Mitchell Orenstein, have voiced doubt about the long-term sustainability of what he and others term the 'dependent market economies' of CEE. Governments' dedication to keeping labour costs low despite workers' high skills means that 'they will have difficulty moving up the value chain'.[14] Orenstein's prognosis of permanent dependence for many (though not all) of the CEE countries is decried in sharper terms by others. A collection of essays edited by geographer Salvatore Engel-Di Mauro, for instance, warns against 'Global Imperialism in EU Expansion' (Engel-Di Mauro, 2006), and economic historian Hannes Hofbauer's study *EU-Expansion* bears the similarly ominous subtitle 'From *Drang nach Osten* towards Peripheral EU-Integration', which alludes to 19th-century German dreams of settling and subjugating Eastern European lands. Hungarian political scientist Attila Melegh, moreover, points out that the concept of an 'East–West slope' in the political discourse about accession not only prompts CEE countries to scramble for position on the upper end of the slope, thus forestalling any solidarity among them, but captures assumptions of a civilizational hierarchy harking back to the 19th century (2006). In short, perceptions of east–west inequality are seen to herald the return to a colonial construction of cultural difference.

By contrast, others borrow the term 'empire' from Michael Hardt and Antonio Negri's eponymous work (2000), to foreground more dispersed operations of power. The anthology *Empire's New Clothes: Unveiling EU Enlargement* (2001), edited by Joszef Böröcz and political scientist Melinda Kovacs, shares this new understanding of integration with sociologist Manuela Boatcă and cultural geographer Ulrich Best (2006), for instance, who examine evidence for the avid participation of Central and Eastern Europeans in discourses of European enlargement and integration. Best traces the shift from the imperialist *Drang nach Osten* ('eastward drive') to a new *Drang nach Westen* ('westward drive') in the news magazine *Wprost* during the run-up to the accession referendum. The rewriting of this phrase indicates the need to pay closer attention to the discontinuities in East–West European relations, along with the continuities. The language of 'cooperation' and 'transcending…differences' – once a critical practice directed against

national and (neo)colonial divisions – has now become part of the European discourse of power (Best, 2006: 184–85). While unequal relations are nonetheless embedded in the discourse, they have become harder to discern.

Poland's Eurovision contribution, '*Keine Grenzen/Żadnich granic*', presented by the band Ich Troje in the year preceding the country's EU accession (2003), illustrates such a classically universalist, integrative discourse that is counterposed to a past marked by nationalist competition, imperialist aggression, and military strife. The commentator of the German broadcast that year announced the song as a 'reconciliation ballad for the new Europe'. After the Latvian hosts had relayed greetings from a Latvian cosmonaut on the *Mir* space station, the Polish band implored listeners to envision Europe as it might appear from the vantage point of outer space: 'no borders, no flags, no countries, no peoples, no wars'. The three languages used in the song (Polish, German, and Russian) signalled Poland's newfound self-confidence vis-à-vis its former colonizers: in a borderless world, viewers might surmise, Poland would symbolically claim a place among equals. Pop star Michał Wiśniewski's deep, virile voice and long, black, leather coat might have initially provoked uncomfortable associations with imperialist masculinity, yet the coat's front plackets turned out to be playfully decorated with animal print fabric. As he shrugged it off, moreover, he revealed a pale-blue military uniform festooned with sequins and white doves. Around his neck he wore a large Iron Cross on a glittering choker. His costume, bright magenta hair, pierced face and gaudy jewellery thus signalled a pop reworking of militaristic codes. Yet the politics of this European anthem cannot be reduced to a postmodern camping up of imperialist codes. Rather, it was embedded, with great earnestness and pathos, in the musical conjuring of a young European family. Rather than insisting on the emancipation of Poland (and its Central European neighbours) from the predations of imperialist powers, the song performs an imaginative alignment of Poland with the West, which symbolically dominates and incorporates the East through romantic conquest and familial generation. The lyrics resonate with an 'integrationist' discourse that explicitly rejects nationalism and imperialism as violent, and predicates peace on the overcoming of divisions between peoples, envisioning a world without 'flags, stupid quarrels, different races'. However, the band's choice to embody this integrationist discourse in a young family that, moreover, allegorizes different 'civilizations' drags in the essentialist divisions between genders and generations that long fed colonial fantasies.

Cultural theorists of colonialism have argued that by modelling the relationship between colonizer and colonized on the hierarchy of the

sexes in the bourgeois couple, fantasies turning on the marriage of European husband and native wife cemented their relationship as a permanently and 'naturally' unequal one (Klotz, 1995; Zantop, 1997; Wildenthal, 2001). This inequality drew on – and affirmed – essentialist notions of race as well as gender that were being encoded in Enlightenment anthropology, as well as in European family law, which enshrined patriarchal authority. Germans' colonial eastward drive in the 19th and 20th centuries was likewise propelled by a rich repertoire of literary colonial fantasies, which was not predicated on absolute (racial) difference and geographical distance but operated in the context of geographical adjacency, and ethnic proximity and mixing (Kopp, 2001; Kontje, 2004; Thum, 2006; Liulevicius, 2009). This work resonated with a larger body of scholarship mining rich and distinct archives of images and stories about regions that were adjacent to Western Europe rather than geographically distant. Cultural historians of Central, Eastern, and Southeastern Europe attended to the specificity with which Western Europeans imagined 'the East' (Wolff, 1994), or 'the Balkans' (Hammond, 2004; Boatcă, 2006; Todorova, 2009). As Best's study of *Wprost* demonstrates, these colonial fantasies were acutely present to the Polish public, and arguably informed Eastern Europeans' perception of Ich Troje's song.

Wiśniewski presented *'Keine Grenzen/Żadnich granic'* as a duet with his wife Marta, whose pregnancy was much-advertised though scarcely visible at the time; her continual cupping of her belly nevertheless emphasized her impending motherhood. The couple's trilingual duet consistently gendered the very East–West relations whose transcendence the song appeared to champion, as Marta sang exclusively in Polish and Russian, while Michał sang predominantly in German (with one stanza in Polish). Symbolically, the male lead aligns himself with the West, while Slavic languages are feminized. Whereas Michał moves around the stage and through the audience, Marta remains static; while he gesticulates emphatically and expansively, her gestures are mainly restricted to placing her hand on her belly; whereas his costume is flamboyant, her fairy-tale princess gown is highly conventional. The TV camera remains glued to Michał's face and figure, even when Marta carries the melody, supporting the impression that he is the central agent in this romantic drama. These choices contribute to his embodiment of an active, Western modernity, while she is positioned further down the civilizational slope as the passive, mythic, fecund East.

The song's highly theatrical, final image infuses the performance with a high chivalry that echoes old and enduring discourses of Eastern

European sexual difference: the male singer abruptly kneels down before his lady and leans his forehead against her belly, as she lays her hands on his head.[15] While the romantic drama in the song offers a Polish fantasy of desirability and consummated courtship, with the reformed German-speaking knight paying homage to the Eastern European princess, the chivalry of this image nevertheless assents to the gendered hierarchy familiar from colonial fantasies – now no longer produced by Germans but rather by Poles.

At first glance the final tableau's intensely romanticized heterosexual couple appeals to a universalist, integrative discourse of European belonging. Marta's gesture of blessing Michał's bowed head, which rests against her belly, subtly elevates the young European family into a quasi-sacral realm. Yet a closer examination reveals a rather particularist notion of Europeanness. The heteronormative troping of Polish identity suddenly attained a virulent, homophobic quality in the spring of 2003 – that is, concurrent to the national nomination process to the ESC. At that time an art exhibition that opened in five galleries around the country, followed by a national billboard campaign, featured 30 gay and lesbian couples, and provoked vitriolic reactions on the part of the press and politicians, who decried these images as perverse and foreign to Polish sensibilities (Graff, 2006: 438). Feminist scholar Agnieszka Graff shows how the politicization of homophobia was fuelled by a series of resolutions issued by the European Parliament, which condemned public expressions of homophobia. The Polish press rejected these resolutions as patronizing efforts to Europeanize Poles. Graff traces how, in the post-accession years (2004–2007), Polishness became equated with heterosexuality, and overt homophobia became a privileged vehicle for expressing patriotism and proudly rejecting 'foreign' EU influences (Graff, 2010: 590). She further argues that the deep structure of homophobic prejudice, including its obsession with queers' in/visibility and queer 'lobbies' and conspiracies, reanimated older, anti-Semitic patterns of perception formed around the Jewish 'other' (ibid.: 594), which shored up a Christian Polish self. The Christian overtones of the closing image in *'Keine Grenzen/Żadnich granic'* therefore amplify the heterosexist particularism legible to Polish viewers, though not (yet) to Western European viewers of Ich Troje's performance. This point becomes even clearer when one takes into consideration the video that Ich Troje produced for Polish domestic TV. Set in a church, it thus framed the joining of an international, peaceful community in much more overtly religious terms than the muted allusion that is detectable in the ESC performance. Put differently, the toned-down ESC

performance acceded to the secularist self-understanding of Western Europeans, while the domestic video narrated EU accession as a divinely sanctioned covenant. In sum, what might look to most spectators like a universalist appeal to familial belonging delineated for others a very finite community limited by a Christian covenant and heterosexual orientation. Arguably, after 9/11, and after the invasion of Iraq in the spring of 2003, religion served as key signifier of cultural difference and could no longer work as a universalist discourse of common human-ity. Both Christianity and heterosexuality functioned as discourses of exclusion from a transnational Europe. Ich Troje's distinct address to domestic and international audiences was moderately successful since the song finished in a respectable seventh place.

As ten CEE countries joined the EU, and others in the Balkans, Asia Minor, and among the former Soviet Republics lined up to enter political treaties and trade relations with the EU, performances at the ESC more strongly emphasized national desirability in terms of abundance, figur-ing 'the riches of the East' through ethnic exoticism, sexual allure, and an increasing emphasis on spectacle. Read through the lens of feminist and postcolonial studies, the preponderance of Eastern virgin princesses might be seen to signal the developing market economies' increasing desperation to be penetrated by foreign direct investment and capital inflows (otherwise known as 'Prince Charming'), while their ethniciza-tion flags their consent to low-wage, subordinate status.[16] The figure of the virginal ingénue, embodied by Edyta Gorniak (Poland, 1994), soon morphed into more aggressively sexualized 'fallen women', such as Kasia Kowalska (Poland, 1996), who confessed 'I want to know my sins', or Doris Dragović (Croatia, 1999), who titled her song 'Maria Magdalena'. The religious iconography merges with the iconography of the fairy tale, and later as well with the ethnic codes of folklore to produce a series of sinful Cinderellas in tantalizingly short skirts. Not infrequently, the neocolonial rhetoric of cooperative Eastern servants and willing brides is exaggerated in sadomasochistic scenarios of pimps and whores at the ESC (Figure 11.1). Marcin Mroziński's ballad '*Legenda*', Poland's 2010 Eurovision entry, contrasted the English-singing, grey-suited male lead with a female chorus attired in ethnic costumes and headdresses. He leers at the (collective) 'lovely princess' and promises to be with 'her', although '[she] didn't want me to be by [her] side'. The dancers commence their performance by taking a dramatic bite out of red apples; their re-enactment of the biblical fall from grace inserts them in a misogynistic script that culminates in a disturbingly abusive image, in which Mrozinski takes one woman into a stranglehold and the others

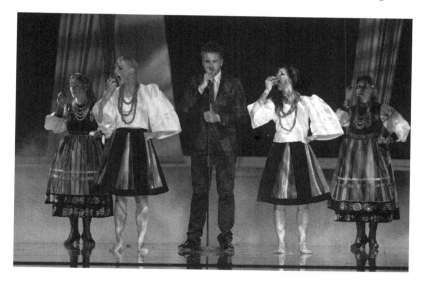

Figure 11.1 Marcin Mroziński and backup singer/dancers perform Poland's entry in the 2010 ESC, *'Legenda'*
Source: Indrek Galetin.

rip off her blouse before she crumples to the floor. This image of male destructive obsession elicits their laconic comment: 'the moral of this is…the knight didn't like her'. The creepy choreography of *'Legenda'* could be decoded, rather cynically, as the flagrant pimping of acquiescent feminized (and ethnicized) populations by governing masculine elites. While this aesthetic appealed to the logic of the fetish, in order to stage national culture as the object of 'European' desire, it is difficult to imagine that acts such as this one offer appealing ego ideals for viewers back home. Mroziński made it to the finals but some of the most hardcore scenarios tended to fare badly among voters.[17]

Anti-cosmopolitanism

So far I have looked at the sexual economy of the ESC predominantly in terms of gendered hierarchies that adapt colonial tropes for claims to belonging, at the price of CEE economies' permanent dependence. My reading of Ich Troje's *'Keine Grenzen'* sought to identify how Poland's integration into cosmopolitan Europe revealed and reinforced internal stratification and East–West divergence, and foreshadowed an increasingly essentialist European imaginary that may be less overtly Christian

than '*Keine Grenzen/Żadnich granic*' but that claims postnationalism and multiculturalism as empirical achievements of European culture, positing them as seemingly universal values against which all others are measured and usually fall short. Chris Calhoun (2009) and others have argued that cosmopolitanism – notwithstanding its universalist aspirations – has become a discourse of exclusion and oppression in Europe. It serves to sharpen the contours of Europe's non-democratic rivals and adversaries, or ostracize ostensibly bigoted immigrant and transient populations, including Muslims and Roma.

Immanuel Wallerstein's wide-ranging *European Universalism: A Discourse of Power* (2006) helps to clarify why cosmopolitanism is evoked by some as an aspirational, self-correcting discourse spurring democratization and the global spread of universal principles of justice, and by others as an empirical discourse describing European cultural achievements against which others are measured (and tend to fall short). He traces a series of terms through which Europeans couched their own partial interests in universal language: from Christianity and modernity to democracy and human rights, Europeans' arrogation of embodying universal values served to legitimate their particularist endeavours to conquer, convert, and exploit others. Wallerstein calls this 'European universalism' and contrasts it with 'universal universalism'.[18] To distinguish between the two requires us to acknowledge that we do not yet know what truly universal norms, standards, values, and principles are. Wallerstein's philosophical reflections illuminate the exigencies of constructing universal norms in a world marked by entrenched power differences that are propped up by polarizing, hierarchizing patterns of perception and structures of knowledge, such as Orientalism and its regional variants. To overcome Eurocentric structures of knowledge and power entails recognizing 'the particularist nature of universalist perceptions, analyses, and statement of values' in which Europeans have become so adept, and accepting them as one of many particularisms engaged in a dialogue about what is universal. Wallerstein concludes with an emphasis on unknowable outcomes: 'We are required to universalise our particulars and particularize our universals simultaneously and in a kind of constant dialectical exchange, which allows us to find new syntheses that are then of course instantly called into question' (Wallerstein, 2006: 49). Both the increasing internal heterogeneity of European countries and the inclusion of economic and political unification of the European polity as a whole require the principled deconstruction of 'European universalism' and vigorous pursuit of a challenging dialectic of rights and identities, in which no interlocutor

may simply assume to represent universal norms. Cosmopolitanism, I maintain, is but the latest in the series that Wallerstein lists. Imagined as the horizon of democratic self-transformation, it could spur powerful, ongoing struggles with and across differences. Yet 'cosmopolitanism' as the new keyword of our times has been co-opted as a descriptor of European identity that forecloses the open-ended process of change, not only in the writings of scholars from Ulrich Beck to Jürgen Habermas, but in the choice of countries like Albania (2010) or Estonia (2001) to flag their Europeanness by including black artists in their ESC presentations, masking the discrimination of resident Roma and Russian minorities, respectively.

What makes the critique of European cosmopolitanism as a 'discourse of power' so difficult, moreover, is that the governing class in CEE countries is among its most avid supporters. National allegory as produced by countries' public broadcasters registers the proximity of cultural forms to the interests of ruling elites. The pimping scenarios I sketched above figure the obscene disconnect between economic and political elites hobnobbing in Brussels and increasingly immiserated, disaffected populations with little say in their communities' distribution of resources. As historian Perry Anderson (2007) has contended, EU expansion exacerbated the community's already considerable democratic deficit: 'the more extended the Community became, the less chance there was of any deepening of its institutions in a democratic direction, for the more impractical any conception of popular sovereignty in a supranational union would become' (Anderson, 2007: 14). Eastern expansion therefore furthered the development of a minimalist, neoliberal state run by technocratic, transnational elites, to the exclusion of a pan-European public sphere or active democratic participation.

The final performance I would like to consider here separates out the desire for popular sovereignty from that for European belonging. To the degree that it rejects the European cosmopolitan regime, it develops an anti-cosmopolitan rhetoric. Drawing on Wallerstein's terminology, we could say that it proposes 'universal universalism' as an alternative to European universalism (Figure 11.2). The song 'Sweet People' presented by the Ukrainian singer Alyosha directly addresses the discrepancy between an official European cultural imaginary and democratic sovereignty. The official video that she submitted to the ESC dramatizes the clash between screened advertisements of happy families and the post-industrial landscape of Eastern Europe, where the dream of skilled work, a good education for all, and egalitarian social provisions lies in ruins.[19] As Alyosha wanders through the apocalyptic landscape of an

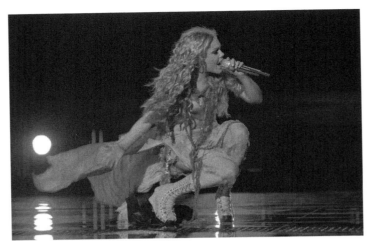

Figure 11.2 Ukraine's Alyosha performing 'Sweet People' in the 2010 ESC
Source: Indrek Galetin.

abandoned socialist city centre, brown-grey images of empty high-rises with a civic centre and a school, the deserted spaces are spliced with colourful sequences of a black family playing at the beach, the wedding of a white couple, and parents blissfully tossing their laughing kids into the air. If we read the dotting, or puncturing, of the landscape with screens as a causal relationship, namely that the proliferation of Western propaganda causes the deterioration of the social, this sequence could be read as a critique of the Western familial imaginary. The dilapidated socialist architecture exudes a melancholy mood, but the video is not nostalgic for the socialist past. In fact, if we consider the video's setting not just as a generic image of the communist-industrial past but as the historic city of Prypyat, ground zero of the Chernobyl nuclear disaster of 1986, any nostalgic reading would be blocked.[20] Given that the catastrophe was exacerbated by the Soviet government's secrecy, and its disregard for the health of its citizens, this visit to Prypyat retrieves memories and emotions from its ruins that cannot be reduced to 'ostalgia': the now-abandoned gyms, libraries, and playgrounds conjure the civic life of that era as places of social integration, even as that civic life never translated into active citizenship or democratic sovereignty.

The song's first lines – 'Oh sweet people, what have we done?...all that we've built /tumbles and is gone' – mourn more than the never-realized potential of communist sociability; the glossy screens are

included in this eulogy as signs of a future that is already past and was perhaps never achieved. In the constellation of empty factories and screens, we might thus also read the creative destruction unleashed by the free market, and the 'tumbling' of that market. Against the background of contemporary Ukraine, the 'we' in the opening question could be understood as a reference to those whose hopes for mass sovereignty had been dashed twice: first by the repressive communist state and, more recently, by its antithesis, Viktor Yushchenko's government (2004–2010). By placing Alyosha in the despoiled cityscape of Prypyat, the video dates her as not just a member of the Chernobyl generation but as a member of the Orange Revolution generation. The 2004 elections in Ukraine would have been the first in which she and her cohort could vote; the elections of February 2010, in which all the hopes awakened by that revolution were buried, preceded Alyosha's nomination to represent Ukraine at the ESC by only a month. Both Western media and Viktor Yushchenko's opposition party had cast the 2004 elections as a choice between democratization and orientation to Europe on the one side, and political repression and corruption, along with dependency on Russia, on the other. The month-long, peaceful demonstrations in Kiev, which succeeded in placing the elected President Yushchenko in office, became known as the Orange Revolution. Yushchenko, a finance expert by profession and chairman of Ukraine's central bank before he entered politics, ran on a platform that promised to rid government of corruption, stimulate economic growth by lowering taxes (the standard neoliberal formula), and steer the country away from Moscow and towards Europe, whose border, after the 2004 enlargement, now reached Ukraine. Looking back over Yushchenko's presidency, Russian-American journalist Keith Gessen (2010) chronicled the crumbling of hopes that had peaked in the Kiev demonstrations: corruption and cronyism had proved to be intractable, and, instead of prioritizing economic reconstruction, Yushchenko had became absorbed by symbolic politics and identity building that proved divisive. In short, his presidency was a tremendous disappointment to the erstwhile orange revolutionaries; in 2010 he was voted out of office.

Alyosha's 'we' evokes those who, in 2010, lacked any real alternatives to Russian-style repression and a European notion of democracy that had exhausted itself in a vapid ideology of diversity. More specifically, the 25-year-old's inclusion in that 'we' marks her as one of those who embraced the turn to Europe as the most direct way to democracy, and who were so rudely disappointed. The singer's reminder 'this is your home!' calls on viewers to recognize ecosystems and social systems as

vulnerable and interdependent. 'Home' denotes oceans and forests, but also public schools and communal facilities. By contrast, the conventional signifiers of 'home' – televized images of happy black and white families – are literally shattered, as the monitors screening them are shown falling through a hole in the floor of an abandoned building, an image that resonates with the disenchantment of those who dreamed of Europe as a harbinger of democracy.

This transitional moment is not as luddite as it first appears. The video's final sequence shows a child watching an image of Alyosha standing on a dark beach on another TV, stretching out his hands towards the screen, as Alyosha walks towards him to pick him up in the final frame. We might object that futurity in this conclusion is again predicated on the generative metaphor of the family, and thus appears to recuperate that which the song criticized in the first half. However, I would argue that the video's plea for a future in which the child can survive does not hinge on the conventional opposition of technological (screen) versus organic (humans), in which the latter must be purged of the former and a pristine state must be restored. By placing Alyosha in both, the video suggests that the power of the electronic imaginary and the media platforms that deliver it can be harnessed for planetary environmental and social reconstruction. We must learn to live in, and with, the mess we have made. The screen's capacity for inciting desire and identification – represented by the child's reaching hands – can and must be marshalled to ensure survival and well-being. And in the architectural and photographic refuse at ground zero the traces of that well-being, which had only been partially attained, can serve to impel new imaginaries. The video offers a critique of what's on the screen and who owns the server, as it were, not a facile dismissal of modern digital media *tout court*.

'Sweet People' attempts to cull from the refuse of particular, violent regional histories – the Chernobyl disaster; communist architecture and forms of socialization – a desire for what remained unrealized in it, and posit this unrealized remainder as universal: schooling, leisure, work; civic community; ecological sustainability. In effect, the song not only historicizes its own universal aspirations for a socially and environmentally sustainable life but also contests (and rejects as false) the purportedly universal rhetoric that cosmopolitan Europe has so successfully marshalled, which is embedded in the happy black and white families. On the Eurovision stage, however, the thick referentiality opened up by the video, which placed environmental and social sustainability side by side, and contrasted the cosmopolitan celebration

of ethnic diversity with a lack of political alternatives, lost much of its richness. Alyosha stood in a single, brilliant spotlight, only occasionally bending over as if in agony, while struggling to keep her balance against the powerful wind machine that blew her long hair away from her face. The single-most remarkable aspect of her performance was her costume, which consisted of a tattered robe with red threads draped avantgardistically over it like so many ripped-out veins. She appeared to have just stepped out of the postapocalyptic film *The Road* that showed in theatres that season. This static performance excised the image track that had opened up such rich historical references, and privileged her green message over any other possible readings of the song, including the one I just proposed. The lonely placeholder for its more radical meanings on the website *Alyosha mission* (dormant since the contest) is Alyosha's logo, the anarchist red A in a circle. Her persona was shaped by the consulting firm CFC, whose executives specialize in corporate positioning, reputation management, and nation branding. We might surmise that their expertise was in part responsible for the more rigorous construction of Alyosha's brand image around environmental issues as more immediately consistent with a European sensibility, since responsibility for the environment, commitment to biodiversity, and protection of natural resources are not only uncontroversial but also considered a key aspect of European cosmopolitan identity, and of Europe's self-appointed global environmental stewardship. After the political tragedy of Viktor Yanukovych's election in 2010, what better icon for Ukraine's continued commitment to Western/cosmopolitan values than Ecovision 2010? And who better to embody these values than a Chernobyl baby? In short, the migration from computer screen via the stage to TV screen indexes the Europeanization of 'Sweet People's' cosmopolitanism.

Conclusion

The annual ESC has provided a venue where participating nations from the former Soviet bloc, whose relation to Europeanness may be tenuous, strive to perform claims to belonging and partnership. The metaphor of the European family has served to naturalize the desire for inclusion and organic unity. But as my reading of the Polish song '*Keine Grenzen*' showed, the colonial history of this metaphor drags ideas about racial hierarchy and gendered polarity into visions of European community. In the context of abiding and structural economic dependencies of Eastern on Western European countries, such organic metaphors risk reactivating the archive of colonial fantasies that naturalized inequality

between nations through racialized, gendered allegories. These familial allegories of belonging help to expose the structural power differences embedded in seemingly neutral discourses of post-socialist 'transition' and European 'integration', and help to explain why the emphasis on commonality has at the same time led to the exaggeration of ethnic and gendered differences in the ESC. Whereas in the colonial era the trope of interracial marriage and family shored up a Eurocentric imaginative geography, the eroticization of ethnicity, which can be observed in some of more recent ESC presentations, points to the alienation of neoliberal governing elites and disaffected populations. Nevertheless, because the ESC is a media event that also accommodates corporate and public interests, which may be at odds with the interests of the state and its governing elite, songs may also attempt to particularize 'European universalism' and generate an alternative set of universal values and aspirations out of the refuse of communist history.

The ESC, whose musical homogeneity long served to ritualistically demonstrate membership in a shared culture, became a highly charged venue for enacting as well as contesting the rules of membership at a time when expansion (of the EU and its sphere of influence, and of the EBU) made belonging more profitable but also rendered the convertibility of social into economic capital more uncertain. As the ESC became a privileged stage for broadening as well as guarding the meaning and the limits of Europeanness, the meritocratic premise and democratic protocol of the contest served to objectify its function of reproducing social capital, defined by Pierre Bourdieu as the profits and privileges that accrue from membership of an exclusive network (Bourdieu, 1983: 250). This objectification, on the one hand, serves to conceal more effectively the economic basis of cultural exchange (i.e. the convertibility of social into economic capital) and thus helps the ESC to operate more smoothly as a seemingly neutral display of talent and accomplishment. On the other hand, because 'everything which helps to disguise the economic aspect also tends to increase the risk of loss' (Bourdieu, 1983: 253), the social reproduction of power differences between Europeans and non-Europeans, and among Europeans, has become more uncertain and created new possibilities for envisioning solidarity.

The disgruntlement of citizens with their elected governments is no prerogative of CEE countries. In the mid-aughts, Western European voters, too, signalled their disagreement with governments, whom they perceived to lack a mandate for political decisions of far-reaching importance, by voting no in the referenda held to ratify the proposed EU

constitution. While many pundits explained these votes to be motivated by nationalist sentiments – resentment of Eastern enlargement, fear of increased immigration, and the spectre of Turkish EU membership – few noted the offensively technocratic and elitist character of the document and its haughty attempt to craft a democratic polity 'only in form, not in egalitarian participation' (Calhoun, 2009: 652). To acknowledge that people rightly fear transnational threats to cherished national institutions and social goods does not mean that the nation should be the main locus of solidarity. Much as it has inspired loyalty and love, it has a track record neither for the just distribution of resources, nor for ensuring universal participation. As the EU is on its way to transposing its identity-building project to a supranational scale, the ESC shows that dreams of solidarity might also be sustained by discredited histories. Alyosha's song reminds us that neither communism nor nationalism (nor supranationalism) have made good yet on the promise of mass sovereignty.

Notes

1. The song made it into the top-100 pop charts in nine European countries in spring 2011. See Kucha (2011).
2. An article in the *Independent* estimated the cost at £400 million (Walker, 2012a).
3. Azerbaijan's political rights score reflects the fact that in 2009, President Ilham Aliyev consolidated his authoritarian rule with a referendum that eliminated term limits. Its poor civil liberties score, earned by restrictions on civil society groups and a ban on foreign radio broadcast, will likely decrease next year since the government imposed further restrictive measures to forestall echoes of the Arab Spring.
4. In the week preceding the contest, the BBC's investigative programme *Panorama* took a close look at political repression in Azerbaijan, which included the jailing of dissidents, and police mistreatment and torture of suspected opponents of the government. *Spiegel Online* had already raised concerns about the political situation in the country in 2011.
5. If sexual tolerance is one of the core values of European cosmopolitanism, the ESC has played an active part in yoking sexual diversity to Europeanness. For gay and queer scholarship on the ESC, see Raykoff (2007), Rehberg (2007), and Tobin (2007).
6. The cost of hosting the contest has increased enormously, and the Baku ESC doubled the cost of the previously most expensive contest in Moscow (2009).
7. Yugoslavia had been the only socialist country to compete in the ESC in its Western configuration; since 1994, its successor states Bosnia and Herzegovina, Croatia, Slovenia, Macedonia, and Serbia have competed separately. For a history of the Intervision Song Contest, the socialist counterpart to the ESC, see Miklóssy (2011).

8. Karen Fricker (2009) has argued that the 2008 rule change, which replaced televoting with a mixed televoting-jury system, was designed to put control back into the hands of Western European EBU members, who are the main funders of the event. See also Chapter 4.
9. I found Björn Ingvoldstad's (2007) discussion of the Europop genre especially useful in the context of the musical 'integration' of Europe.
10. Ha referred to the 2002 national nomination process in Germany, where a disproportionate number of contestants came from Southern European immigrant backgrounds. In the broader context of the ESC, I would concur with his assessment that the casting of performers of colour often serves to enhance the cosmopolitan cachet of a country, but that it deflects just as frequently from inter-ethnic tensions within countries. I have developed this argument at length (Sieg, 2013).
11. Moreover, the fragile peripheral economies of Southern, Central, and Eastern Europe have been disproportionately adversely affected by the cascading financial and credit crises since 2006. The destabilization of the CEE economies, which had only just begun to recover from the severe restructuring and contraction of the 1990s, raised doubts in the minds of those political economists who argued that the hardships of the transition had all been worth it and were beginning to pay off (Orenstein, 2009).
12. See Orenstein (2009).
13. Ibid.
14. Note differences between Poland and Hungary, and also Slovenia as an outlier (Orenstein, 2010: 7).
15. Larry Wolff (1994) notes that the flipside to the ostentatious aristocratic etiquette encapsulated in such rituals as the handkiss and the curtsey was the treatment of humans as chattel, which continued until the abolition of serfdom in the course of the 19th century (1861 in Russia; 1864 in Congress Poland). The perceived social, economic, and political 'backwardness' of Eastern Europe assumed an erotic dimension in the 18th- and 19th-century writings of Western European men, who were both repulsed by and attracted to the sexual possibilities of owning female chattel, which they observed in Eastern Europe – a practice that contradicted Enlightenment notions of human dignity and equality. As chivalry and serfdom were associated with the premodern past and excised from modern, bourgeois gender relations, these practices also fuelled fantasies of bondage and submission in works of Giovanni Casanova and the Marquis de Sade that are set in Poland and Russia.
16. Compare Neferti Tadiar's (1998) reading of sexual economies in the Asia-Pacific region, which registers parallel romantic and familial tropes of international relations, and attends to elite discourses of economic incorporation.
17. To note just one example, in Gjoko Taneski's song '*Jas Ja Imam Silata*' (FYR Macedonia, 2010), three distinct masculine types (the businessman, the gangsta rapper, and the hard rocker) were accompanied by blond female dancers in scanty bondage gear, who kept wrapping themselves around the men, while the male singers pushed them to the floor. The group failed to garner enough votes to participate in the finals.

18. Wallerstein's consideration of the invasion of Iraq by the US-led coalition of the willing demonstrates that 'European universalism' includes the US.
19. Videos like Alyosha's, which I discuss below, are posted on the ESC's official website as soon as the national selection process concludes. As the ESC has mushroomed into season-long entertainment, these videos, which often emulate the look of MTV videos, have become important tools for persuading prospective voters. Nevertheless, not all ESC participants have the means to produce videos that meet international professional standards.
20. Alyosha's website at www.alyoshamission.com specifies Prypyat as the setting of the video.

Bibliography

Abdulhadi, Rabab. (2010). 'Sexualities and the Social Order in Arab and Muslim Communities.' *Islam and Homosexuality*. Ed. Samar Habib. Santa Barbara, CA: ABC-CLIO, LLC, 463–487.

Abercrombie, Nicholas, and Brian Longhurst. (1998). *Audiences: A Sociological Theory of Performance and Imagination*. London: Sage.

Abu-Lughod, Lila. (2002). 'Do Muslim Women Really Need Saving? Anthropological Reflections on Cultural Relativism and Its Others.' *American Anthropologist* 104.3: 783–790.

Adams, William Lee. (2010). 'Jane Fonda, Warrior Princess.' *Time*, 25 May, accessed 15 August 2012. http://www.time.com/time/specials/packages/article/0,28804,1990719_1990722_1990734,00.html.

Addison, Paul. (2010). *No Turning Back. The Peacetime Revolutions of Post-War Britain*. Oxford: Oxford University Press.

Ahmed, Sara. (2004). *The Cultural Politics of Emotion*. Edinburgh: Edinburgh University Press.

Ahmed, Sara. (2010a). *The Promise of Happiness*. Durham, NC: Duke University Press.

Ahmed, Sara. (2010b). 'Killing Joy: Feminism and the History of Happiness.' *Signs: Journal of Women in Culture and Society* 35.3: 571–594.

Ahmed, Sara. (2011). 'Problematic Proximities: Or Why Critiques of Gay Imperialism Matter.' *Feminist Legal Studies* 19.2: 119–132.

Alieva, Leila. (2006). 'Azerbaijan's Frustrating Elections.' *Journal of Democracy* 17.2: 147–160.

Alieva, Leila. (2009). 'EU Policies and Sub-Regional Multilateralism in the Caspian Region.' *The International Spectator: Italian Journal of International Affairs* 44.3: 43–58.

Allatson, Paul. (2007). ' "Antes cursi que sencilla": Eurovision Song Contests and the Kitsch-Drive to Euro-Unity.' *Culture, Theory & Critique* 48: 1: 87–98.

Alyosha. (2010). 'Sweet People', online video, accessed 15 April 2012. http://www.youtube.com/watch?v=NT9GFoRbnfc.

Amireh, Amal. (2010). 'Afterword.' *GLQ: A Journal of Lesbian and Gay Studies* 16.4: 635–648.

Anderson, Benedict. (1991). *Imagined Communities: Reflections on the Origin and Spread of Nationalism*. 2nd ed. London: Verso.

Anderson, Perry. (2007). 'Depicting Europe.' *London Review of Books* 29.18: 1–30.

Arsenie, Dan. (2010). 'Paula Seling despre rezultatul la Eurovision 2010: "Mai bine de atât nu se putea!" ' *Evenimentul Zilei*, 30 May, accessed 12 June 2012. http://www.evz.ro/detalii/stiri/eurovision-2010-romania-bronz-germania-locul-intai-896221.html#ixzz1ky86Irw4.

Arsenijević, Vladimir. (2012). 'Godzilla vs. King Kong.' *E-novine.com*. 24 April, accessed 17 May 2012. http://www.e-novine.com/stav/63362-Godzilla-King-Kong.html.

Aston, Elaine and Geraldine Harris. (2006). 'Feminist Futures and the Possibilities of "We"?' *Feminist Futures: Theatre, Performance, Theory*. Eds. Elaine Aston and Geraldine Harris. Houndmills: Palgrave Macmillan, 1–16.

'Azerbaijan.' (2010). Online, accessed 18 July 2011. http://www.freedomhouse. org/template.cfm?page=22&year=2010&country=7775.

Azeri Press Agency (APA). (2012). 'Turkey withdraws from Eurovision Song Contest 2013 in Sweden.' 14 December 2012, accessed 15 December 2012. http:// en.apa.az/news/184452.

Azernews. (2012a). 'Germany sees Azerbaijan as "Important Strategic Partner".' 20 March, accessed 20 May 2012. http://www.azernews.az/azerbaijan/42164. html.

Azernews. (2012b). 'Government brands European Parliament resolution as biased.' 30 May, accessed 5 June 2012. http://www.azernews.az/azerbaijan/ 42451.html.

B92. (2012). 'Ban on Pride Parade Not Defeat but Victory, PM Says.' 4 October, accessed 10 October 2012. http://www.b92.net/eng/news/politics-article.php? yyyy=2012&mm=10&dd=04&nav_id=82485.

Bagirov, Elhan, et al. (2009). 'The Violations of the Rights of Lesbian, Gay, Bisexual, Transgender Persons in Azerbaijan: A Shadow Report.' July, accessed 20 November 2012. http://www2.ohchr.org/english/bodies/hrc/docs/ ngos/LGBT_Azerbaijan96.pdf.

Baker, Catherine. (2008). 'Wild Dances and Dying Wolves: Simulation, Essentialization, and National Identity at the Eurovision Song Contest.' *Popular Communication* 6.3: 173–189.

Baker, Luke and Balazs Koranyi. (2012). 'EU rebuffs critics as it accepts Nobel Peace Prize.' http://www.reuters.com/article/2012/12/10/nobel-eu-idUSL5E8NA54620121210.

Bakić-Hayden, Milica. (1995). 'Nesting Orientalisms: The Case of Former Yugoslavia.' *Slavic Review* 54: 917–931.

Bakker, Sietse. (2010). 'Eurovision flash mob mania to hit Oslo and Düsseldorf.' 26 March, accessed 30 April 2011. http://www.eurovision.tv/page/news?id= 11183&_t=eurovision_flash_mob_mania_to_hit_oslo_and_duesseldorf.

Balibar, Étienne. (2004). *We, the People of Europe? Reflections on Transnational Citizenship*. Trans. James Swenson. Princeton and Oxford: Princeton University Press.

Balibar, Étienne. (2009a). 'Ideas of Europe: Civilization and Constitution.' *IRIS: European Journal of Philosophy and Public Debate* 1.1: 3–17.

Balibar, Étienne. (2009b). 'Europe as Borderland.' *Environment and Planning* 27.2: 190–215.

Balibar, Étienne. (2009c). 'Foreword.' *Romani Politics in Contemporary Europe: Poverty, Ethnic Mobilization, and the Neoliberal Order*. Eds. Nando Sigona and Nidhi Trehan. Houndmills: Palgrave Macmillan, viii–xiii.

Balibar, Étienne. (2010). 'Europe: Final Crisis? Some Theses.' *Theory & Event* 13.2. Online journal, accessed 30 August 2012. https://muse.jhu.edu/journals/ theory_and_event/v013/13.2.balibar.html.

Beissinger, Margaret H. (2001). 'Occupation and Ethnicity: Constructing Identity among Professional Romani (Gypsy) Musicians in Romania.' *Slavic Review* 60: 24–49.

240 *Bibliography*

Beissinger, Margaret H. (2007). 'Muzica Orientala: Identity and Popular Culture in Postcommunist Romania.' *Balkan Popular Culture and the Ottoman Ecumene: Music, Image and Regional Political Discourse.* Ed. Donna A. Buchanan. Lanham, MD: Scarecrow Press, 95–141.

Benhabib, Seyla. (2006). *Another Cosmopolitanism.* Oxford: Oxford University Press.

Best, Ulrich. (2006). 'Between Cross-Border Cooperation and Neocolonialism: EU Enlargement and Polish-German Relations.' *The European's Burden: Global Imperialism in EU Expansion.* Ed. Salvatore Engel-Di Mauro. New York: Peter Lang, 183–208.

Bhabha, Homi K. (1990). 'DissemiNation: Time, Narrative, and the Margins of the Modern Nation.' *Nation and Narration.* Ed. Homi K. Bhabha. London and New York: Routledge, 291–322.

Bhabha, Homi K. (1994). *The Location of Culture.* London: Routledge.

Bhambra, Gurminder K. (2007). *Rethinking Modernity: Postcolonialism and the Sociological Imagination.* Houndmills: Palgrave Macmillan.

Bhambra, Gurminder K. (2010). 'Sociology after Postcolonialism: Provincialized Cosmopolitanism and Connected Sociologies.' *Decolonizing European Sociology: Trans-Disciplinary Approaches.* Eds. Encarnación Gutiérrez Rodriguez, Manuela Boatcă, Sérgio Costa: Farnham: Ashgate, 33–48.

Bhambra, Gurminder K. (2011). 'Cosmopolitanism and Postcolonial Critique.' *The Ashgate Research Companion to Cosmopolitanism.* Eds. Maria Rovisco and Magdalena Nowicka. Farnham: Ashgate, 313–328.

Billig, Michael. (1995). *Banal Nationalism.* London: Sage.

Bjelić, Duan I. and Obrad Savić. (2002). *Balkan as Metaphor.* Cambridge, MA: Massachusetts Institute of Technology Press.

Björnberg, Alf. (2007). 'Return to Ethnicity: The Cultural Significance of Musical Change in the Eurovision Song Contest.' *A Song for Europe.* Eds. Ivan Raykoff and Robert Deam Tobin, 13–24.

Blagojević, Jelisaveta. (2011). 'Between Walls: Provincialism, Human Rights, Sexualities and Serbian Public Discourses on EU Integration.' *De-Centring Western Sexualities: Central and Easter European Perspectives.* Eds. Robert Kulpa and Joanna Mizielińska. Farnham: Ashgate, 27–41.

Boatcă, Manuela. (2006). 'No Race to the Swift: Negotiating Racial identity in Past and Present Eastern Europe.' *Human Architecture: Journal of the Sociology of Self-Knowledge* 1: 91–104.

Boatcă, Manuela. (2007). 'The Eastern Margins of Empire: Coloniality in 19th Century Romania.' *Cultural Studies* 21.2: 368–384.

Bodur, Marella, and Susan Franceschet. (2002). 'Movements, States and Empowerment: Women's Mobilization in Chile and Turkey.' *Rethinking Empowerment: Gender and Development in a Global/Local World.* Eds. Jane Parpart, Shirin M. Rai, and Kathleen A. Staudt. London and New York: Routledge, 112–132.

Bolin, Göran. (2006). 'Visions of Europe. Cultural Technologies of Nation States.' *International Journal of Cultural Studies* 9.2: 189–206.

Böröcz, József, and Melinda Kovacs, Eds. (2001). *Empire's New Clothes: Unveiling EU Enlargement.* E-book, accessed 14 October 2011. http://aei.pitt.edu/144/1/Empire.pdf.

Bourdieu, Pierre. (1983). 'Ökonomisches Kapital, kulturelles Kapital, soziales Kapital.' *Soziale Ungleichheiten*. Ed. Reinhard Kreckel. Göttingen: Otto Schartz & Co, 183–198.

Bourdon, Jérôme. (2007). 'Unhappy Engineers of the European Soul: The EBU and the Woes of Pan-European Television.' *The International Communication Gazette* 69.3: 263–280.

Boym, Svetlana. (2001). *The Future of Nostalgia*. New York: Basic Books.

Bracke, Sarah. (2012). 'From "Saving Women" to "Saving Gays": Rescue Narratives and Their Dis/Continuities.' *European Journal of Women's Studies* 19.2: 237–252.

Breitburg, Kim. (2010). 'Tak chasto pobezhdat' Rossiya ne mozhet.' *Vzglyad. Delovaya Gazeta*. 27 May, accessed 10 July 2011. http://www.vz.ru/culture/2010/5/27/405561.html.

Brey, Marco. (2009). 'Svetlana Loboda fights family crimes'. 17 April, accessed 20 December 2011. http://www.eurovision.tv/page/news?id=2111&_t=svetlana_loboda_fights_family_crimes.

Brooks, Ethel. (2010). 'Stop This State Persecution of Roma.' *Guardian*. 18 August, accessed 6 January 2013. http://www.guardian.co.uk/commentisfree/libertycentral/2010/aug/18/persecution-roma-must-stop.

Buchanan, Donna. (2007). 'Bulgarian Ethnopop along the Old Via Militaris: Ottomanism, Orientalism, or Balkan Cosmopolitanism?' *Balkan Popular Culture and the Ottoman Ecumene: Music, Image and Regional Political Discourse*. Ed. Donna A. Buchanan. Lanham, MD: Scarecrow Press, 225–267.

Bucharest Herald. (2012). 'Associated Press: Mandinga's Zalelilah, a Global Mishmash.' 31 May, accessed 5 June. http://www.bucharestherald.ro/dailyevents/41-dailyevents/33593-associated-press-mandingas-zaleilah-a-global-mishmash.

Buck-Morss, Susan. (2000). *Dreamworld and Catastrophe: The Passing of Mass Utopia in East and West*. Cambridge, MA: Massachusetts Institute of Technology Press.

Buckley, Mary. (1997). *Post-Soviet Women: From the Baltic to the Central Asia*. Cambridge, UK: Cambridge University Press.

Burrell, Ian. (2006). 'Terry Wogan: Welcome to his World.' *The Independent*. 23 January, accessed 18 August 2012. http://www.independent.co.uk/news/media/terry-wogan-welcome-to-his-world-524224.html.

Butler, Judith. (1999). *Gender Trouble: Feminism and the Subversion of Identity*. New York: Routledge.

Butler, Judith. (2008). 'Sexual Politics, Torture, and Sexual Time.' *The British Journal of Sociology* 59.1: 1–23.

Calhoun, Craig. (2009). 'Cosmopolitan Europe and European Studies.' *SAGE Handbook for European Studies*. Ed. Chris Rumford. London, Los Angeles: Sage, 637–654.

Christensen, Miyase, and Christian Christensen. (2008). 'The After-Life of Eurovision 2003: Turkish and European Social Imaginaries and Ephemeral Communicative Space.' *Popular Communication* 6.3: 155–172.

Clark, Greg. (2008). *Local Development Benefits from Staging Global Events*. Paris: OECD Publishing.

Clough, Patricia Ticineto, and Jean Halley, Eds. (2007). *The Affective Turn: Theorizing the Social*. Durham: Duke University Press.

Coleman, Stephen. (2008). 'Why Is the Eurovision Song Contest So Ridiculous? Exploring a Spectacle of Embarrassment, Irony and Identity.' *Popular Communication* 6.3: 127–140.

Comaroff, John, and Jean Comaroff. (2009). *Ethnicity, Inc.* Chicago and London: University of Chicago Press.

Commission of the European Communities. (1992). 'Treaty of European Union.' Luxembourg: OOPEC.

The Conservative Party (UK). (2012). 'Immigration', accessed 15 August 2012. http://www.conservatives.com/Policy/Where_we_stand/Immigration.aspx.

Constant, Caroline. (2004). 'Succès kitch.' *L'humanité hebdo*. 22 May, accessed 5 September 2012. http://www.humanite.fr/node/344956.

Council of Europe. (2011a). 'Hammarberg: "Lesbian, gay, bisexual and transgender people still face discrimination in Europe."' *Council of Europe: Human Rights Europe*, 23 June, accessed 10 September 2012. http://www.humanrightseurope.org/2011/06/hammarberg-%E2%80%9 Clesbian-gay-bisexual-and-transgender-people-still-face-discrimination-in-europe%E2%80%9D/.

Council of Europe. (2011b). 'Discrimination on Grounds of Sexual Orientation and Gender Identity in Europe', accessed 10 September 2012. Strasbourg: Council of Europe Publishing. http://www.coe.int/t/Commissioner/Source/LGBT/LGBTStudy2011_en.pdf.

'Cronica Cârcotaşilor.' (2008). 'Paula Seling cu Salam la Cronica Cârcotaşilor.' Prima TV. Online video of television programme, accessed 27 November 2011. http://www.youtube.com/watch?v=JnPrf1I23-k&feature=related.

Cvetkovich, Ann. (2012). *Depression: A Public Feeling*. Durham, NC: Duke University Press.

Deeb, Lara, and Dina Al-Kassim. (2011). 'Introduction.' *Journal of Middle East Women's Studies* 7.3: 1–5.

Delanty, Gerard. (1995). *Inventing Europe: Idea, Identity, Reality*. Basingstoke: Palgrave Macmillan.

Delanty, Gerard. (1997). 'Models of Citizenship: Defining European Identity and Citizenship.' *Citizenship Studies* 1: 285–303.

Delanty, Gerard, and Chris Rumford. (2005). *Rethinking Europe: Social Theory and the Implications of Europeanization*. London: Routledge.

De Man, Paul. (1996). 'The Concept of Irony.' *Aesthetic Ideology*. Ed. Andrzej Warminski. Minneapolis and London: University of Minnesota Press, 163–184.

De Medeiros, Paulo. (2011). 'A Failure of Imagination? Questions for a Post-imperial Europe.' *Moving Worlds* 11.2: 91–101.

Derrida, Jacques. (1992). *The Other Heading: Reflections on Today's Europe*. Trans. Pascale-Anne Brault and Michael Naas. Bloomington and Indianapolis: Indiana University Press.

Derrida, Jacques. (2005). *Paper Machine*. Trans. Rachel Bowlby. Stanford: Stanford University Press.

Díez Medrano, Juan. (2009). 'The Public Sphere and the European Union's Political Identity.' *European Identity*. Eds. Jeffrey T. Checkell and Peter J. Katzenstein. Cambridge: Cambridge University Press, 81–107.

Dolan, Jill. (2005). *Utopia in Performance: Finding Hope at the Theatre*. Ann Arbor: University of Michigan Press.

Doty, Alexander. (1993). *Perfectly Queer: Interpreting Mass Culture.* Minneapolis and London: University of Minnesota Press.

Douzinas, Costas. (2007). *Human Rights and Empire: The Political Philosophy of Cosmopolitanism.* New York: Routledge-Cavendish.

Dyer, Richard. (1992). *Only Entertainment.* London: Routledge.

The Economist. (2009). 'Put in More Flags.' 14 May, accessed 12 July 2012. http://www.economist.com/node/13653939.

The Economist. (2012a). 'Baku in her Finest.' *The Economist.* 19 May, accessed 30 December 2012. http://www.economist.com/blogs/easternapproaches/2012/05/eurovision-2012-diary.

The Economist. (2012b). 'Georgian Politics: Mikheil Saakashvili Concedes Defeat.' 2 October, accessed 5 October 2012. http://www.economist.com/blogs/easternapproaches/2012/10/georgian-politics.

The Economist. (2012c). 'Turkish Politics: How Will Turkey Respond to the Downing of Their Unarmed Plane?' 25 June, accessed 5 October 2012. http://www.economist.com/blogs/newsbook/2012/06/turkish-politics.

Einhorn, Barbara. (1993). *Cinderella Goes to Market: Citizenship, Gender and Women's Movements in East Central Europe.* London: Verso.

Eisenstadt, Shmuel Noah. (2000). 'Multiple Modernities.' *Daedalus: Multiple Modernities* 129.1: 1–29.

Eisenstadt, Shmuel Noah. (2001). 'The Civilizational Dimension of Modernity: Modernity as a Distinct Civilization.' *International Sociology* 16.3: 320–340.

Eisenstadt, Shmuel Noah. (2003). *Comparative Civilizations and Multiple Modernities.* Leiden: Brill.

Eisenstadt, Shmuel Noah. (2006). *The Great Revolutions and Civilizations of Modernity.* Leiden: Brill.

Elder, John. (2012). 'A Vision of Hell, or Just a Few Sour Notes?' *Sunday Age.* May 27: 1.

Emerson, Michael, Ed. (2011). *Interculturalism: Europe and Its Muslims: In Search of Sound Societal Models.* Brussels: Center of European Policy Studies.

Engel-Di Mauro, Salvatore. (2006). *The European's Burden: Global Imperialism in EU Expansion.* New York: Peter Lang.

ESCdaily.com. (2011). June 27, accessed 20 September 2012. http://www.escdaily.com/rte-posts-eurovision-profit/.

Estonian Human Development Report 2000. United Nations Development Programme.

European Broadcasting Union. (2012). 'Extracts from the 2012 Eurovision Song Contest Rules.' Geneva, accessed 21 August 2012. http://www.eurovision.tv/upload/press-downloads/2012/ESC_2012_public_version_Rules_ENG.pdf.

European Parliament's Intergroup on LGBT Rights. (2012). 'European Parliament Strongly Condemns Homophobic Laws and Discrimination in Europe.' 24 May, accessed 10 September 2012. http://www.lgbt-ep.eu/press-releases/european-parliament-strongly-condemns-homophobic-laws-and-discrimination-in-europe/.

European Parliament. (2012). 'European Parliament Resolution of 24 May 2012 on the Fight against Homophobia in Europe (2012/2657(RSP)).' 24 May, accessed 5 June 2012. http://www.europarl.europa.eu/sides/getDoc.do?type=TA&reference=P7-TA-2012-0222&language=EN&ring=P7-RC-2012-0234.

European Roma Rights Center. (2004). *Stigmata: Segregated Schooling of Roma in Eastern and Central Europe*. Budapest. http://www.errc.org/cikk.php?cikk=1892.

'The Eurovision Song Contest.' (1981). BBC. 4 April. 155 mins.

'The Eurovision Song Contest.' (1982). BBC. 24 April. 130 mins.

'The Eurovision Song Contest.' (1991). BBC. 4 May. 195 mins.

'The Eurovision Song Contest.' (1994). BBC. 30 April. 185 mins.

'The Eurovision Song Contest.' (1996). BBC. 18 May. 190 mins.

'The Eurovision Song Contest.' (1997). BBC. 3 May. 190 mins.

'The Eurovision Song Contest.' (2003). BBC. 24 May. 190 mins.

'The Eurovision Song Contest Final.' (2008). BBC. 24 May. 196 mins.

Eurovision Song Contest. (2009). Russia. Polnaya Versia. DVD.

Eurovision Song Contest. (2012). Official Russian website, accessed 9 December 2012. http://www.eurovision.org.ru.

Evans, Elizabeth Jane. (2011). 'The Evolving Media Ecosystem: An Interview with Victoria Jaye.' BBC. *Ephemeral Media: Transitory Screen Culture from Television to YouTube*. Ed. Paul Grainge. Houndmills & New York: Palgrave Macmillan, 105–121.

Fassin, Éric. (2010). 'National Identities and Transnational Intimacies: Sexual Democracy and the Politics of Immigration in Europe.' *Public Culture* 22.3: 507–529.

Fassin, Éric. (2011). 'A Double-Edged Sword: Sexual Democracy, Gender Norms and Racialized Rhetoric.' Online, accessed 15 September 2012. http://www.law.uchicago.edu/files/files/EF%20Double-Edged%20Sword%20IN%20TERMS%20OF%20GENDER1.pdf.

Fenn, Daniel, Omer Suleiman, Janet Efsathiou, and Neil F. Johnson. (2005). 'How Does Europe Make Its Mind up? Connections, Cliques, and Compatibility between Countries in the Eurovision Song Contest.' Arxiv.org. 10 May, open access publishing site, accessed 15 August 2012. http://arxiv.org/abs/physics/0505071.

Fiaramonti, Lorenzo. (2012). 'Promoting Human Rights and Democracy: A New Paradigm for the European Union.' *The European Union and the Arab Spring: Promoting Democracy and Human Rights in the Middle East*. Ed. Joel Peters. Lanham, MD: Lexington Books, 17–31.

Fischer, Sabine. (2012). 'The European Union and the Insiders/Outsiders of Europe: Russia and the Post-Soviet Space.' *Review of European Studies* 4.3: 32–44.

Florida, Richard. (2002). *The Rise of the Creative Class: And How It's Transforming Work, Leisure, Community and Everyday Life*. New York: Basic Books.

Florin Salam and Paula Seling Live. (2008). 'Tu nu vezi.' Online video, accessed 27 November 2011. http://www.youtube.com/watch?v=yVOnP250pI0&feature=related.

Fricker, Karen. (2008). 'The Eurovision Song Contest: Kitsch, Queer, or Otherwise?' Singing Europe: Spectacle and Politics in the Eurovision Song Contest conference. Volos, Greece. 1 March. Unpublished conference presentation.

Fricker, Karen. (2009). 'Opening Address.' Eurovision and the 'New' Europe inaugural workshop. University of Warwick, UK. 19 June. Unpublished conference presentation.

Fricker, Karen, Elena Moreo, and Brian Singleton. (2007a). 'Part of the Show: The Global Networking of Irish Eurovision Song Contest Fans.' *Performing Global Networks*. Eds. Karen Fricker and Ronit Lentin. Newcastle: Cambridge Scholars Publishing, 139–162.

Frith, Simon, Ed. (1989). *World Music: Politics and Social Change.* Manchester: Manchester University Press.

Gal, Susan. (1991). 'Bartók's Funeral: Representations of Europe in Hungarian Political Rhetoric.' *American Ethnologist* 18: 440–458.

Gardner, Lyn. (2010). 'Access Denied: How Fortress Britain Is Blocking Cultural Exchange.' *Guardian*, 6 September.

Garrigos, Raphaël, and Isabelle Roberts. (2010). 'Faut-il sortir de la zone Eurovision?' *Libération*, 29 May.

Gasparyan. Arthur. (2012). 'Russkaya evroruletka: Baku uvidit Pugachevu v laptyakh!' *Moskovsky Komsomolets.* 11 March, accessed 25 April 2012. http://www.mk.ru/culture/interview/2012/03/10/679894-russkaya-evroruletka-baku-uvidit-pugachevu-v-laptyah.html.

Gatherer, Derek. (2006). 'Comparison of Eurovision Song Contest Simulation with Actual Results Reveals Shifting Patterns of Collusive Voting Alliances.' *Journal of Artificial Societies and Social Simulation* 9.2. Online journal, accessed 15 August 2012. http://jasss.soc.surrey.ac.uk/9/2/1.html.

Gec, Jovana. (2012). 'Serbia Gay Pride March Banned.' *Huffington Post World*, 30 September, accessed 5 October 20. http://www.huffingtonpost.com/2011/09/30/serbia-gay-pride-march-ban_n_988974.html.

Geen, Jessica. (2011). 'Concerns over Eurovision 2012 Host Azerbaijan's Gay Rights Record.' *Pink News.*16 May, accessed 11 September 2012. http://www.pinknews.co.uk/2011/05/16/concerns-over-eurovision-2012-host-azerbaijans-gay-rights-record/.

Gender and Development, ILGA-Europe, and Global Rights. (2009). 'The Violations of the Rights of Lesbian, Gay, Bisexual, Transgender Persons in Azerbaijan: A Shadow Report.' July, accessed 10 September 2012. http://www2.ohchr.org/english/bodies/hrc/docs/ngos/LGBT_Azerbaijan96.pdf.

Georgiou, Myria. (2008). ' "In the End, Germany Will Always Resort to Hot Pants": Watching Europe Singing, Constructing the Stereotype.' *Popular Communication* 6.3: 141–154.

Georgiou, Myria and Cornel Sandvoss, Eds. (2008). Special Issue: 'Euro Visions: Culture, Identity and Politics in the Eurovision Song Contest.' *Popular Communication* 6.3: 125–126.

Gessen, Keith. (2010). 'The Orange and the Blue: The Revolution is Over.' *The New Yorker.* 1 March: 30–37.

Gifford, Chris. (2008). *The Making of Eurosceptic Britain: Identity and Economy in a Post-Imperial State.* Aldershot: Ashgate.

Gilbert, Helen and Jacqueline Lo. (2007). *Cosmopolitics: Cross-cultural Transactions in Australasia.* Houndmills: Palgrave Macmillan.

Gilman, Sander. (1986). *Jewish Self-Hatred: Anti-Semitism and the Hidden Language of the Jews.* Baltimore: John Hopkins University Press.

Gilman, Sander. (1991). *The Jew's Body.* New York: Routledge.

Giorgi, Liana, and Monica Sassatelli. (2011). 'Introduction.' *Festivals and the Cultural Public Sphere.* Eds. Gerard Delanty, Liana Giorgi, and Monica Sassatelli. New York: Routledge, 1–11.

Gilroy, Paul. (2005). *Postcolonial Melancholia.* New York: Columbia University Press.

Gluhovic, Milija. (forthcoming). 'Cosmopolitanism.' *Performance Studies: Key Words, Concepts, and Theories.* Ed. Bryan Reynolds. Houndmills: Palgrave Macmillan.

Gluhovic, Milija. (2013). *Performing European Memories: Trauma, Ethics, Politics.* Houndmills: Palgrave Macmillan.

Gojayev, Vugar, and Rasul Jafarov. (2012). 'Business as Usual or Change for Azerbaijan after Eurovision?' *Open Society European Policy Institute,* 28 June, accessed 12 September. http://www.opensocietyfoundations.org/voices/business-usual-or-change-azerbaijan-after-eurovision.

Gold, Tanya. (2004). 'Europe in all its Tacky Caterwauling Glory.' *Independent,* 17 May, accessed 15 August 2012. http://www.independent.co.uk/opinion/commentators/tanya-gold-europe-in-all-its-tacky-caterwauling-glory-563657.html.

Gorton, Kristyn. (2007). 'Theorizing Emotion and Affect: Feminist Engagements.' *Feminist Theory* 8.3: 333–348.

Graff, Agnieszka. (2006). 'We Are (Not All) Homophobes: A Report from Poland.' *Feminist Studies* 32: 434–449.

Graff, Agnieszka. (2010). 'Looking at Pictures of Gay Men: Political Uses of Homophobia in Contemporary Poland.' *Public Culture* 22.3: 583–603.

Greer, Germaine. (2007). 'Go, Marija! Eurovision's Triumphant Lesbian Gypsy.' *Guardian.* 21 May, accessed 14 June 2012. http://www.guardian.co.uk/culture/tvandradioblog/2007/may/21/gomarijaeurovisionstriumpha.

Gregg, Melissa, and Gregory J. Seigworth. (2010). *The Affect Theory Reader.* Durham: Duke University Press.

Gripsrud, Jostein. (2007). 'Television and the European Public Sphere.' *European Journal of Communication* 22.4: 479–492.

Gruszczynska, Anna, Ed. (2012). 'Parades of Pride or Shame? Documenting LGBTQ Visibility in Central and Eastern Europe.' *Sextures* 2.2, special issue. Online journal, accessed 10 October 2012. http://sextures.net/volume-2-issue-2.

Guardian. (2012). 'Serbia's Gay Pride Gathering to Take Place Indoors.' 4 October, accessed 8 October 2012. http://www.guardian.co.uk/world/2012/oct/04/serbias-gay-pride-indoors.

Gumilev, Lev. (1989). *Ethnogenez i biosphera Zemli.* Mocow: Gidrometeoizdat.

Gumpert, Matthew. (2007). '"Everyway that I can": Auto-Orientalism at Eurovision 2003.' *A Song for Europe.* Eds. Ivan Raykoff and Robert Deam Tobin, 147–158.

Ha, Kien Nghi. (2005). *Hype um Hybridität: Kultureller Differenzkonsum und postmoderne Verwertungstechniken im Spätkapitalismus.* Bielefeld: transcript.

Habermas, Jürgen, and Jacques Derrida. (2003). 'February 15, or, What Binds Europeans Together: Pleas for a Common Foreign Policy, Beginning in Core Europe.' *Old Europe, New Europe, Core Europe.* Eds. Daniel Levy, Max Pensky, and John Torpey. London: Verso, 3–13. Also in *Constellations* 10.3: 291–297.

Habib, Samar. (2010). 'Introduction: Islam and Homosexuality.' *Islam and Homosexuality.* Ed. Samar Habib. Santa Barbara, CA: ABC-CLIO, LLC, xvii–lxii.

Halberstam, Judith. (2011). *The Queer Art of Failure.* Durham and London: Duke University Press.

Hamersveld, Ineke van, and Arthur Sonnen, Eds. (2009). *Identifying with Europe: Reflections on a Historical and Cultural Canon for Europe.* Amsterdam: Boekmanstudies, EUNIC Netherlands, SICA.

Hammond, Andrew. (2004). *The Balkans and the West: Constructing the European other, 1945–2003.* Aldershot: Ashgate.

Hansen, Peo. (2004). 'In the Name of Europe.' *Race and Class* 4.3: 49–62.

Hansen, Randall. (2000). *Citizenship and Immigration in Post-War Britain: The Institutional Origins of a Multicultural Nation.* Oxford: Oxford University Press.

'Happy Hour Interview with Paula Seling.' (2008). ProTV channel, online video, accessed 27 November 2011. http://www.youtube.com/watch?v= VA6vvErvYQ&feature=related.

Harding, Luke. (2012). 'Letter from Tbilisi: Georgia Embraces Democracy but Destroys its Past.' *Guardian*, 14 October, accessed 2 December 2012. http://www.guardian.co.uk/commentisfree/2012/oct/14/georgia-embracing-democracy-destroying-past?INTCMP=SRCH.

Harrison, Brian. (2010). *Finding a Role? The United Kingdom, 1970–1990.* Oxford: Clarendon Press.

Harvie, Jen, and Keren Zaiontz. (2013). 'CfP: The Cultural Politics of the Olympics: Performing Global Britishness.' Online, accessed 5 January. http://qmul.academia.edu/KerenZaiontz/Posts.

Hasso, Frances S. (2011). 'Desiring Arabs (Review).' *Journal of the History of Sexuality* 20.3: 652–656.

Hastings, Chris. (2008). 'Terry Wogan is a Problem, says Eurovision Chief.' *Telegraph*, 10 May, accessed 16 August 2012. http://www.telegraph.co.uk/news/celebritynews/1944611/Terry-Wogan-is-a-problem-says-Eurovision-chief-Bjorn-Erichsen.html.

Henry, Julie, Tom Chivers, and agencies. (2008). 'Eurovision Song Contest: Sir Terry Wogan Questions His Future as UK Limps in Last.' *Telegraph*, 25 May, accessed 15 July 2012. http://www.telegraph.co.uk/news/uknews/2025086/Eurovision-Song-Contest-Sir-Terry-Wogan-questions-his-future-as-British-entry-Andy-Abraham-limps-in-last.html.

Herzog, Dagmar. (2010). 'Post coitum triste est …? Sexual Politics and Cultures in Postunification Germany.' *From the Bonn to the Berlin Republic: Germany at the Twentieth Anniversary of Unification.* Eds. Jeffrey Anderson and Eric Langenbacher. New York and Oxford: Berghahn Books, 131–159.

Hills, Matt. (2009). 'From BBC Radio Personality to Online Audience Presence: the Relevance of Fan Studies to Terry Wogan and the TOGs.' *The Radio Journal – International Studies in Broadcast and Audio Media* 7.1: 67–88.

Hobsbawm, Eric. (1995). *Age of Extremes: The Short Twentieth Century 1914–1991.* 2nd ed. London: Abacus.

Hochberg, Gil Z. (2010). 'Introduction: Israelis, Palestinians, Queers: Points of Departure.' *GLQ: A Journal of Lesbian and Gay Studies* 16.4: 493–516.

Hofbauer, Hannes. (2007). *EU-Osterweiterung: Historische Basis, ökonomische Triebkräfte, soziale Folgen.* Vienna: Promedia.

Hoggart, Simon. (2012). 'Simon Hoggart's Week: If Only This Was the Last Eurovision Song Contest.' *Guardian*, 25 May, accessed 26 May. http://www.guardian.co.uk/theguardian/2012/may/25/simon-hoggarts-week-eurovision-song.

Holdsworth, Nadine. (2010). *Theatre & Nation.* Houndmills: Palgrave Macmillan.

Holmwood, Leigh. (2009). 'Eurovision is "Rubbish", Terry Wogan Tells European Broadcasters.' *Guardian*, 6 May, accessed 26 May 2012. http://www.guardian.co.uk/media/2009/may/06/eurovision-terry-wogan-rubbish.

Howard, Mark Morjé. (2003). *The Weakness of Civil Society in Post-Communist Europe.* Cambridge, New York: Cambridge University Press.

Hrycak, Alexandra. (2006). 'Foundation Feminism and the Articulation of Hybrid Feminisms in Post-Socialist Ukraine.' *East European Politics and Societies* 20:1: 69–100.

Hunt, Tristram. (2012). 'Olympic Pageant Riled the Right by Showing the Reality of New Britain.' *Guardian.* 28 July, accessed 20 August. http://www.guardian. co.uk/sport/2012/jul/28/olympic-pageant-reality-new-britain.

Hurley, Erin. (2010). *Theatre & Feeling.* Houndmills: Palgrave Macmillan.

Hurley, Erin. (2011). *National Performance: Representing Québec from Expo 67 to Céline Dion.* Toronto: University of Toronto Press.

Huskey, Eugene. (2010). 'Pantouflage a la russe: The Recruitment of Russian Political and Business Elites.' *Russian Politics, From Lenin to Putin.* Ed. Stephen Fortescue. Houndmills: Palgrave Macmillan, 185–204.

Huyssen, Andreas. (1991). 'After the Wall: The Failure of German Intellectuals.' *New German Critique* 52.Winter: 109–43.

Ich Troje. (2003). 'Keine Grenzen/Zadnich granic.' Online video, accessed 15 April 2012. http://www.youtube.com/watch?v=rPsykIXpk2Y.

ILGA-Europe. (2011). 'Annual Review 2011 on Azerbaijan.' Online, accessed 16 September 2012. http://www.ilga-europe.org/home/guide/country_by_country/azerbaijan/ilga_europe_annual_review_2011_on_azerbaijan.

Imre, Aniko. (2009). *Identity Games: Globalization and the Transformation of Media Cultures in the New Europe.* Cambridge, MA: Massachusetts Institute of Technology Press.

Independent (UK). (2007). 'Sweet Song for Serbia.' 14 May, accessed 15 June 2012. http://www.independent.co.uk/opinion/leading-articles/leading-article-sweet-song-for-serbia-448729.html.

Ingvoldstadt, Björn. (2007). 'Lithuanian Contests and European Dreams.' *A Song for Europe.* Eds. Ivan Raykoff and Robert Deam Tobin, 99–110.

'Istoriya Pervogo Kanala.' (2011). 29 January, broadcast, accessed 10 July 2011. *1TV.RU.* http://www.1tv.ru/total/pi=2271.

Jameson, Fredric. (2005). *Archaelogies of the Future: The Desire Called Utopia and Other Science Fictions.* London: Verso.

Jivraj, Suhraiya, and Anisa de Jong. (2011). 'The Dutch Homo-Emancipation Policy and its Silencing Effects on Queer Muslims.' *Feminist Legal Studies* 19.2: 143–158.

Jordan, Paul. (2011). *The Eurovision Song Contest: Nation Building and Nation Branding in Estonia and Ukraine.* PhD thesis, Central and East European Studies, University of Glasgow.

Jørgensen, Anders. (2007). 'Skrid, det er vores fest.' *Information* (DK). 25 July, accessed 15 August 2012. http://www.information.dk/140224.

Kaelble, Hartmut. (2010). 'Preface.' *Building a European Public Sphere: From the 1950s to the Present.* Eds. Robert Frank, Hartmut Kaelble, Marie-Françoise Lévy, and Luisa Passerini. Brussels, New York: P.I.E. Peter Lang, 9–18.

Kagan, Robert. (2008). 'New Europe, Old Russia.' *The Washington Post.* 6 February, accessed 24 November 2011. http://www.washingtonpost.com/wp-dyn/content/article/2008/02/05/AR2008020502879.html.

Kaldor, Mary. (2007). 'Oil and Conflict: The Case of Nagorno Karabakh.' *Oil Wars.* Eds. Mary Kaldor, Terry Karl, and Yahia Said. London: Pluto, 157–182.

Karahasanoğlu, Songül, and Gabriel Skoog. (2009). 'Synthesizing Identity: Gestures of Filiation and Affiliation in Turkish Popular Music.' *Asian Music* 40.2: 52–71.

Kavka, Misha. (2008). *Reality Television, Affect and Intimacy: Reality Matters.* Houndmills: Palgrave Macmillan.

Khunkham, Kritsanarat. (2010). 'Raab erklärt Grand Prix zur nationalen Aufgabe.' *Die Welt.* 22 January, accessed 3 April 2012. http://www.welt.de/vermischtes/article5930797/Raab-erklaert-Grand-Prix-zur-nationalen-Aufgabe.html.

Kishkovsky, Sophia. (2008). 'Eurovision Triumph by Dima Bilan Gives Russia Another Shot of Pride.' *The New York Times.* 25 May, accessed 6 November 2011. http://www.nytimes.com/2008/05/25/world/europe/25iht-russia.4.13196959.html?_r=0.

Klotz, Marcia. (1995). *White Women and the Dark Continent: Gender and Sexuality in German Colonial Discourse from the Sentimental Novel to the Fascist Film.* PhD thesis, Stanford University, Stanford, CA.

Kontje, Todd. (2004). *German Orientalisms.* Ann Arbor: University of Michigan Press.

Kopp, Kristin. (2001). *Contesting Borders: German Colonial Discourse and the Polish Eastern Territories.* PhD thesis, University of California, Berkeley, CA.

Kratochvíl, Petr. (2008). 'The Discursive Resistance towards EU-Enticement: The Russian Elite and (the Lack of) Europeanisation.' *Europe-Asia Studies* 60: 397–422.

Kucha, Pecha. (2011). 'Eurovision Winner "Running Scared" by Ell/Nikki Makes Huge Impact in European Music Charts.' 3 August. Online, accessed 3 March 2013. https://eurovision2012.wordpress.com/tag/azerbaijan/.

Kulpa, Robert, and Joanna Mizielińska. (2011). *De-Centring Western Sexualities. Central and Eastern European Perspectives.* Farnham: Ashgate.

Lane, Anthony. (2010). 'Only Mr. God Knows Why: The Meaning of the Eurovision Song Contest.' *The New Yorker.* 28 June, accessed 3 June 2012. http://www.newyorker.com/reporting/2010/06/28/100628fa_fact_lane/.

Lang, Gladys Engel, and Kurt Lang. (2001). *Etched in Memory: The Building and Survival of Artistic Reputation.* Champaign, IL: University of Illinois Press.

Langer, Annette. (2012). 'Intolerant Eurovision Host: Gays Face Rampant Homophobia in Azerbaijan.' *Spiegel Online.* 5 May, accessed 20 May. http://www.spiegel.de/international/world/homophobia-rampant-in-eurovision-host-country-azerbaijan-a-835265.html.

Laruelle, Marlène. (2008). *Russian Eurasianism. An Ideology of Empire.* Trans. Mischa Gabowitsch. Baltimore: Johns Hopkins University Press.

Lauwens, Jean-François. (2010). 'Ce show que l'on adore détester.' *Le Soir.* 29 May.

Lee, Catherine, and Robert Bideleux. (2009). ' "Europe": What Kind of Idea?' *The European Legacy: Toward New Paradigms* 14:2: 163–176.

Lemish, Dafna. (2007). 'Gay Brotherhood: Israeli Gay Men and the Eurovision Song Contest.' *A Song for Europe.* Eds. Ivan Raykoff and Robert Deam Tobin, 123–133.

Leveau, Rémy, Khadija Mohsen-Finan, and Catherine Wihtol de Wenden, Eds. (2002). *New European Identity and Citizenship.* Aldershot: Ashgate.

Levin, Laura, and Marlis Schweitzer, Eds. (2011). 'Performing Publics.' *Performance Research* 16.2: 1–6.

Lévy, Daniel, Max Pensky, and John C. Torpey, Eds. (2005). *Old Europe, New Europe, Core Europe: Transatlantic Relations after the Iraq War.* London: Verso, 2005.

Libertatea. (2010a). 'Il vor descalifica pentru că e țigan.' 25 January, accessed 27 November 2011. http://www.libertatea.ro/detalii/articol/il-vor-descalifica-pentru-ca- este-tigan-273398.html.

Libertatea. (2010b). 'Marina Almășan: Prezența lui Florin Salam la Eurovision ar fi fost o pată de culoare', 6 February, accessed 27 November 2011. http://www.libertatea.ro/detalii/articol/marina-almasan-prezenta-lui-florin-salam-la-eurovision-ar-fi-fost-o-pata- de-culoare-275270.html.

Liljeström, Marianne, and Susanna Paasonen, Eds. (2010). *Working with Affect in Feminist Readings: Disturbing Differences.* London; New York: Routledge.

Lindström, Therese. (2012). 'Schlaget om schlagerarenan over.' DN.se. 9 July, accessed 20 August. http://www.dn.se/kultur-noje/musik/slaget-om-schlagerarenan-over.

Lisle, Debbie. (2006). *The Global Politics of Contemporary Travel Writing.* Cambridge: Cambridge University Press.

Liulevicius, Vejas Gabriel. (2009). *The German Myth of the East: 1800 to the Present.* Oxford, New York: Oxford University Press.

LOCOG (The London Organising Committee of the Olympic Games and Paralympic Games Ltd.). (2012). 'London 2012 Olympic Games Opening Ceremony Media Guide.' Online, accessed 15 August. http://www.london2012.com/mm/Document/Documents/Publications/01/30/43/40/OPENINGCEREMONYGUIDE_English.pdf.

Lukić, Jasmina, Joanna Regulska, and Darja Zavirsek, Eds. (2006). *Women and Citizenship in Central and Eastern Europe.* Burlington: Ashgate.

Luscombe, Tim. (2005). 'Terry-land: Nul Point.' *New Statesman.* 23 May, accessed 15 August 2012. http://www.newstatesman.com/node/150708.

MacFayden, David. (2008). *Russian Television Today. Primetime Drama and Comedy.* London: Routledge.

Maldonado-Torres, Nelson. (2007). 'On the Coloniality of Being.' *Cultural Studies* 21: 240–270.

Marian-Bălașa, Marin. (2006). 'Virusul "antimanele" sau Despre muzică și segregare în cultura și societatea românească.' *Anuarul Institutului de Etnografie și Folclor "Constantin Brăiloiu"* Serie Nouă 17: 77–87.

Massad, Joseph A. (2007). *Desiring Arabs.* Chicago: University of Chicago Press.

Mazawer, Mark. (2011). 'Is Vladimir Putin's Eurasian Dream Worth the Effort?' *Guardian,* 7 October, accessed 5 November. http://www.guardian.co.uk/commentisfree/2011/oct/07/vladimir-putin-eurasian-dream.

McAdams, A. James. (2010). 'The Last East German and the Memory of the German Democratic Republic.' *From the Bonn to the Berlin Republic: Germany at the Twentieth Anniversary of Unification.* Eds. Jeffrey Anderson and Eric Langenbacher. New York: Berghahn Books, 51–62.

McRobbie, Angela. (2009). *The Aftermath of Feminism: Gender, Culture and Social Change.* London: Sage.

Mehlig, Holger. (2010). 'Stefan Raab und seine "nationale Aufgabe," Stern.de, 22 January, accessed 3 March 2012. http://www.stern.de/kultur/musik/eurovision-stefan-raab-und-seine-nationale-aufgabe-1537703.html.

Melegh, Attila. (2006). 'Perspectives on the East-West Slope in the Process of EU Accession.' *The European's Burden: Global Imperialism in EU Expansion.* Ed. Engel-Di Mauro. New York: Peter Lang, 165–182.



Muñoz, José Esteban. (2009b). *Cruising Utopia: The Then and There of Queer Futurity*. New York: New York University Press.

Muse, John. (2010). 'Flash Mobs and the Diffusion of the Audience.' *Theater* 40.3: 9–24.

Naas, Michael. (2008). *Derrida from now on*. New York: Fordham University Press.

Nalich, Petr. (2010). 'Nalich, kotoryj gulyaet sam po sebe.' *Vzglyad. Delovaya Gazeta*. 15 March, accessed 10 July 2011. http://www.vz.ru/culture/2010/3/15/383806.html.

Nelson, Fraser. (2012). 'Eurovision Song Contest is the Real Union of Europe.' *Telegraph*. 25 May, accessed 15 August. http://www.telegraph.co.uk/culture/tvandradio/eurovision/9289950/Eurovision-Song-Contest-is-the-real-union-of-Europe.html.

News.Az. (2012). 'Gay Parade in Baku: To Be or not to Be?' 12 January, accessed 18 May. http://www.news.az/articles/52533.

Nobel Prize. 2012. 'The Nobel Peace Prize 2012'. 12 October, accessed 24 October. http://www.nobelprize.org/nobel_prizes/peace/laureates/2012/.

Nölke, Andreas, and Arjan Vliegenthart. (2009). 'Enlarging the Varieties of Capitalism: The Emergence of Dependent Market Economies in East Central Europe.' *World Politics* 61: 670–702.

Nordstrom, Louise. (2012). 'Tutu: EU Not Worthy to Win Nobel Peace Prize'. 30 November, accessed 12 December. http://news.yahoo.com/tutu-eu-not-worthy-win-nobel-peace-prize-133224912.html.

Novikova, Irina. (2006). 'Gender Equality in Latvia: Achievements and Challenges.' *Women and Citizenship in Central and Eastern Europe*. Eds. Jasmina Lukić, Joanna Regulska, and Darja Zaviršek. Aldershot: Ashgate, 101–117.

Objektiv.tv. (2012). 'Opposition Activists Harassed (Baku, Azerbaijan).' 23 June, accessed 30 October 2012. http://www.youtube.com/watch?v=rLZi4JcmVDU.

O'Connor, John Kennedy. (2005). *The Eurovision Song Contest. 50 years. The Official History*. London: Carlton Books.

O'Connor, John Kennedy. (2010). *The Eurovision Song Contest: The Official History*. London: Carlton Books.

Ong, Aiwha. (2003). *Buddha Is Hiding: Refugees, Citizenship, and the New America*. Ewing, NJ: University of California Press.

Orenstein, Mitchell A. (2009). 'What Happened in East European (Political) Economies? A Balance Sheet for Neoliberal Reform.' *East European Politics and Societies*, November: 479–490.

Orenstein, Mitchell A. (2010). 'The Political Economy of Financial Crisis in Central and Eastern Europe: Poland and Hungary Compared.' Online, accessed 25 July 2011. http://www.gwu.edu/~ieresgwu/assets/docs/Crisis_Paper_Orenstein.pdf.

Ost, David. (2005). *The Defeat of Solidarity: Anger and Politics in Postcommunist Europe*. Ithaca: Cornell University Press.

O'Toole, Fintan. (1997). *The Lie of the Land: Irish Identities*. London: Verso.

Outhwaite, William. (2006). *The Future of Society*. Oxford: Blackwell Publishing.

Paasonen, Susanna. (2011). *Carnal Resonance: Affect and Online Pornography*. Cambridge, MA: Massachusetts Institute of Technology Press.

Pajala, Mari. (2006). *Erot järjestykseen! Eurovision laulukilpailu, kansallisuus ja televisiohistoria*. Jyväskylä, Finland: Nykykulttuurin tutkimuskeskus.

Pajala, Mari. (2007a). 'Finland, Zero Points: Nationality, Failure, and Shame in the Finnish Media.' *A Song for Europe*. Eds. Ivan Raykoff and Robert Deam Tobin, 71–82.

Pajala, Mari. (2007b). 'Closeting Eurovision: Heteronormativity in the Finnish National Television.' *SQS – Journal of Queer Studies in Finland* 2.7: 25–42.

Pajala, Mari. (2011). 'Making Television Historical: Cultural Memory of the Eurovision Song Contest in the Finnish Media 1961–2005.' *Media History* 17.4: 405–418.

Panizza, Francisco. (2005). 'Introduction: Populism and the Mirror of Democracy.' *Populism and the Mirror of Democracy*. Ed. Francisco Panizza. London and New York: Verso, 1–31.

Passerini, Luisa, Ed. (2002). *Figures d' Europe/ Images and Myths of Europe*. Oxford: Peter Lang.

Passerini, Luisa. (2007). *Memory and Utopia: The Primacy of Intersubjectivity*. London: Equinox.

Passerini, Luisa. (2012). 'Europe and Its Others: Is There a European Identity?' *The Oxford Handbook of Postwar European History*. Ed. Dan Stone. Oxford: Oxford University Press, 121–138.

Pavlyshyn, Marko. (2006). 'Envisioning Europe: Ruslana's Rhetoric of Identity.' *SEEJ* 50.3: 469–485.

Pedwell, Carolyn, and Anne Whitehead, Eds. (2012). 'Affecting Feminism: Questions of Feeling Feminist.' *Feminist Theory* 13.2.: 115–129.

Peters, Joel. (2012). *The European Union and the Arab Spring: Promoting Democracy and Human Rights in the Middle East*. Lanham, MD: Lexington Books.

Puar, Jasbir. (2007). *Terrorist Assemblages: Homonationalism in Queer Times*. Durham, NC: Duke University Press.

Puar, Jasbir. (2011). 'Citation and Censorship: The Politics of Talking About the Sexual Politics of Israel.' *Feminist Legal Studies* 19.2: 133–142.

Radio Golos Rossii. (2012). 'Hit 'Buranovskih babushek' pereveli na russkij yasyk.' 12 March, accessed 25 April 2012. http://rus.ruvr.ru/2012_03_12/68223946/.

Rahman, Momin. (2010). 'Queer as Intersectionality: Theorising Gay Muslim Identities.' *Sociology* 44.5: 944–961.

Rajar.co.uk. (2012). 'Rajar Data Release; Quarter 3, 2012.' Online, accessed 25 October. http://www.rajar.co.uk/docs/2012_09/National%20Stations% 20Q3%202012.pdf.

Ramazani, Jahan. (2009). *A Transnational Poetics*. Chicago and London: University of Chicago Press.

Raykoff, Ivan. (2007). 'Camping on the Borders of Europe.' *A Song for Europe*. Eds. Ivan Raykoff and Robert Deam Tobin, 13–24.

Raykoff, Ivan and Robert Deam Tobin, Eds. (2007). *A Song for Europe: Popular Music and Politics in the Eurovision Song Contest*. Aldershot: Ashgate.

Rehberg, Peter. (2007). 'Winning Failure. Queer Nationality at the Eurovision Song Contest.' *SQS – Journal of Queer Studies in Finland* 2.7: 60–65.

Rehberg, Peter and Tuhkanen, Mikko. (2007). 'Danzing Time. Dissociative Camp and European synchrony.' *SQS – Journal of Queer Studies in Finland* 2.7: 43–59.

Reinelt, Janelle G. (2001). 'Performing Europe: Identity Formation for a "New" Europe.' *Theatre Journal* 53.3: 365–387.

Reinelt, Janelle G. (2006). 'Toward a Poetics of Theater and Public Events: In the Case of Stephen Lawrence.' *TDR: The Drama Review* 50.3: 69–87.

Reinelt, Janelle G. (2011). 'Rethinking the Public Sphere for a Global Age.' *Performance Research* 16.2: 16–27.

Remington, Thomas F. (2008). *Politics in Russia.* 5th ed. New York: Pearson; Longman.

Reynolds, David. (2006). *From World War to Cold War: Churchill, Roosevelt, and the International History of the 1940s.* Oxford: Oxford University Press.

RFE/RL's Balkan Service. (2012). 'Serbian Gay Rights Activists Hold Symbolic Protest.' 6 October, accessed 12 October. http://www.rferl.org/content/serbia-gay-rights-activists-parade/24731321.html.

Risse, Thomas. (2010). *A Community of Europeans? Transnational Identities and Public Spheres.* Ithaca: Cornell University Press.

Roberts, Andy. (2009). *Flying the Flag: The United Kingdom in Eurovision.* Bloomington, IN: AuthorHouse.

Ross, Andrew. (1989). 'Uses of Camp.' *No Respect: Intellectuals and Popular Culture.* London: Routledge, 135–170.

Rybak, Alexander. (2010). 'Eurovision was the Peak of my Career.' *EurovisionTV.* 20 November, accessed 30 November 2011. http://www.eurovision.tv/page/news?id=22133&_t='Eurovision+was+the+peak+of+my+career'+Rybak+says.

Sabsay, Leticia. (2012). 'The Emergence of the Other Sexual Citizen: Orientalism and the Modernisation of Sexuality.' *Citizenship Studies* 16.5–6: 605–623.

Sakwa, Richard. (2012). 'Russia as Eurasia: An Innate Cosmopolitanism.' *Europe and Asia Beyond East and West.* Ed. Gerard Delanty. London: Routledge, 215–227.

Salmon, Caspar. (2011). 'Review. "Britain's Got Talent": No, It Really Hasn't'. 18 April, accessed 12 December 2012. http://www.pajiba.com/tv_reviews/review-britains-got-talent-no-it-really-hasnt.php.

Sandberg, Marian. (2009). 'Casey To Design ESC in Moscow.' *LiveDesignOnLine.* 3 February, accessed 24 November 2011. http://livedesignonline.com/news/casey_designs_esc_moscow_0202/index.html.

Sandip, Roy. (2005). 'Can Gay Marriage Protect Europe from Subway Bombers?' *Pacific News Service,* 13 July, accessed 17 September 2012. http://news.newamericamedia.org/news/view_article.html?article_id=a517da0536e361e88382124f9dd53bb3.

Sanremo Festival. Event website, accessed 5 January 2013. www.sanremo.rei.it.

Sassatelli, Monica. (2009). *Becoming Europeans: Cultural Identity and Cultural Policies.* Houndmills: Palgrave Macmillan.

Savage, Mark. (2010). 'Germany Drags Eurovision into the 21st Century.' BBC New Entertainment & Arts. 30 May, accessed 3 March 2012. http://www.bbc.co.uk/news/10192518.

Savodnik, Peter. (2011). 'Eurovision: Nation Branding via Cheesy Pop Music.' *Bloomberg Business Week.* 9 June, accessed 2 February 2012. http://www.businessweek.com/magazine/content/11_25/b4233082012236.htm.

Schmidt, Ingo. (2011). 'European Capitalism: Varieties of Crisis.' *Alternate Routes: A Journal of Critical and Social Research* 22: 71–85.

Scribner, Charity. (2005). *Requiem for Communism.* Cambridge, MA: Massachusetts Institute of Technology Press.

Sedgwick, Eve Kosofsky. (1997). 'Paranoid Reading and Reparative Reading; or, You're So Paranoid, You Probably Think This Introduction Is about You.' *Novel*

Gazing. *Queer Readings in Fiction.* Ed. Eve Kosofsky Sedgwick. Durham: Duke University Press, 1–37.

Sieg, Katrin. (2002). *Ethnic Drag: Performing Race, Nation, Sexuality in West Germany.* Ann Arbor: University of Michigan Press.

Sieg, Katrin. (2008). *Choreographing the Global in European Cinema and Theater.* Houndmills: Palgrave Macmillan.

Sieg, Katrin. (2013). 'Wii are Family: Performing Race in Neoliberal Europe.' *Theatre Research International* 38.01: 20–33.

Sigona, Nando and Nidhi Trehan, Eds. (2009). *Romani Politics in Contemporary Europe: Poverty, Ethnic Mobilization and the Neoliberal Order.* Houndmills: Palgrave Macmillan.

Siim, Jarmo. (2012). '39 Countries to take part in Eurovision 2013.' 21 December, accessed 30 December. http://www.eurovision.tv/page/news?id=70813&_t=39_countries_to_take_part_in_eurovision_2013.

Silverman, Carol. (2007). 'Trafficking in the Exotic with "Gypsy" Music: Balkan Roma, Cosmopolitanism and "World Music" Festivals.' *Balkan Popular Culture and the Ottoman Ecumene: Music, Image and Regional Political Discourse.* Ed. Donna A. Buchanan. Lanham, MD: Scarecrow Press, 335–361.

Sindelar, Daisy. (2012). 'Eurovision Glitz Is Assured, But For Azerbaijan's Gays, It's Same Old Song.' *Radio Free Europe.* 17 May, accessed 19 May. http://www.rferl.org/content/azerbaijan-eurovision-gay-rights-lgbt/24584507.html.

Sing for Democracy. (2012). Online, accessed 6 January 2013. http://www.singfordemocracy.org/reports/general-report-on-human-rights#.

Singleton, Brian, Karen Fricker, and Elena Moreo. (2007). 'Performing the Queer Network: Fans and Families at the Eurovision Song Contest.' *SQS – Journal of Queer Studies in Finland* 2.7: 12–24.

Skeggs, Beverley, and Helen Wood. (2012). *Reacting to Reality Television: Performance, Audience and Value.* London: Routledge.

Smith, Helena. (2012a). 'Greece Shocked at EU Peace Prize Amid Economic "War".' *Guardian*, 12 October.

Smith, Helena. (2012b). They're not singing any more: Eurovision suffers a rash of withdrawals.' 30 November, accessed 5 December. http://www.guardian.co.uk/tv-and-radio/2012/nov/30/eurovision-withdrawals-not-singing-anymore.

Smith, Kathleen E. (2002). *Mythmaking in the New Russia. Politics and Memory During the Yeltsin Era.* Ithaca and London: Cornell University Press.

Solomon, Alisa. (2003). 'Viva la Diva Citizenship: Post-Zionism and Gay Rights.' *Queer Theory and the Jewish Question.* Eds. Daniel Boyarin, Daniel Itzkovitz, and Ann Pellegrini. New York: Columbia University Press, 149–165.

Solomon, Thomas. (2007). 'Articulating the Historical Moment: Turkey, Europe, and Eurovision 2003.' *A Song for Europe.* Eds. Ivan Raykoff and Robert Deam Tobin, 135–146.

Sontag, Susan. (1990). 'Notes on "Camp."' *Against Interpretation and other Essays.* New York: Picador, 275–292.

Spencer, Mel. (2012). 'Peter Tatchell Urges Eurovision Singers to Fight for Free Speech in Azerbaijan.' *Pink News.* 25 May, accessed 27 May. http://www.pinknews.co.uk/2012/05/25/peter-tatchell-urges-eurovision-singers-to-fight-for-free-speech-in-azerbaijan/.

Spencer, Robert. (2009). 'The Politics of Imperial Nostalgia.' *Racism, Postcolonialism, Empire.* Eds. Graham Huggan and Ian Law. Liverpool: Liverpool University Press, 176–196.

256 *Bibliography*

256 *Bibliography*

Spiegel Online. (2010). 'Eurovision's Next Winner?: The Cult of Lena-ism.' 21 May, accessed 2 February 2012. http://www.spiegel.de/international/europe/0,1518,695965,00.html.

Spiegel Online. (2012a). 'Berlin Sees Eurovision as Forum for Civil Rights.' 14 March, accessed 1 May. http://www.spiegel.de/international/europe/westerwelle-says-song-contest-should-be-forum-for-promoting-civil-rights-a-821261.html.

Spiegel Online. (2012b). 'Powerful Pipes and Pipelines: Can Eurovision Burnish Azerbaijan's Image?' 5 May, accessed 6 May. http://www.spiegel.de/international/zeitgeist/powerful-pipes-and-pipelines-can-eurovision-burnish-azerbaijan-s-image-a-762622.html.

Spivak, Gayatri Chakravorty. (1988). 'Can the subaltern speak?' *Marxism and the Interpretation of Culture.* Eds. Cary Nelson and Lawrence Grossberg. Chicago: University of Illinois Press, 271–313.

Stanton, John. (2012a). 'Slovakia withdraws from the 2013 Eurovision Song Contest.' 6 December, accessed 6 December. http://www.eurovisionary.com/eurovision-news/slovakia-withdraws-2013-eurovision-song-contest.

Stanton, John. (2012b). 'Bosnia and Herzegovina withdraws from the 2013 Eurovision Song Contest.' 14 December, accessed 14 December. http://www.eurovisionary.com/eurovision-news/bosnia-herzegovina-withdraws-2013-eurovision-song-contest.

Stewart, Susan. (1993). *On Longing: Narratives of the Miniature, the Gigantic, the Souvenir, the Collection.* Durham, NC: Duke University Press.

Storvik-Green, Simon. (2012). 'Malmö 2013: The technical arms race is over.' 26 October, accessed 5 November. http://www.eurovision.tv/page/news?id=malmoe_2013_the_technical_arms_race_is_over.

Straumanis, Andris. (2002). 'Naumova Gives up Tibet Trip for Tallinn.' *Latvians Online.* 17 April, accessed 13 October 2011. http://latviansonline.com/news/article/3031/.

Sullivan, Caroline. (2007). 'Out for the Count.' *Guardian.* 23 November, accessed 5 August 2012. http://www.guardian.co.uk/music/2007/nov/23/popandrock7.

Sultanova, Shahla. (2012). 'After the Curtain Call, A Crackdown Begins.' *Inter Press Service News Agency,* 19 June, accessed 12 September. http://www.ipsnews.net/2012/06/after-the-curtain-call-a-crackdown-begins/.

Szeman, Ioana. (2009). ' "Gypsy Music" and Deejays: Orientalism, Balkanism and Romani Musicians.' *TDR: The Drama Review* 53: 98–116.

Szeman, Ioana. (2010). 'Collecting Tears: Remembering the Romani Holocaust.' *Performance Research* 15: 54–59.

Szeman, Ioana. (forthcoming). *Stages of Erasure: Romani Citizenship and Gypsy Performance in Postsocialist Multiculturalism.*

Tadiar, Neferti X. M. (1998). 'Sexual Economies in the Asia-Pacific Community.' *What is in a Rim? Critical Perspectives on the Pacific Region Idea.* Ed. Arif Dirlik. Boulder: Westview, 183–210.

Taneski, Gjoko. (2010). 'Jas ja imam silata.' Online video, accessed 15 April 2012. http://www.youtube.com/watch?v=51g0IDr9sBc.

Tatchell, Peter. (2011). 'Not a Safe Country for LGBT People, or for Anyone Who Protest and Dissents.' 16 May, accessed 15 October 2012. http://www.petertatchell.net/international/world_general/eurovision-2012-serious-human-rights-abuses-in-azerbaijan.htm.

Tatchell, Peter. (2012). 'Azerbaijan Fails Human Rights Test for Eurovision.' 24 May, accessed 15 October. http://www.petertatchellfoundation.org/azerbaijan/azerbaijan-fails-human-rights-test-eurovision.

Taylor, Debbie. (1985). 'Women: An Analysis.' *Women: A World Report*. Ed. Debbie Taylor. London: Methuen, 1–98.

Taylor, Laurie, and Bob Mullan. (1987). *Uninvited Guests: The Intimate Secrets of Television and Radio*. London: Coronet.

'Terry Wogan Biography.' (2012). BBC Radio 2 website, accessed 2 August. http://www.bbc.co.uk/radio2/ presenters/terry-wogan/.

Thum, Gregor, Ed. (2006). *Traumland Osten: Deutsche Bilder vom östlichen Europa im 20. Jahrhundert*. Göttingen: Vandenhoeck & Ruprecht.

Thynne, Jane. (2009). 'Barely A Dry Eye as Sir Terry Wogan Signs Off.' *The Independent*. 18 December, accessed 2 August 2012. http://www.independent.co.uk/news/media/tv-radio/barely-a-dry-eye-as-sir-terry-wogan-signs-off-1844507.html.

The Times of India. (2012). 'Fortress Britain.' 12 June, accessed 6 August. http://articles.timesofindia.indiatimes.com/2012-06-12/edit-page/32176109_1_immigration-norms-foreign-students-spouses.

Tisdall, Simon. (2012). 'Iran and Turkey's Meeting Reveals New Approach to Syria.' *Guardian*, 25 October, accessed 2 November. http://www.guardian.co.uk/world/2012/oct/25/iran-turkey-new-approach-syria.

Tobin, Robert Deam. (2007). 'Eurovision at 50: Post-Wall and Post-Stonewall.' *A Song for Europe*. Eds. Ivan Raykoff and Robert Deam Tobin, 25–36.

Todorova, Maria. (1997; 2009). *Imagining the Balkans*. Oxford: Oxford University Press.

Tomz, Michael. (2007). *Reputation and International Cooperation: Sovereign Debt Across Three Centuries*. Princeton, NJ: Princeton University Press.

Torbakov, Igor. (2004). 'Russia's Eastern Offensive: Eurasianism Versus Atlanticism.' *The Jamestown Foundation Eurasia Daily Monitor* 1.38. 24 June. Online, accessed 7 February 2011. http://www.cdi.org/russia/312–13.cfm.

Troitsky, Artemy. (2005). 'Evrovidenie bez fua-gra.' *Radio Svoboda*. 13 May. Online, accessed 6 November 2011. http://www.svobodanews.ru/content/article/1731003.html.

Troitsky, Artemy. (2008a). 'Bilana postaralis; ukrepit' co vsekh storon.' *Novosti Showbisnessa*. 25 May. Online, accessed 6 November 2011. http://www.shoowbiz.ru/showbiznews/2066.html.

Troitsky, Artemy. (2008b). 'Osoboye mneniye. Interview with Artemy Troitsky and Marina Starostina.' *Echo Moskvy*. 12 March. Online, accessed 6 November 2011. http://www.echo.msk.ru/programs/personalno/500040-echo.phtml.

Troitsky, Artemy. (2010a). 'Rok umer davno, no pohorony proshli pyshno.' *Novaya Gazeta* 63. 16 June. Online, accessed 6 November 2011. http://www.novayagazeta.ru/data/2010/063/22.html.

Troitsky, Artemy. (2010b). 'Evrovidenie ne Umret, poskol'ku dur' bessmertna.' MIXNEWS. 1 June. Online, accessed 6 November 2011. http://www.mixnews.lv/ru/world/interviews/2010-06-01/585.

Tuhkanen, Mikko. (2007). 'Introduction: Queer Eurovision, Post-Closet.' *SQS – Journal of Queer Studies in Finland* 2.7: 8–11.

Tuhkanen, Mikko, and Annamari Vänskä, Eds. (2007). Special Issue: 'Queer Eurovision.' *SQS: Journal of Queer Studies in Finland* 2.7.

Turner, Michael J. (2010). *Britain's International Role, 1970–1991.* Houndmills: Palgrave Macmillan.

'TV Total'. (2007). Pro 7 (Germany). 5 May, accessed 3 March 2012.

'TV Total.' (2010). Pro 7 (Germany). 28 May, accessed 3 March 2012.

'TV Total. (2011). Pro 7 (Germany). 12 May, accessed 3 March 2012.

Tworzecki, Hubert. (2008). 'A Disaffected New Democracy? Identities, Institutions and Civic Engagement in Post-communist Poland.' *Communist and Post-Communist Studies* 41: 47–62.

US Department of State. (2011). '2010 Human Rights Report: Azerbaijan.' 8 April, accessed 16 September 2012. http://www.state.gov/j/drl/rls/hrrpt/2010/eur/154413.htm.

Vänska, Annamari. (2007). 'Bespectacled and over the Top. On the Genealogy of Lesbian Camp.' *SQS: Journal of Queer Studies in Finland* 2.7: 66–80.

Verdery, Katherine. (1991). *National Ideology under Socialism: Identity and Cultural Politics in Ceausescu's Romania.* Berkeley: University of California Press.

Verdery, Katherine. (1996). *What Was Socialism, and What Comes Next?* Princeton: Princeton University Press.

Verney, Susannah. (1993). 'From the "Special Relationship" to Europeanism: PASOK and the European Community, 1981–89.' *Greece 1981–89: The Populist Decade.* Ed. Richard Clogg. Houndmills: Palgrave Macmillan, 131–153.

Vidmar-Horvat, Ksenija. (2010). 'Consuming European Identity: The Inconspicuous Side of Consumerism in the EU.' *International Journal of Cultural Studies* 13.1: 25–41.

Vovk, Svetlana. (2012). ' "Eurovision – 2012": pobedili sila i neporochnost.' RIA.NOVOSTI. 27 May. Online, accessed 9 December 2012. http://ria.ru/culture/20120527/658463879-print.html.

Vuletic, Dean. (2007). 'The socialist star: Yugoslavia, Cold War Politics and the Eurovision Song Contest.' *A Song for Europe.* Eds. Ivan Raykoff and Robert Deam Tobin, 83–98.

Waites, Matthew. (2009). ' "Critique of Sexual Orientation" and "Gender Identity" in Human Rights Discourse: Global Queer Politics beyond the Yoyakarta Principles.' *Contemporary Politics* 15.1: 137–156.

'Wake Up To Wogan.' (2012). BBC Radio 2 website, accessed 3 August 2012. http://www.bbc.co.uk/programmes/b006z6tc.

Walker, Shaun. (2012a). 'Protesters Bundled away on Eve of Eurovision; Rights Activists in Azerbaijan are Hoping for Support this Evening.' *Independent.co.uk.* 26 May.

Walker, Shaun. (2012b). 'Boom-bang-a-bust Glitz of Eurovision proves too costly for some in age of austerity.' 25 November, accessed 25 November. http://www.independent.co.uk/news/world/europe/boombangabust-glitz-of-eurovision-proves-too-costly-for-some-in-age-of-austerity-8348984.html.

Wallerstein, Immanuel. (2006). *European Universalism: The Rhetoric of Power.* New York: New Press.

Warburg, Bettina. (2010). 'Germany's National Identity, Collective Memory and Role Abroad.' *Power and the Past: Collective Memory and International Relations.* Eds. Eric Langenbacher and Yossi Shain. Washington: Georgetown University Press, 51–70.

Ward Jouve, Nicole. (1991). *White Woman Speaks with Forked Tongue: Criticism as Autobiography*. London: Routledge.

Warner, Michael. (2002). *Publics and Counterpublics*. Brooklyn: Zone Books.

Webster Wilde, Lyn. (1999). *On the Trail of The Women Warriors*. London: Constable.

Whelehan, Imelda. (2000). *Overloaded: Popular Culture and the Future of Feminism*. London: Virago.

White, Brian. (1992). *Britain, Détente and Changing East-West Relations*. London: Routledge.

White, Jim. (2007). 'Everything Changes...Except Eurovision.' *Daily Telegraph*. 14 May, accessed 3 August 2012. http://www.telegraph.co.uk/comment/personal-view/3639890/Everything-changes.-.-.-except-Eurovision.html.

White, Stephen, Ian McAllister, and Valentina Feklyunina. (2010). 'Belarus, Ukraine, and Russia: East or West?' *British Journal of Politics and International Relations* 12: 344–367.

Whitehouse, David. (2007). 'Why We Watch...Eurovision.' *RadioTimes*. 27 August.

Whybrow, Nicolas. (2010). *Performance and the Contemporary City: An Interdisciplinary Reader*. Houndmills: Palgrave Macmillan.

Wickström, David-Emil, and Yngvar Steinholt. (2009). 'Visions of the (Holy) Motherland in Contemporary Russian Popular Music: Nostalgia, Patriotism, Religion, and *Russkii Rok*'. *Popular Music and Society* 32: 313–330.

Wildenthal, Lora. (2001). *German Women for Empire, 1884–1945*. Durham: Duke University Press.

Williams, Morgan E. (2004). 'Ruslana Wins! Ukraine Wins!' *ArtUkraine.com*. 16 May, accessed 14 November 2011. http://www.artukraine.com/old/events/rus_evr4.htm.

Wintour, Patrick. (2012). 'Theresa May Considers Curbs on UK Migration.' *Guardian*. 7 October.

Wogan, Terry. (1998). 'Forward.' *The Complete Eurovision Song Contest Companion*. Eds. Paul Gambaccini, Tim Rice, Jonathan Rice, and Tony Brown. London: Trafalgar Square, 1998.

Wolff, Larry. (1994). *Inventing Eastern Europe: The Map of Civilization on the Mind of the Enlightenment*. Stanford: Stanford University Press.

Wortmann, Söhnke, dir. (2003). *Das Wunder von Bern*. Film. Germany.

Wroe, David. (2010). 'Keepin' It Real: Can Lena's Calculated Chaos Win Eurovision?' *The Local*. 28 May, accessed 2 February 2012. http://www.thelocal.de/society/20100528-27495.html.

Yair, Gad. (1995). ' "Unite Unite Europe". The Political and Cultural Structures of Europe as reflected in the Eurovision Song Contest.' *Social Networks* 17.2: 147–161.

Yair, Gad, and Daniel Maiman. (1996). 'The Persistent Structure of Hegemony in the Eurovision Song Contest.' *Acta Sociologica* 39.3: 309–325.

Yuval-Davis, Nira. (1997). 'Women, Citizenship and Difference.' *Feminist Review* 57: 4–27.

Zantop, Susanne. (1997). *Colonial Fantasies: Conquest, Family, and Nation in Precolonial Germany, 1770–1870*. Durham: Duke University Press.

Zielonka, Jan, Ed. (2002). *Europe Unbound: Enlarging and Reshaping the Boundaries of the European Union*. London: Routledge.

Zimonjic, Vesna Peric. (2007). ' "New" Serbia Makes a Triumphant Debut on Eurovision Stage.' *Independent*. 14 May, accessed 5 November 2012. http://www.independent.co.uk/arts-entertainment/music/news/new-serbia-makes-a-triumphant-debut-on-eurovision-stage-448761.html.

Žižek, Slavoj. (2008). *Violence*. New York: Verso.

Index

Printed and bound in Great Britain by
CPI Antony Rowe, Chippenham and Eastbourne